BRITISH DESIGNERS AT HOME

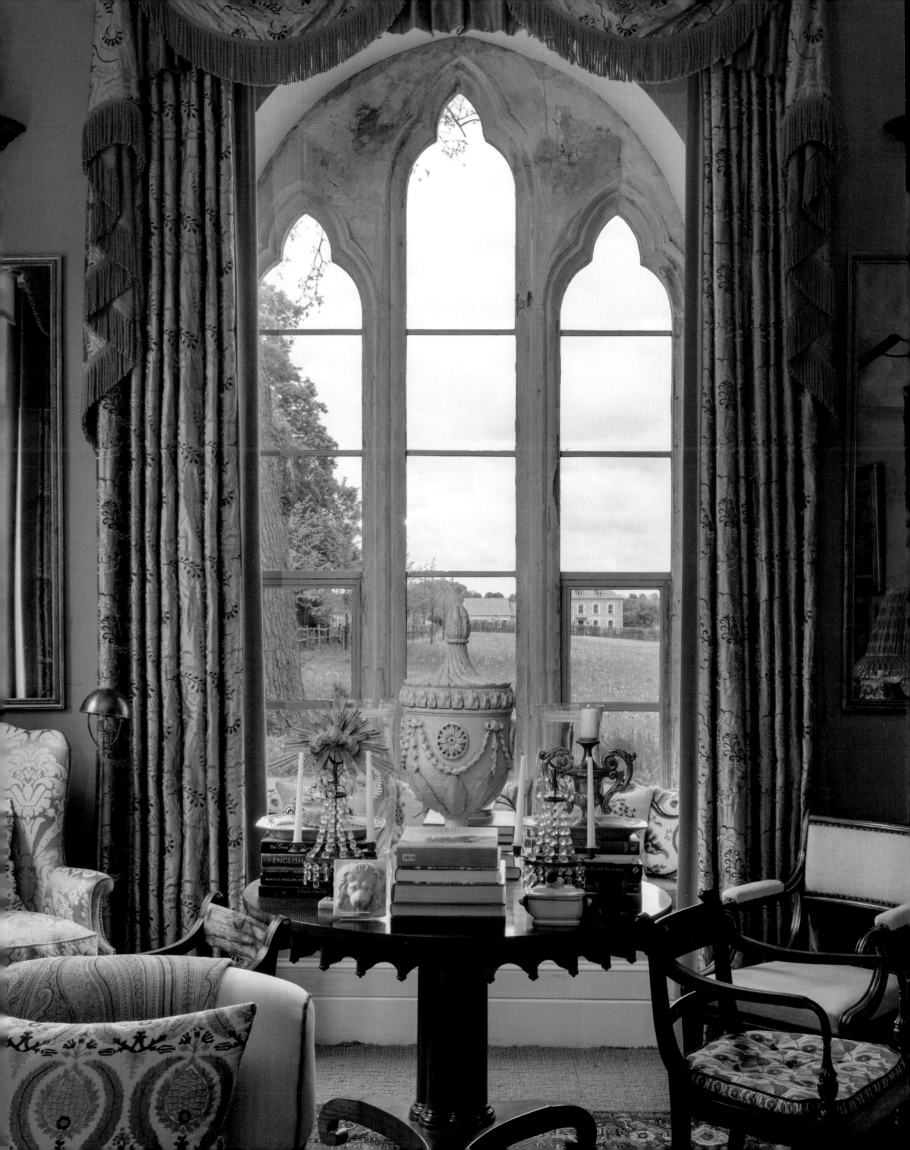

BRITISH DESIGNERS AT HOME

JENNY ROSE-INNES

Photography by Simon Griffiths

Hardie Grant

BOOKS

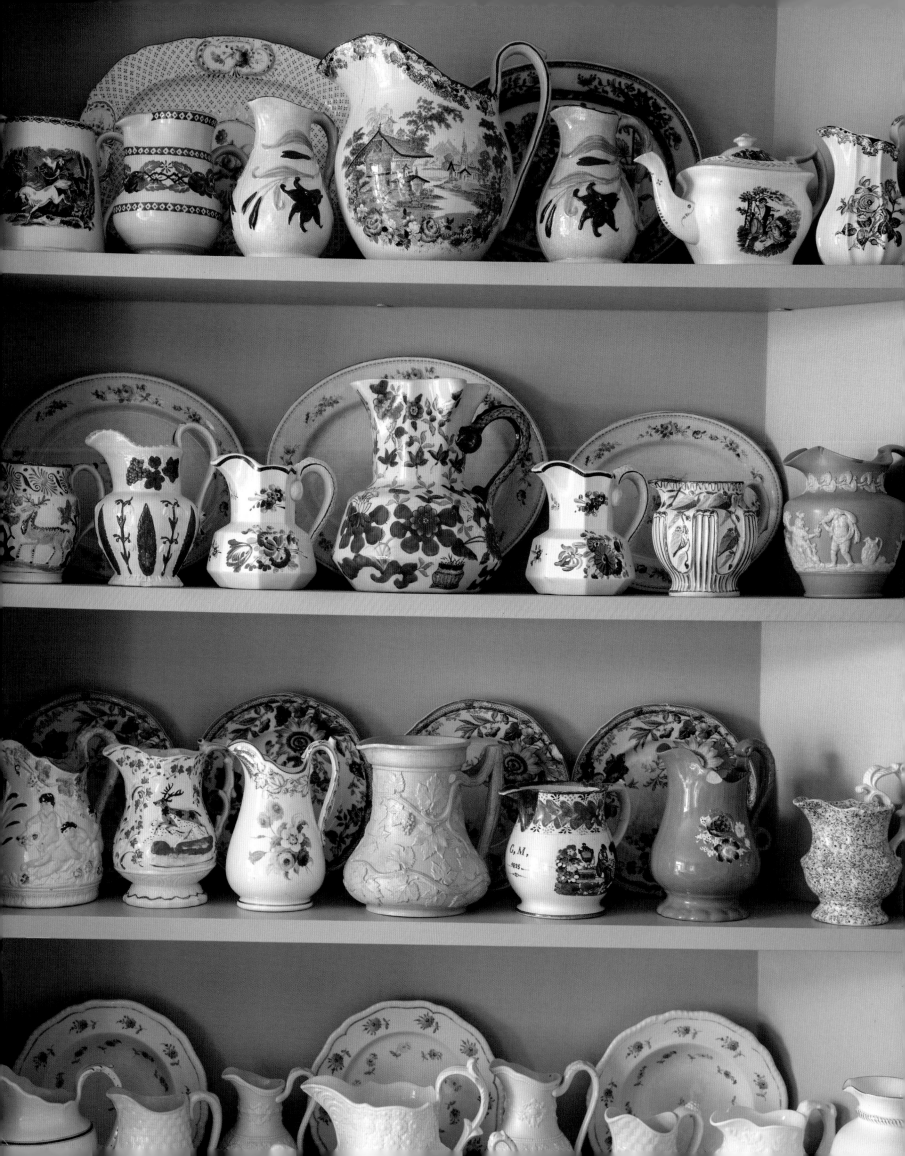

CONTENTS

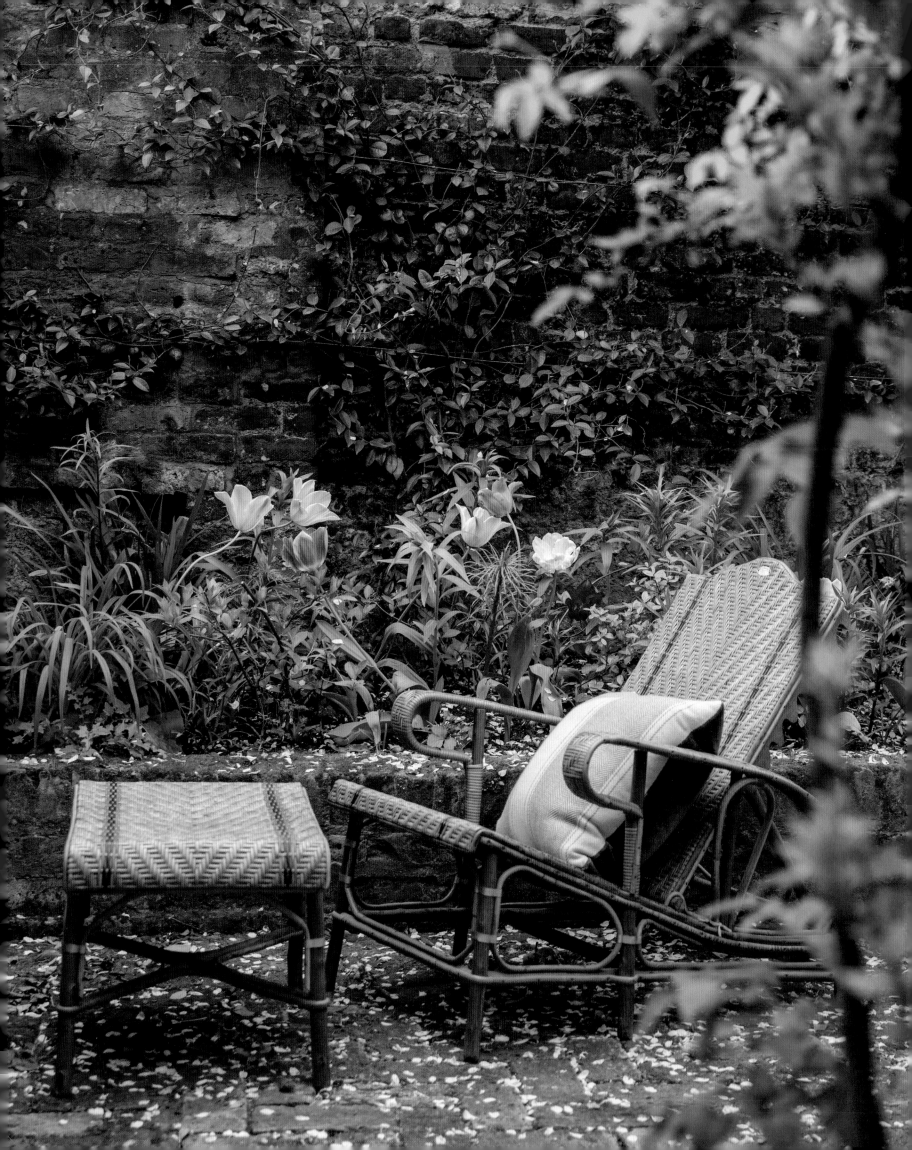

INTRODUCTION

A few years ago, the idea of writing a book on British interior designers would never have crossed my mind. My background in design is unconventional and, as a South African living in Australia, I would not have seemed the most likely contender for such a task. But, now, having done it, it almost appears inevitable that, somehow or other, I would have made it happen.

As a young girl, I fell in love with the English way of life – especially life in the countryside – through books. Every week, my mother and I would visit the library near our home in South Africa, and I would choose up to three books at a time. She encouraged me to read the books she had read as a child – at first it was Enid Blyton, and then I moved through *The Wind in the Willows*, *Lark Rise to Candleford*, the *Just William* books, Georgette Heyer and Jane Austen and on and on. In some ways, it was like looking at the British Isles through the wrong end of a telescope from a very long way away – it was intense and highly focused, and I was happy to get lost in a world that resonated strongly with me.

England was the very first country I visited on my first overseas trip when I was in my early twenties. I was overwhelmed by the beauty of the countryside and the excitement of London, and, having lived vicariously through the books of those authors I'd loved so much, almost felt as though I had come home.

Back in South Africa as a young woman, I devoured every British magazine I could lay my hands on. I'd pick up ideas from them, and try to imagine myself there. Then, in 1988, our family had the good fortune to move to Cheltenham for two years, and I was able, at last, to properly indulge my love of the British countryside and embrace as many aspects of English life as I could.

I was also able to nip up to London quite often. I would visit design centres and shops, and bookshops. I have always been interested in design and, over the course of my married life, have lived in many different houses, almost all of which my husband, Michael, and I have either built from scratch or renovated. Even as a young girl, I would help my parents redecorate various rooms in the house or plan renovations. However, having access to the shops and designers I'd only ever read about in magazines was thrilling. I particularly remember buying beautiful fabric from Nina Campbell's shop in Walton Street. I'll also never forget my first visit to the original Colefax and Fowler headquarters in Brook Street or to Robert Kime's shop in Museum Street.

Since our move to Australia in 2004, my passion for interiors has grown even more, mainly through meeting some of the local designers living here. I've come to realise that I make sense of the world, and really start to feel at home, through houses and gardens, and seeing how people live. Visiting those designers I'd met in their own houses prompted me to write my first book, *Australian Designers at Home*. I was interested in what had led them to design, and wanted to know how they tackled the design of their own homes.

Opposite. A favourite spot to relax in Beata Heuman's London garden.

As well as helping me to feel even more at home in my adopted country, working on the Australian book also led me back to the great design companies in the UK, and to the designers I had admired for so many years. Deciding to write to them with the idea of producing a second book about British designers seemed to be the next logical step.

I thought about who I'd like to feature, and decided that, as with the first book, it would be designers whose work resonated with me for one reason or another. Of course, I contacted those designers whose shops I'd first visited 30 years ago, and was more than delighted when they agreed to the prospect of having someone from the other side of the world land on their doorstep. I also got in touch with a number of others, including younger designers whose work I'd first come across on Instagram – the power of social media – and whose latest projects I look out for with great interest.

In all, we visited more than 20 designers at home all over the UK, which was my idea of a dream come true. As expected, each one had a very individual approach to design, but what all of them had in common was an ability to create a home, in the true sense of the word, that was just right for them.

The idea of home is almost always bound up in stories and the passing of time: the object passed down by a favourite grandmother; the thought of winter evenings by the fireside; the quiet hours spent reading a book in the armchair that catches the light at the right time of day. For me, having been brought up on a steady diet of English life, the opportunity of seeing these amazing designers at home, and getting at least some idea of how they live, was both a privilege and an honour. It was truly an experience I shall never forget. This book is a tribute to their creative minds and generosity of spirit.

Opposite. A detail of the early 19th-century Chinoiserie wallpaper in Edward Bulmer's bedroom.

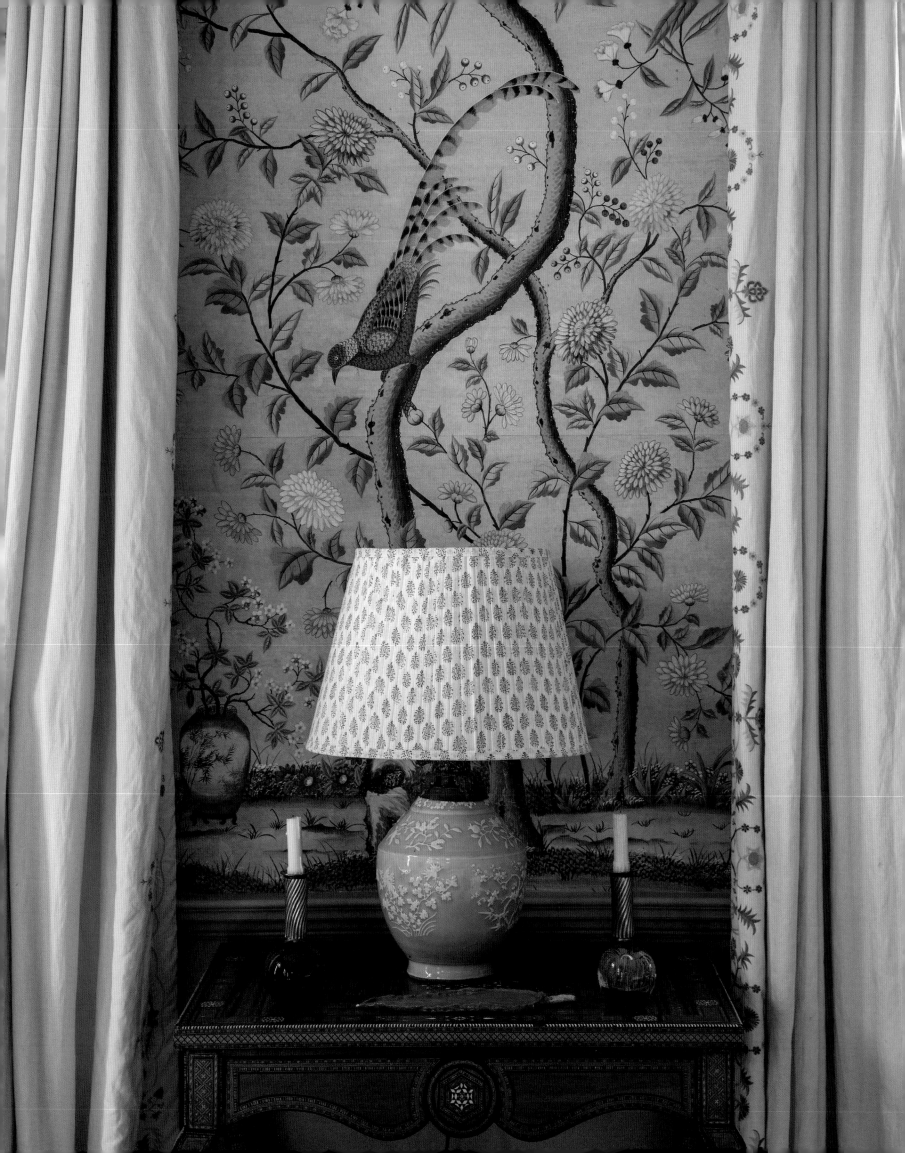

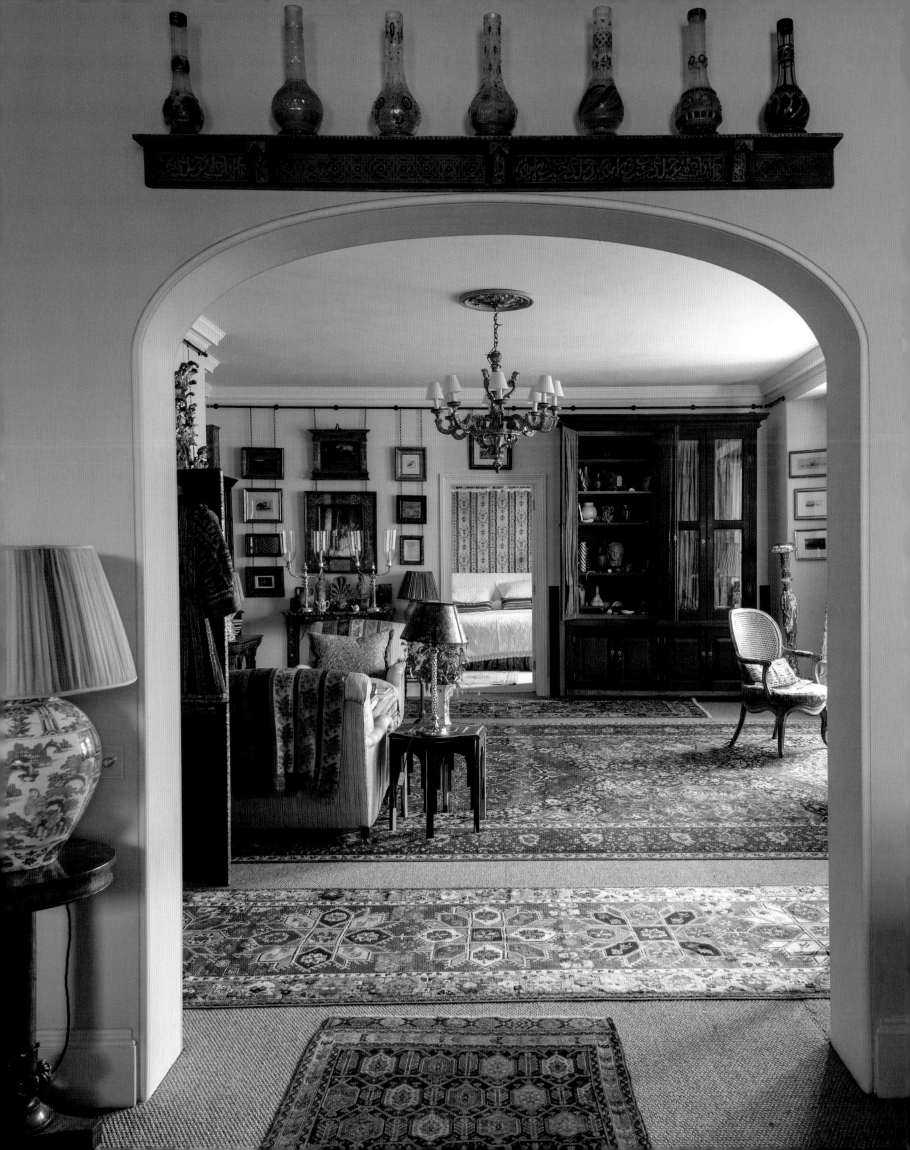

ROBERT KIME

For Robert Kime, every room starts with a rug. 'You have to start with something,' he says, 'and I always think a carpet is the easiest thing.' It doesn't need to be expensive. The Ziegler in his sitting room, for example, was bought in the local auction house in Marlborough, Wiltshire, near where he used to have a shop, 'and shows quite a lot of wear'.

A rug can define a space, break up a large room or highlight a particular area – it can play a number of roles. That worn rug, though, seems fitting, representing life and history, and providing a platform for his collection of fascinating objects.

With a background in antiques and a passion for history, it is unsurprising that Robert's London flat is full of interesting things, from a rare screen covered in Chinoiserie paper that he picked up at an auction for just a few pounds to William Wordsworth's own leather chair, which sits behind the desk in his study.

As a child, Robert, who started collecting coins at the age of five, used to spend hours in the garden shed, known as the 'green shed' even though it was black. It was piled high with 'junk' left behind by relatives who had gone to India. 'It was my idea of heaven – I used to muck about and play, and used to decorate it,' he says. 'This was probably when I was six or seven – so that's where I learnt how to do it. There were lots of pots, carpets, curtains – in those days, you didn't sell it, you stored it.'

He left home at 16, and later, while reading history at Oxford, was forced to sell the family's furniture, including the green shed's contents, due to financial hardship. 'I learnt the hard way what everything was worth, which was very important to me,' says Robert. 'I made a lot of mistakes – it wasn't easy, but we did it.'

For the rest of his student days, he took every Thursday off to search for antiques. 'I used to go around Oxfordshire on the bus, and do seven shops on the way to Burford, and seven on the way back.' He had such a good eye that he sold some of his finds to his college at Oxford and to the wife of the master of his college. 'I sold a marvellous Nollekens bust to Worcester College, which they've still got. I really enjoyed it, learnt a lot and ended up being quite well-to-do!'

His first job after university was with Miriam Rothschild, the mother of a college friend. She was selling her house and commissioned him to sell its contents. 'I was very fond of her and kept in touch for years,' says Robert. 'Whenever she was short of money, she would call me in to look through her stuff and find something to sell – she didn't trust anybody but me. I made some good discoveries there – she had a little watering can that had been made for Marie Antoinette.'

His path to design came through his work as a dealer. Clients admired his own home, and asked him to design theirs. His fabric and wallpaper range came about early on, when he realised his stock of old textiles wouldn't last forever, and that he couldn't find anything new he liked. 'I worked with a wonderful woman, Gisella Milne-Watson – we bring out six new designs each year.' With his own projects, he either uses antique textiles, often showing signs of wear, or fabrics he has designed.

Robert is revered in the design world, and his portfolio is impressive – he has worked extensively with the Prince of Wales as well as many well-known names in music and film, often decorating several houses for them. Perhaps part of his success comes down to his approach: 'I've never thought of myself as a designer – I don't really work like most designers,' he says. 'Working with objects, they have to mean something, and when you put them together, they mean something different.'

During his adult life, he lived in a number of houses with his wife, Helen Nicoll, author of the *Meg* and *Mog* children's books, and their two children. Looking at photos of each house in his book, *Robert Kime*, the same objects and pieces of furniture appear time and again, in different configurations. They're here, too, in the flat he has been in for the past three years, providing a sense of continuity and familiarity. Helen died in 2012, and the flat, a 10-minute walk from his shop in Pimlico, is the first place Robert has set up on his own since he was 23.

When he initially saw it, the third-floor flat was a jumble of panelled rooms. 'There were twice as many rooms as there are now,' he says. Part of its appeal was that it was 'tall enough', unusual for the third floor in the Regency building. He reconfigured the layout, knocking out walls, creating arches, installing fireplaces and changing the functions of various rooms, to create a richly layered environment.

The entry hall, which used to be a lavatory and cloakroom, gives a sense of what's to come, with its well-worn Turkish runner, enormous painting of dogs and horses, arrangement of rugs and pictures on the side wall, and statue in one corner.

Turning right from the hall, an archway leads into the light-filled sitting room. To the right of this is Robert's study, with its original William Morris carpet, and to the left, his bedroom, with views out over a steeple. The pale blue walls form a cooling backdrop for Robert's collection of artworks, textiles and objects. The flat is filled with flowers, following his visit to Covent Garden flower markets the day before our visit – one of the most notable arrangements is on the living room mantelpiece, as lidded pots alternate with vases of tiny bunches of lily of the valley.

Off the passage leading to the kitchen is the dining room, one wall of which is dominated by a George Gascoyne painting, which is so big it had to be brought in through a window. The deep terracotta colour of the walls is in contrast to the pale blue walls elsewhere. Past the kitchen is a guest room and bathroom.

Throughout the flat, Robert's love of history, travel, objects and art is evident, and so, too, is his skill in combining pieces. Seventeenth-century Chinese jars sit on kitchen cupboards; in the same room is a painting by Howard Carter, who discovered Tutankhamun's tomb. Egyptian figures stand on a side table in front of a painting of a pyramid. Ceramics from various places and of varying ages sit on every available surface, grouped together with an intriguing mix of objects, the original function of which is, at times, difficult for an amateur to determine.

A William Morris armchair in Robert's study is still upholstered in its original fabric; behind his desk is a framed 17th-century carpet from Aleppo that he found in Turkey. 'I go to Turkey a lot – I love it,' he says. The Chippendale four-poster in his bedroom is hung with an antique chintz, whereas the curtains in his study are of his own design. All Robert's artworks, which include an Eric Ravilious watercolour and medieval paintings, are hung on chains from a brass rail to make them easier to move from place to place – a sign of the impermanence of any one scheme.

It's hard to believe he has lived in the flat for such a short time; it looks as if it has evolved over years. It's even more of a surprise to hear it only took a matter of weeks to put the whole scheme together. 'I work quickly,' he says. I ask him if it feels like home now. 'Yes, it's fine – I think I like it here,' he says.

'I LEARNT THE HARD WAY WHAT EVERYTHING WAS WORTH, WHICH WAS VERY IMPORTANT TO ME. I MADE A LOT OF MISTAKES – IT WASN'T EASY, BUT WE DID IT.'

Opposite. An English School painting of the Great Pyramid of Giza hangs beside the fireplace in the study. Egyptian figures are arranged on the Frosterley fossil marble-topped table.

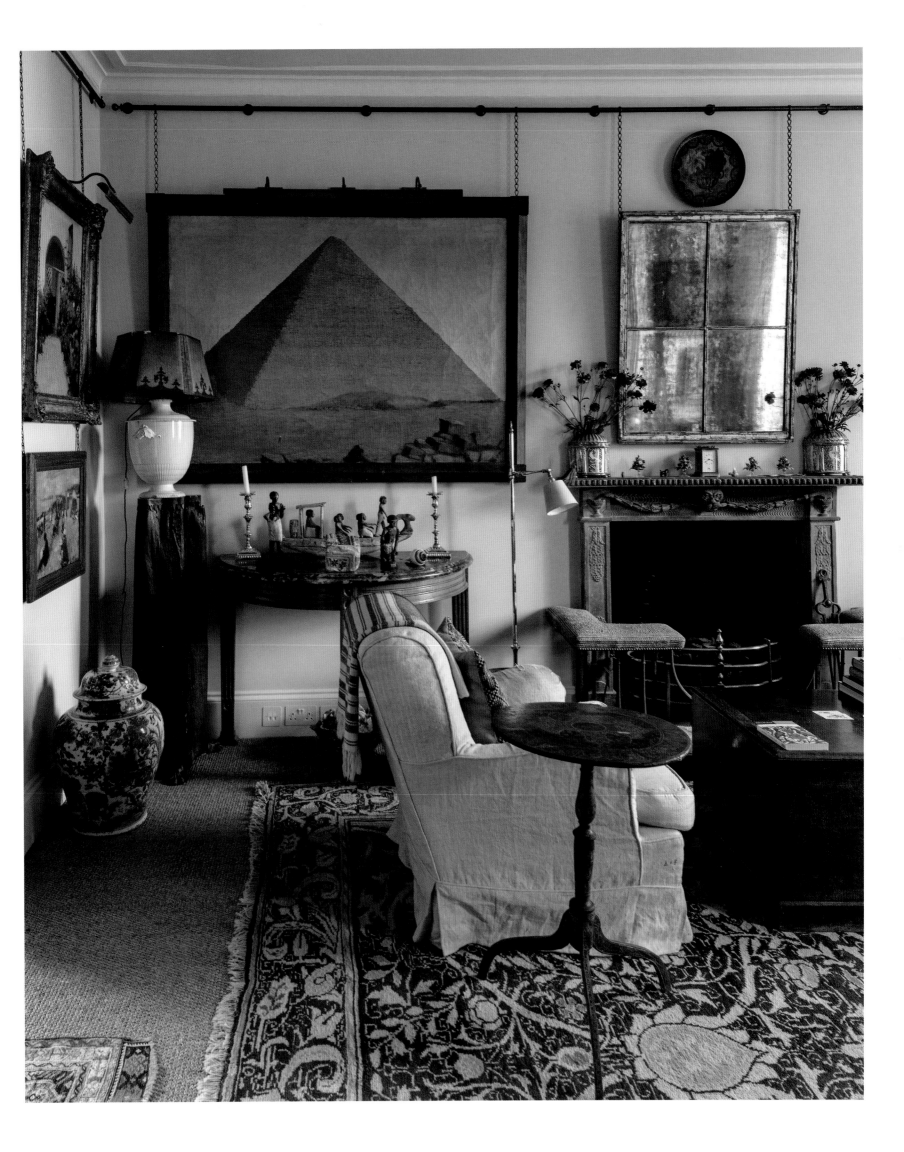

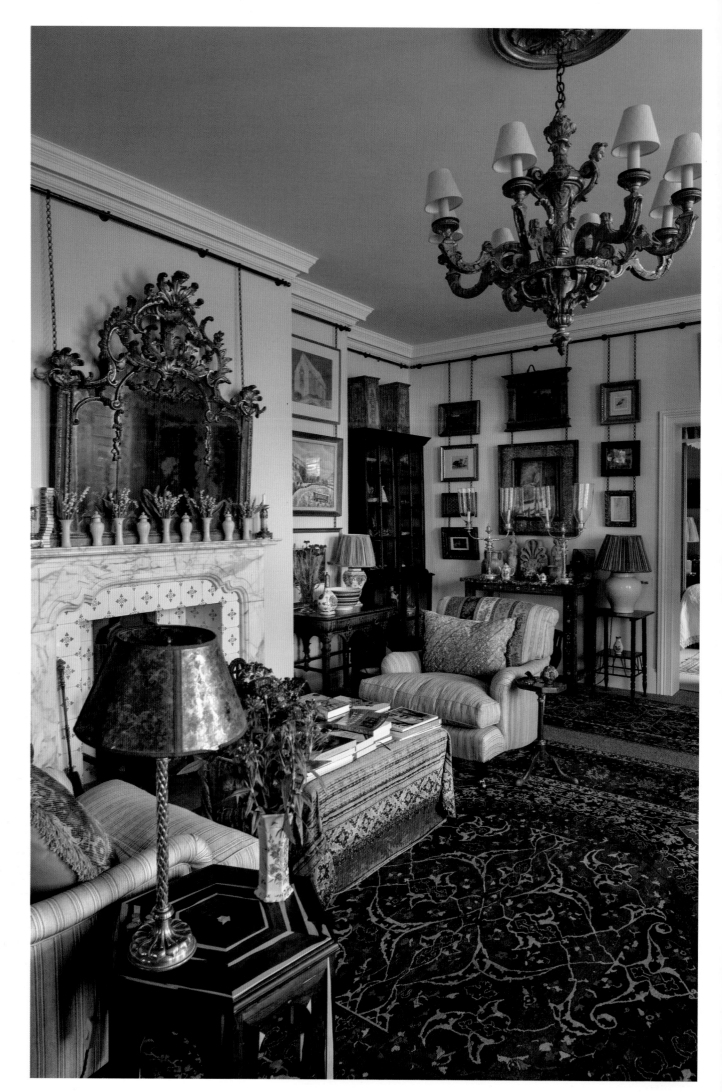

This page. When Robert moved into the flat, he installed new fireplaces and radically opened up spaces. Robert Kime Savernake chairs in the sitting room are upholstered with his 'Tynemouth Ticking' fabric. The mirror is 18th-century and northern Italian.

Opposite, clockwise from top left. A corner of the dining room; the George Gascoyne painting in the dining room is so big it needed to be brought in through the window; a watercolour by Eric Ravilious; a large painting of horses and dogs in the entrance hall.

Overleaf. Antique Brangwyn fabric has been used for both curtains and headboard in the guest bedroom. Wall-mounted Robert Kime Paris lamps hang on either side of the bed.

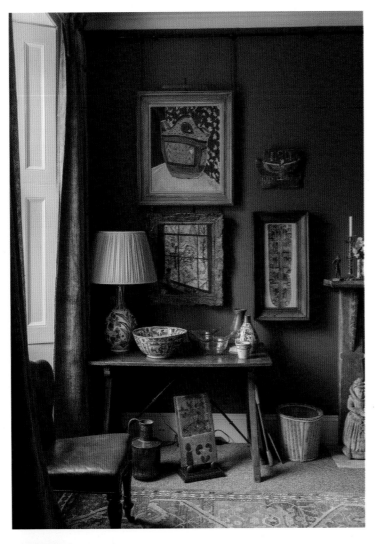
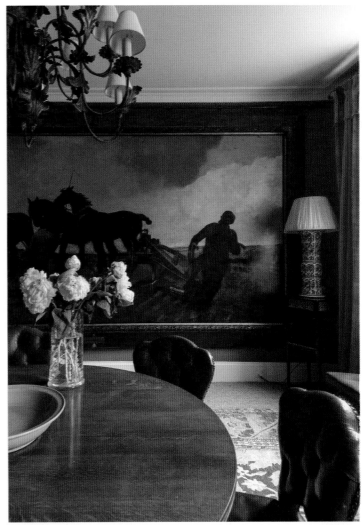
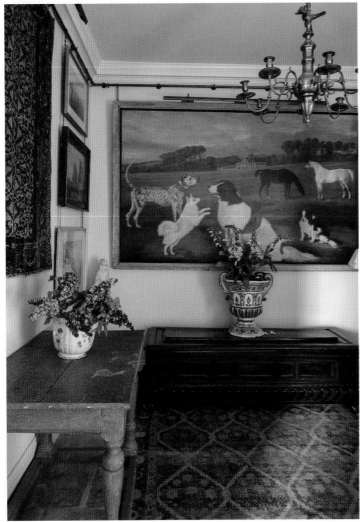
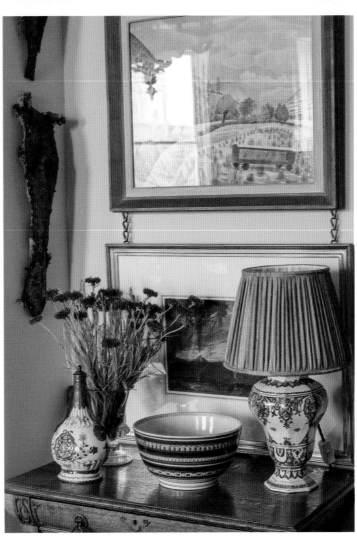

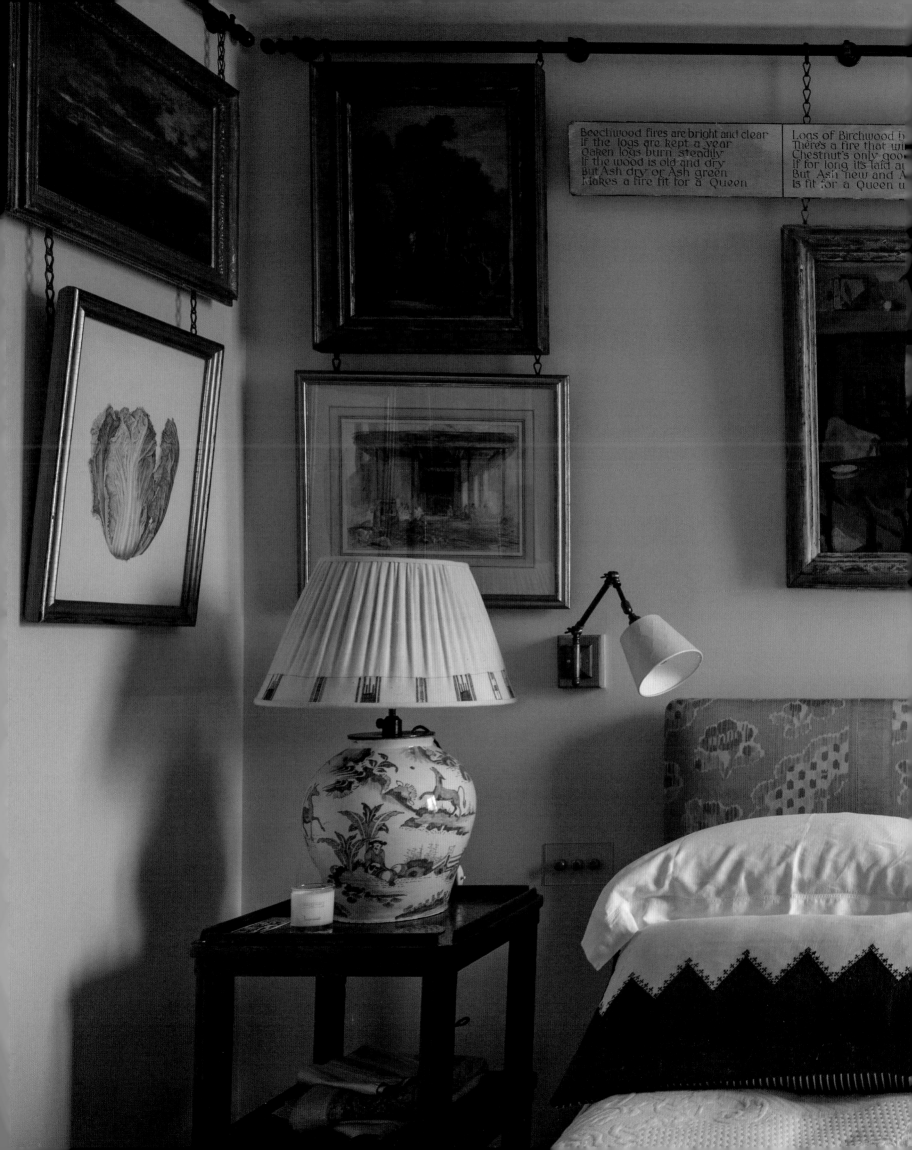

Beechwood fires are bright and clear
If the logs are kept a year
Oaken logs burn steadily
If the wood is old and dry
But Ash dry or Ash green
Makes a fire fit for a Queen

Logs of Birchwood b...
There's a fire that wi...
Chestnut's only goo...
If for long its laid at...
But Ash new and A...
Is fit for a Queen u...

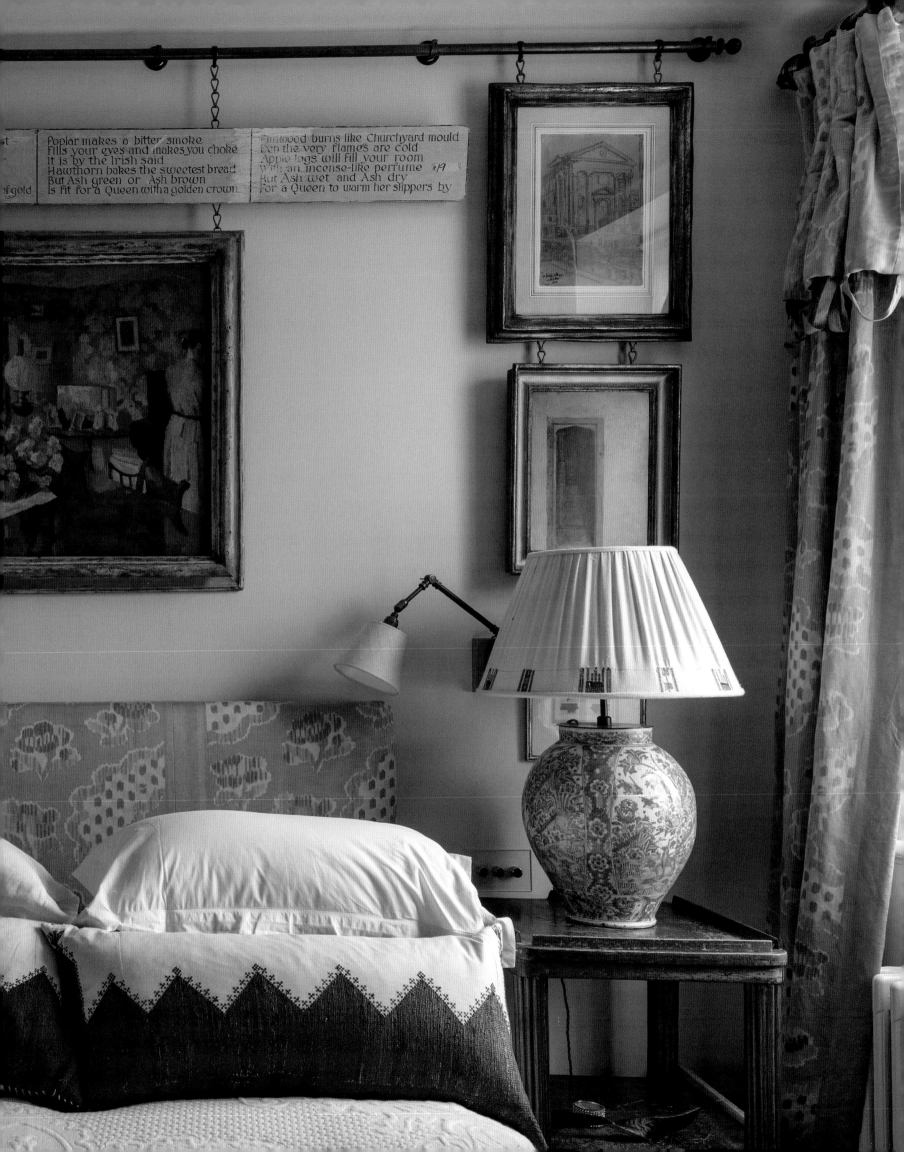

Poplar makes a bitter smoke
Fills your eyes and makes you choke
It is by the Irish said
Hawthorn bakes the sweetest bread
But Ash green or Ash brown
Is fit for a Queen with a golden crown

Elmwood burns like Churchyard mould
E'en the very flames are cold
Apple logs will fill your room
With an incense-like perfume
But Ash wet and Ash dry
For a Queen to warm her slippers by

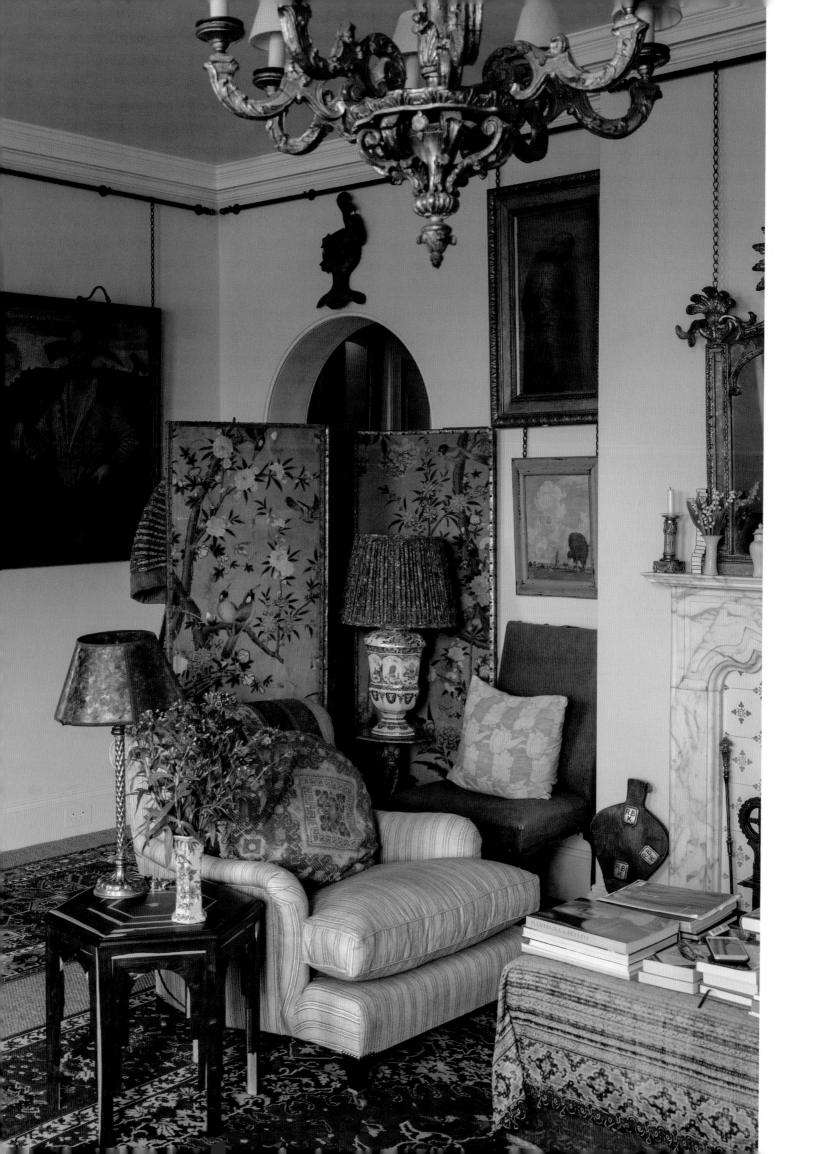

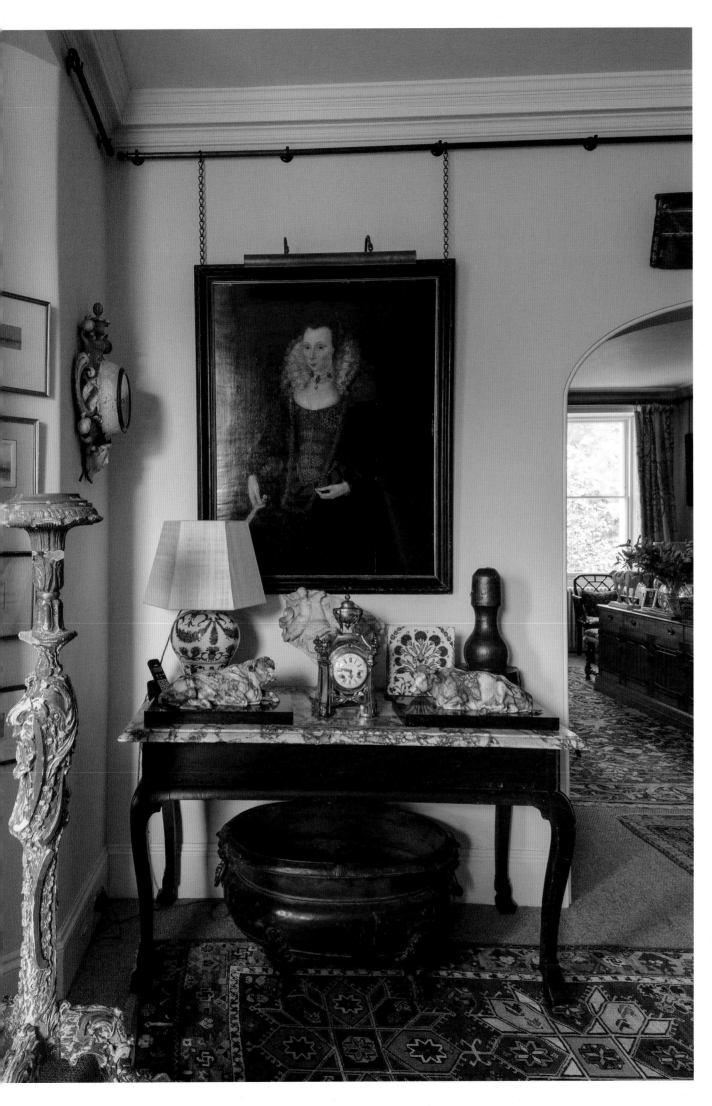

Opposite. The screen in the sitting room, covered in Chinoiserie paper, is one of the first things Robert ever bought. An early 19th-century Delft blue and white vase has been converted into a lamp, with an antique fabric shade. All artwork hangs on chains from a Robert Kime brass rail.

This page. An English school portrait of a lady, circa 1600, hangs above a George II oak and marble-topped side table, with 18th-century European bronze cistern beneath. The wall colour is Little Greene 'Gauze Mid'.

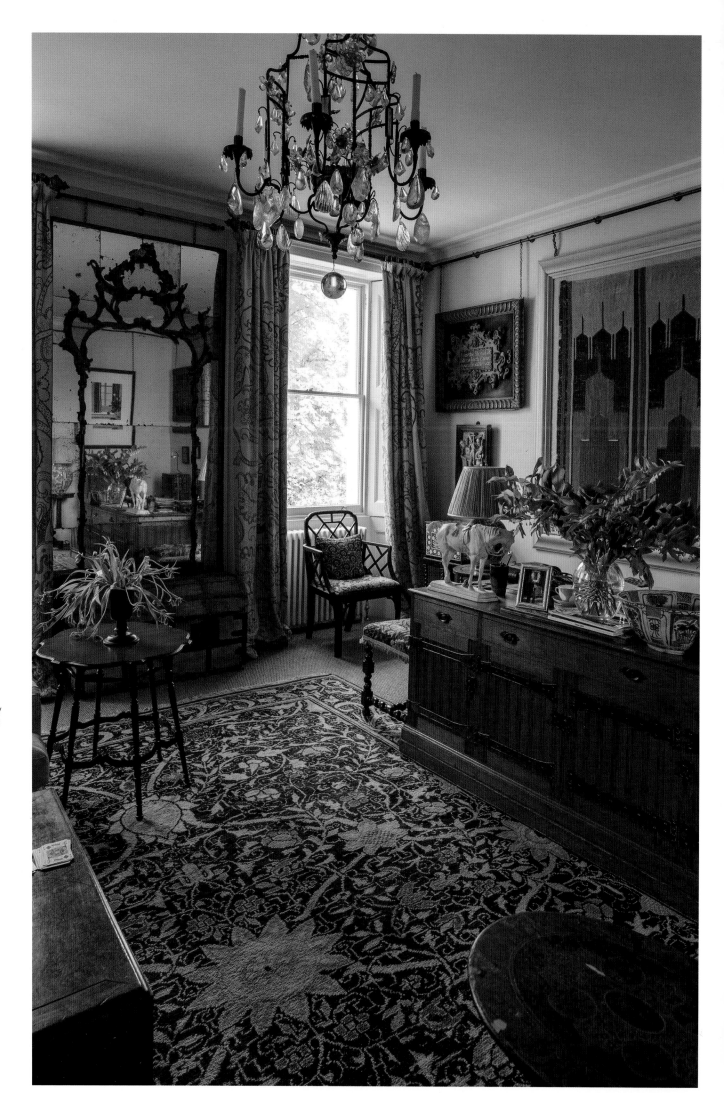

This page. In Robert's study, a much-loved framed 17th-century Aleppo carpet, which he found in Turkey, hangs behind his desk. The wool Arts and Crafts carpet is by William Morris.

Opposite, clockwise from top left. A collection of 17th-century Chinese jars sits on top of the kitchen cupboards; a portrait of Sir John Gilbert hangs above a George III serpentine commode; in Robert's study, David Hockney's *Rue de Seine* provides a contrast to the William Morris chair, still upholstered in its original fabric; crewelwork curtains add further richness to the scene, which includes framed carved and painted psalms from the 16th century, a medieval alabaster panel of Christ in the Garden of Gethsemane and an Indian inlaid hardwood cabinet from the late 17th or early 18th century.

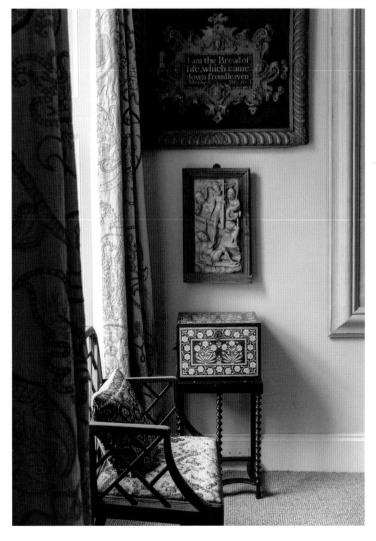
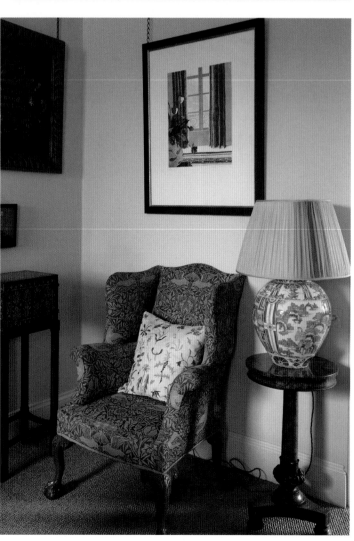

Q&A

How do you like to relax?

By reading – anything. All my books would fill this house, and I've got to sort them out, but just can't face it. Actually, I might sell them.

Is there any designer you particularly admire?

Geoffrey Bennison was a marvel. You see, he was an artist first, then became a dealer and then a decorator. It was like that for me, too. He had such an eye for objects – I really understood it when I saw him. I loved him – he was wonderfully funny, but died too young. He used to come to visit us when we lived in Wiltshire, and once I found him sitting in the drawing room. I asked him what he was doing, and he said, 'I'm just learning.' He was working out what I had done, and why.

Flowers or foliage?

I love flowers – I like going to the market and getting them. I put them all in a box, then get a taxi and bring them home. In the country, I always had a garden – I loved making them. In France, I made an Islamic garden. It has a rill, which runs all the way through one part of the garden; on either side, I planted pale blue irises and a row of quinces. I'm crazy for Islam – I go to the Middle East twice a year with an Egyptian friend, and we just go where we want. I used to go to Syria, and can't bear what's happened there – it was so beautiful.

Do you still collect anything?

Old textiles – I'm always looking for them.

Is there anything you'd change about this flat?

Yes, I'd like all the lights to work!

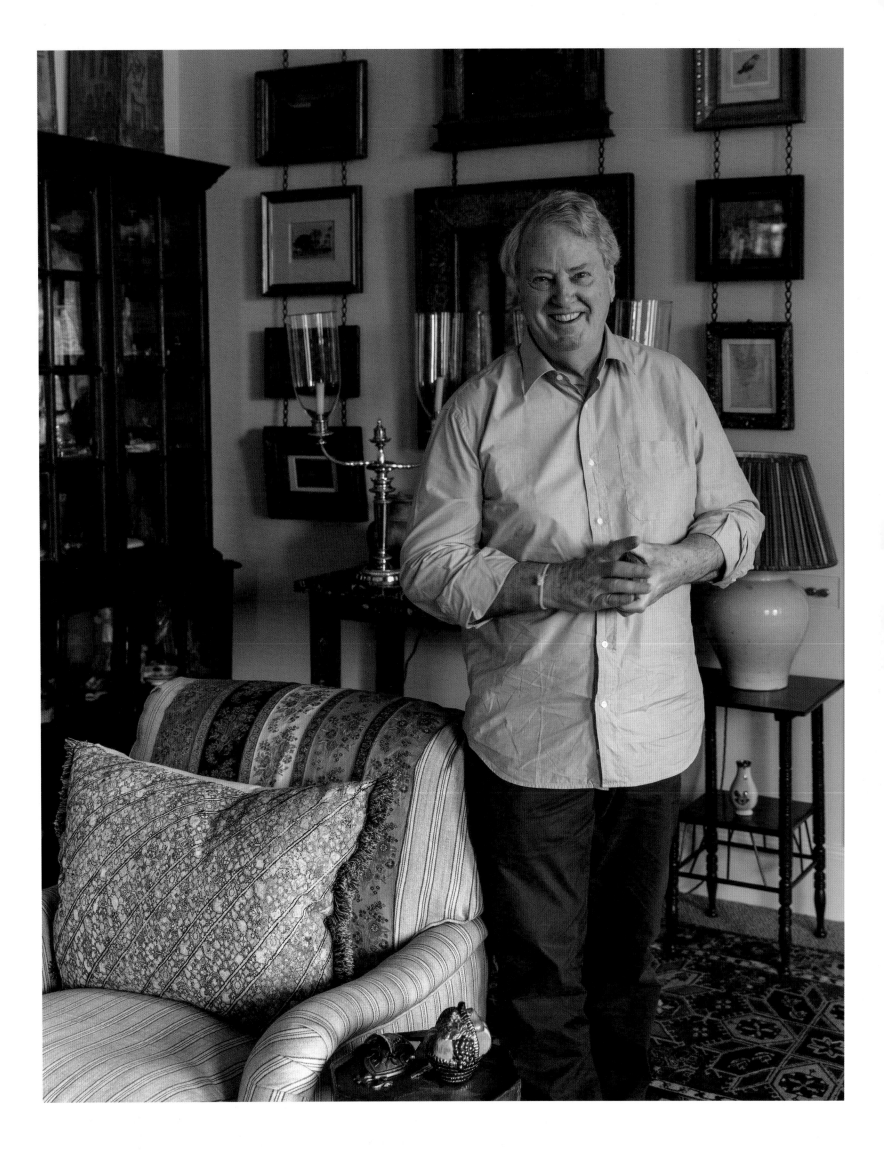

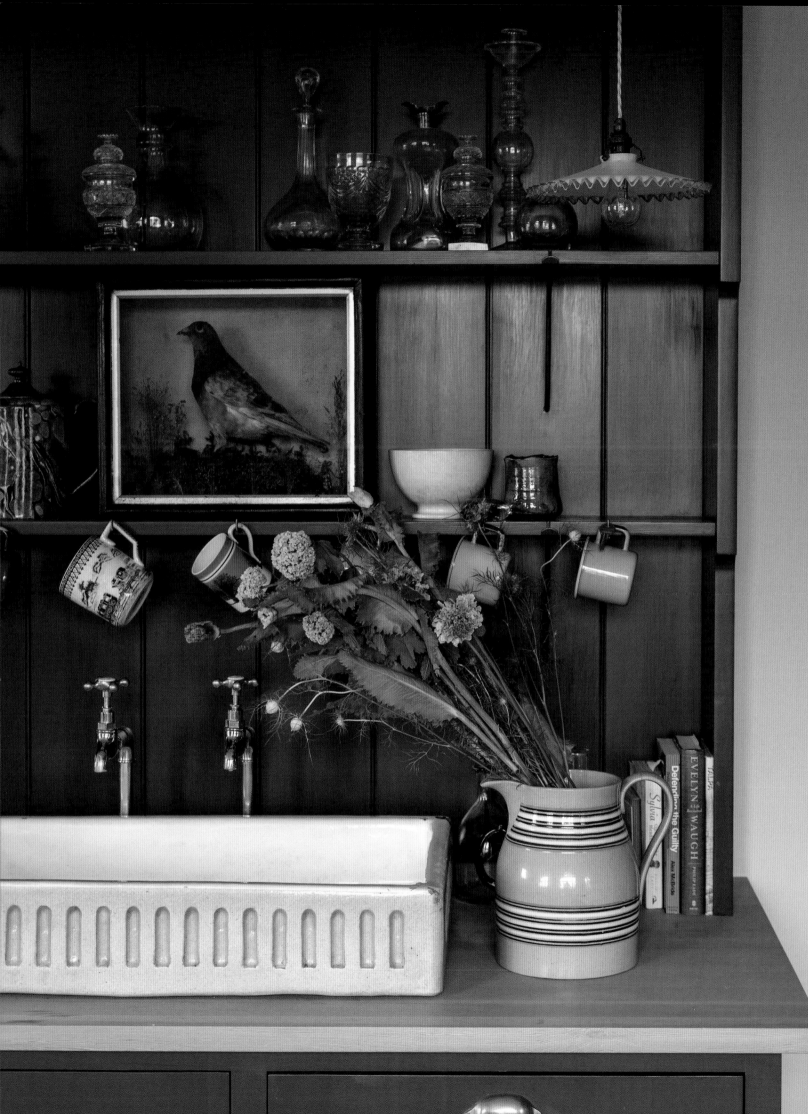

RITA KONIG

When we visited Rita Konig at her farmhouse in County Durham, she and her husband, Philip Eade, hadn't yet decided which bedroom they wanted to sleep in. 'We're currently floating between bedrooms to find out where we want to be!' she says. More than anything, this epitomises her non-prescriptive attitude to design – she didn't walk into the house and immediately put in place her plans on exactly how the couple and their young daughter, Margot, should use it. 'I didn't want to make set decisions but, rather, wanted to make sure the house looked as if it had evolved over time, and not look too decorated.'

The rambling stone house has been in Philip's family for generations, but had been rented out for many years. 'When I first saw it about four years ago, I realised its potential,' says Rita. 'It wasn't falling down, but was just shabby and a bit of a brute, with Sixties windows and awful bathrooms with plastic shower curtains.' There were also long corridors, a maze of little rooms and an internal staircase that was dark and uninviting.

'We managed to get rid of all the corridors and open up the rest of the house,' she says. 'We had to remove a couple of floors and rebuild them, but then began to realise that we didn't want to do unnecessary things.' As well as dealing with damp issues and replacing the roof, the staircase was moved, and the garages converted into a kitchen/dining room and scullery, with two bedrooms and bathrooms overhead, bringing the total to seven bedrooms and five bathrooms.

'I love having somewhere for people to come and stay,' says Rita. 'The bedrooms work very easily because of the positions of the bathrooms – everyone feels as if they have their own, even though they aren't "en suite". It just doesn't feel like the kind of house that should have en suite bathrooms.'

The new kitchen wing is now one of Rita's favourite parts of the house. 'I was worried that it would be dark, as it's on the north side of the house,' she says, 'but the northern light is so pretty, and we have the morning light streaming in through the eastern windows as well.' It also overlooks what Rita refers to as 'the lumpy field, which is so nice to look at' – in reality, a buried medieval village on their land. 'It's a heritage site, and no-one is allowed to plant anything or build anything there.'

The timber kitchen was designed by Christopher Howe and made by Plain English. It's traditional in style, but even here, in this room, are signs of Rita's distinctive take on design – classically English on the one hand and yet individually modern on the other, with a mix of restraint and whimsy, cheerful bursts of colour and a slightly unconventional approach. 'I've learnt along the way that there aren't rules – it doesn't matter. It's amazing how much doesn't matter.'

Her love of colour is most in evidence in the sitting room, with its rich green walls, curtains lined in blue fabric, vibrant artworks, mismatched upholstery, and a colourful rug that came from Robert Kime.

Opposite. A vintage stuffed pigeon, bought on Instagram, inhabits the kitchen shelves, among an array of decanters, candlesticks and other pieces that Rita has either collected or inherited.

One aspect Rita particularly loves about the house, which the family uses for weekends and holidays, is the opportunity to put together things that she's bought 'at fairs or on Instagram late at night'; or that once belonged to friends, and 'old things that were in my mother's storage'. In one of the bedrooms, for instance, the delicate lace curtains behind the four-poster William Yeoward bed were a gift from her mother, the designer Nina Campbell. In another room, there are six watercolours of a Sir John Soane-designed house that her father was born in.

Rita showed a flair for interior design when she was very young. 'I grew up in London and was always very interested in what was going on,' she says. 'I went with my mother Nina to trade fairs from an early age, and realised there was a great deal of excitement in gathering stuff to decorate a room. I much prefer that side of things to just choosing the fabrics.'

Her first job was as a researcher for fashion and art journalist and biographer Meredith Etherington-Smith, who was, at the time, working at *Harpers & Queen*. Rita then went to work in Nina Campbell's shop, took on a few design projects and also began writing columns for magazines and newspapers. She did contemplate opening her own shop, but decided against it and, a short time later, wrote her first book, *Domestic Bliss*. She later moved to New York, without much of a plan, but ended up writing more and building up her design portfolio. 'I loved my time in New York, but ultimately my heart belongs to London,' she says. 'I was there for six years and have huge affection for it. I have wonderful friends in the US and still work there a lot.' Recent jobs include a hotel in Los Angeles and new houses in Martha's Vineyard, Sag Harbor and Nashville.

Soon after, when she moved back to London, she started doing workshops at home, sharing her knowledge of design, revealing her sources, and giving practical advice on how to create comfortable spaces. 'They have been very popular,' she says. 'Some of my friends didn't want a decorator and wanted to do it themselves, which made me realise the gap in the market.' As well as slotting these in between design projects, Rita still writes for magazines, and designs furniture, bedlinen and other homewares, which she sells from her online shop. She has also recently launched an online decorating course.

Meanwhile, the farmhouse is an ongoing project. 'We want to plant an orchard and lots of trees,' says Rita. 'I'd also love to do something with the barns – one is a medieval chapel and it would be lovely to have meals in there.' There's a sense, though, that the house will never quite be finished, and she likes it that way. 'It's good to leave gaps in a room, so that you can add things or change things later.'

'I DIDN'T WANT TO MAKE SET DECISIONS BUT, RATHER, WANTED TO MAKE SURE THE HOUSE LOOKED AS IF IT HAD EVOLVED OVER TIME, AND NOT LOOK TOO DECORATED.'

Opposite. The TV room was designed to comfortably fit in as many people as possible to watch a movie or football match. Rita likes the contrast here between the delicate wallpaper, 'Arbor Day' by Twigs, and the more robust furnishing fabrics. The sofa is upholstered in 'Charlton' ginger corduroy from Tissus d'Hélène.

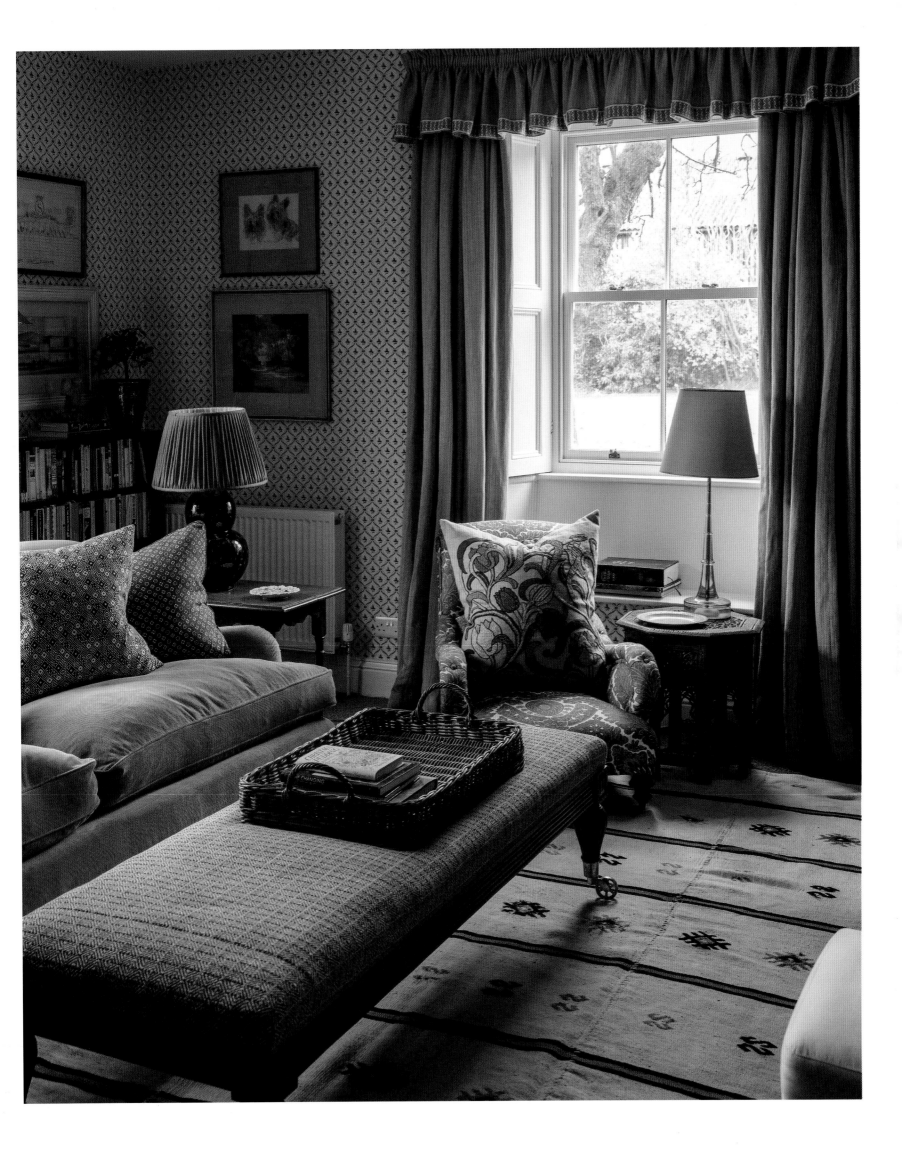

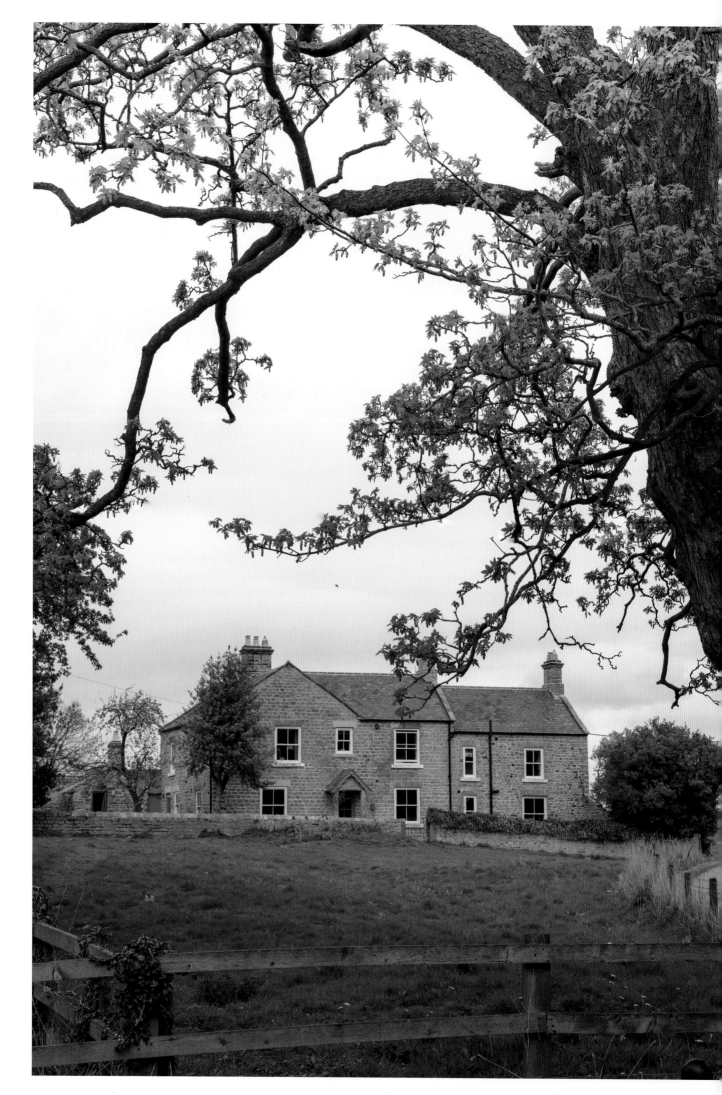

This page. A long gravel driveway leads up to the stone house.

Opposite, clockwise from top left. A bucolic scene on the mound of the buried medieval village; boots and shoes, including slippers designed by Penelope Chilvers and the late William Yeoward for his Screw Cancer charity, are lined up beside an antique Swedish bench, from William Yeoward; the kitchen, which is part of the new wing, features a 19th-century Italian table, with antique Cotswold ladderback chairs.

Overleaf. When Rita was renovating the house, she realised early on that she'd never been in a green room she didn't like, so decided on Edward Bulmer's 'Invisible Green' for the sitting room, which is mostly used at night. She wanted everything in the room to be harmonious, but not coordinating, to give the feeling that it had evolved over time.

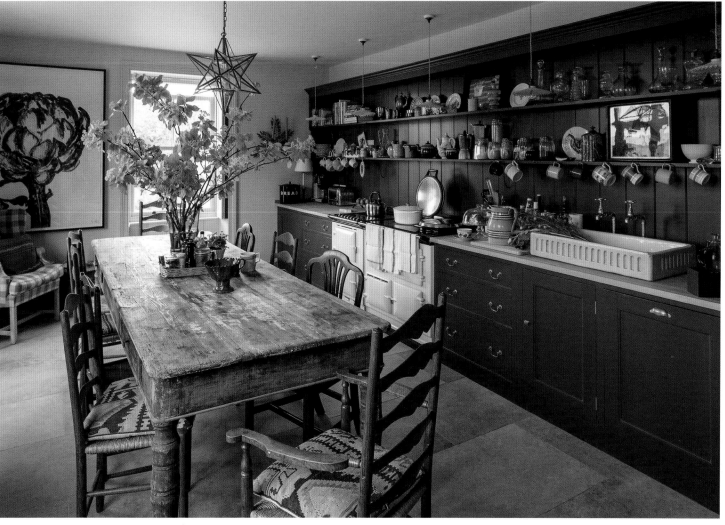

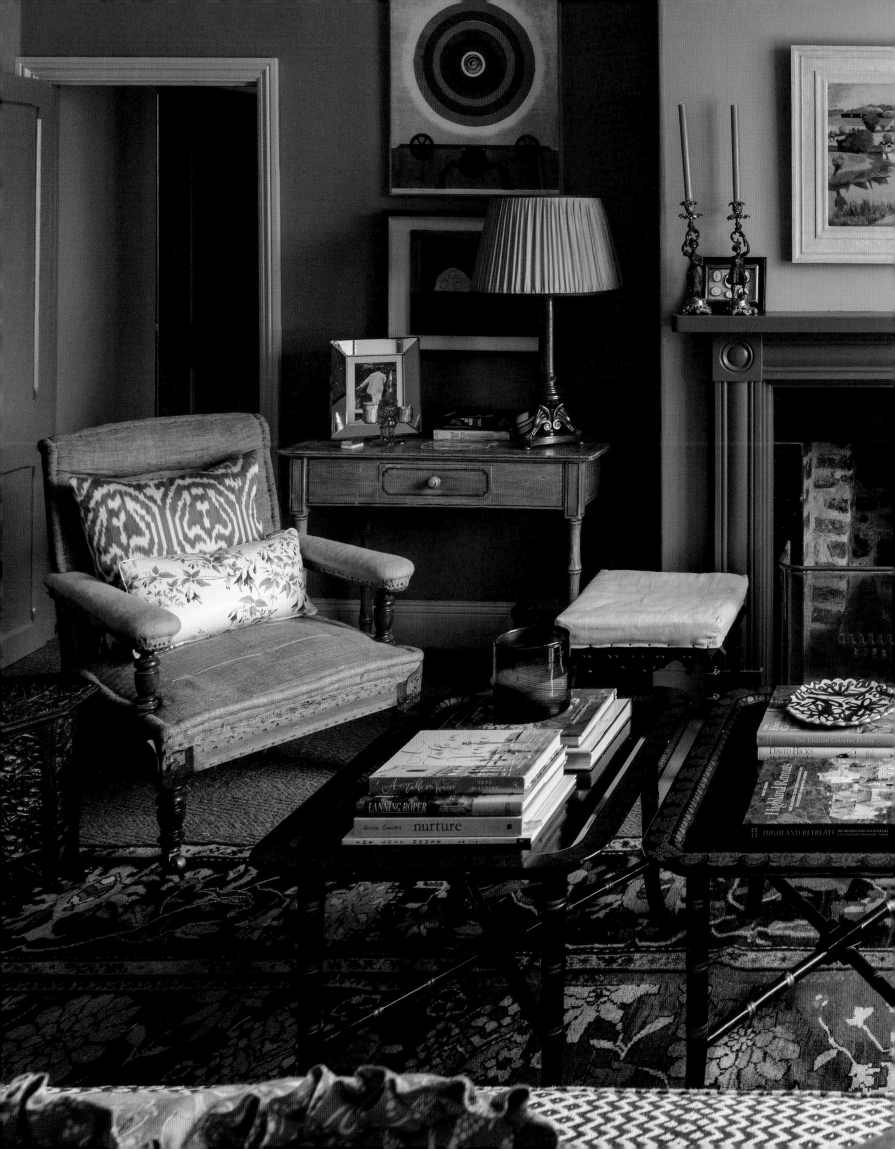

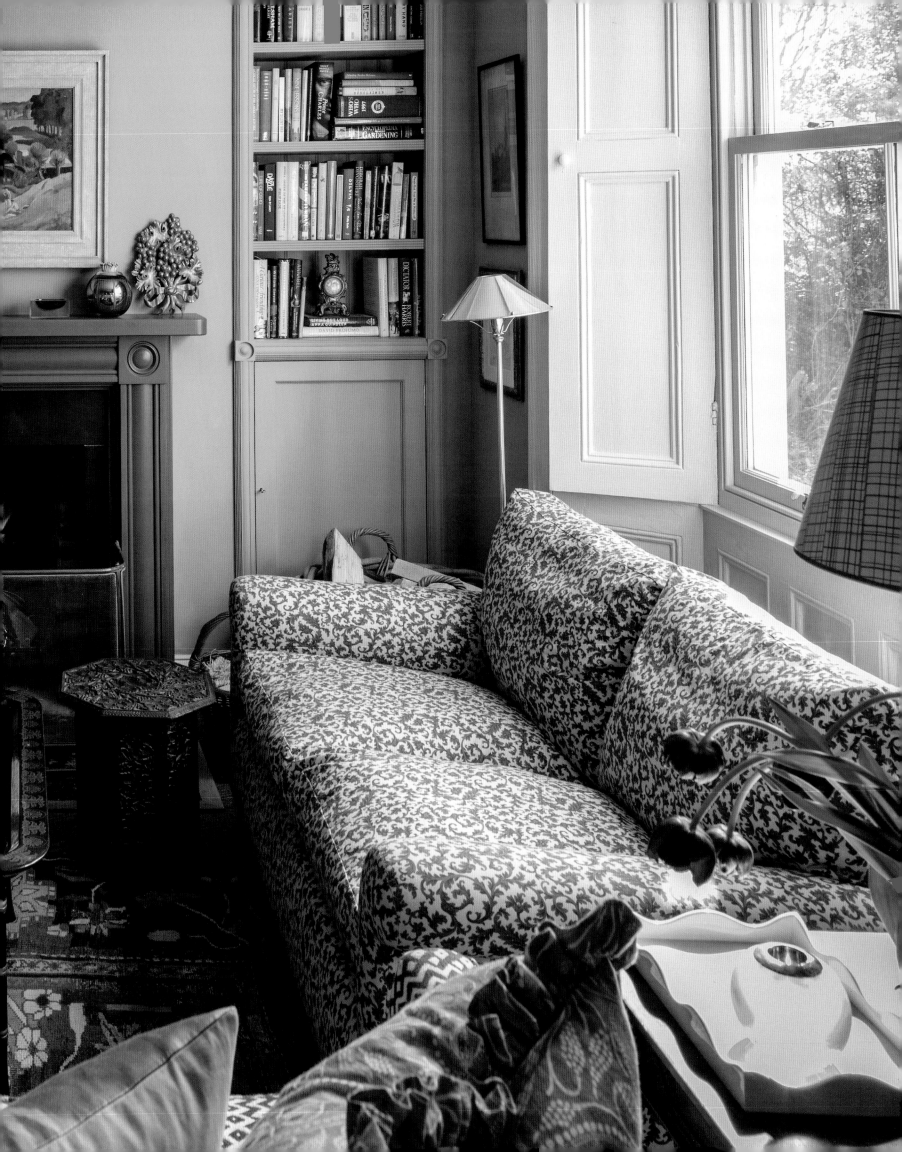

This page. One of the bedrooms is papered in 'Belle Île' by Nina Campbell. Rita inherited the Cotswolds chair from her father.

Opposite, clockwise from top. Rita's whimsical approach to design can be seen in a bedroom, in which walls, an armchair and sofa are covered in mismatching Schumacher fabrics; Rita designed the headboard, and covered it in Schumacher 'Knox' cotton in Rose; vintage fabric, bought in the States, is used for the blind in the bathroom.

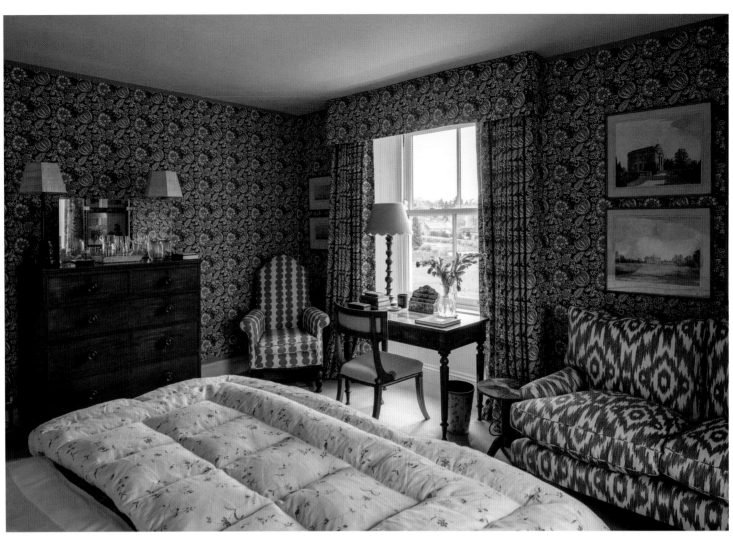
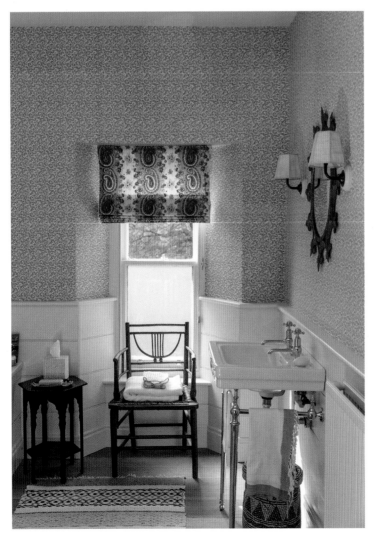
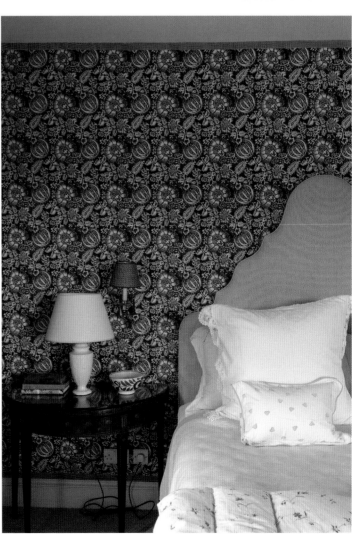

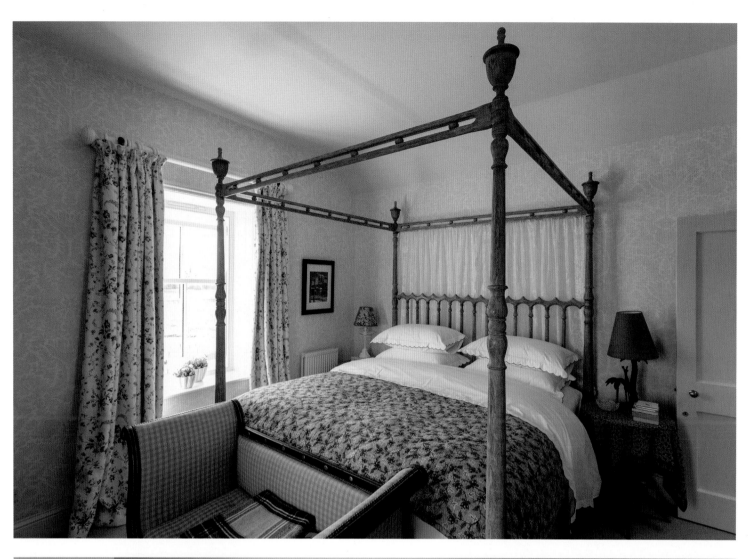
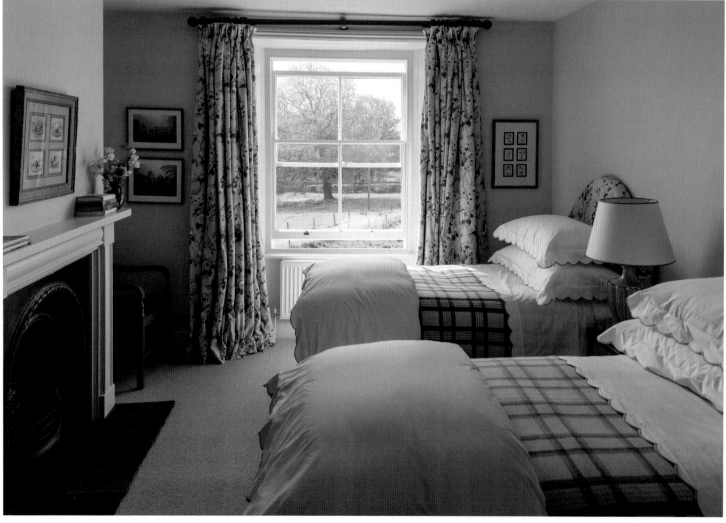

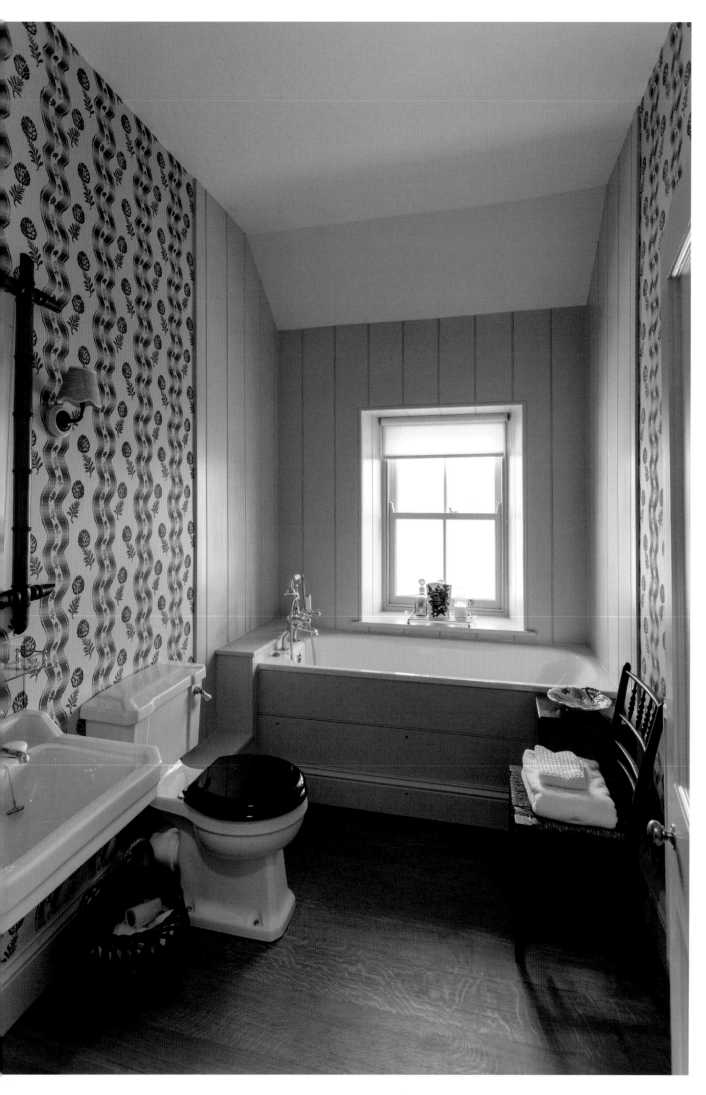

Opposite, above. The Morris four-poster bed by William Yeoward in the main bedroom is dressed with bed linen from Angela Wickstead and a vintage quilt from Katherine Poole.

Opposite, below. Rita wanted this guest bedroom to be appealing to both adults and children, and made the curtains and bedheads in the same Jean Monro 'Hydrangea & Rose' chintz.

This page. A bathroom is papered in 'Pommes de Pin' by Le Manach, which contrasts with the simple wall panelling and English oak flooring.

Q&A

What's your idea of home?

Where you collapse at the end of the day, where your friends gather. It's a living thing rather than something static. I always think of a room as a place where I will sit, rather than how it will look from the doorway. So, a smell, a feeling, a sound...

Do you have a mentor?

William Yeoward – I loved the way William and Colin Orchard did their rooms and tablescapes. I also love how Christopher Howe lets things be so chic, but also old and utilitarian, and Robert Kime for the softness in the way he decorates. And Bryan Ferry for his terrific eye and how he puts things together.

How do you begin a project?

With a furniture layout before any fabrics. Then, by osmosis, the room starts to speak to you. The flow that follows is so exciting.

How would you describe your design aesthetic?

I guess there's an American influence – the crispness of America, mired with a more English classical, traditional, comfortable, practical and a modern unstuffiness.

Do you like to change things?

Of course – I get to indulge those desires on other people! It's a good trade to be in if you like shopping.

How are you at cooking?

I like it, but very rarely have time to do it. And then I don't know what to do, so it usually ends up being roast chicken. I need to plan menus more!

Do you collect anything in particular?

I love plates, pottery, and I suppose that suggests people coming for dinner. I love china and glass and having a drink – in a glass that I have to wash myself and dry properly. Beautiful glass is my weakness and it must sparkle!

Flowers or foliage?

This is the first time I've really done foliage, but I think it works in the country.

What can't you live without?

Freshly laundered sheets.

What's your idea of luxury?

Pressed linen, the smell of pressed linen. Also 'enough'. How the Italians are masters of the perfect-sized plate of pasta etc. Too much is a burden, not enough feels poor.

How do you relax?

What I find really relaxing is to be on my own, shopping in a junk shop.

How do you spend weekends here?

We all take ages to get up, which is quite nice. Then have long breakfasts, and might go out to the pub for lunch. We're still getting to know the area, so we go exploring. We need to start walking, too!

What would you grab if there was a fire?

The oil painting of tulips my mum gave me, and probably my jewellery box. But the weird thing is that once something is gone, it's gone.

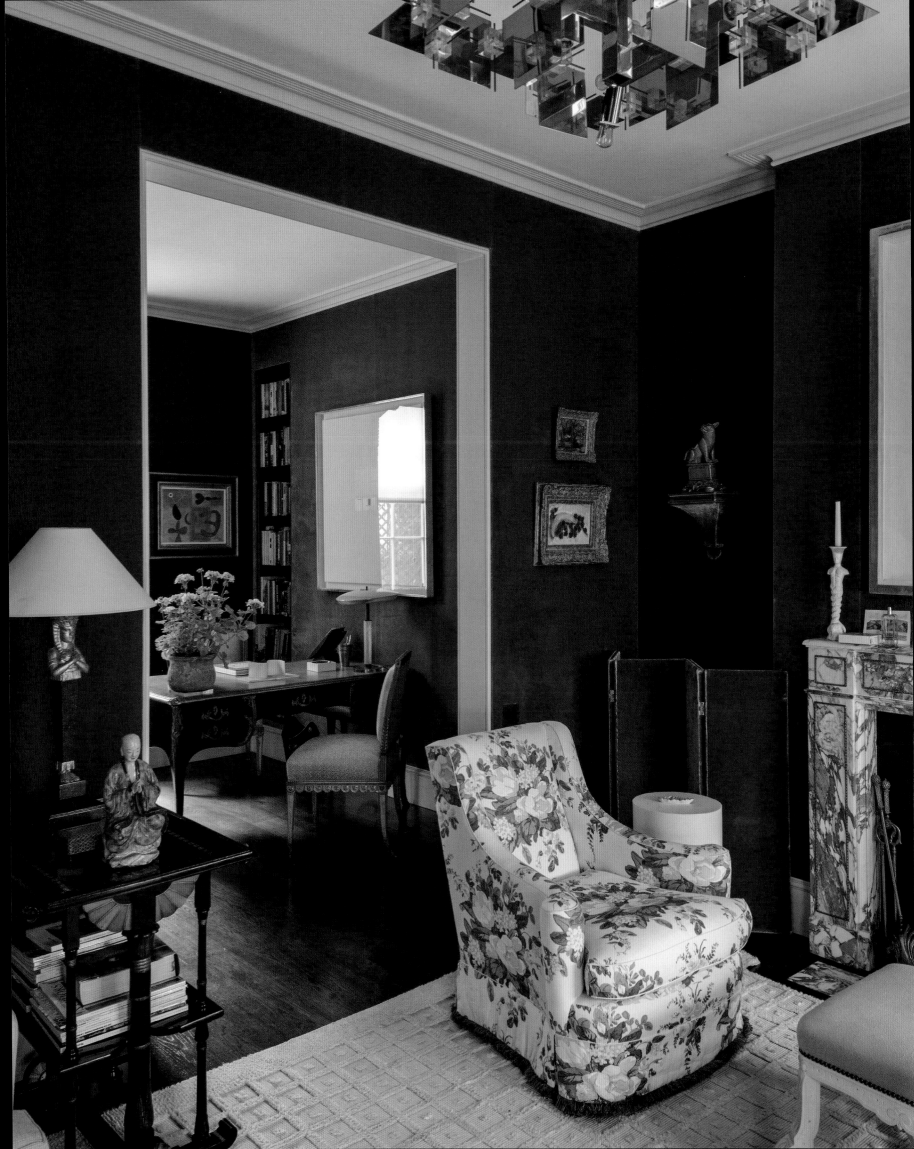

VEERE GRENNEY

'Growing up in New Zealand, my vision for life was that I would live in a Georgian terrace house,' says London designer Veere Grenney. 'I would be dressed like John Steed from *The Avengers* and when I walked out the front door, I would be anonymous. So this house does it for me!'

The late Georgian house, close to Hyde Park in Bayswater, has strong architectural features. Its layout is reasonably conventional. In the basement is a sitting room, cloakroom, bedroom, bathroom and laundry, while the kitchen, dining and another small sitting room are on the ground floor. A double drawing room, and dressing room doubling as a guest bedroom, sit above that; and at the top of the house is the master bedroom and bathroom. Linking the four floors is a stone staircase, set within deep olive walls combed in an intricate wave pattern – a paint effect that Veere often uses in his design work.

When Veere first saw the house several years ago, it hadn't been touched for 40 years, and was lacking many of its original features except for the 1820 stone staircase. Veere reinstated skirtings and cornices in keeping with the period, replaced doors with his favourite Soane-detailed ones and added curved walls to the stairwell. He also installed fireplaces in the three main rooms. Then came the colour palette and finer details, as he set about using, at times, strong colours, unexpected textures and beautiful objects to create a sense of serenity and comfort that's a feature of all his work.

Most of the walls are upholstered. 'We do fabric walling in a way that appears seamless,' he says. 'You don't notice it until you touch the wall. It's perfect for inner-city life.' In contrast, 'the house has naked floors, which I love – the walls take care of the noise. I love the luxury around the walls, and modesty of the floors.'

The first experience of calm is in the entrance hall, where a monochromatic abstract painting hangs above a marble-topped table. It continues to the narrow kitchen, tiled from floor to ceiling in white subway tiles. The mood changes in the dining and sitting rooms on the other side of the hall, with the walls of both rooms upholstered in an exuberant Fortuny damask. Against this unlikely backdrop hangs part of Veere's collection of British post-war artworks, which he began collecting when he arrived in England. The small sitting room doubles as a library, with Billy Baldwin-inspired bookcases and a sofa, designed by Veere, that he has described as being 'perfect for relaxing'.

The double drawing room on the floor above is, perhaps, the most sumptuous area in the house, with its walls hung in moss green silk velvet, woven in Paris, and curtains of the same fabric. To counterbalance this, Veere has also used lots of white, including a linen carpet, Breche marble fireplace (modelled on the late Duke and Duchess of Windsor's one in Paris) and pale chintzes. Around the rooms, gold accents and objects the colour of lapis lazuli add to the opulence of the scene.

Opposite. In the drawing room, looking through to the library, a chair designed by Veere Grenney Associates and upholstered in 'Aurora' by Nicholas Haslam Ltd, sits next to the Breche marble fireplace, also by Veere Grenney Associates. The striking chandelier was designed by Gaetano Sciolari in about 1950.

'When I light the fire and the curtains are drawn at night, it's truly wonderful,'
he says. Also on this floor is a wedge-shaped guest room with a single tented bed,
boxed off by curtains and a built-in bookcase at the foot. 'Every client loves a nook!'

On the top floor, in a room with upholstered white walls and inspired by the
work of David Hicks, the four-poster bed, hung in white curtains with a saffron
trim, takes centre stage. There's a lightness that is in complete contrast to the rooms
below. 'It's beautiful to wake up to,' says Veere.

The pleasure of putting this house together, he says, is that it gave him the
opportunity to decorate again in the way he'd been trained many years before.

Veere's life in decorating really began as a boy in New Zealand. 'All I ever wanted
to do was look at houses,' he says. 'I would bicycle around Auckland with my friend,
and visit houses that were being built. My mother loved houses as well – we always
talked about redoing rooms.' Veere even remembers being punished during
a chemistry class when caught drawing the layout for a house instead of
concentrating on science. His mother also adored 'auctions, furniture, beautiful
things and the garden, and was interested in food. Funnily enough, I am as well,
because I think food goes with all of them.'

When Veere arrived in England in his early twenties, having travelled overland,
he was living the hippie lifestyle and ended up spending a year in Morocco. He had
been captivated by 'the museums, furniture and taste' in London but 'developed
a sense of beauty even more' once he got to Morocco. Back in London, he eventually
ran an antiques stall at Portobello Road market, visiting National Trust houses in
every spare moment.

After a few years, he wanted to break into the decorating business and wrote
to everyone he knew. 'I got my first break when Mary Fox Linton, who used to
buy antique furniture from me, offered me a job in her showroom – this changed
everything. From her, I learnt to decorate; it was scary but I loved it immediately.'

Veere worked for Fox Linton for some years, and then went out on his own
before being offered a job at Colefax and Fowler. 'I was in my late thirties by then
and, in many ways, it was the best thing I ever did. It gave me the gravitas and, more
importantly, I learnt about tailoring and quality. They had the best quality craftsmen
and builders. Until then, I had all the ideas of what was beautiful, but there I learnt
the importance of understated elegance with quality.'

Since 1996, Veere has had his own business, with anywhere between eight and
12 employees. His mainly domestic projects have taken him around the world, from
Tel Aviv to Mustique. 'My work is very varied – from the grandest house to a beach
house.' It also includes his own ranges of fabric, wallpaper and furniture.

Veere himself travels not just for work, but to visit his various homes. Falling in
love with Morocco as a young man, he now owns Gazebo, a house in Tangier. And,
some years ago, he bought The Temple, a former fishing lodge in Suffolk once
owned by David Hicks, that Veere first saw in a book on the designer when he was
a teenager in New Zealand. It is, he says, 'my absolute heart'. At The Temple and
Gazebo, he is able to pursue another of his passions – gardening. During the
summer, his London house is filled with roses and dahlias, and potted geraniums,
that he brings back from weekends in the country.

It's unlikely, he says, that he will ever settle in just one house permanently; but
where he ends up, eventually, remains to be seen. 'I'd love to do something else in
four or five years – there are a few more houses in me, I think!'

Opposite. In the dining room, the walls are upholstered
in an exuberant Fortuny damask. 'I love bare wooden
floors,' says Veere. 'The upholstered walls take care of
the noise.'

Overleaf. In the double drawing room, the walls are hung
with artwork by William Scott, Roger Hilton and Victor
Pasmore. As elsewhere in the house, furniture is a mix
from different eras: an Arts and Crafts side table is at one
end of the sofa, while a Gabriella Crespi Lotus Leaves
side table from 1975 is at the other.

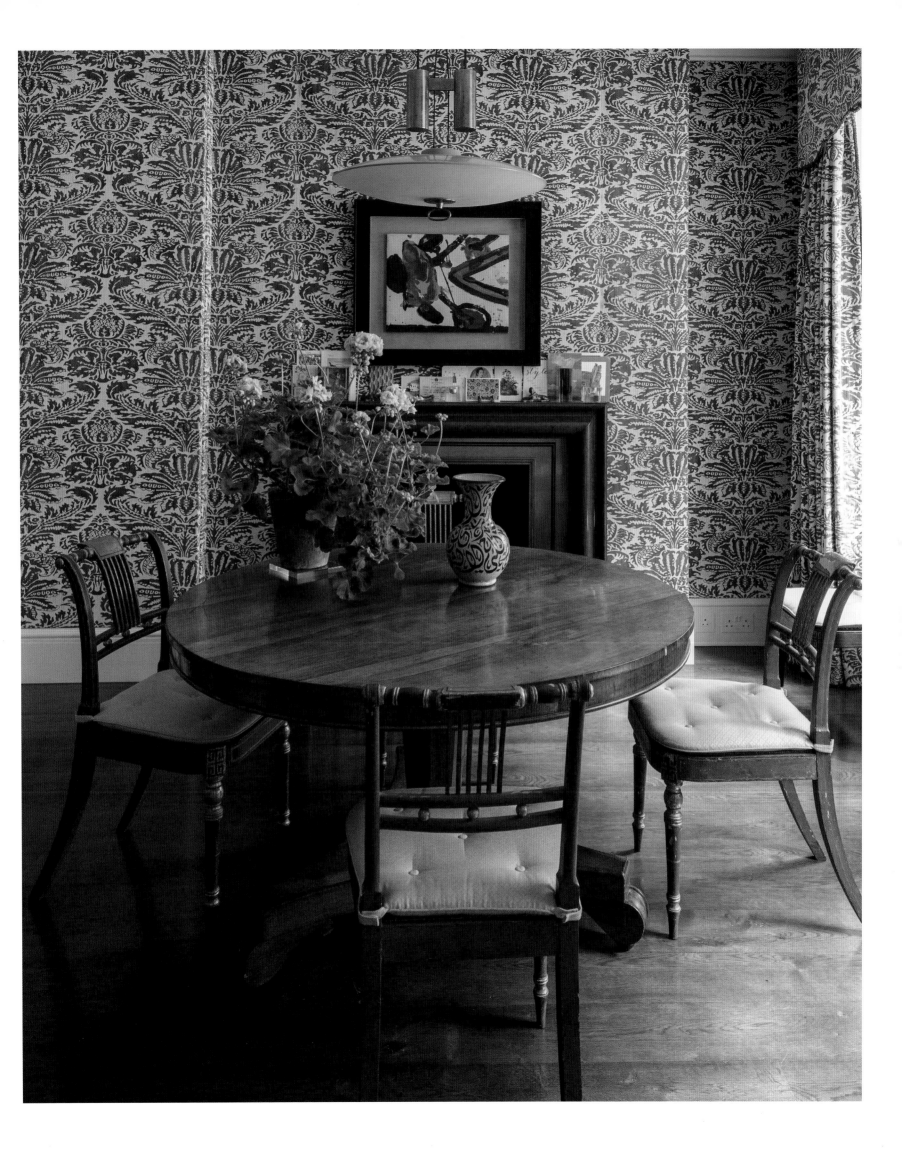

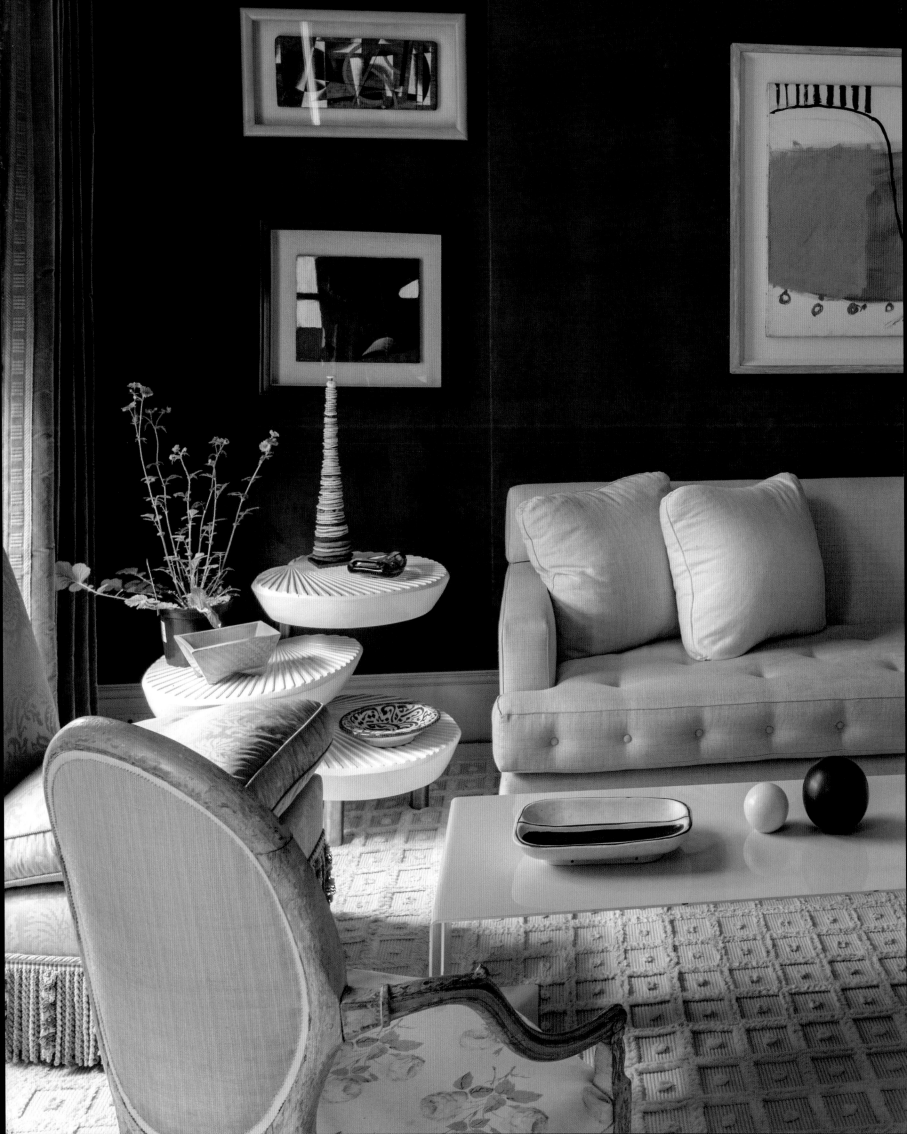

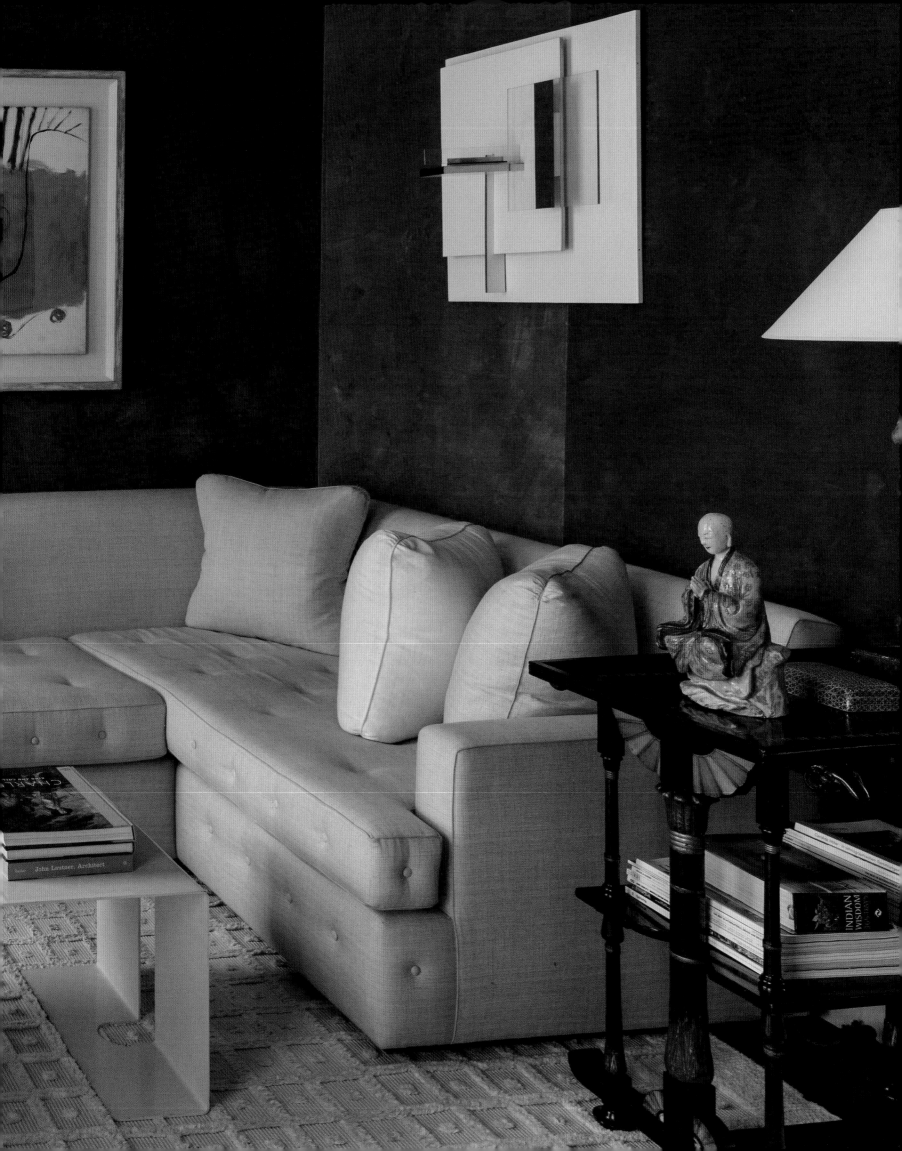

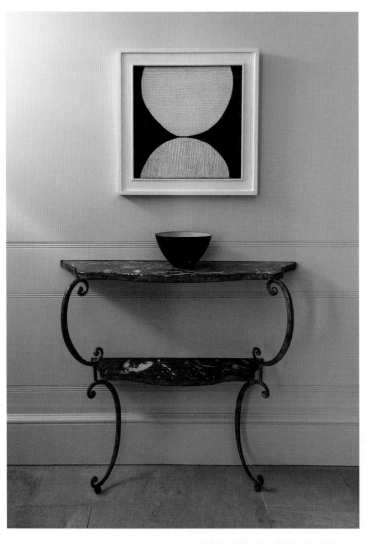
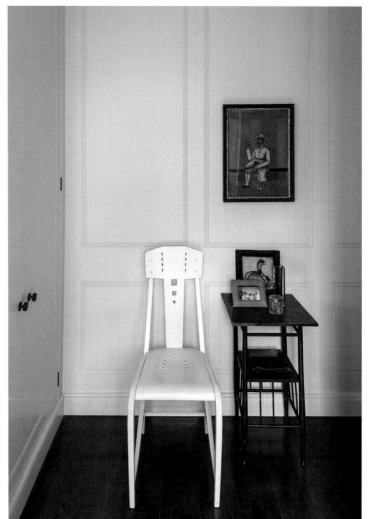
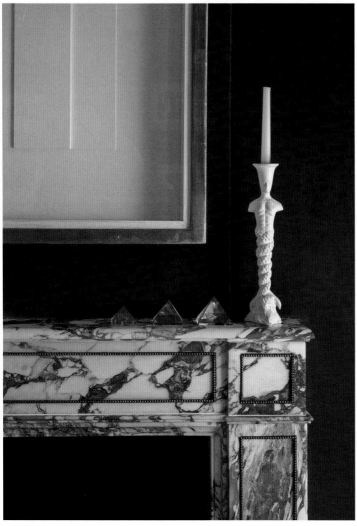
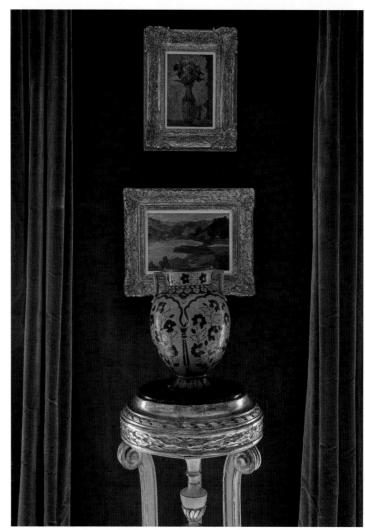

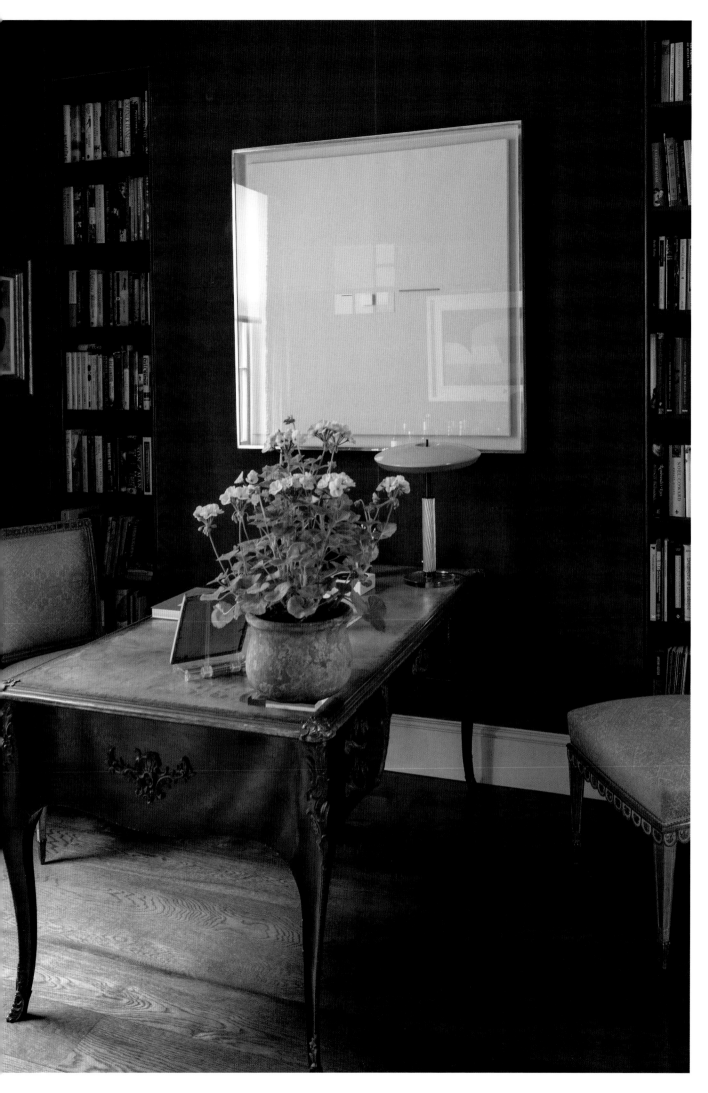

Opposite, clockwise from top left.
A work by an unknown artist is in contrast to a 1930s French bronze and marble console in the hallway; an E.W. Godwin table sits next to a chair by Hoffmann in the main bedroom; a Persian vase that once belonged to Cecil Beaton is displayed on an 18th-century pedestal; an Oriel Harwood candlestick forms part of an arrangement on a fireplace designed by Veere Grenney Associates.

This page. The Maison Jansen desk was commissioned by Billy Baldwin for La Fiorentina in the South of France. The chairs are part of a set of eight, from a suite of 50, made in Austria in about 1792, and the artwork is by Richard Lin.

45

This page. An artwork by Sarah Guppy, in a frame with lacquer finish by Veere Grenney Associates, is offset by the specialist paint finish Veere often applies to walls.

Opposite. Leather doors, designed by Veere Grenney Associates, provide a foil for the original stone staircase.

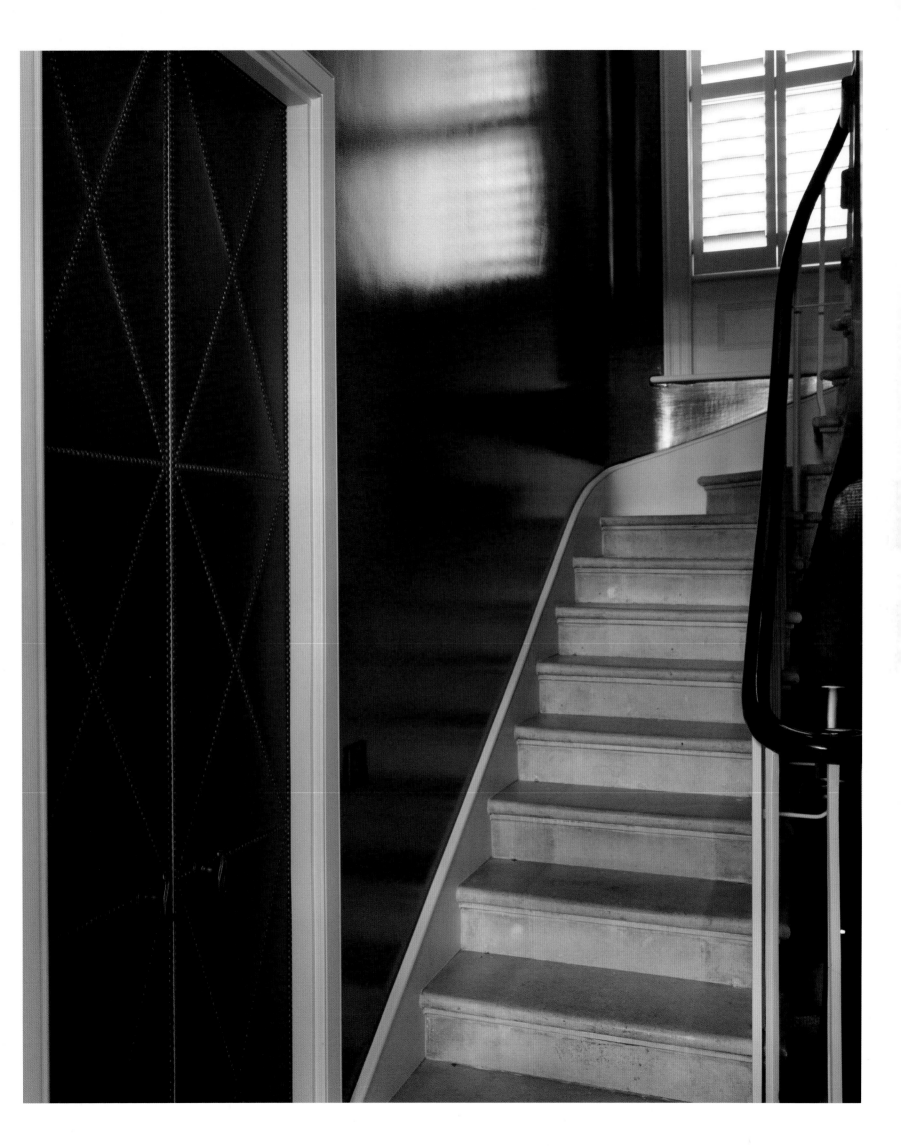

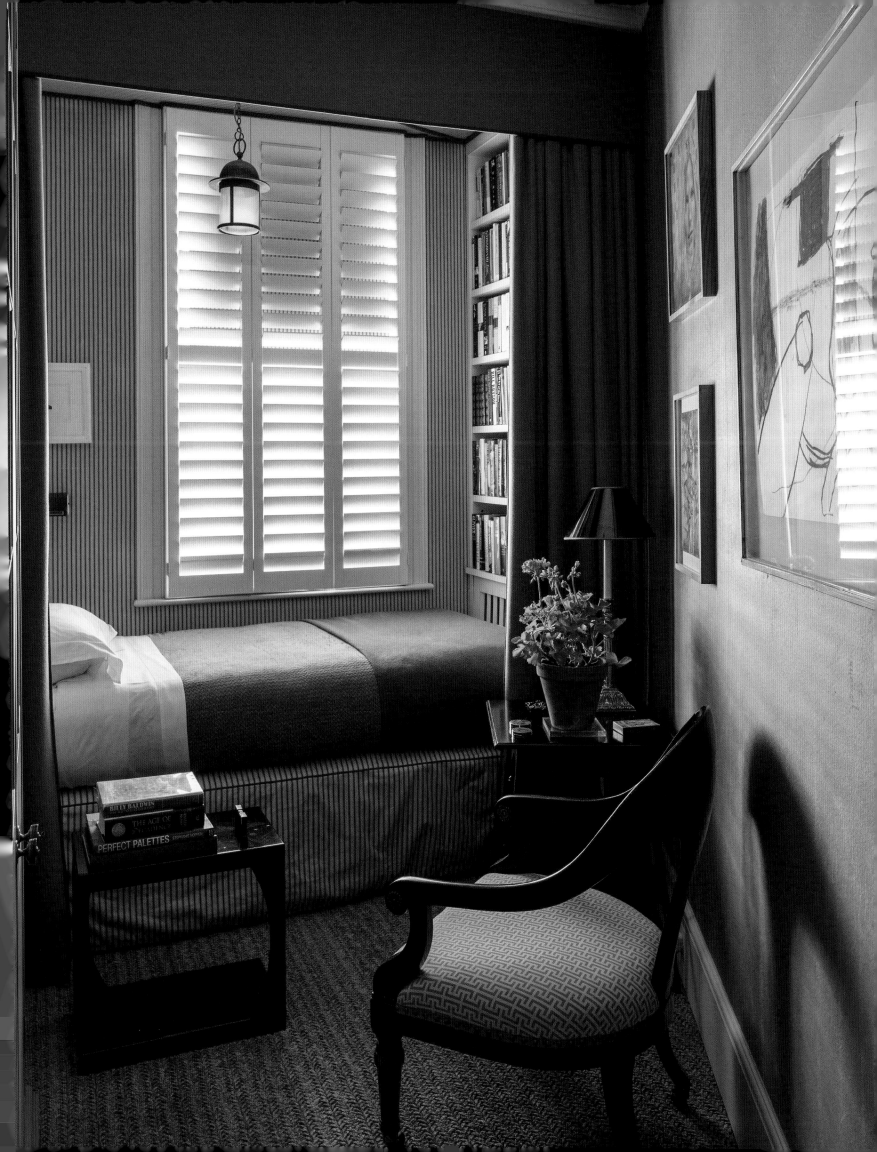

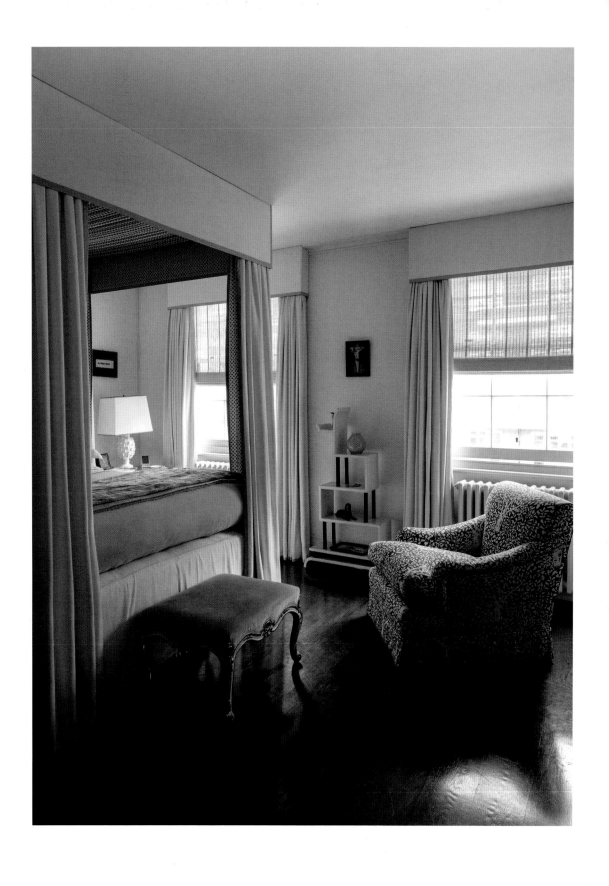

Opposite. Sandra Jordan alpaca was used for walls and bed curtains in the guest bedroom, enhancing the cocoon effect of the small room.

This page. In the main bedroom, antique white serge trimmed in saffron silk taffeta is used for the walls, curtains and bed. Veere Grenney Associates designed the armchair.

Q&A

What does home mean to you?

A beautiful house with a garden – that's what it has to be. My parents were English and emigrated to New Zealand after the war. When I'm in England, I talk about New Zealand as being home, but when I'm in New Zealand, I talk about England as home. I thank god every day that I was born in New Zealand – I adore going back there.

What's your idea of luxury?

I suppose, to me, it is comfort and beauty, with beauty being the most important of all. Or it could be always having fresh flowers, or a cashmere blanket on the bed. Of course, as you get older, nothing is nicer than a good lunch with a glass of wine, and lying on the bed for half an hour under a cashmere blanket! Unfortunately, luxury these days often denotes self-indulgence, which I don't like – I prefer generosity.

Who has influenced you in your career?

David Hicks.

Do you have a favourite design book?

The ones by David Hicks.

How do you relax?

By walking and reading. I always relax at The Temple – relaxing is routine, which I love. I walk for about two to three hours a day, fiddle around in the greenhouse, have a very nice lunch, and half an hour on the bed in the afternoon. I have a drink in the evening and read, and watch a bit of television. A roaring fire, a beautiful room, a good book and the dog, then I'm set.

What do you like to read?

Everything – novels, historical books, biographies – I find it very relaxing.

What can't you live without?

Beauty. But I suppose I also couldn't live without a very good bed.

What would you grab if there was a fire?

The dog, of course. On the object front, one caveat I would make, that is quite scary, is that when you put everything into storage you forget about it all. It could only be for two months, but when it comes out, it's like Christmas all over again. So it makes you realise, very strongly, that really nothing is that important.

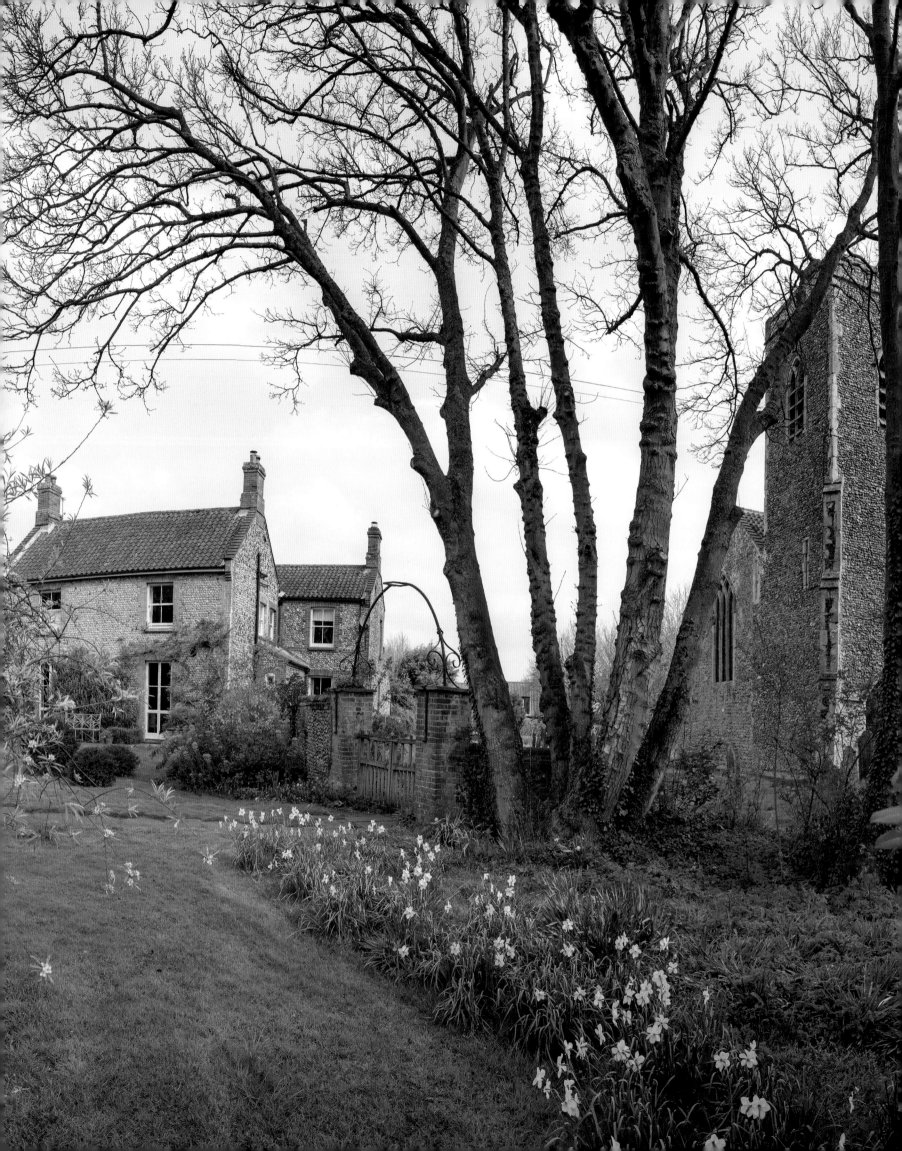

WENDY NICHOLLS

I t's hardly surprising that Wendy Nicholls fell in love with her country house. It's in an idyllic setting, surrounded by an acre and a half of garden, with a gate leading to the 14th-century village church next door. The original farmhouse dates back to the early 18th century, and the front part to about 1870 when it became the vicarage. At the time, she still owned a cottage up the road where she had been spending weekends for the previous 35 years. Stopping at a garage for coffee, she spotted the house in a local paper and managed to view it that afternoon. As she opened the gate, she was smitten.

Wendy made an offer the following week, and despite mild panic at the thought of owning two properties in the country as well as her flat in London, transactions all fell into place and the cottage was sold before the completion day.

Since Wendy, who is head designer for Sibyl Colefax & John Fowler, moved in about six years ago, she decided against making any major alterations, apart from repainting and 'dollying it up a bit. Every single room had a feature wall – the guest room had a terrifying wallpaper of tropical birds and flamingos.'

However, she did focus on her own bedroom. Three rooms were converted to form a bedroom, dressing room and bathroom. 'I thought, "Actually it's for me, so why not."' She also blocked up, moved, removed or added a number of doors, installed skirtings and cornices, and replaced Victorian mantelpieces with less elaborate ones, reusing the tiles in the corridor. Because it was very irregular, she 'tidied up' the entrance hall by adding an archway, and also installed new bookcases. 'I didn't really want to have books in the passageway, but if I ever leave London to live in the country, I will have a library.'

As far as other aspects of the house go, she has a relaxed attitude. 'I haven't changed the carpet on the stairs. Perhaps one day, when I'm feeling rich, I will,' she says. Similarly, 'I've got the kitchen from hell, which I've never altered. One day, I'll do something about it.' Equally, as a lifelong swimmer, she did have thoughts of installing a pool, 'but it was going to be too expensive. There's a perfectly good thing called the sea for swimming in!'

There's a sparseness to the way the house is decorated, which is perhaps more by circumstance than design. 'I've used the furniture I had in the previous cottage, and spread it out here,' she says. 'The cottage had exactly the same accommodation, but just on a smaller scale.'

The peacefully sparing quality of the interior is heightened by the alterations Wendy has made. The double drawing room used to be a parlour and dining room, separated by double doors. Wendy widened the opening, replacing the doors with a triple one. She then reused the double doors between her bedroom and bathroom.

The dining room (which was originally the keeping room) has lovely views over the graveyard, and is used every weekend when Wendy has people over for lunch or dinner. Two Scottish chairs flank a Regency Chinoiserie dresser, where Wendy

Opposite. A view of Wendy's house and the 14th-century church next door.

displays her faience plates for 'the French house that didn't happen!'. On top is a pottery face Wendy made when she was 11.

Throughout, the designer has used pieces and fabrics she has acquired through Colefax and Fowler – the lantern in the hall, for instance and the Ditchley lights. The seat cushion of a Swedish painted bench in the hallway was handmade by Wendy in Colefax and Fowler's 'Seaweed and Roses'. The 'Toile de Riom' curtains in the dining room and painted chest of drawers in the main bedroom were bought from the Colefax and Fowler shop when it was still in Brook Street.

Wendy's interest in design dates back to her childhood – the very first house she worked on was her doll's house. 'I had white shoeboxes that became summer bungalows for my dolls, and they used to travel between the two in a Jeep. I collected colourful parasols that my mother brought home from drinks parties.'

She had every intention of becoming an art historian, but 'ploughed my exams' and fell into interior decoration. 'I had thought I might quite like to do it, but thought it was perhaps a bit frivolous.' After working with a number of different London decorators, she joined Colefax and Fowler in 1976 knowing that it would be a good place to increase her knowledge of decorating and design history. She has been with the group ever since. In the early days, she and some friends would go off every weekend, without fail, and visit National Trust and other historic houses around the country.

Wendy has a flat in London, but spends every weekend in the country, just as she did with her previous cottage. 'Last summer, I spent a week here – the longest I've ever stayed in the house,' she says. There's a sense of peace she finds here, whether looking out from the dining room to the graveyard and daffodil field beyond, or reading in the drawing room. 'I tend to sit in the pale blue chair by the window, where I gaze out at the garden,' says Wendy. 'For me, it really is worth the two-and-a-half hour drive. Increasingly, I find it very difficult to leave each week.' And equally easy to return to.

'I'VE USED THE FURNITURE I HAD IN THE PREVIOUS COTTAGE, AND SPREAD IT OUT HERE. THE COTTAGE HAD EXACTLY THE SAME ACCOMMODATION, BUT JUST ON A SMALLER SCALE.'

Opposite. A 19th-century rush-seated chair in a corner of the main bedroom. Echoes of the random Delft tiles in the hearth are evident in the A La Place Clichy rug.

This page. Scottish Regency mahogany chairs, covered in brown linen, surround the dining room table, which was found locally. Sitting against the right-hand wall is a Danish fruitwood table with tiled top.

Opposite, clockwise from top left. In the hallway, the staircase, which had rotted, was rebuilt in a basic style, with Wendy adding 'turban' finials 'to help it a bit'; the banner pelmet and blind in Colefax and Fowler 'Convolvulus' chintz, now discontinued, were previously in one of Wendy's smaller cottage windows; the drawing room, which looks out over the garden.

Overleaf. The directoire chair, with fruitwood frame, in the drawing room came from Sibyl Colefax Antiques. Hanging over the fireplace is Clifford Fishwick's *Clouds: Lundy*. 'I adore Lundy, but to be candid, this does not remind me of it!' says Wendy.

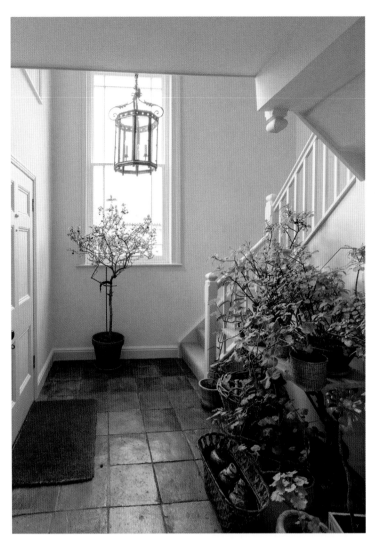

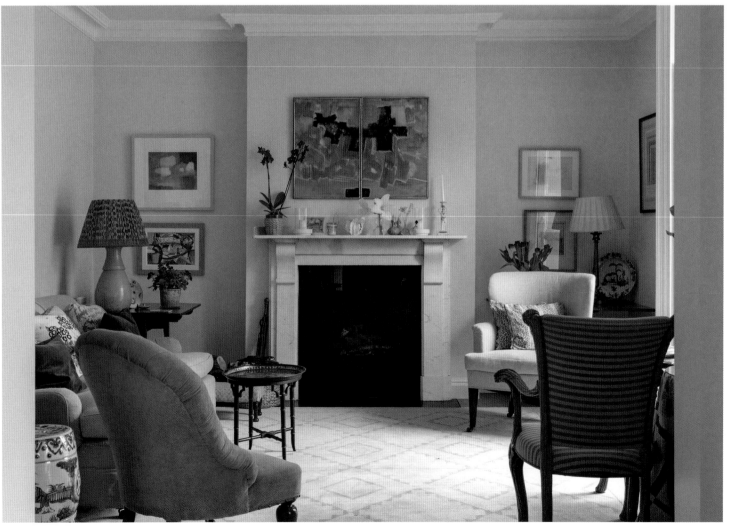

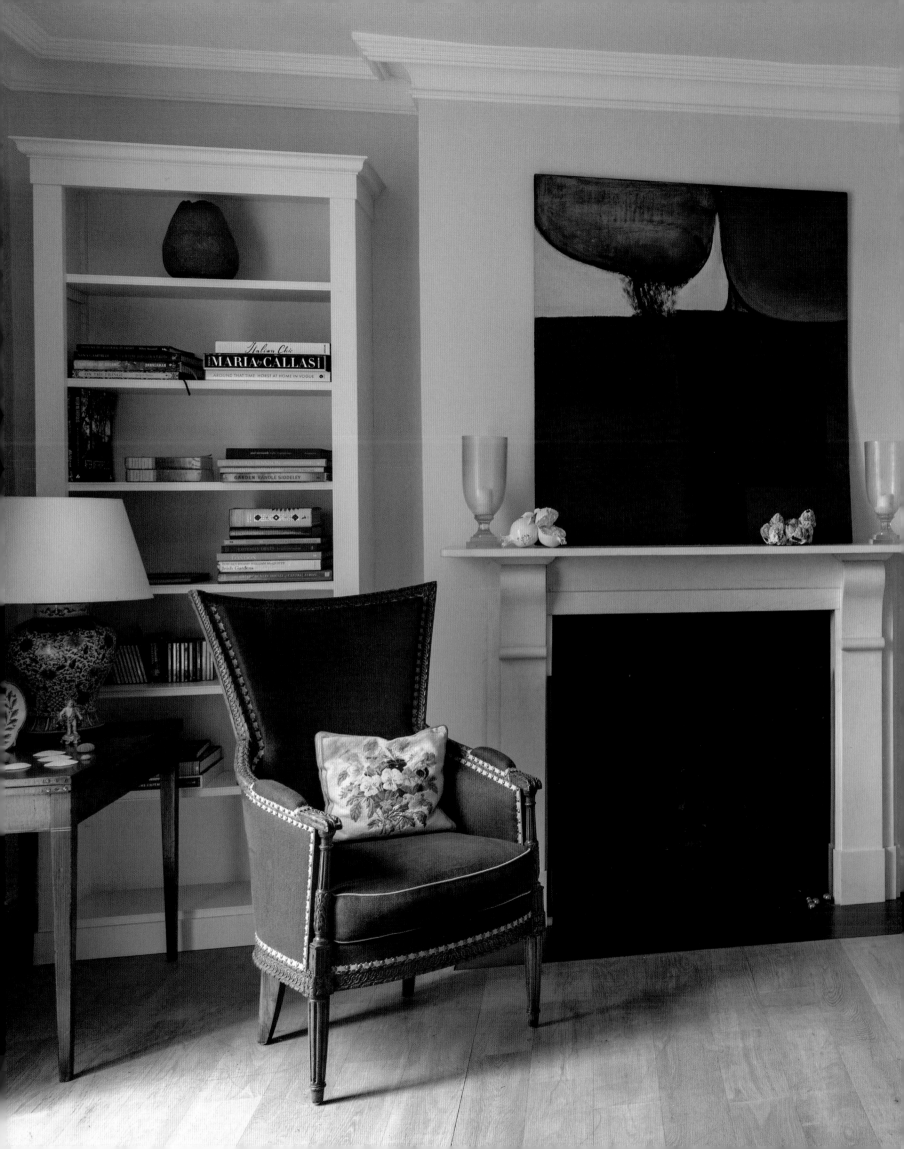

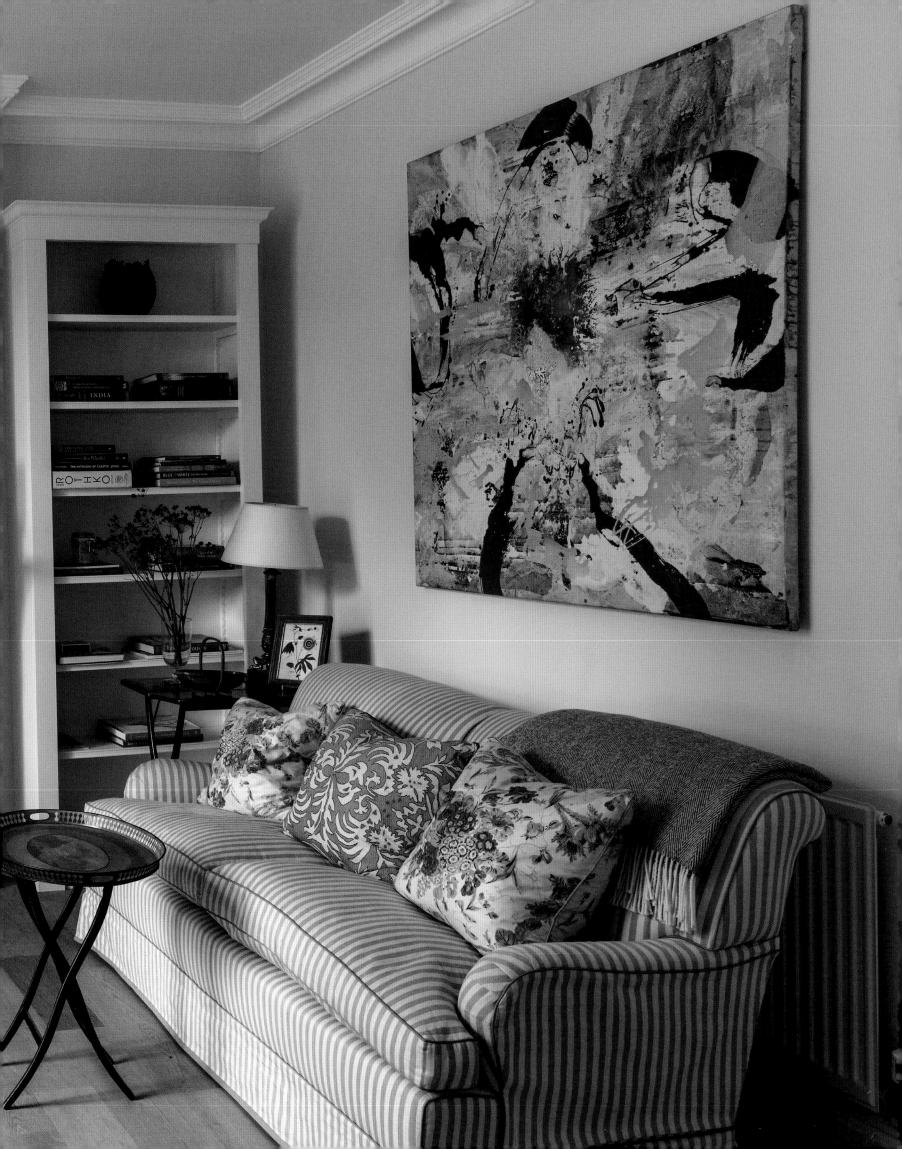

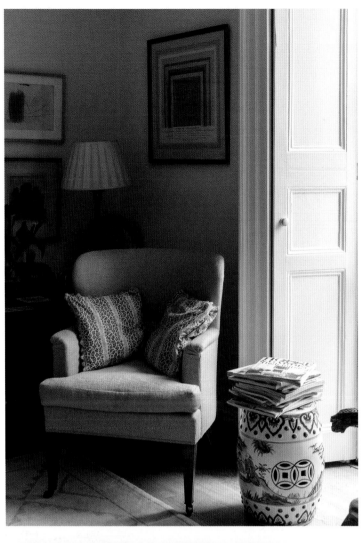
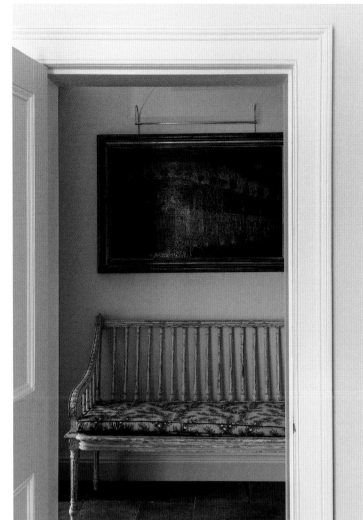

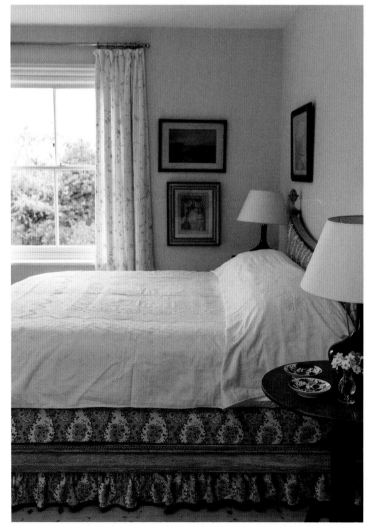

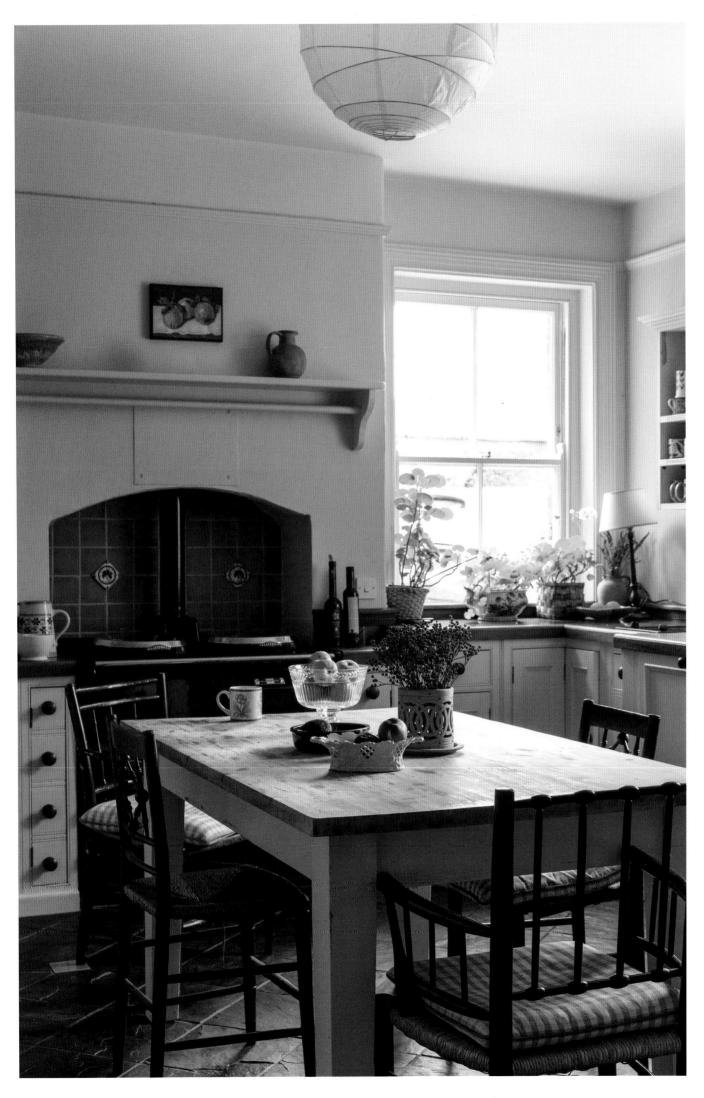

Opposite, clockwise from top left.
Wendy's favourite chair overlooks
the garden; a 17th-century Italian
painting of a terrace with orange
trees hangs above an 18th-century
Swedish bench; a reproduction
French bed is upholstered in a now
discontinued Comoglio fabric; the
bowl on a 19th-century painted
washstand is planted with
a scented geranium.

This page. Wendy has plans to
renovate the kitchen at some point.
Sussex chairs are used for seating
at the kitchen table, and the oil
painting of quinces over the Aga
came from Marrakesh.

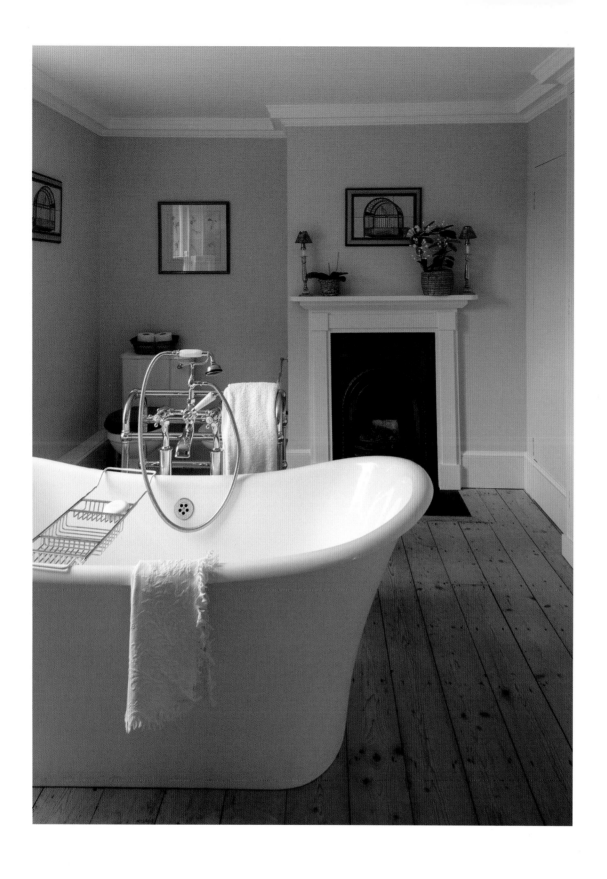

This page. There's nothing utilitarian about the bathroom, with its fireplace, 19th-century Delft tile pictures and watercolours of wildflowers.

Opposite. Wendy chose Colefax and Fowler 'Caroline' chintz for the blind and ottoman in the bedroom, as she had always loved the way John Fowler used it in the drawing room at Fentiman House.

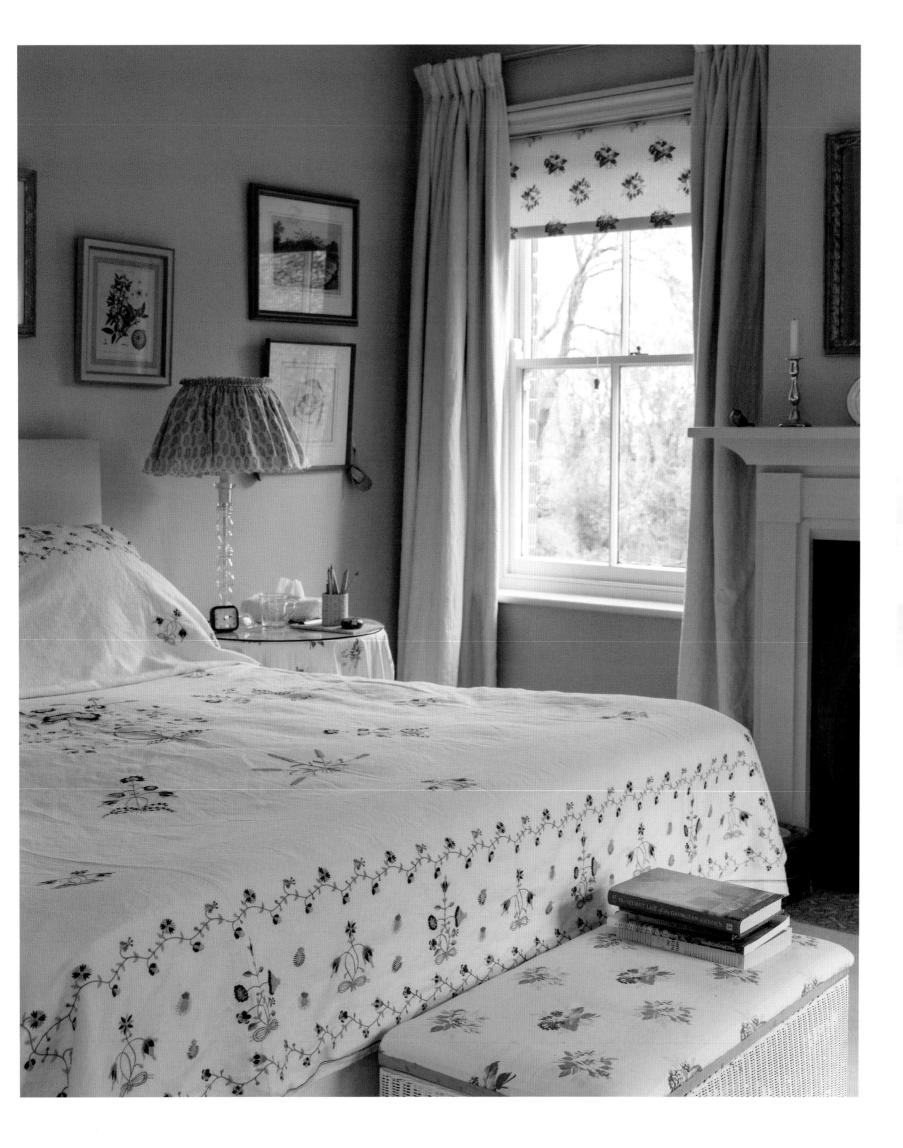

Q&A

What's your idea of home?

This house in the country is more my home than my apartment in London. Home is somewhere to come and be calm. I also love to entertain – this is it for me. London is where I go to sleep; I've never 'lived' there.

Are you tempted to frequently change things?

No – I will only change something when it's worn through. I love doing a room, but after that, that's it!

Is there anyone who's been of particular inspiration to you?

Hugh Henry – he is really very, very good. He has a tremendous eye and just hits the right note. Chester Jones is fantastic, too – very, very good at creating extraordinary atmosphere.

Do you collect anything?

Nothing specifically, really. I collect things that are beautiful, in passing.

What's your idea of entertaining?

I like to have people to lunch or dinner, and do it every weekend. I don't especially enjoy cooking, but I do it. The best thing in the world is the shed down the road – they have produce that people have brought in, so you'll buy a bag of broccoli or potatoes for a pound. In the next village along, there's a fisherman; in summer you can collect the lobsters, crabs and fish – it's perfect.

Fiction or non-fiction?

I love reading anything I can lay my hands on.

Sheets and blankets or duvets?

I've always preferred sheets and blankets, but when I moved to the country I found duvets much simpler. I've got silk duvets on every bed now because they are hypo-allergenic and come apart for summer.

Flowers or foliage?

I absolutely love bringing flowers in from the garden – I can't be in a house without some flowers. The minute I get into a house, even if it's after midnight, I'm out there with scissors. In summer, I'll be out there in my pyjamas. To me, it's the most important thing in the world.

What's your favourite season?

Spring, when everything starts waking up.

What's your idea of luxury?

Peace, silence and fresh air. Real luxury is to sit on a beach and have a swim – I've been going to the Isles of Scilly for the past few years, and it's absolutely ravishing.

If there was a fire, what would you grab?

A basket full of loose photographs of people and places I have loved.

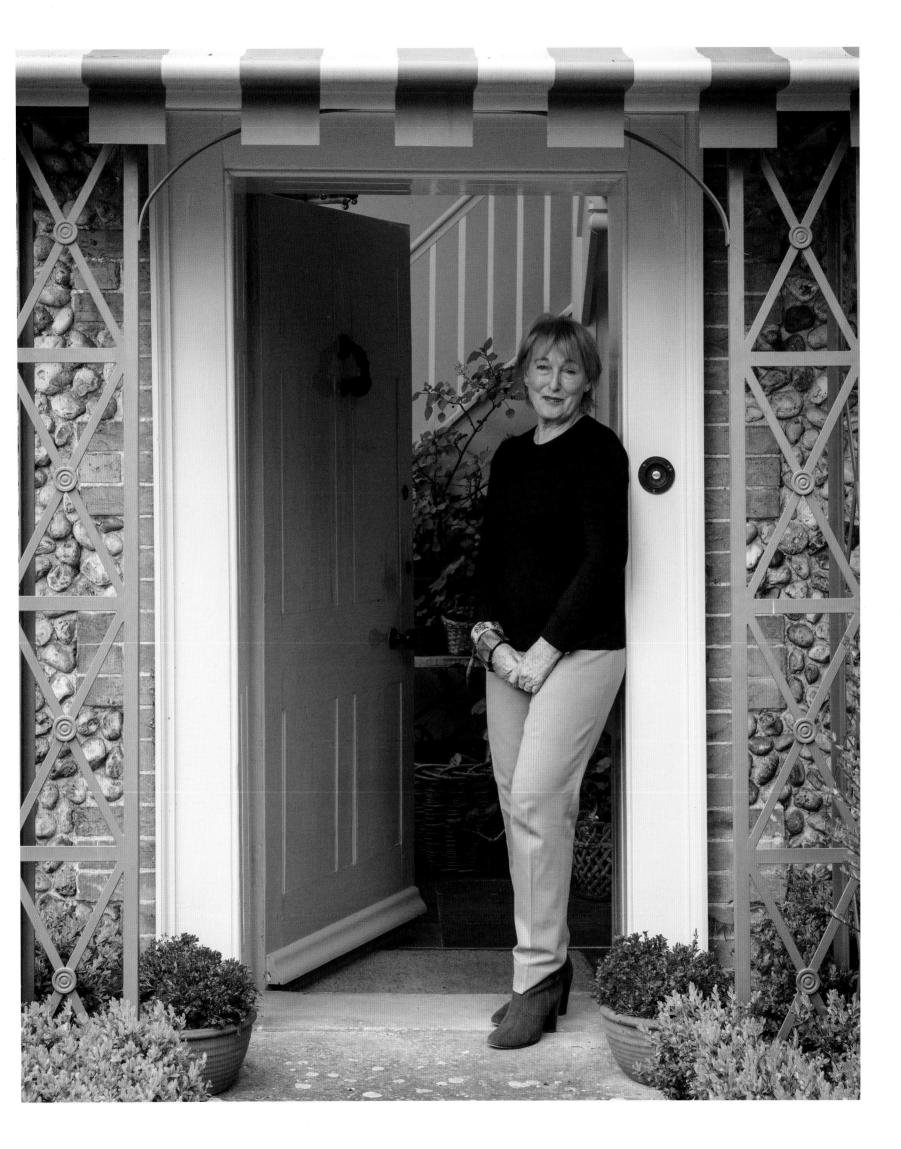

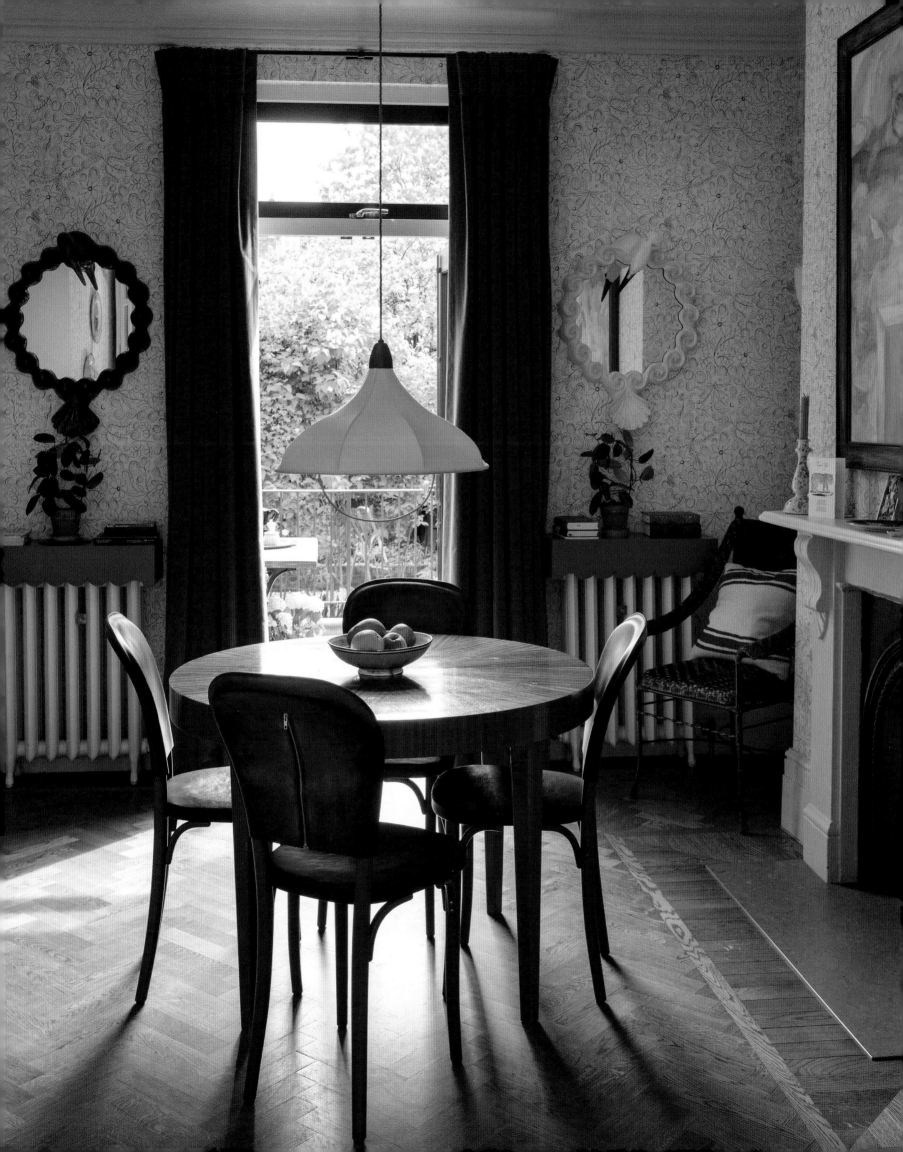

BEATA HEUMAN

I t is rare to start writing about one designer by talking about another, but in the case of Beata Heuman, who was named *House & Garden* UK's inaugural interior designer of the year in 2018, it's impossible not to bring in Nicky Haslam's name early on. Beata, known for her colourful and original schemes, worked with Haslam, who she describes as having an 'irreverent approach to life', for nine years until she went out on her own in 2013. 'I owe him so much,' she says.

The connection between the two began, of all places, at a funeral. Brought up in the south of Sweden, Beata had plans to study literature at university, but instead, at the age of 21, found herself in London working in a delicatessen. She was also doing an interior design course, which she wasn't enjoying at all. 'I was telling a woman I'd met at the funeral that it would probably be better to be working for an interior designer instead of doing the course.' Amazingly, the woman put her in touch with Nicky Haslam – 'I didn't really know who he was at the time. I went to see him, his business was booming and he hired me on the spot.'

The lack of hierarchy in his office, which Beata emulates in her own business, meant she was 'thrown in at the deep end, running massive projects and designing furniture pretty early on. The most important thing I learnt from him was to be fearless, not to take the path of least resistance, especially when designing bespoke furniture. And his sense of humour – I love to design a room that has some humour in it.' He also taught her a lot about design history, she says. 'He had so many reference books that he always went back to – it's so important to be informed by the past.'

The lessons learnt with Nicky Haslam are much in evidence in all Beata's projects, including the Victorian house she has lived in for the past four years with her husband, John, and two young daughters, Gurli and Alma, in London's Hammersmith. 'We completely fell in love with it straightaway,' she says. 'So many houses like this get picked apart and become open plan, but this was quite well designed to begin with and unspoilt.' She did, however, extend it slightly at the back, which allowed the space to be reconfigured. The kitchen was moved from the basement to the ground floor, making space for a guest room, utility and second little kitchen below. She also built a small patio outside the dining room with steps into the garden. Apart from that, no major changes were made to the layout.

Beata has created an interior that is joyful and unexpected, with echoes of her Swedish childhood and evidence of her interest in design history and the wider world, as well as subtle wit. 'As a child, I loved rearranging my room,' she says. 'I loved playing with my doll's house, and making furniture for it. Even then, I had little sketchbooks – I used to draw the room and sketch bits of furniture. I was always interested in creating other worlds.'

An example of her wit can be found on the walls of the dining room. 'I love the fact that it looks as though someone has just drawn onto the wall,' she says. In fact,

Opposite. Bentwood chairs, with zipped leather covers, sit around the dining table, which was designed in the 1930s by Axel Einar Hjorth for the Stockholm department store NK. Solid oak parquet flooring is laid in a typical Scandinavian pattern.

she worked with the company Tibor to create a wallpaper based on enlargements of doodles by the firm's founder, textile designer Tibor Reich. Reich's grandson, Sam, who now runs the company, named the design 'Beata'. The Claudia Rankin plates hanging on the wall only increase the level of whimsy.

The radiators, with scalloped shelves on top, and timber herringbone floors throughout the house, are further additions. 'I tried to make the floor look as if it could have been here for quite a long time.' There's an equally timeless quality to the Snowdrop Rise and Fall light, one of many designs in the house by Beata. It hangs above the Swedish table, which was designed by Axel Einar Hjorth in the 1930s. But then the zippered dark green leather covers on the bentwood chairs take you to another world altogether, in a surprising and witty way.

In the living room, worlds collide again – above the fireplace hangs a 100-year-old banner from Africa's former Kingdom of Dahomey, while on each side sits a slightly Regency-inspired Lire cabinet, designed by Beata, topped by a Chinoiserie vase wired up as a lamp.

In Beata's hands, not everything is as it seems. An armoire-like unit in the kitchen, visible from the dining room, actually houses the refrigerator. She describes the kitchen ceiling as 'a real labour of love – I'd seen the idea in patisseries in Vienna and Scandinavia. They're individual pieces of glass, of all different sizes, and of course the ceiling wasn't completely straight. We got it right in the end.'

Upstairs, the walls of Gurli's bedroom have been hand-painted with endearing parkland scenes, based on the murals that Ludwig Bemelmans (of *Madeline* fame) did for New York's Carlyle hotel in the 1940s.

Even outside, Beata has been inspired by her travels – a wave detail on a timber trellis screen has been copied from one she saw on a visit to Le Petit Trianon at Versailles recently. The garden room, named 'Chatsworth', was built by the previous owners. Beata has kept the name, and has worked her magic on it. Rubber stencils were used to decorate the walls: 'It's quite a detailed pattern and was a fairly big job.' She furnished the room with an oversized armchair upholstered in one of her favourite Pierre Frey fabrics. 'It's lovely to sit here at night after the children are in bed,' she says. 'Just to have a drink and relax. Having a bit of distance from the house yet still being here really works.'

'AS A CHILD, I HAD LITTLE SKETCHBOOKS – I USED TO DRAW THE ROOM AND SKETCH BITS OF FURNITURE. I WAS ALWAYS INTERESTED IN CREATING OTHER WORLDS.'

Opposite. A Lire cabinet with horsehair panels, designed by Beata Heuman, houses speakers. A vintage vase has been wired up as a lamp.

Overleaf. The living room is a mix of old, new and bespoke, with a vintage Moroccan rug and antique banner along with a Venus chair by Soane, bespoke sofa upholstered in a Christopher Farr linen and a fireguard from Nicholas Haslam's OKA Collection, which Beata worked on.

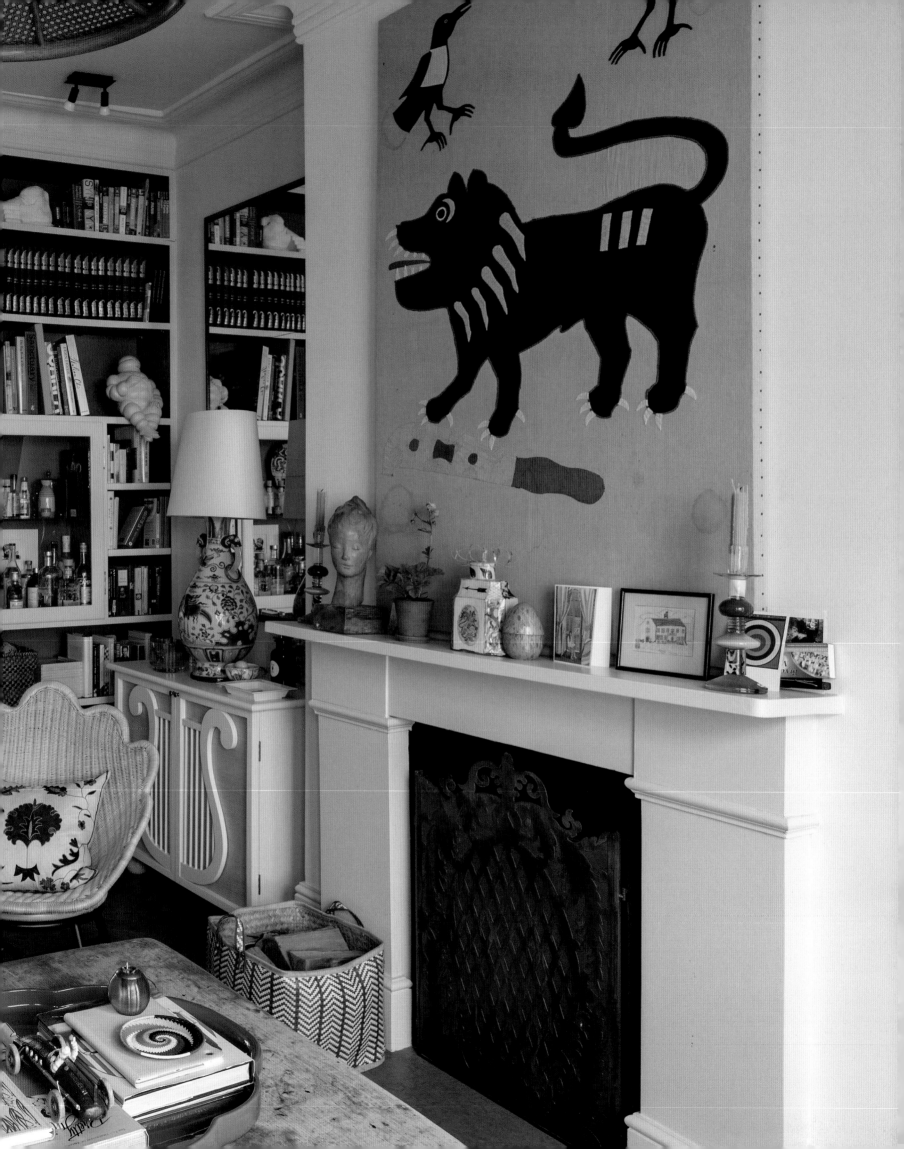

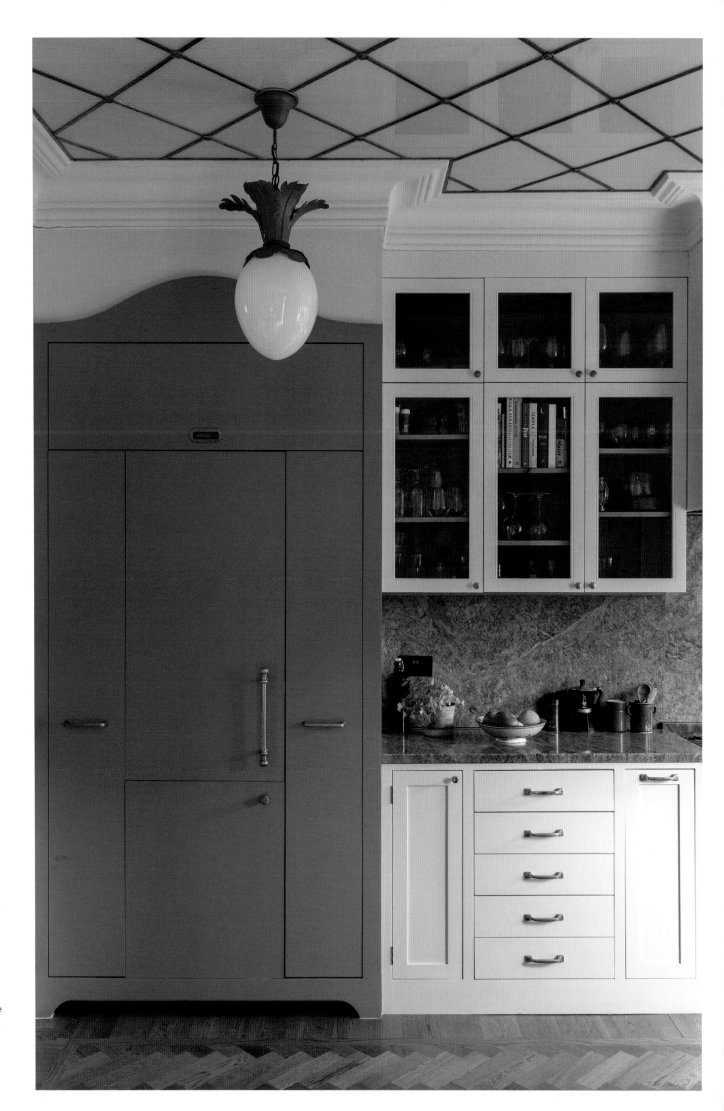

This page. In the kitchen, the armoire-like unit, with bespoke handles, houses the refrigerator. The Dodo Egg pendant was designed by Beata Heuman, and is part of her collection.

Opposite. The kitchen features a glass ceiling inspired by European patisseries. The blind is in a Le Manach stripe by Pierre Frey, with Samuel & Sons midnight blue grosgrain trim.

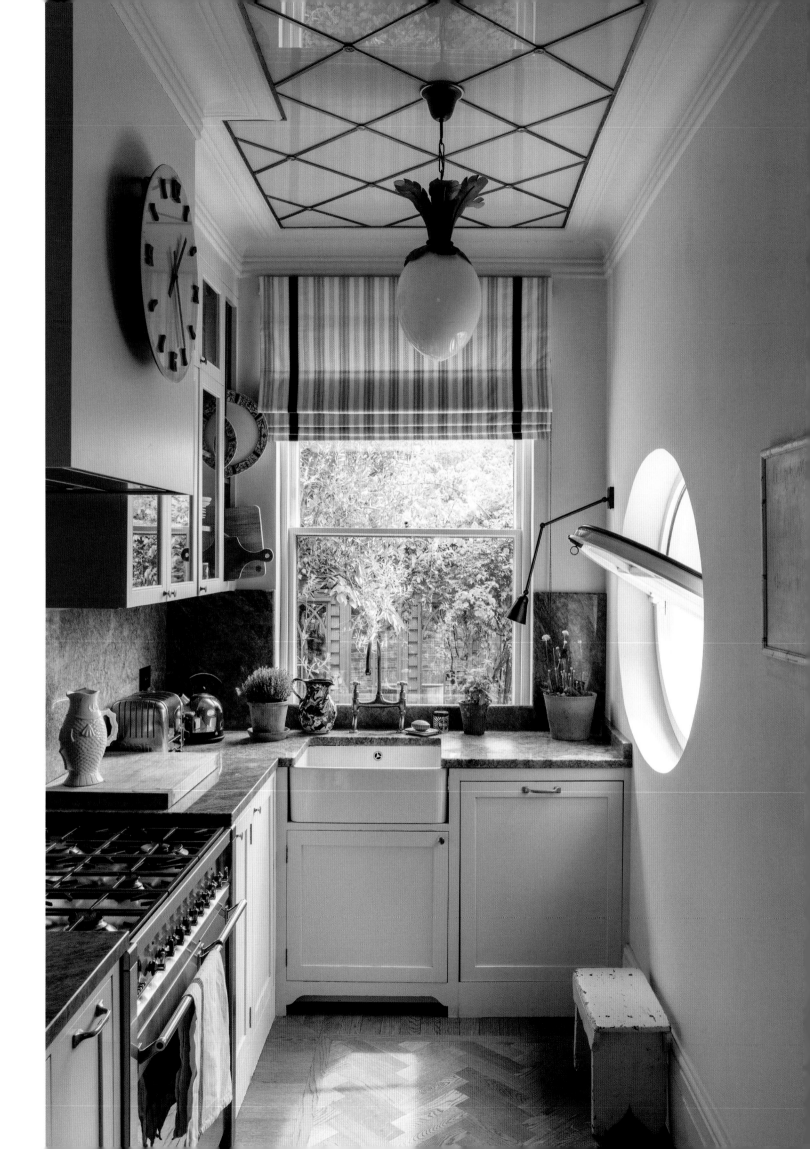

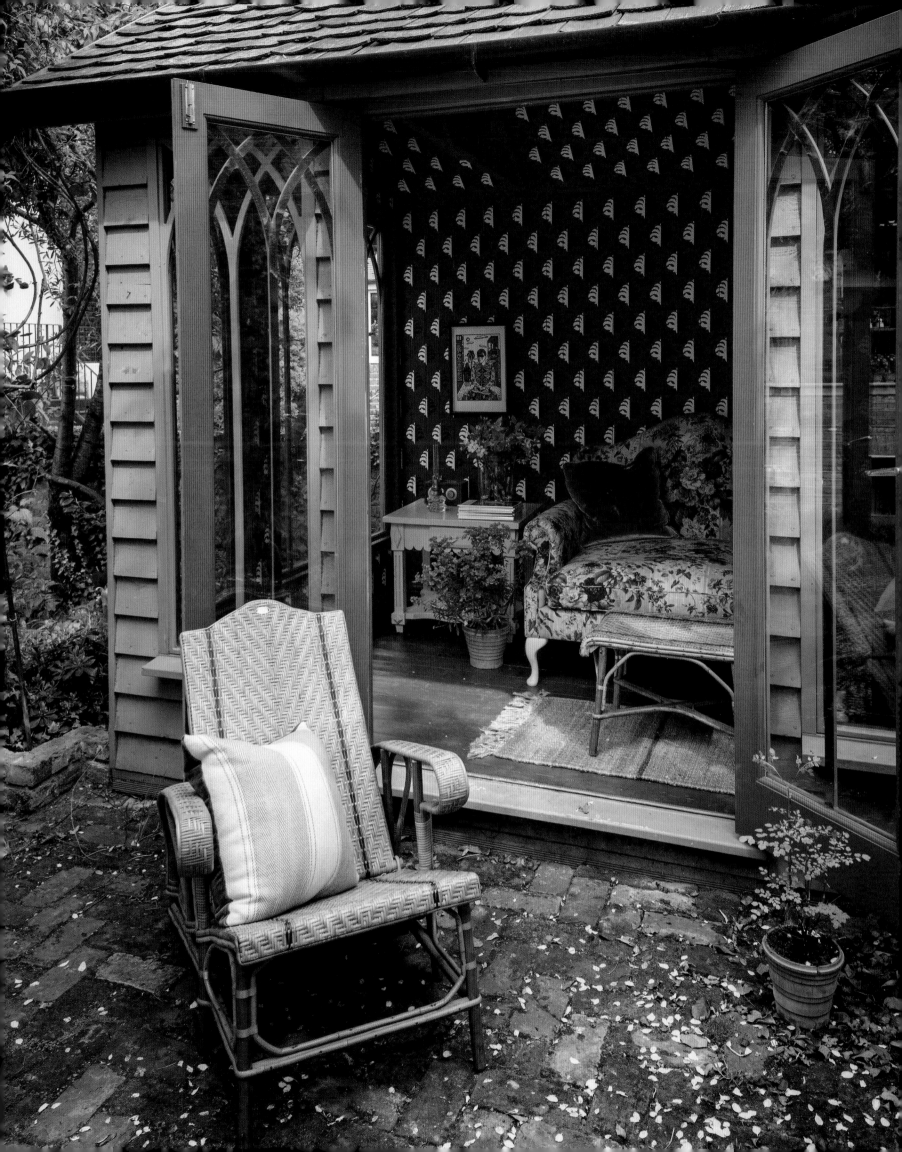

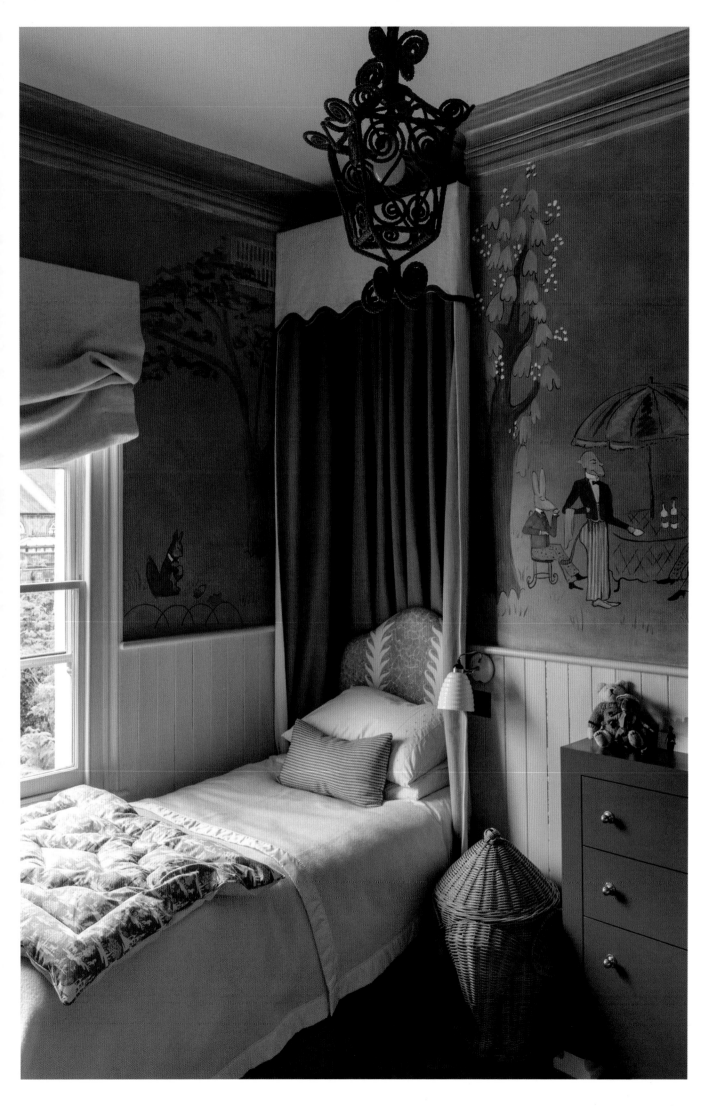

Opposite. The walls of the garden room were decorated using stencils, and a bespoke loveseat was upholstered in Le Manach 'Mortefontaine' in bleu vert by Pierre Frey.

This page. 'Palm Drop' by Beata Heuman is used for the bedhead in Gurli's room. The bespoke chest is cleverly built into an old fireplace opening and is much deeper than it looks. Ludwig Bemelmans' murals for The Carlyle hotel in New York provided the inspiration for the wall treatment.

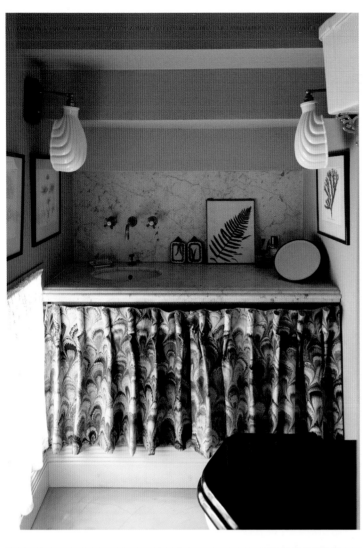
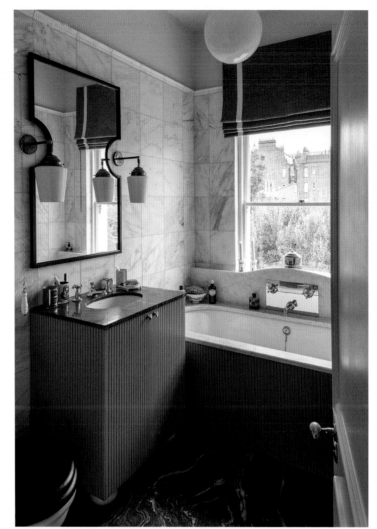
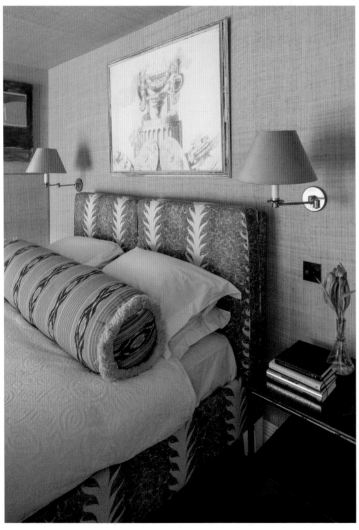
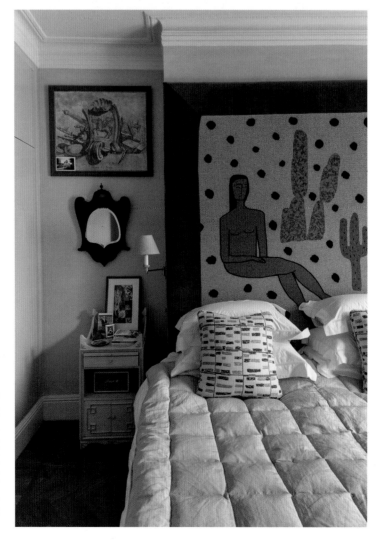

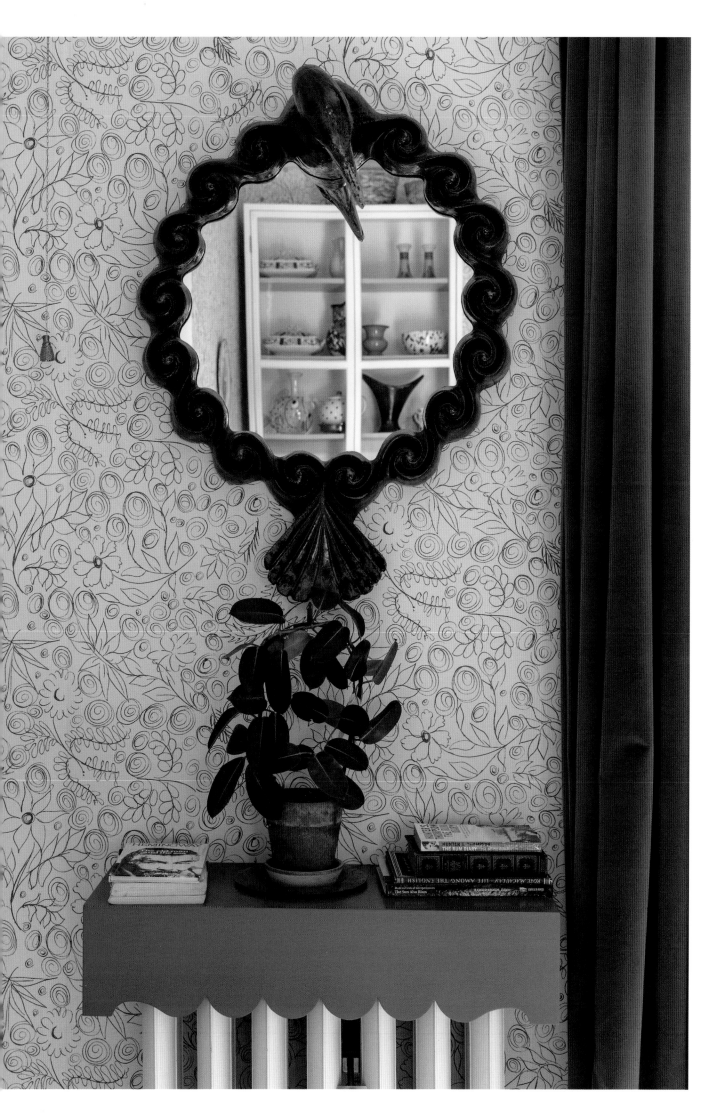

Opposite, clockwise from top left. Vanity skirt in 'Marbleized Velvet' by Beata Heuman is both luxurious and unpretentious; bespoke and vintage elements combine in the bathroom; the headboard in the main bedroom has been created from a throw with an Abbott + Boyd velvet border; the bespoke bed in a guest bedroom

This page. In the dining room, the handmade stoneware Cormorant mirror by Gail Dooley reflects Beata Heuman's Swan Cabinet, part of her collection. The radiator is cloaked in a scalloped shelf, and the wallpaper, based on doodles, was created for the room by Beata with the company Tibor.

Q&A

What does home mean to you?

At the moment, it feels like my whole world is here. It's the backbone of my whole existence. My husband often sits here on weekends and says how lucky we were to find this house, and we talk about what we might still do to it. It's close to the river and we can take these amazing walks. Having grown up in the countryside, it's something I really value, and it doesn't really feel as if my children are growing up in the city. We feel very blessed.

How would you describe your design aesthetic?

I guess it's layered, with a sense of humour and quite clean. I try to streamline things, and think a lot about practicality and having things that are easy to live with. In the beginning, we were designing quite a few small spaces, and it was very important for things to work really well. I try not to get influenced by trends.

Do you have a key project?

Yes, it was the one I got just after I'd left Nicky Haslam's. It's called 'West London Townhouse' on my website. They were very 'up' for us doing something a bit different, and then allowed me to have it published, which was incredibly helpful. It was a wonderful opportunity to show people an example of the work I love doing best, which in turn led to other very interesting projects.

What is your favourite room to design?

I quite like bathrooms, actually. I like to make them a bit special, and think about them more creatively. I also like designing kitchens – making them more bespoke and making sure they don't date.

Are you often tempted to change things in the house?

Every now and then, but I guess I haven't been here for that long yet. But I do look forward to time passing, and adding to what is already here.

What can't you live without?

My coffee in the morning. I love the ritual of making it – it's my treat and inspires me to get up. I have a large cappuccino and an apple and almonds every morning – so quite healthy.

What would you grab if there was a fire?

Above the fireplace in the dining room is a painting by a woman whose son was a great friend of my father's, and died quite young. He was my unofficial godfather and I was very fond of him. We always used to play cards, and one day he folded up a card and wrote, 'I ♥ U' and placed it in a matchbox. I could never leave that behind. But I realise I shouldn't get too attached to everything here. They are just things at the end of the day.

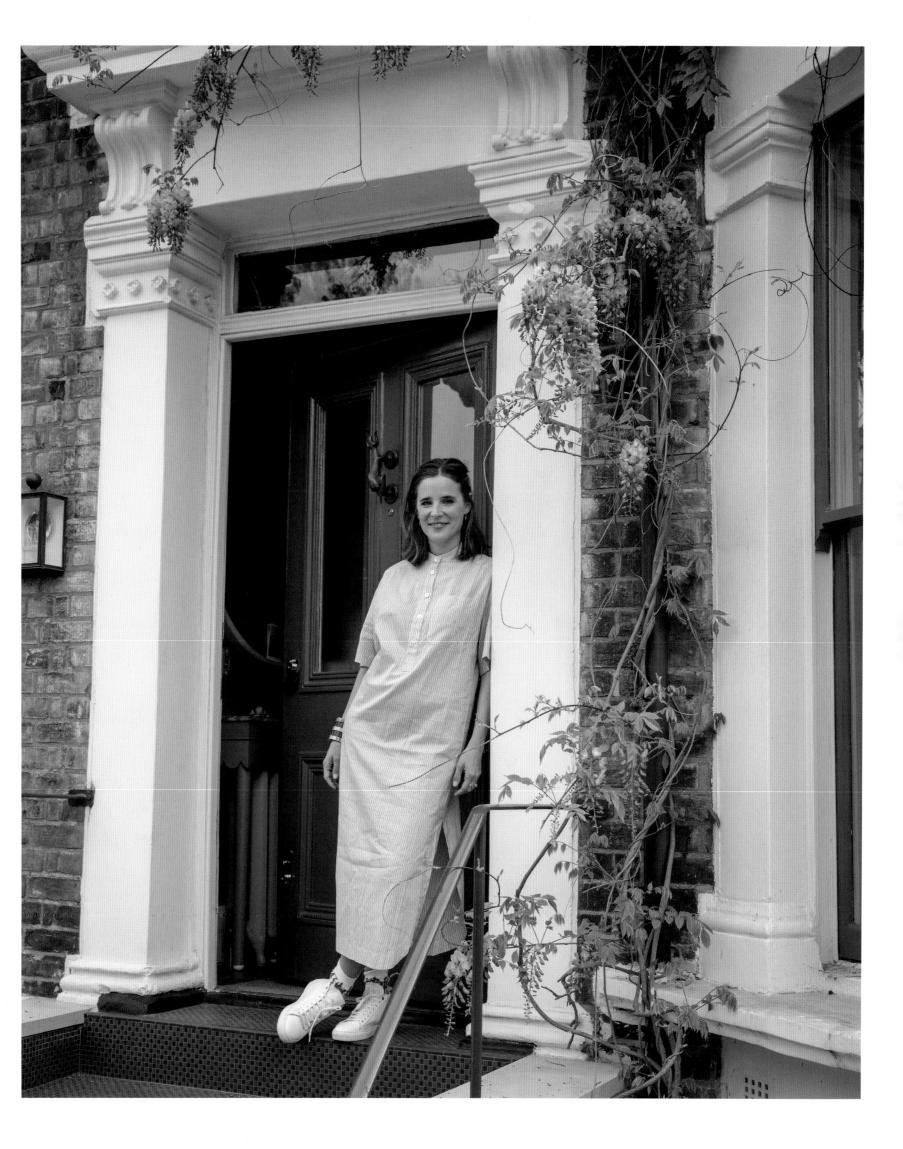

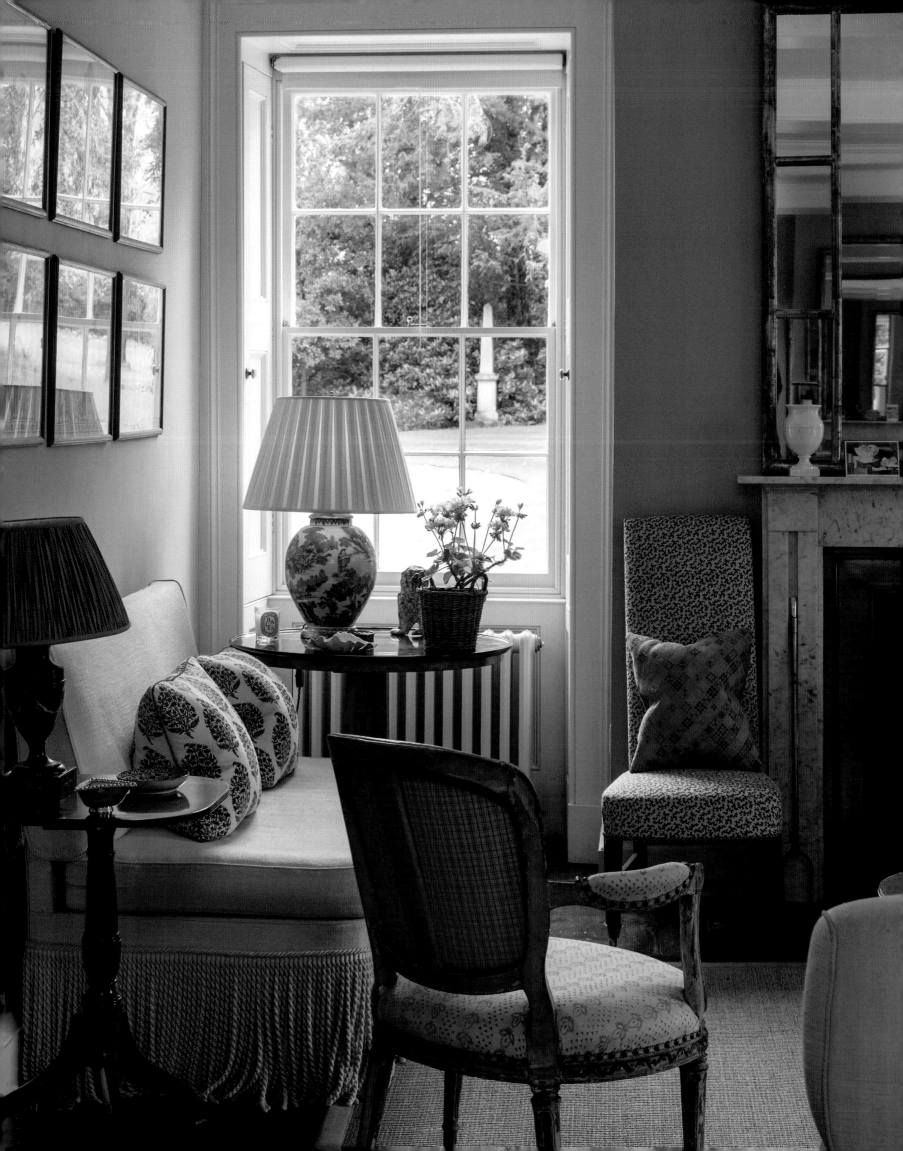

ROGER JONES

A sense of belonging is essential to the notion of home. For many years, Roger Jones and his partner, Gregory Chambers, had lived in London during the week and spent weekends at their cottage in Wiltshire. When they outgrew their country home, they searched for two years for a larger house, mainly in East Anglia, as that's where many of their friends live. 'Everything I looked at was either too expensive or too done up by other people – I wanted a project.'

One weekend in 2003, the couple were in Cardiff, and made a nostalgic visit to Llandaff, where the Welsh-born Roger hadn't been since he was a child. 'I felt at home,' he says. The house search switched to Wales and, nine months later, they moved into an old rectory in the hills near the Welsh border. The earliest part of the house was a tithe barn for the church, dating back to the 15th or 16th century, with a two-room cottage attached. Over the years, various additions were made, the last being a conservatory in the 1920s that was falling down by the time Roger saw it.

With this house, which the couple head to on weekends with their lurcher Patch, Roger certainly had the project he had been looking for. Before they started, they lived in it for almost a year to work out what needed to be done, and then approached Craig Hamilton for architectural help.

The layout was only altered slightly, but one major change came about when Craig convinced Roger to move the front door from the southern to the western side, and designed a portico for it. An arched recess was created in the hallway out of space stolen from the drawing room next door, and the dilapidated conservatory was replaced with a garden hall, also designed by the architect. To bring in more light, new windows were added in various parts of the house, care being taken to ensure the joinery matched that of existing windows in the same room. Upstairs, bathrooms were created on landings, so as not to encroach on the bedrooms.

What was once a dining room is now a library – Roger designed the bookcases, and brought in a mantelpiece that he had removed from the drawing room. The walls in the library were in a poor state, so he decided to upholster them in fabric. The same Larsen linen was also used for the curtains. The old kitchen was turned into the dining room, next to an extension housing the new kitchen.

Two small parlours were combined to create the new drawing room, and two additional windows were installed to bring in more light. Mahogany double doors, designed by the architect, provide an elegant entry from the hallway. A fireplace was opened up, and a marble mantelpiece was made for it to match the original one (brought from elsewhere in the house) at the other end of the room. The room has become a favourite place to sit on long summer evenings, 'to enjoy the fading light'.

As much as possible, items such as doors, windows, tiles and baths were reused or reclaimed. Taking the notion of recycling to extremes, when the couple found the trunk of a long-fallen cedar tree beneath some rhododendrons, they had it planked in varying widths and used it as floorboards for the main bedroom.

Opposite. To bring more light into the drawing room, Roger and Gregory installed sash windows on either side of the fireplace on the western wall, with shutters and hardware replicating the original windows on the northern wall.

In the entry hall, the timber floor was replaced with Ancaster limestone. 'I got an amazing deal from the stone yard,' says Roger. Months later, when he inspected the stone, 'I realised it was third grade with lots of fossil marks, which explained the low price – but I decided it was quite appropriate for a modest country house.'

In the dining room, flagstones from outside were brought in to replace modern black ceramic tiles. Roger used a Kathryn Ireland striped fabric, now discontinued, for curtains in this room. 'I love this fabric; it's only humble ticking, but it is big and bold, and really gives a lift to what is probably my favourite room in the house.'

In the bathroom next to the main bedroom, walls are hung with 'Tarrytown', a Hamilton Weston paper, a reproduction of an early 19th-century one found in a house about 30 miles away. 'So it has a Welsh connection,' says the designer.

Roger and Gregory didn't need to buy much furniture – most came from their cottage in Wiltshire and a flat in London, and there are some family pieces. One recent acquisition is an oak coffer in the hall: 'The only piece of Welsh furniture in the house!' says Roger. One slightly troublesome item is the 1780s four-poster bed in the guest room. 'It's such a performance to make up that if we have people to stay, we tend to put them in another room!' Two more guest rooms are yet to be redone.

In the attic, which would have once been staff quarters – 'There are still marks of the candle flames on one of the beams' – Roger used his favourite, now discontinued, Colefax and Fowler chintz, 'Climbing Geranium'. 'We had it in our previous cottage – I unpicked a double bedspread, a bed valance and two pairs of curtains. I begged, borrowed and stole other bits from wherever I could, and there was just enough to do the curtains and twin bed valances for this room.'

Roger's life in design started at the age of 10, when he was allowed to choose the paint colours and curtain fabrics for his bedroom. As a child, he also used to read his mother's copies of *House & Garden*. 'There were floor plans of the houses in each article – I was fascinated by them, to see how rooms connected.' However, he studied history and law at Cambridge, and trained for the bar before working as a barrister for a number of years. He became a parliamentary counsel, a high-powered senior government post that involved drafting bills for parliament. He had every intention of staying at the centre of decision-making, but in 1994, through a friend, was offered a job running the antiques department at Colefax and Fowler.

'I became used to visiting antique shops with my parents, and that habit developed into a pastime – particularly after I had a flat of my own in London, and some money to spend. The invitation, when it came, to go shopping for antiques with the Colefax and Fowler cheque book was irresistible.'

After a few years in charge of the company's antiques business, Roger began to take on decorating projects. 'My first job came about after our cottage in Wiltshire was in *House & Garden*. I think, all along, I had probably thought it was something I would be good at, but I was a bit too reserved to try until I was asked.' He has no regrets about the varied course his life has taken so far. 'I've been lucky to be able to exercise different talents during different periods of my life, and I have enjoyed them all – in different ways.'

Currently, Roger's talents are being directed towards the garden in Wales. It was overgrown when he and Gregory moved in and they're now reclaiming part of the land that is still covered in weeds and brambles. They've done an enormous amount of work, including installing a vegetable garden and greenhouse, and creating terraces and new beds. 'It's incredibly frustrating as I'm usually only here on weekends,' he says. 'There is always a project in hand; as one is being completed, the next is being planned. It stops me from getting bored, and it is so rewarding.'

'I BECAME USED TO VISITING ANTIQUE SHOPS WITH MY PARENTS, AND THAT HABIT DEVELOPED INTO A PASTIME – PARTICULARLY AFTER I HAD A FLAT OF MY OWN IN LONDON, AND SOME MONEY TO SPEND.'

Opposite. The divided staircase was one of the reasons Roger bought the house. The stairs and arches date from about 1780; the low arched doorway leads to the old kitchen and service quarters.

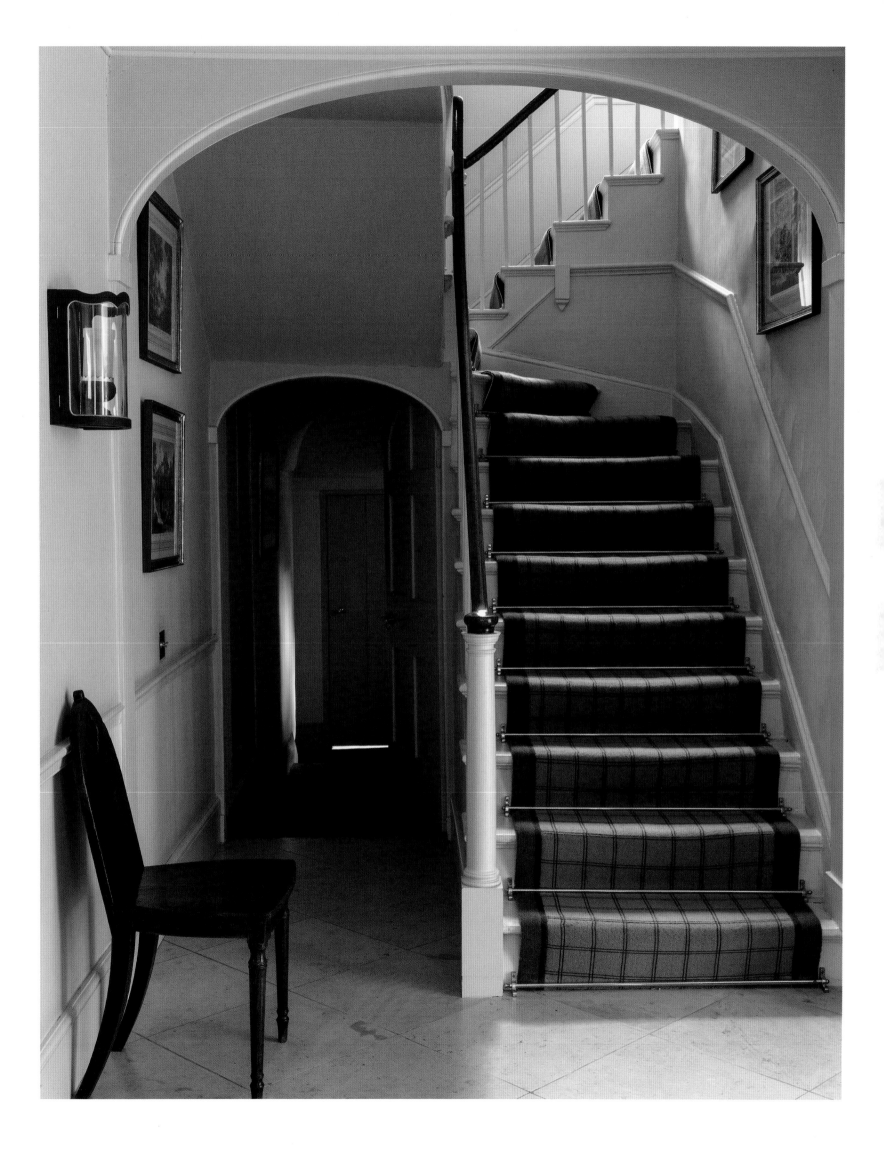

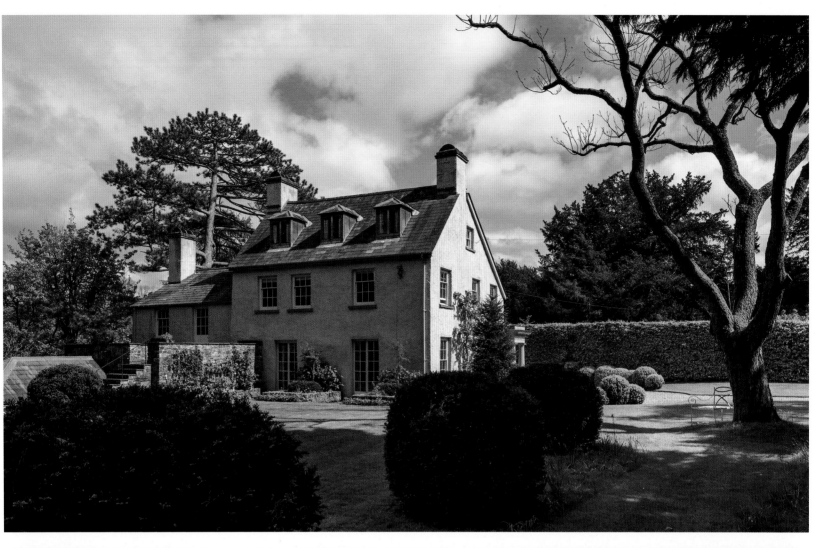

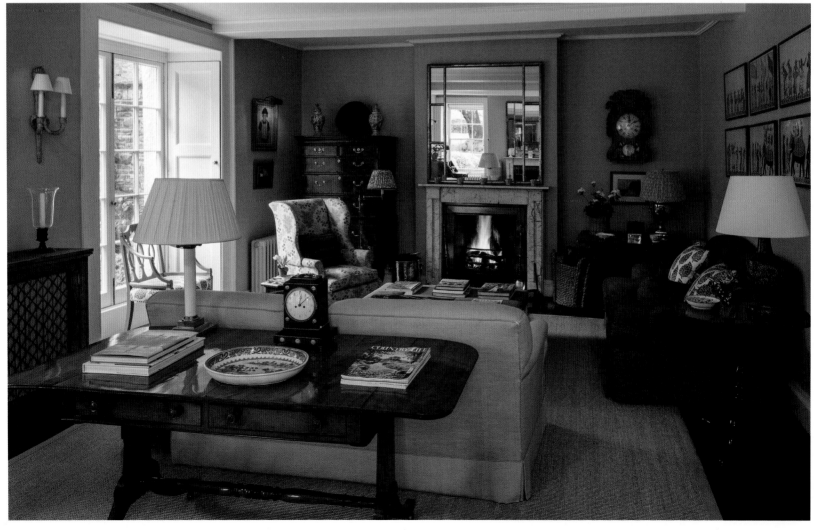

Opposite, above. A view of the house from the north-west. The three dormer windows and four of the sash windows are new. Three other windows were restored to sashes, replacing casements installed in the 1920s.

Opposite, below. The drawing room occupies the footprint of the tithe barn, the earliest part of the house. The fireplace had been blocked up, and the mantelpiece was made to match one at the other end of the room. Roger bought the early 18th-century tallboy at Sibyl Colefax & John Fowler antiques department in 1994, which led to him being invited to join the company.

This page. Roger found the unfinished oil portrait of a young girl by Carl Fischer at an auction in Copenhagen the week before he went to work at Colefax and Fowler. This is the one he'd save if there was a fire. Below is an oil sketch by Algernon Newton.

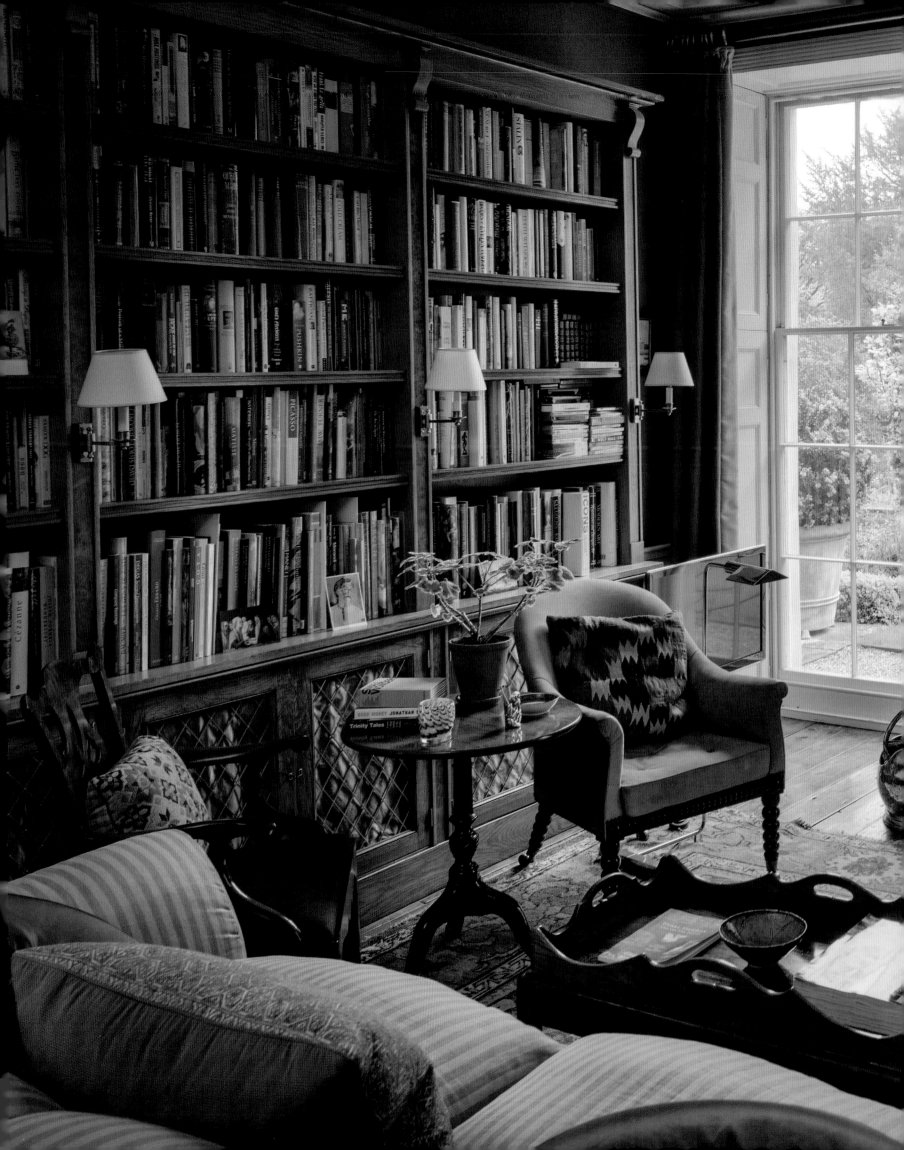

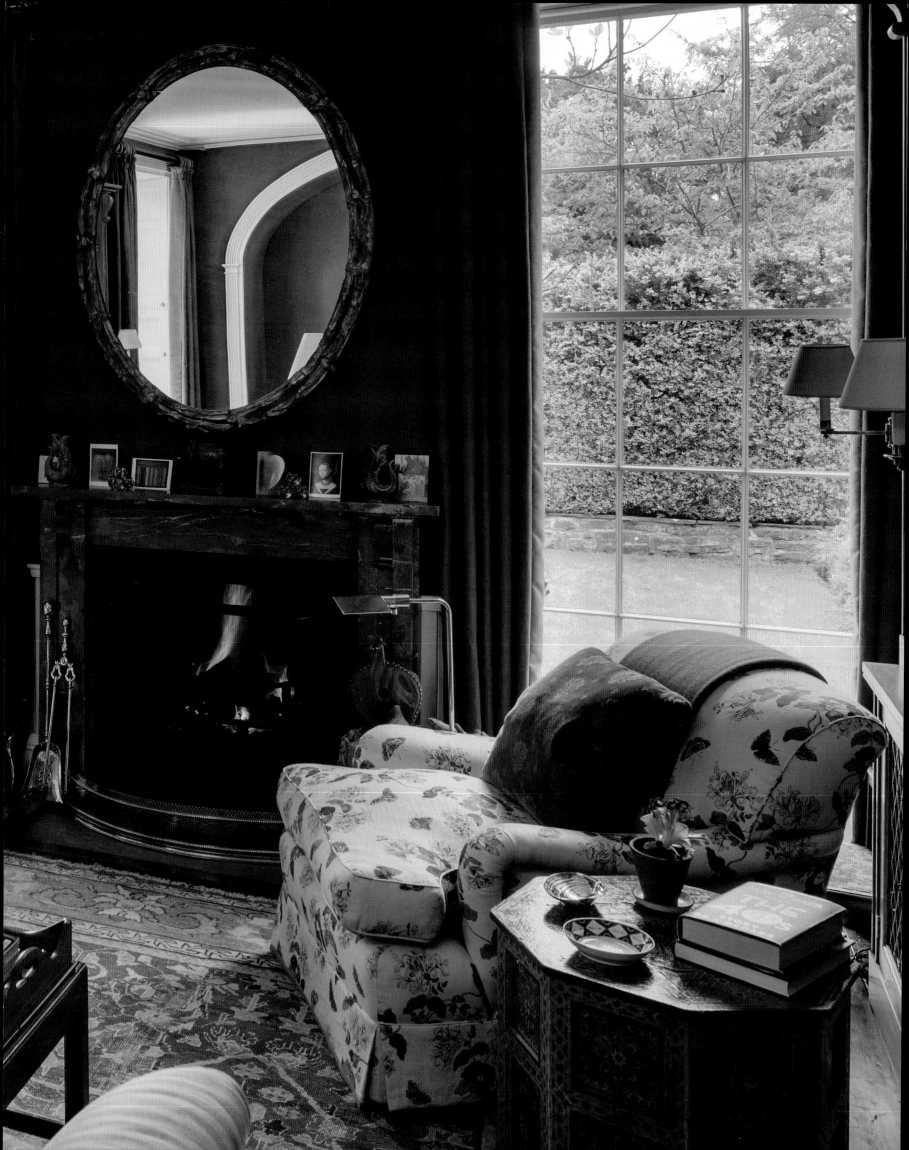

Previous page. The library is in the 1810 wing, and was formerly the dining room. Roger put back the full-height sash windows, which had been changed to French windows in the 1920s, and restored the shutters. The marble mantelpiece was originally in the drawing room. Roger designed the bookcases, the lower parts of which hide radiators.

This page. The dining room was originally the kitchen, while the new kitchen beyond was built on the foundations of a demolished scullery. Originally in the garden, the flagstone flooring has been laid over underfloor heating.

Opposite, clockwise from top left. The drawing room, looking through to the hall; the kitchen table overlooks the back garden; the arched recess in the hall contains one of Roger's favourite pieces of furniture, a late 18th-century mahogany chest from Schleswig-Holstein; the garden hall; an early 18th-century Chinese export lacquer bureau in the drawing room; the Aga was a present from Roger's sister; curtains in the attic bathroom were made from Roger's childhood bedroom ones; new terracing has a vegetable garden at one end.

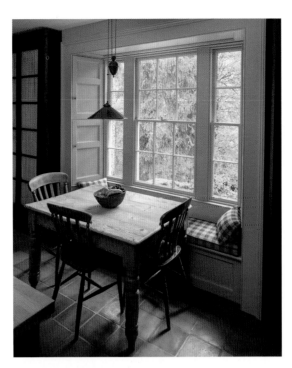
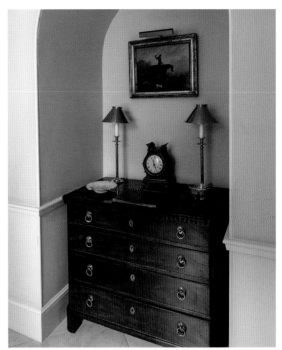
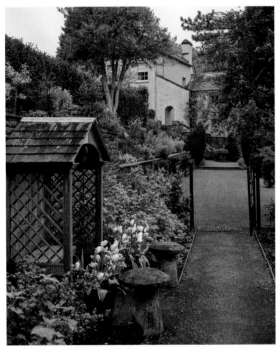
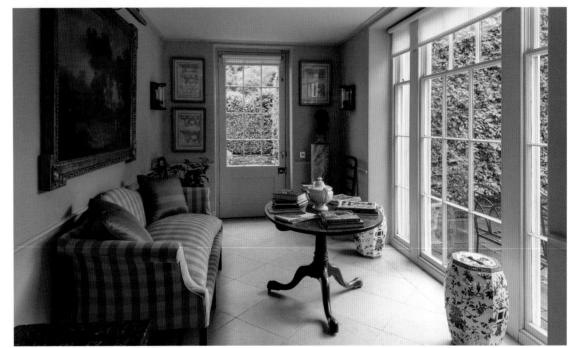
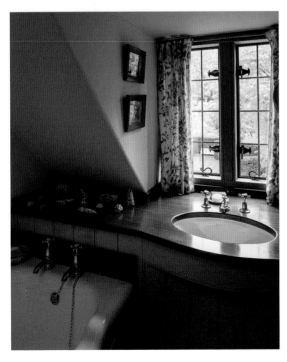
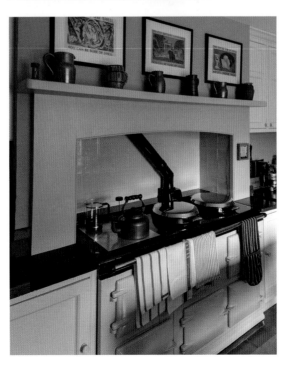

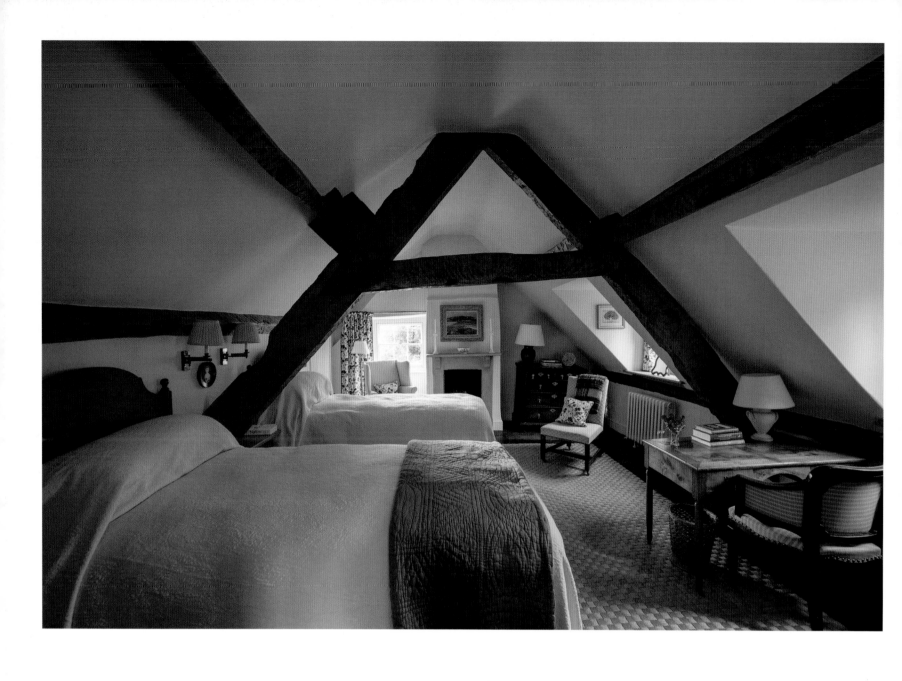

This page. Roger had the original 19th-century wooden mantelpiece in the attic bedroom painted by Penelope Sutherland to look like stone. There are still candle marks on one of the beams from the time when the room was used as staff quarters.

Opposite. Roger designed the joinery in the main bathroom to match the Edwardian mahogany bath panel. Walls are decorated in the reproduction of an early 19th-century wallpaper found in a house around 30 miles away.

Q&A

What does home mean to you?

In London we have a small flat in a 1930s block, which I've done in a sort of mid-century style – it's very much where we spend the week. Whereas the house is home, and I've put my heart into it. Living in an old house connects one with the past, and somehow creates more of a sense of belonging. It's also where I have all the things, collected over the years, that mean a lot to me.

Who do you find inspiring in design?

I will always be grateful to Tom Parr, who took me on at Colefax and Fowler and became a real friend. I learnt so much from him about interior decoration, at which he was a consummate professional. My decoration is different from his, but he worked at a different time and perhaps for a different sort of clientele. I admire David Mlinaric very much. He is a great decorator who does 'modern' just as well as the traditional grand houses for which he is renowned. I also hold Chester Jones in the highest regard; his work is intelligent, appropriate and always original.

Do you collect anything in particular?

Not really. I used to buy English ceramics – creamware and that sort of thing rather than fine porcelain – for their visual appeal rather than in a scholarly way, but I've now got so much that I've stopped. What I would love to collect is modern British art, but I haven't the budget to buy things of the quality I would want.

How good are you at relaxing?

Absolutely hopeless. I never sit down – my sister teases me, because she is the opposite. Here, there are always things to do, but when I go into my greenhouse, I suddenly feel at peace. When we arrive here on Friday after a long drive, I take a slow walk around the garden to wind down before I come inside.

What's your idea of luxury?

Properly laundered Irish linen sheets.

Flowers or foliage?

The main part of the garden is just green: grass, hedges, simple topiary and trees. But we have a new, long herbaceous border I am enjoying getting to grips with, and I love going over my pots of pelargoniums in the greenhouse. I prefer flowering plants to cut flowers in the house, though I like doing small, cottage arrangements of simple flowers for bedrooms when friends are staying.

What can't you live without?

Häagen-Dazs salted caramel ice cream.

Do you have a favourite design book?

I still look at Chester Jones' book on Colefax and Fowler; even though the interiors pictures now look somewhat dated, the principles described are still ones we follow today. The projects featured in the more recently published book about Chester Jones' own work fill me with admiration. Recently, I have been looking at books about Renzo Mongiardino; his work is inspirational when one has a project calling for a more elaborate, international style of decoration, as I have at present.

Do you like entertaining?

Somewhat to our surprise, this area has proved to be quite wonderful socially, with interesting people of all sorts, and we have made a lot of friends. Not as often as we should, we have local friends for lunch or dinner, and we also have friends from further afield to stay. Most weekends, however, we are here on our own, and I love that.

What would you grab if there was a fire?

Probably one picture in the drawing room. I'd be heartbroken if I lost it – that one has my heart.

NINA CAMPBELL

Nina Campbell's house in London, which she calls 'The Hut', used to have gothic cornices. To her, they were at odds with the design of the house: 'It was all a bit bijou, so I took them out.' At the same time, she replaced the dark red quarry tiles with warm wooden floors. As the ceilings on the ground floor are quite low, she decided to paint them in gloss, which allows the light to shimmer and bounce off them, giving an illusion of space.

It's for that reason, too, that Nina has used mirrors liberally and in unexpected places – slivers between bookcases, within and around a fireplace, and framed on a column. As well, secret sandblasted glass doors slide away to open up and close off various spaces between the living and dining rooms and the kitchen. Throughout the house, which has been Nina's home for 15 years, there's a mix of practicality and decisiveness, of warmth and comfort, indicative of her general approach to design.

As someone whose design projects have included everything from a grand residence on mainland China to a house in Amman for a member of the Jordanian royal family, it is not surprising that Nina's own home is anything but ordinary. 'I knew I didn't want a regular house,' she says. 'This used to be the studio for the famous sculptor Frank Dobson, who lived next door.'

Apart from its provenance, and the fact that she knows a lot of people in the area, there were two aspects of the building, which had been standing empty for years, that Nina found particularly appealing. 'When I was viewing the property, I went upstairs and looked out of the window onto the magnolia, which was in full bloom, in the neighbour's garden. I knew then that I had to make it work.'

At the time, though, the former studio was too small for Nina's needs. 'When I realised I could do the basement, I decided to buy it,' she says. 'We dug down and created the bedroom, bathroom, sitting room and laundry.' Just off the downstairs bedroom, a tiny patio painted green, and with a glass ceiling, visually extends the room and brings in extra light. Pull-out beds in the sitting room are used by her grandchildren when they come to visit. Another little patio off that room introduces yet more light to the basement area.

Nina did a similarly major renovation to the rest of the house, reconfiguring the layout. A garden is now planted in the area where the front door used to be; the front door has been moved to where there was once an extension 'with a nasty leaking glass roof'.

She installed a brass fire surround, which she bought in the States, in the sitting room, only to be told by the council that it wasn't deep enough to be used as a gas fireplace. 'So it's an *Alice in Wonderland* version,' she says.

In her bedroom, she created a walk-in dressing room behind a jib door beside the bed. When Nina and her daughter, interior designer Rita Konig, temporarily swapped houses after Rita had a baby, the dressing room was the perfect spot for the cot. Nina again used mirror on the doors between her bedroom and bathroom,

Opposite. As the ceilings on the ground floor are slightly low, Nina had those in the drawing room and dining room finished in gloss to create an illusion of height. Much of the furniture is of her own design, including the two Rita chairs in front of the window and the Grace table between them.

with mirrored handles completing the picture. Having completely stripped the interior of the former studio, the only thing salvaged was the bath, which now sits in her bathroom.

During her childhood, Nina's family moved house quite often in London's Belgravia, and her parents always allowed her to decide what her room would look like. Some of her attempts at decorating, she says, were rather sophisticated – one of her favourite wallpapers was a Cole & Son Toile de Jouy of women playing tennis. She went on to study at the Inchbald School of Design, before starting work, at 19, with John Fowler, of Sibyl Colefax & John Fowler.

After a few years, Nina went out on her own – some of her early work included designing London private members' clubs, Mark's Club and Annabel's, for Mark Birley. She also opened her shop in Walton Street, Knightsbridge, selling home accessories and gifts, and eventually began designing fabrics, wallpapers and trimmings. Her collections eventually expanded into furniture, chinaware and homewares, and many of her creations are available internationally.

Nina now has two shops, and about 21 staff in total. Her daughter Alice works from the Walton Street shop, dealing with retail as well as PR and marketing, and her son Max does the buying for it. Nina works either from her showroom at Chelsea Harbour or from Walton Street. 'I can't work from home,' she says.

At home, however, she has used Nina Campbell fabrics – the curtains in both the dining room and drawing room are 'Cathay Parade', which she based on an old document she found at Christie's auction house. The wallpaper and curtains in the guest bedroom are from her new range.

Nina also has pieces designed and made by friends and relatives. In the guest bedroom, portraits by her sister-in-law of her children Max and Rita hang on either side of the bed; a portrait of Alice hangs on the opposite wall. A large mirrored cupboard in the dining room, which now houses all her china and tableware, was made by William Yeoward to hide a radiator in her previous house – he amusingly included her initial 'N' into the design. Various ceramics by Kate Malone, another friend, are displayed around the house, and the banisters on the stairs up to Nina's bedroom are a copy of a set designed by her friend, interior designer Melissa Wyndham, for another project. 'The staircase had very limited space and the design suited perfectly,' says Nina. 'Melissa sent over the drawings. I love being surrounded by "friends" in my house.'

'WHEN I WAS VIEWING THE PROPERTY, I WENT UPSTAIRS AND LOOKED OUT OF THE WINDOW ONTO THE MAGNOLIA, WHICH WAS IN FULL BLOOM, IN THE NEIGHBOUR'S GARDEN. I KNEW THEN THAT I HAD TO MAKE IT WORK.'

Opposite. Paintings by Kate Corbett Winder and Fiona McAlpine hang above a chest of drawers by Birgit Israel in an alcove off the sitting room. Vases on the chest are by Kate Malone.

Overleaf. Mirrors have been used, often in unexpected places, such as around a fireplace, to visually enlarge the room. Sliding patterned glass doors open up and close off various spaces between the living and dining areas and the kitchen.

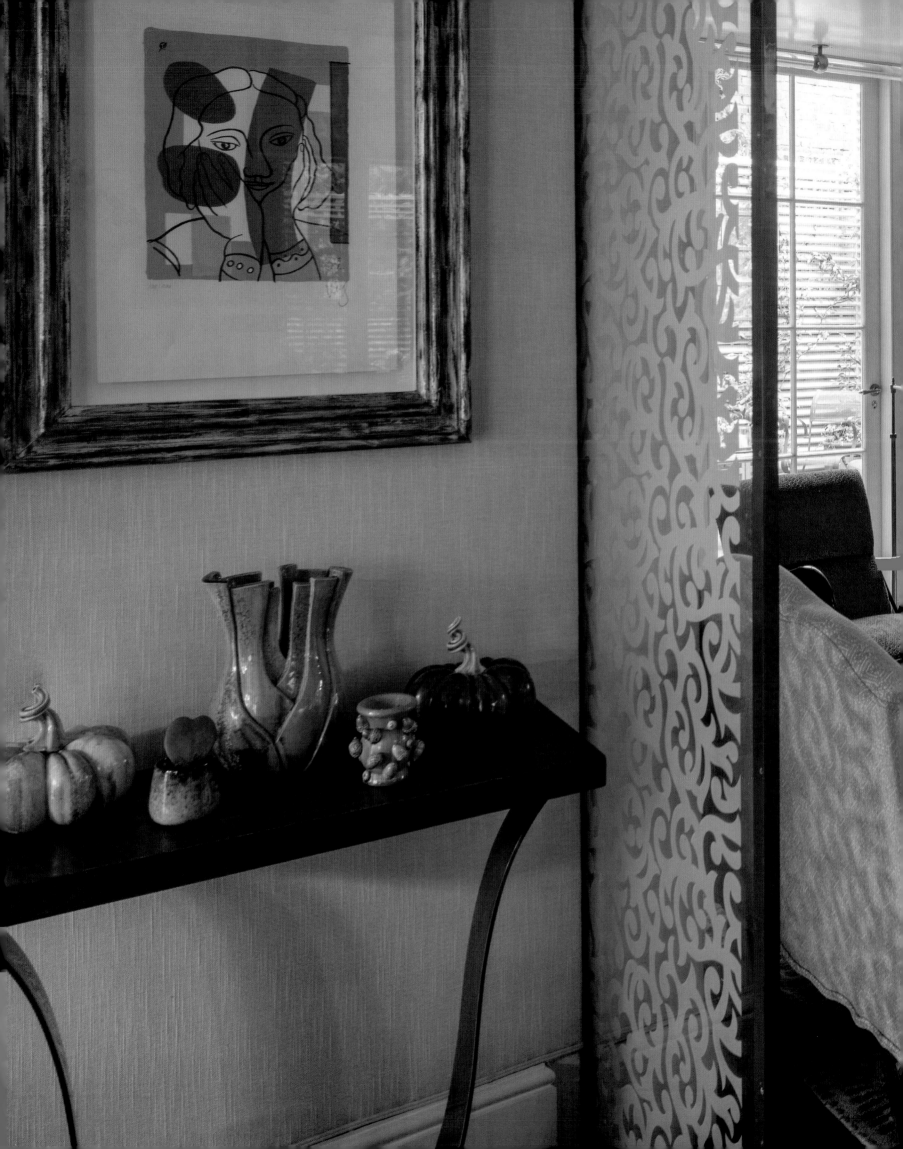

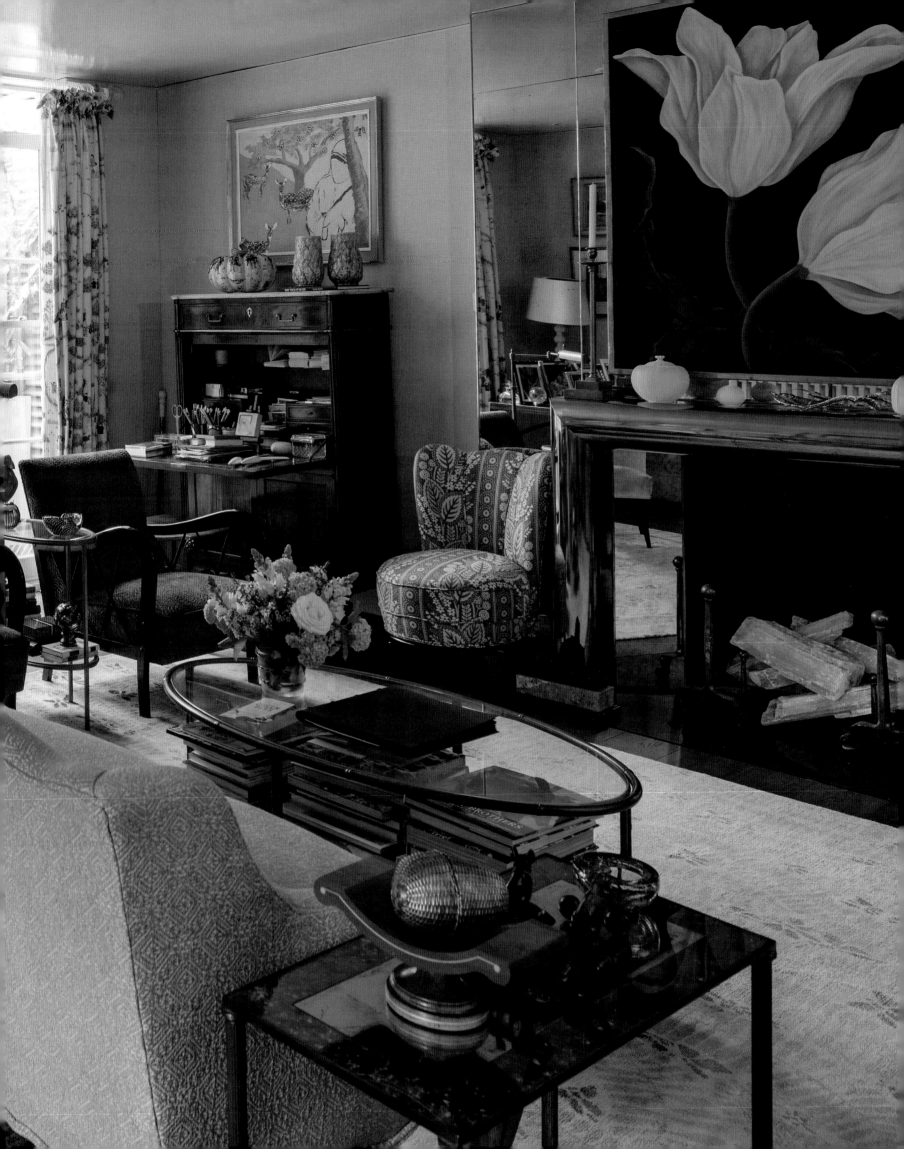

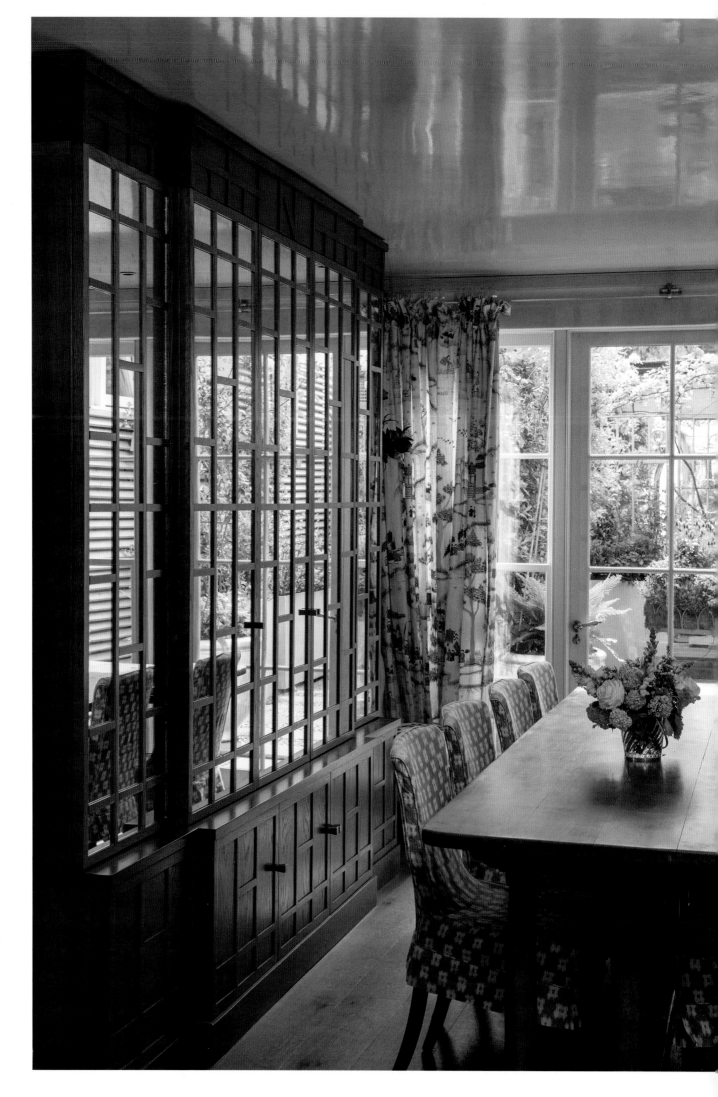

This page. William Yeoward designed the cupboard in the dining room, and included the letter 'N' into the design above the doors. The cupboard has moved many times with Nina, and needed to be shortened to fit into this space.

Opposite, clockwise from top left. A portrait of Nina's son, Max, by her late sister-in-law, Charmian Campbell, hangs in the guest bedroom; a portrait of Rita Konig by her friend Xandy Beckett; mirrored doors separate the bedroom from the bathroom, which contains an antique mirrored cabinet which Nina converted into the vanity unit.

Q&A

What does home mean to you?

It means entertaining and having people around, and having a sense of calm and comfort and relaxation. I like everyone to think they can feel relaxed here. I have lots of people come to stay, so we have breakfast together and then everyone goes off and does their own thing.

How good are you at relaxing?

I'm quite good actually! I get up late or go to the movies. Even when I travel, I always seem to end up seeing friends. I love mixing with younger people who are vibrant and have a point of view.

What are your views on brown furniture?

I think it's very ill-informed to say that brown furniture doesn't have a future. A nice piece of brown furniture in the room is so good – a mix is important.

You travel a lot for work – do you have a special routine?

I get on the plane and drink water only, and have food I've bought from Fortnum & Mason – smoked salmon and black bread. Coming back is a bit more dodgy. I try to sleep for a bit and then catch up with movies.

What's your favourite room to design?

A bedroom is rather exciting, because you can get into all the details of luxury, such as beautiful hangers and sheets. Practicality and comfort are very important to me.

What type of work do you do mainly?

I used to do a lot of country houses in England, but seem to be doing a lot more work abroad now. When I worked in Jordan, I felt it was important to work with local artists and makers. I've learnt so much about other cultures and customs by buying locally, which is fun.

Do you read much?

I've recently had my reading curtailed because of cataract removal. But I love books with a point of view, books that make you think – I loved *The Lemon Tree* and *Suite Française*.

What's your idea of luxury?

When I wake up and realise I don't have to get up! Getting a coffee, taking it back to bed and watching the news.

What would you grab if there was a fire?

Obviously Theo and Twigs, my dogs, and the pumpkin made by my friend Kate Malone.

PAOLO MOSCHINO
AND PHILIP VERGEYLEN

West Sussex was a part of the world Paolo Moschino and Philip Vergeylen were already familiar with. They had been renting there for two years, and loved it so much that they wanted to buy in the area. When they first saw the farmhouse they now own, they'd made their decision even before they stepped inside. 'The outside was most important, because we knew we could fix whatever was inside,' says Paolo. They knew straightaway that this house, on two acres of land, was exactly what they were after.

They loved the look of the part Tudor, part 19th-century house, but the garden, at first viewing, wasn't to their taste. 'It was the opposite of what I like,' says Philip. 'The terrace was curved and I like straight lines. I'm afraid there are few flowers in our garden, it's mainly green.' Adds Paolo, 'We see it from indoors, and it's the same the whole year round, which is what we like.'

While they were sure they'd be able to sort out the interior of the house, the couple struggled with the exterior landscape. 'First of all, we are not gardeners,' says Philip. It was only when a friend sent an aerial photo of the house that he could see where he could create garden rooms. 'All the hedges and trees and planting you see now were non-existent.' They built a greenhouse, which is now full of flowering indoor plants and climbers, and a small pond in the wild garden and a swimming pool, which they use a great deal in summer. It wasn't all plain sailing. An outside table, the top of which was an olive press, was delivered to the house from Italy for a reasonable price. 'But they delivered it to the gate,' says Philip. 'Moving it to the right position in the garden was like building the pyramids!'

The couple's willingness to tackle a job that's completely new to them, and to be confident in their ability to deal with the house itself is unsurprising, given their backgrounds. Neither of them had originally intended to work in design, but have managed to build very successful careers in the field.

Paolo, who majored in political science at university in Florence, worked in fashion for a short time in London before getting a job with Nicky Haslam. In 1995, Paolo bought Nicholas Haslam Ltd and further developed the retail side of the business before Philip joined him in 2012. Philip had been to business school in Brussels and worked for American Express for 17 years before moving into interiors. 'I was lucky, of course, because Paolo already had the shop, so I could jump into that space,' he says. 'Design has always been my passion.' He designed the couple's first apartment, which ended up winning an international interior design competition. Philip now heads up the design studio while Paolo takes care of retail and the business side of things. With projects all over the world, I ask, 'Do you ever have arguments?' 'All the time,' they laugh. 'Every day!'

When it came to the inside of their farmhouse, the couple virtually reconfigured it, opening up the staircase and jumble of dark rooms on the ground floor, and built an extension, containing a dining room, study and conservatory, at the back.

Opposite. Paolo Moschino and Philip Vergeylen's farmhouse in West Sussex contains a Tudor section, to the right of the front door and, to the left, a later 19th-century addition.

'We used reclaimed bricks so the addition is seamless,' says Paolo. Finding reclaimed materials, including oak for the flooring, was not an easy task; because of this, the renovation, which was expected to take six months, took two years. A barn, in very poor condition and with a dirt floor, was also converted into guest accommodation. A portrait of Philip's great-great-grandfather hangs in a bedroom upstairs. 'I guess he never thought he would end up in a barn!' he says.

Each room in the main house has a different character, from the blue and white dining room, 'which we never use as a dining room', and the lofty new extension looking out to the garden, to the cosy drawing room with pickled beams and the sitting room with its terracotta walls, usually used at night. To lighten up the interior, most rooms have been painted in pale colours, in slightly muddy hues.

Every now and then, there are completely unexpected features. The starting point for the blue and white room, for instance, was a screen that Philip had bought in Paris. To balance the otherwise white room, he and Paolo commissioned artist and muralist Dawn Reader, who has been working with them for years, to extend the screen's tree motif onto the walls. 'It made such a difference,' says Paolo. Apparently, she loved doing it because it felt so organic, though painting the tiny cloakroom walls in strict geometric lines was more of a challenge. Reader also decorated the walls of one of the four bedrooms upstairs in a gentle leaf design, where Philip used one of his favourite fabrics by Le Manach for the bedcover and curtains. He had planned to continue it on the walls, but as they were wonky and there were beams everywhere, that would have been impossible.

As with downstairs, each room contains an intriguing mix of objects from different periods and places, indicative of Philip and Paolo's broad-ranging tastes. The result is a serene sense of order in the midst of abundance.

When the couple comes down to the country for the weekend, they each have their own way of enjoying it. As Philip has to travel so much for work, he sets himself down and doesn't leave the house, while Paolo likes pottering around, visiting the local garden centre or nearby town.

It's a house that works well when it's just the two of them and Jack, their French bulldog. Equally, it expands to accommodate friends for the weekend or, at Christmas, all of Philip's family, who visit at that time of year. Their Christmas Eve meal is a feast of lobster, turkey with all the trimmings, plus foie gras, which his family brings over from Belgium. 'And there's the bûche de noël, which my mother brings over, but sometimes she forgets,' says Philip. 'Then there's a family argument as to who has forgotten it.' The next day, they have leftovers and watch the Queen's speech on television. All in all, a little bit European, a little bit English and very fitting indeed.

'THE OUTSIDE WAS MOST IMPORTANT, BECAUSE WE KNEW WE COULD FIX WHATEVER WAS INSIDE.'

Opposite. On a wall of the guest bedroom in the barn, a collection of convex Regency mirrors surrounds a portrait of Philip's great-great-grandfather.

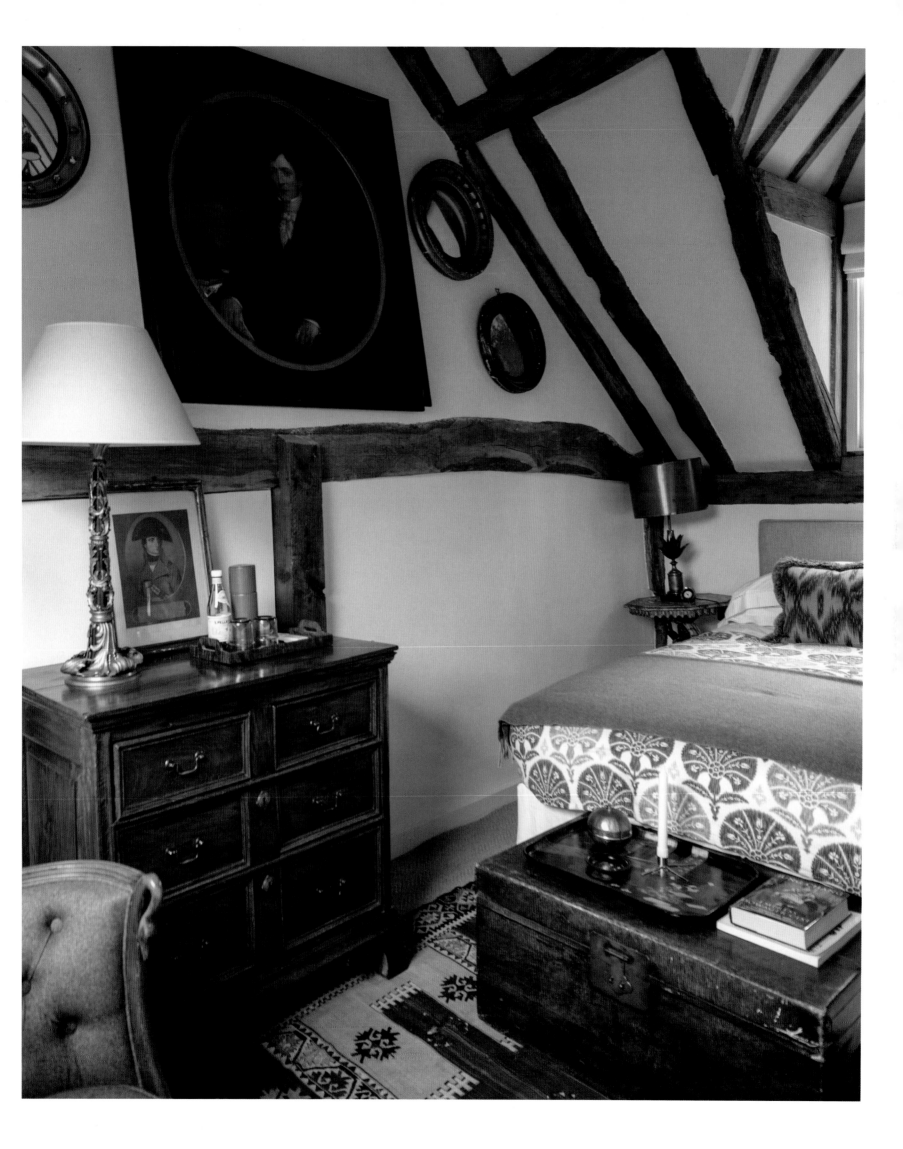

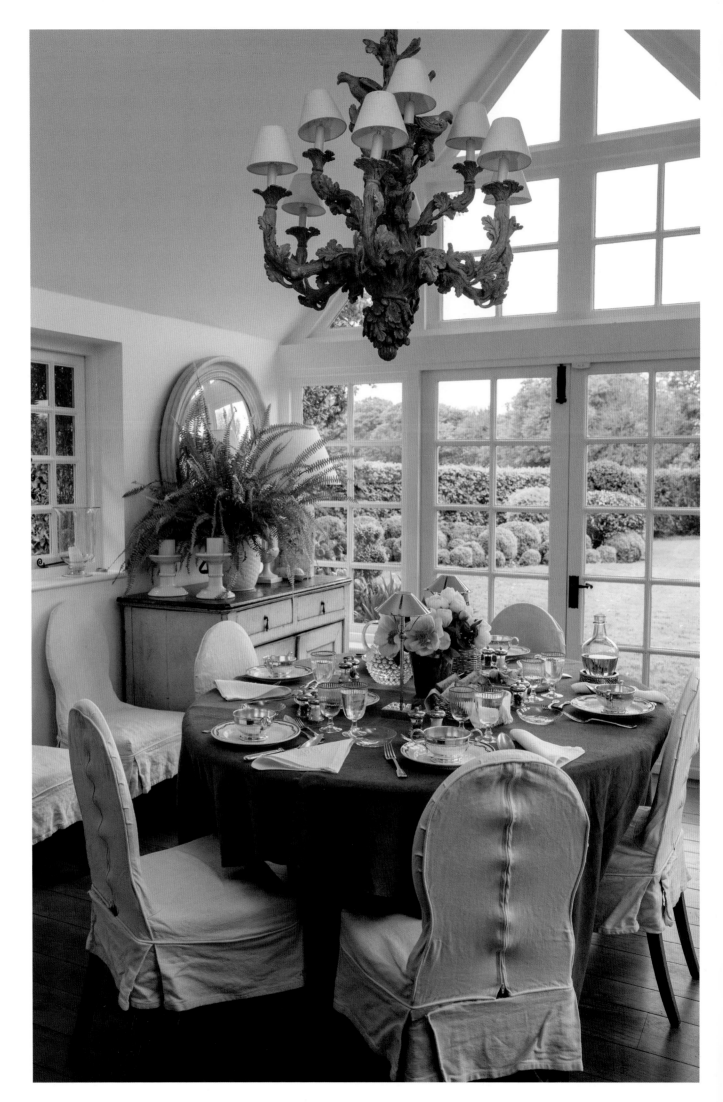

This page. A Dove chandelier, from Nicholas Haslam Ltd, hangs above the table in the kitchen, in the newest part of the house.

Opposite, clockwise from top. The guest barn, on the left, was derelict when Paolo and Philip bought the property; the couple installed the greenhouse, which is full of flowering indoor plants; 'the infamous table' with the olive press top from Italy.

Overleaf. The dining room, with a collection of antique Delft porcelain. An 18th-century French screen hangs on the end wall, which provided the starting point for Dawn Reader's mural.

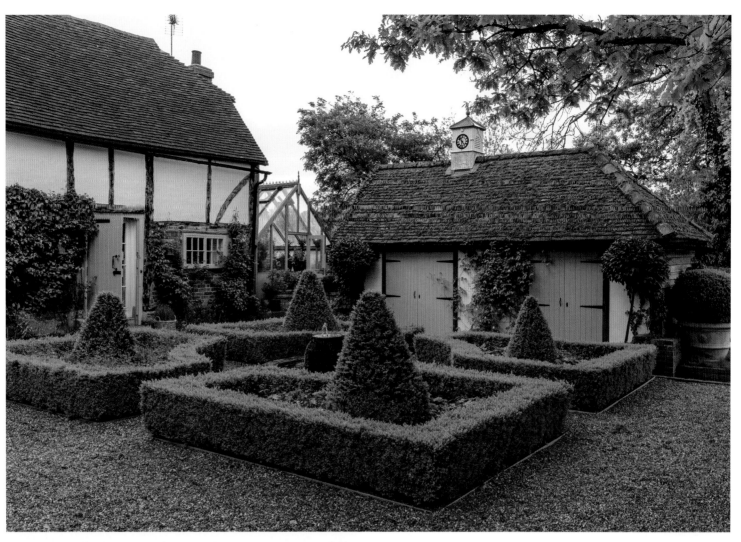

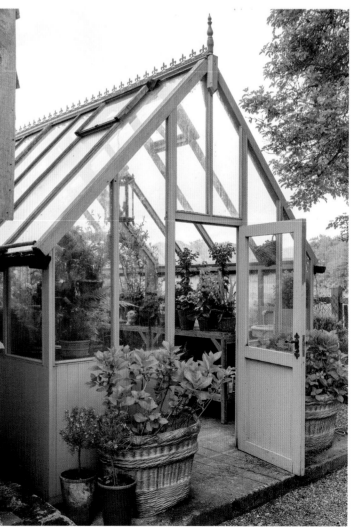

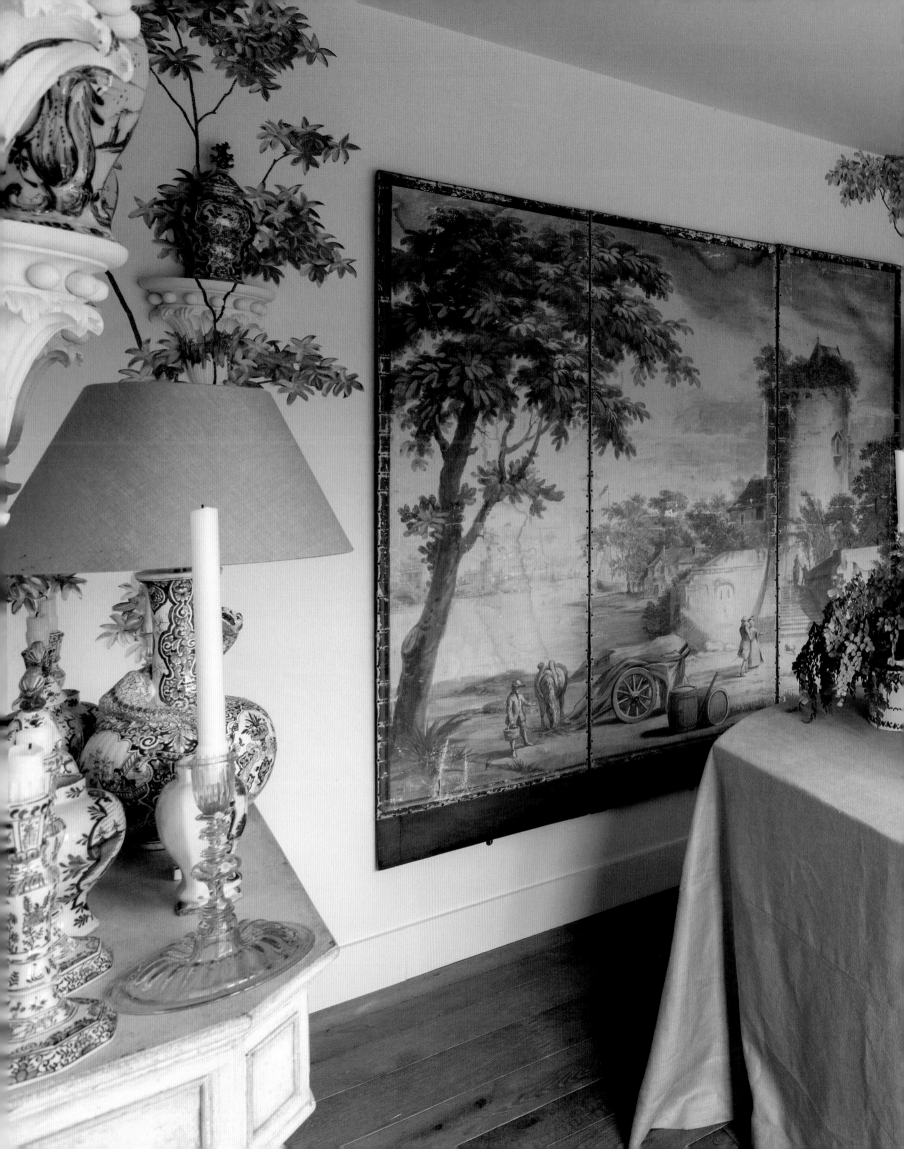

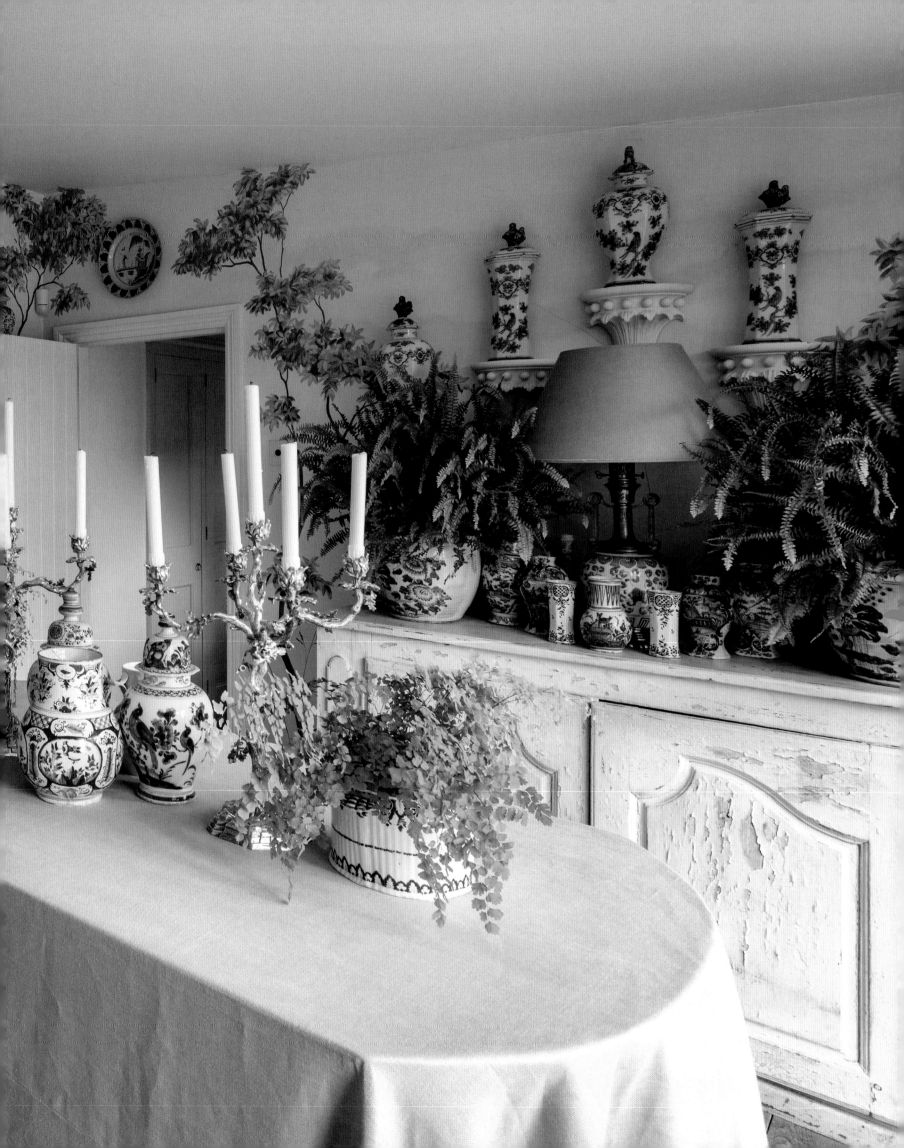

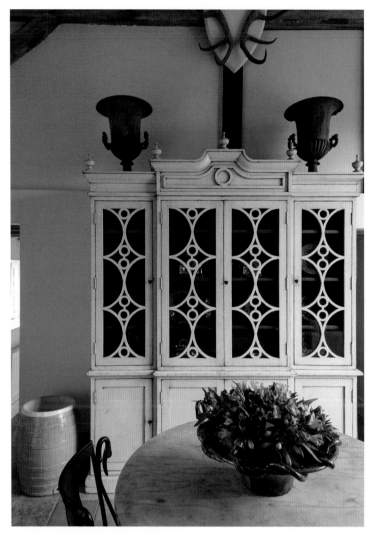
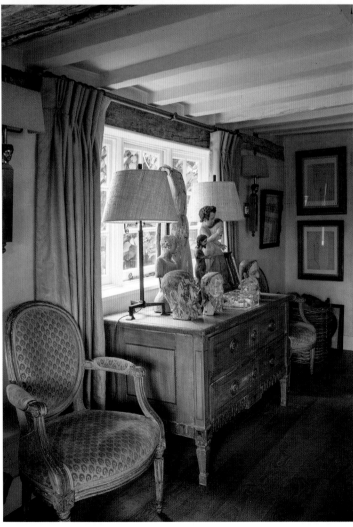
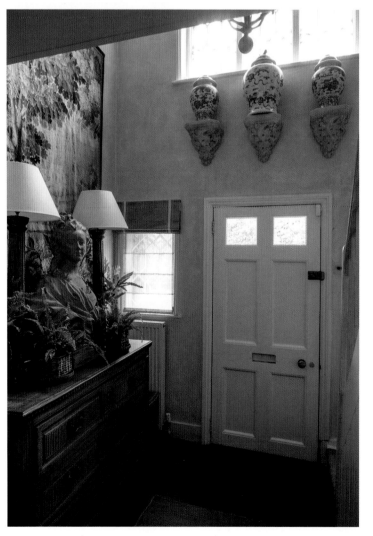

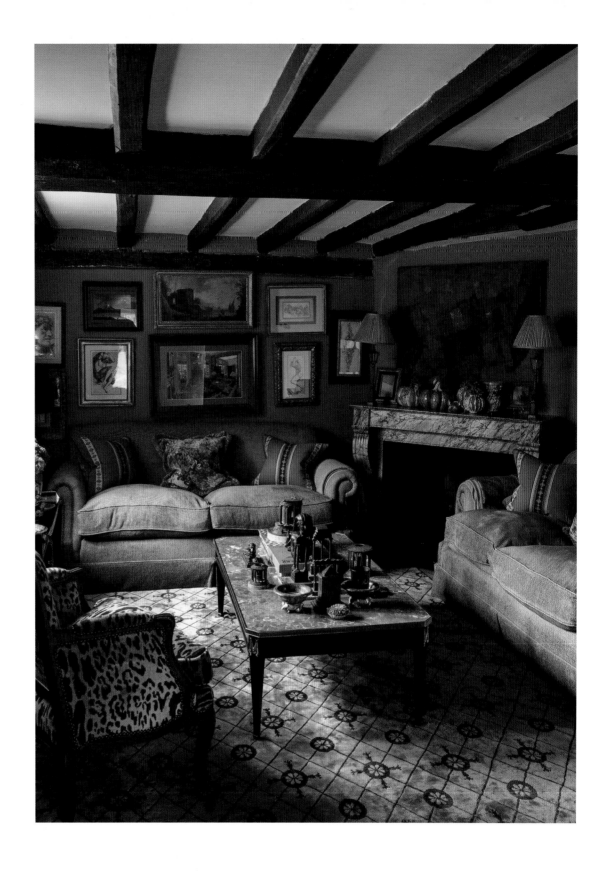

Opposite, clockwise from top left. In the drawing room, a collection of silver tortoises from Buccellati and the gravestone of Elsie de Wolfe's last dog are arranged on the coffee table, which was converted from an old door; a Hollywick vitrine from Nicholas Haslam Ltd provides storage in the guest barn; a 17th-century Flemish gobelin tapestry hangs in the entrance; a reclaimed Belgian timber floor is used in the drawing room.

This page. Above the sofa in the sitting room, a collection of French and Italian Old Master drawings surround the Penny Graham watercolour of the couple's library in London. Above the fireplace is a French abstract bought at the Charles Sévigny-Yves Vidal auction. The rug, based on a Madeleine Castaing design, echoes the blues of the vintage coffee table by Maison Jansen in Paris.

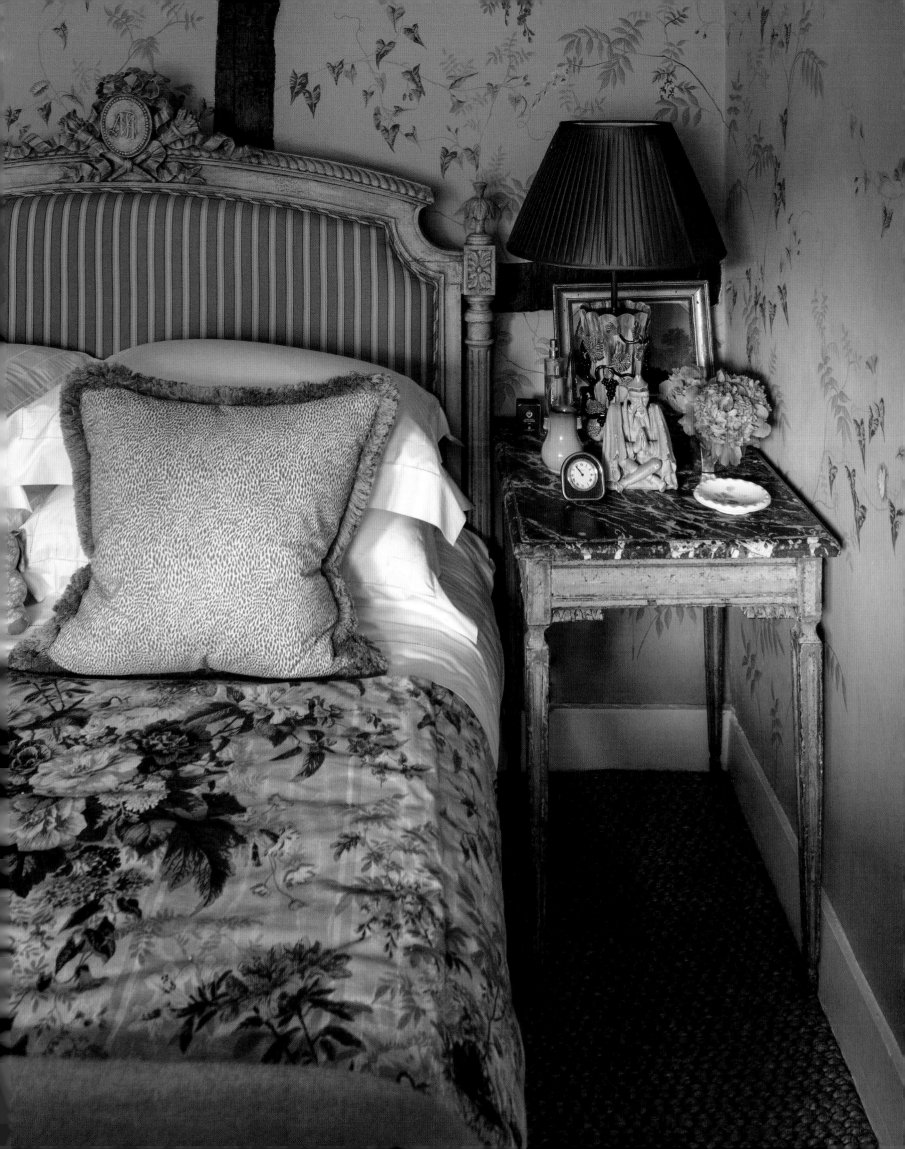

Opposite. In one of the bedrooms, Philip chose one of his favourite Le Manach fabrics, 'Mortefontaine Gris', for the bedcover and curtains. It was this that muralist Dawn Reader used as inspiration for her design on the walls.

This page. The design of the painted walls, again by Dawn Reader, is based on the bamboo panelling in Madeleine Castaing's Paris apartment.

Q&A

What's your favourite room to design?

Paolo Moschino: A bedroom.

Philip Vergeylen: A dining room – I love a bit of theatre.

Are you tempted to change your interiors a lot?

PV: Yes, all the time, but Paolo hates change.

What's your design aesthetic?

PM: Classic with a twist.

Has anyone been a great inspiration to you in your career?

PV: Albert Hadley, Stéphane Boudin and Billy Baldwin – we buy every design book that was ever printed.

What's your idea of luxury?

PM: Space and quiet.

PV: Contentment – when I'm with nice people in a nice place with nice food. You take one element out and it's no longer nice.

Who made the renovation and design decisions here?

PV: I think we made them together – I made the suggestions, and Paolo agreed!

What would you grab if there was a fire?

PV: There's a framed letter from Wallis Simpson addressed to 'Horst', who worked for Elsie de Wolfe, thanking him for the delivery of two sofas. I bought it in LA at the Elsie de Wolfe Foundation. Also, my books.

In the living room above the sofa is a watercolour by Penny Graham of our library in London. I wanted to give this as a present to Paolo, and expected her to take a photo and paint it at home. But, of course, she painted it in the library and was there every day for three weeks – which ruined the surprise.

But, of course, firstly, Jack!

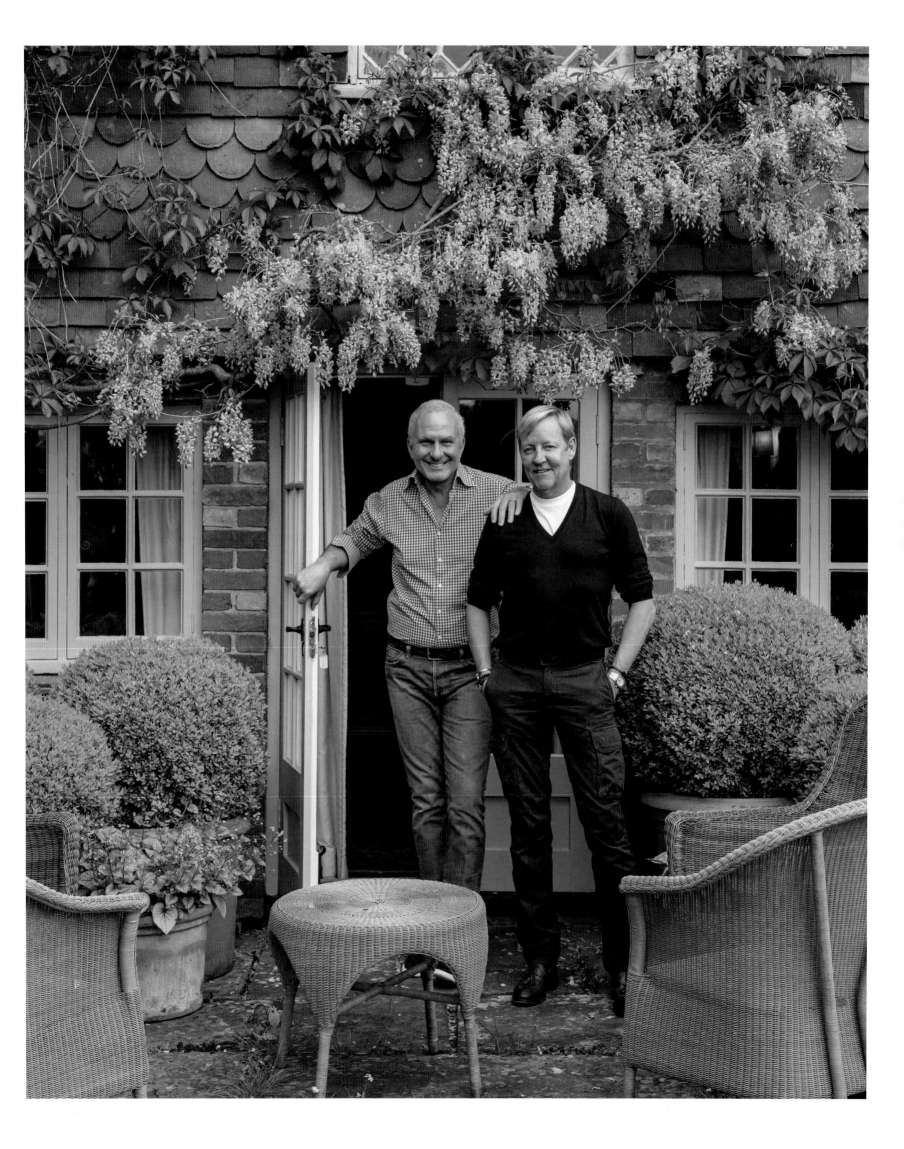

ALIDAD

'For me, when I'm doing a house, it is not only about how pretty it is, but rather about all the things that are unseen and unsaid,' says Alidad. 'How the room functions, where you sit down and have a cup of tea. The lighting and power points have to be considered – it's no good thinking only about the décor.' He says his clients sometimes think he's 'too fussy or too pedantic, but when it's all finished, they realise why'.

Having been in his London flat, close to Grosvenor Square in Mayfair, for more than 30 years, Alidad has had plenty of time to put into practice his design ideas. For him, it's vital to live in a place that looks as if it's evolved, mixing elements from different times and places. 'A home is somewhere in which a family has been collecting from different periods,' he says. 'This place has a mixture of centuries, all together. I wouldn't want to create, say, an 18th-century house, because I don't want it to feel like a museum.'

While Alidad likes to consider every sense when he is designing, it is his sixth sense that, perhaps, more than anything, contributes to the success of his work. 'It's that voice in my head that tells me how far to go, that "one more fabric is going to kill this room",' says the designer, who is renowned for his sumptuous yet supremely comfortable interiors.

Of all the flats in his block, Alidad's was the only one with not only its original layout, but also original cornices and skirtings – 'which was a relief for me, because I usually have to put them back. Many houses in London have unfortunately had terrible conversions, using the quickest, cheapest methods.'

The richness of the hallway is a promise of what is to come, with its crimson suede-like walls, and antique gold braidwork highlighting the architectural features. 'I had to link some very overpowering rooms,' he says. 'It would have been very strange entering them from a white space.' The first is the east-facing drawing room, his 'pretending the sun is out room. I always say to my clients that, if they have enough rooms, they should try to have one sunny one and one dark, womb-like one.'

His pale yellow room is a particularly nice place to be in the morning. 'I wanted a sunny room because, as you know, in London there is often no sunshine.' In the evenings, Alidad likes to sit in the red room. 'During the day it doesn't make sense, but at night, all the colours shimmer and the room comes alive.' Its walls were elaborately hand-painted in 1984. The room has gradually evolved over time, with Alidad adding to it over the years. At one time, he refrained from hanging pictures on the walls as he felt they were 'almost sacred', but he got to the point where he had done everything else he could, and so he started adding paintings, and still continues to do so. 'I like a sort of surface chaos in rooms like these – with things on top of one another, such as all the small rugs.' The reason the rugs are there, he explains, is because the carpet underneath is threadbare in places. 'I couldn't do that for my clients, but I can do it for myself!'

Opposite. Alidad loves jib doors, and used two of them in the hallway to overcome the problem of having too many overly visible doors. The engravings, after Francis Smith, are all finished by hand. The plaster mould of a lion's head is a modern piece.

The dining room is also reserved for night-time, although for many years it was Alidad's office; and, in some ways, he has viewed it as a showroom for his work. 'I wanted it to be something that reflected me, something warm, but also showing people what I could do,' he says. The embossed leather-lined walls, based on old designs, and antiqued, 'are something we do quite a lot'. An enormous cupboard on one side of the room is used to store dinnerware. 'Everything I do leans towards "over-sizing". I love to use large-scale wallpapers in small spaces to deceive the eye.' Originally, the room was candlelit, 'until my cleaning lady complained and we had electric sconces installed'.

Alidad was born and brought up in Iran. 'My mother had an amazing eye and I liked things that were arty when I was a child, but was lucky enough to be good at maths as well.' His childhood, he says, was idyllic but, for the sake of his father's health, the family moved to Switzerland for a short time when Alidad was 15, before settling in London. 'We hated leaving Tehran, and then hated leaving Geneva.' Perhaps those peripatetic teenage years may go partway towards accounting for his attachment to his Mayfair flat, even though the ceilings have collapsed not once, but twice, in every room. Even when he first saw the apartment, the dining room had no ceiling. 'This is only the second flat I have owned,' he says. 'When I walked into it, I realised that this was it. I have never bought and sold property. For me to move is such a hassle, and my look is not something I do in five minutes.'

In London, Alidad studied statistics and computer science at university before doing the Sotheby's Works of Art course. When he bought the flat, he was the head of Sotheby's Islamic department, but after a few years found his position there too specialised and wanted to branch out. 'When I reached 30, panic came over me that I wanted to do something of my own.' The idea had been to 'become a designer and a bit of a dealer' by furnishing the flat and having all its contents on sale. It took him no time at all to realise he wasn't interested in selling objects; he was far more interested in designing spaces.

His big breakthrough came when Min Hogg, founding editor of *The World of Interiors* magazine, visited his partially renovated flat at the end of the Eighties and asked when he was going to finish it. 'I said, "Soon", but that went on for a year. Eventually, she gave me an ultimatum. I had 12 pages in the magazine in 1990, so this is the flat that launched me.' From then on, most of his interiors clients have come via word of mouth, and he's also launched textile and furniture collections.

Five years ago, Alidad redid the flat after one of its ceiling disasters. 'The girls in the office said, "You've got to do something different", but I didn't want to, it's part of history. In the end, it stayed more or less the same, but we added a sort of veneer on it.' One new feature he happily points out is the wall detailing in the drawing room – which he bought incredibly cheaply from a hardware chain. 'It appeals to me to have a bit of "Ikea" in some of my work – it can make a home.' But more than anything, he likes to acknowledge an English trait he has picked up. 'In Europe, it was all about sets of chairs and stiff two-seater sofas, with everyone sitting upright. Here, you plonk into a sofa and sink into deep Howard chairs – so deep that you can curl up in them. That's the ultimate in comfort.'

'THIS PLACE HAS A MIXTURE OF CENTURIES, ALL TOGETHER. I WOULDN'T WANT TO CREATE, SAY, AN 18TH-CENTURY HOUSE, BECAUSE I DON'T WANT IT TO FEEL LIKE A MUSEUM.'

Opposite. The 18th-century Italian bronze sculpture, after the antique Laocoön, sits on a marble-topped mahogany dwarf bookcase, part of which is early 19th century. The painting above is attributed to Francesco Noletti.

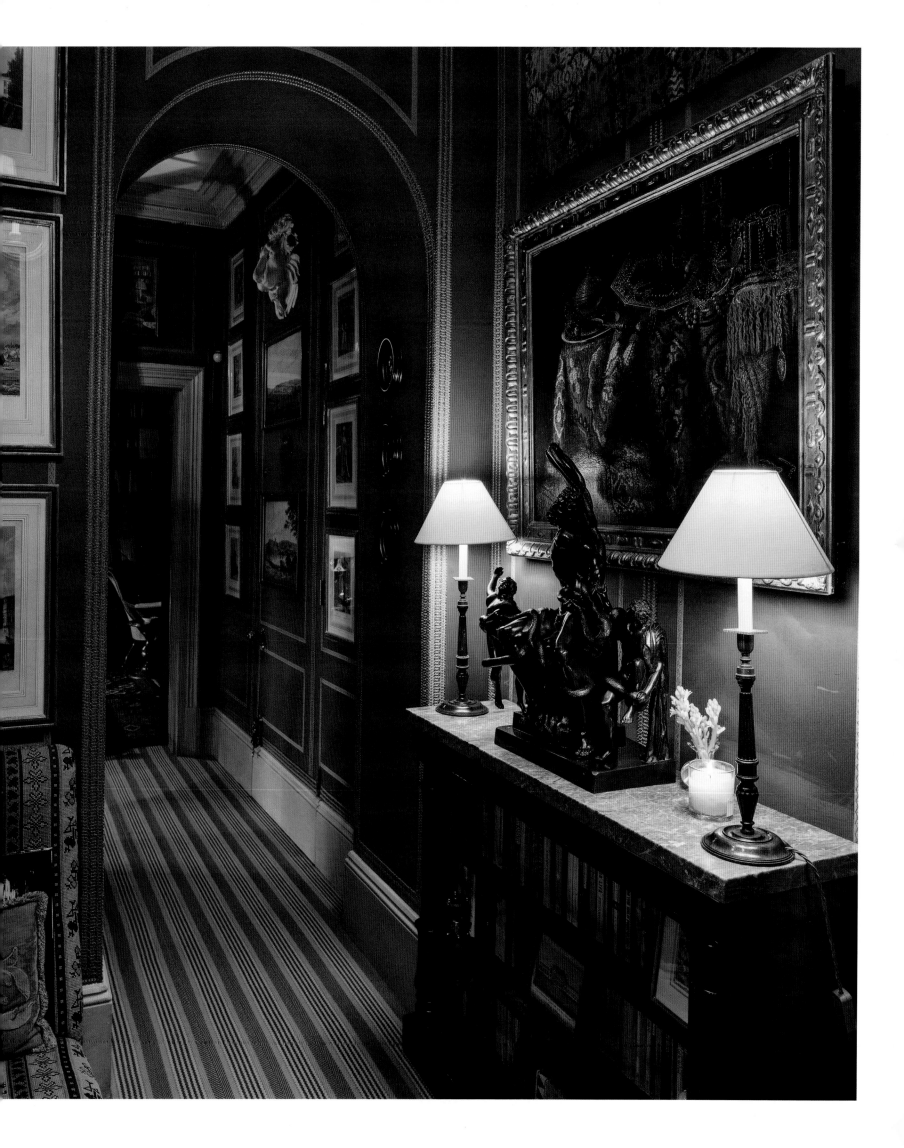

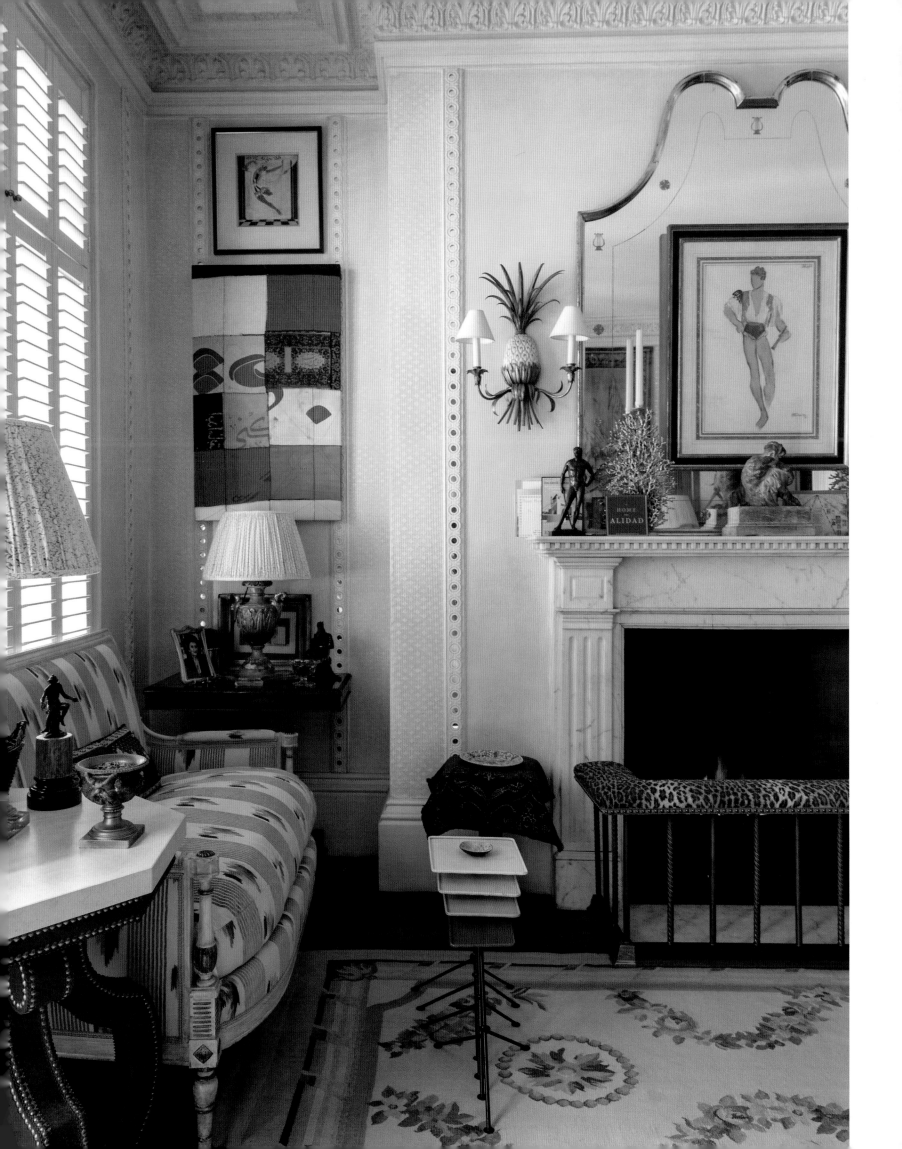

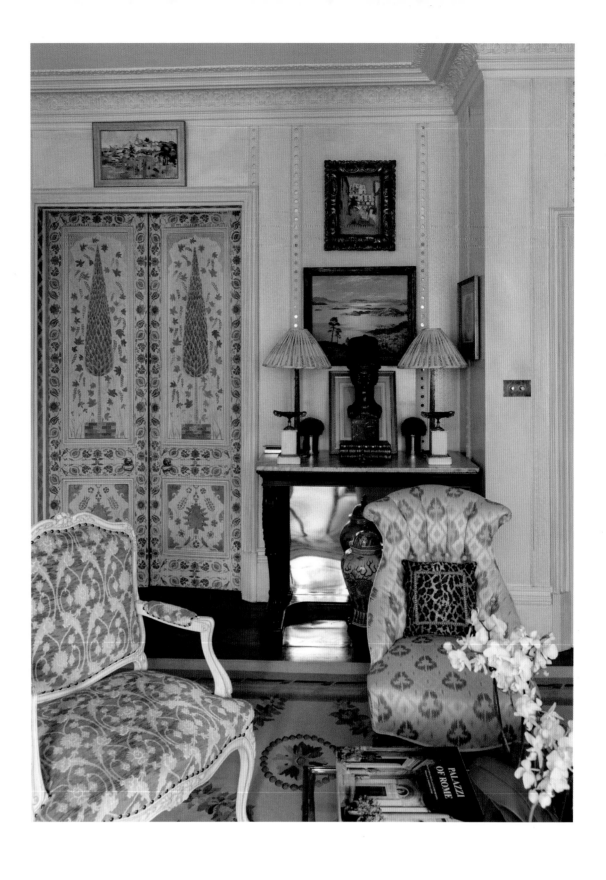

This page. The doors, hand-painted by Alex Davison, were inspired by 16th-century Ottoman motifs. Alidad added a mirror beneath the table to hide plugs and wires.

Overleaf. A 17th-century Flemish tapestry, possibly from Antwerp or the Southern Netherlands and depicting a battle scene, holds a prominent position at one end of the drawing room.

Opposite. The wall detailing in the drawing room was bought very inexpensively from a hardware chain. The painting above the fireplace is by costume designer Hugh Stevenson, and shows William Chappell as a shepherd

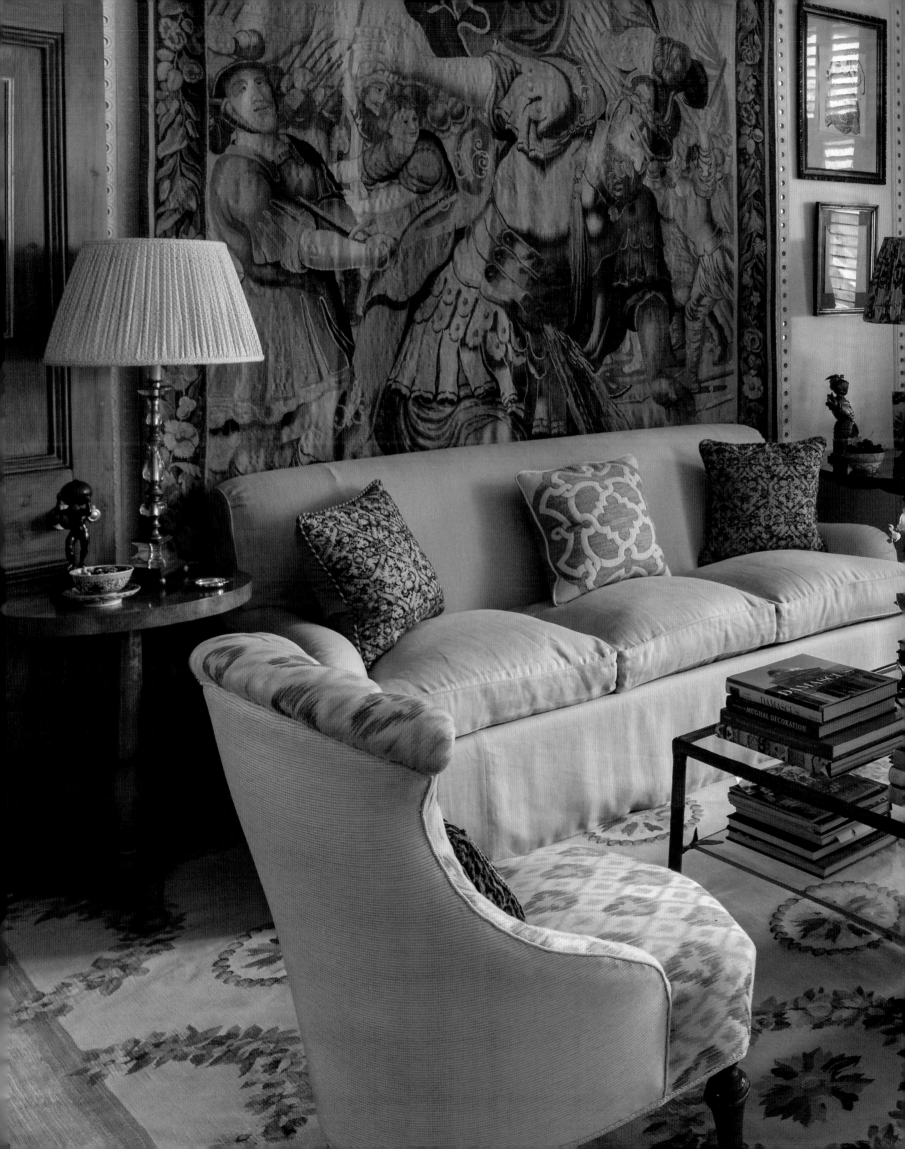

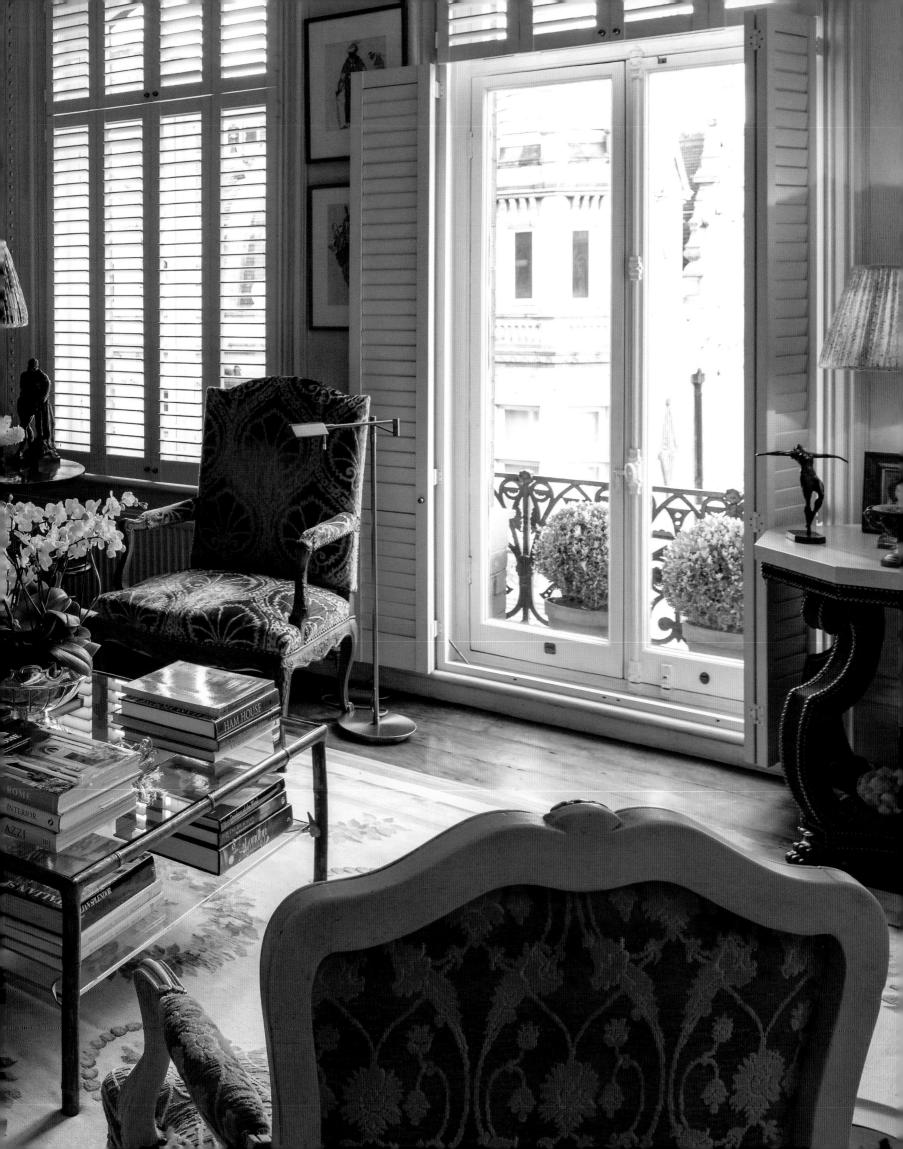

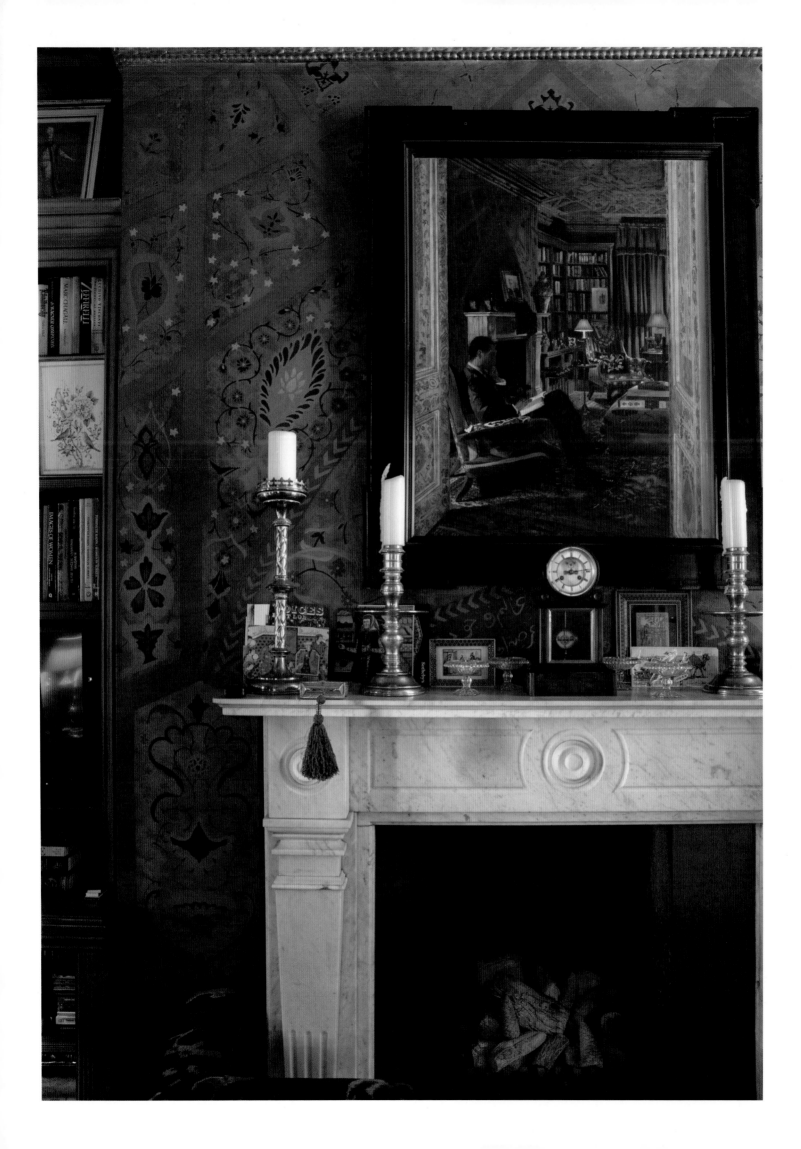

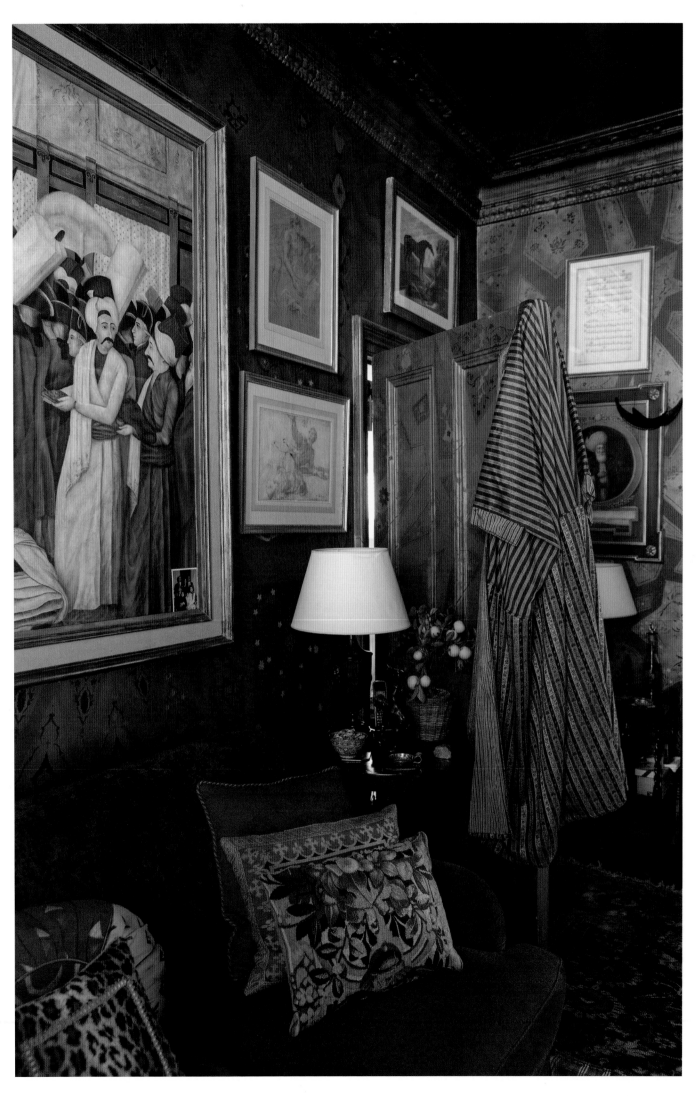

Opposite. The painting over the fireplace is by Victor Edelstein, a couturier who made dresses for Diana, Princess of Wales, before becoming a painter.

This page. In the red room, Alidad's young face is hidden in the large painting, which he commissioned about 30 years ago. The scene is of the Grand Vizier giving audience to an Austrian envoy.

Overleaf. *The Council Chamber in the Doge's Palace, Venice*, painted in the 20th century in the manner of Joseph Heintz, hangs above Alidad's Augustus console table in the dining room.

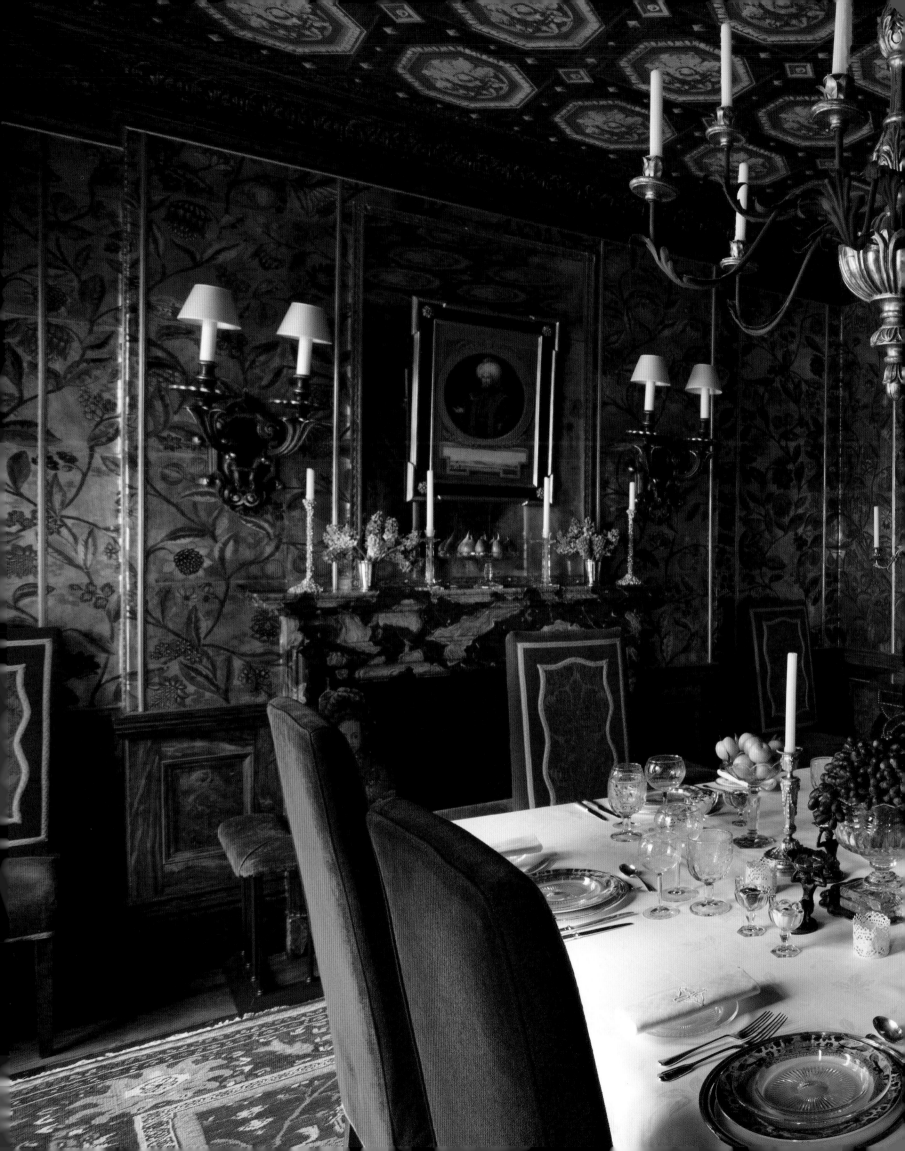

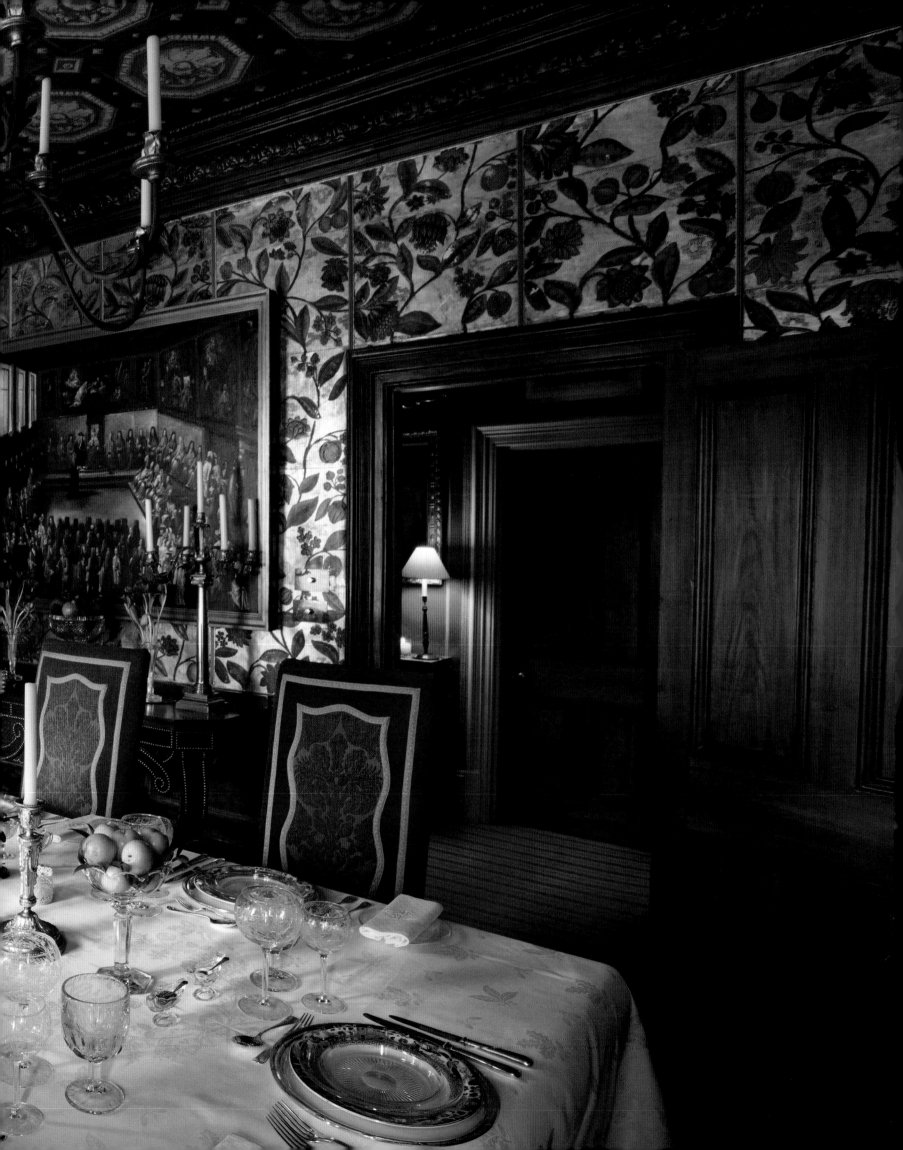

Q&A

What does home mean to you?

Everything – I need a stable home, otherwise I can't function. I travel a lot, but know I'm coming home. I need the familiarity and the familiar structures of home.

How do you relax?

I really don't know how to – it's terrible. I love going out for a drink on a Friday night, and we do have a lot of fun in the office – I will always be slightly childish. There is so much fun and laughter there.

What can't you live without?

My shower!

Do you collect anything?

I never collect – I like to be open. It leaves the opportunity for different things to come into my life.

Is there anyone who's inspired you?

When I started becoming interested in interior design, I liked Geoffrey Bennison and all the rooms he did. I used to love going into his shop in Pimlico – his vision and the way he mixed things. Of course, he was very English and I suppose I began doing a more oriental version of his Englishness.

What's your favourite room to design?

I love doing libraries – cosy rooms, womb-like, really comfortable rooms. A dining room is less interesting to me than a drawing room or study – I love rooms that really get used.

Fiction or non-fiction?

For me, biographies are the most interesting, because I'm interested in human psychology and what happens, and the interactions between people. You realise it was the same old bloody nightmare 300 years ago as it is now. That sort of fascinates me and reassures me.

Sheets or duvets?

I hate big beds – I'm a very bad sleeper and bedding is important. I'm sheet mad – I used to have a house in France and had about 400 sheets. I'm sheet, napkins and linen mad!

What would you grab if there was a fire?

I was thinking about the Nijinsky sculpture – I'm attached to it and also not attached. Also, the sculpture in the hall. I can never throw anything away, and yet, if everything had to go, I would accept it.

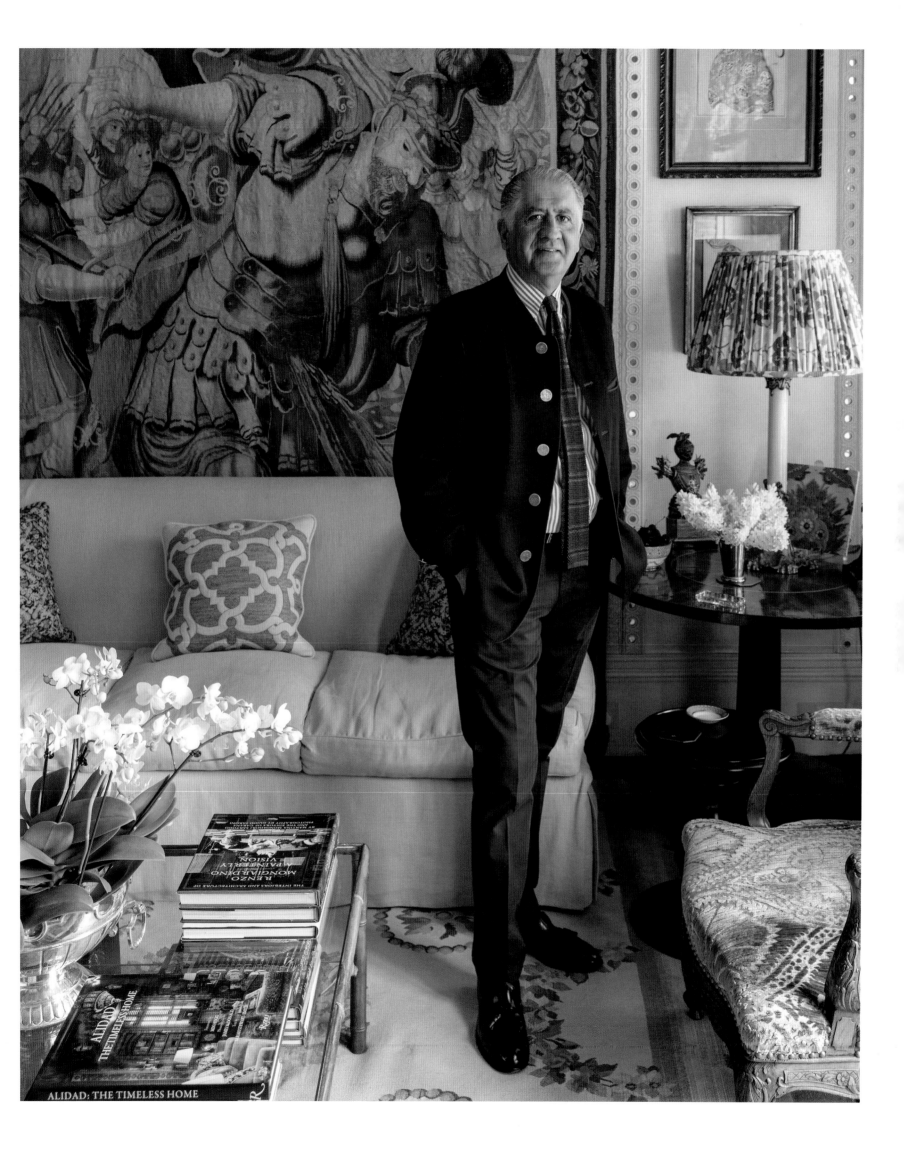

ALIDAD: THE TIMELESS HOME

RENZO MONGIARDINO PAINTERLY VISION

THE INTERIORS AND ARCHITECTURE OF GUIDO TARANI

EMMA BURNS

When Emma Burns' parents first saw their property in Oxfordshire, she says, 'it was derelict, with a beaten earth floor and chickens living upstairs. The garden was a mound of rubble and old cars.' Emma inherited Dovecote in 2002 after her mother died and, looking at the work she has done on it since, also inherited her parents' resolve to make the most of these old buildings, which used to be the dovecote, stables and hay barn for Bampton House next door.

'My parents had been looking for a project – they saw it on the Sunday and bought it on the Monday,' says the designer. Friends and family were coerced to go there on weekends to fix it up. This took four years, and Emma, who heads her own design team at Sibyl Colefax & John Fowler, talks about them camping in the barn. Her parents furnished the house 'out of skips and with leftovers', so when Emma and her late partner, Menno, moved in, they decided to 'sort the house out for us'.

Apart from bringing their own furniture, one of the first things they did was to put in a new kitchen, which meant removing an old pine island and installing an Aga. It also meant replacing lino with old flagstones to match the floor in the hall (put in by Emma's mother), making a door taller 'and grander to marry up with the drawing room door on the other side of the hall', and using reclaimed doors for cupboards and larder.

'We hardly ever leave this room, and I've crammed 12 people around the table for lunch,' says the designer. With its portraits and other decorative elements on the walls, the wing armchair in the corner and the 'slightly hippie and relaxed' Robert Kime 'Ashoka' panel curtains, the kitchen feels more like a living room that happens to have a sink and Aga in it.

Emma, who shares the house with her children Bobby and Amelia, son-in-law Alex, granddaughter Hope, and Dahlia the pug, also opened up the entrance to the house by replacing the large, solid doors with a half-glazed door and sidelights. 'It changed the house dramatically – the light floods in, making it feel twice as big,' she says. She also 'fiddled about' with the bedrooms upstairs and 'tweaked' the drawing room, adding an antique stone bolection fireplace and new cornice.

The walls of the drawing room are painted in Farrow & Ball 'Chemise'. 'This room is never light,' she says. 'I love the contrast of the thundery walls with the printed linen slip covers.' The coffee table is in an oxblood tint – Emma used the reverse of a Kenzo belt when she was describing the shade she wanted to the painter. A corner cupboard, which Emma had originally bought for her mother, stands in the room, its shelves filled with books and decorative items. 'My mother wouldn't have it in the house – she said it was clearly haunted. I'd always thought if you were a ghost, you wouldn't want to be in a corner cupboard, but would play a more central role.' There are a few black-and-white family photos on a table top. 'I don't like colour photos on display – they belong in albums,' she says.

Opposite. A Colefax and Fowler Gothic lantern is used to light the entrance hall, which includes an armchair upholstered in a now discontinued Colefax chintz and a carver, the seat of which is covered in point de Hongrie.

At the top of the stairs is the dovecote, original to the house and after which the house is named – Emma's sense of fun comes through when you notice the family of decoy doves now living there. A floor-to-ceiling bookcase houses only detective novels. 'We've all been obsessed with crime novels for years,' she says. 'Here, I've got really old green Penguin paperback ones, which I especially love.'

The most radical change she has made to the property has been to convert the stone barn into a library, using the original bricks from the loose boxes in the house to pave around the outside. 'Menno and I painted all the bookshelves ourselves,' she says. The space is cleverly designed with galleries at either end, supported by the bookcases which conceal, via hidden doorways in the shelves, a bathroom at one end and, at the other, a bar area. A bedroom in the eaves is reached via a ladder. A television is tucked away in a large cupboard that Emma bought from Robert Kime. It's a room used for relaxing, for entertaining and, sometimes, for sleeping. 'When we have guests, I tend to sleep here and put the guests in my room in the house,' says Emma. 'It's the most glorious place to sleep, because you have the whole of the barn roof above you.' Furniture and artefacts are a mix of family pieces and those that Emma has picked up along the way, in keeping with her approach throughout her home.

Her ability to put things together in an individual way began when her parents used to let her rearrange their furniture and rehang their paintings. She also spent a lot of her childhood by the sea in Devon with her architect grandmother. 'She was wildly creative – she did a lot of sewing, gardening and drawing – we were always making things.' Emma's mother wanted her to be a dress designer but, instead, after secretarial and cooking courses, she trained with the decorating firm Charles Hammond before moving to Colefax and Fowler in 1984. 'I wanted to work there more than anything in the whole world,' she says.

She always imagined herself as 'a complete and utter Londoner', and thought she was absolutely ensconced there. But as she's getting more passionate about the garden at Dovecote, she's finding herself drawn away from the capital in a way she didn't expect.

On top of sharing Dovecote with her family, she's swapped her house in London with Amelia and Alex for their much smaller flat. She says it gave them a bit more space with their daughter, and 'I've found it quite nice living in the little flat – it simplifies my life in a way, and it could do with simplifying!' There's a sense that houses in Emma's family, are, like memories, for sharing, passing on and keeping.

'MY PARENTS HAD BEEN LOOKING FOR A PROJECT – THEY SAW IT ON THE SUNDAY AND BOUGHT IT ON THE MONDAY.'

Opposite. A portrait of Mrs Haddock, Emma's great-great-aunt, inhabits a spot above the sideboard in the kitchen. The room feels more like a living room that happens to have a sink and Aga in it.

Overleaf. The exterior of the house has timberwork and shutters painted in Farrow & Ball 'Pigeon' in gloss.

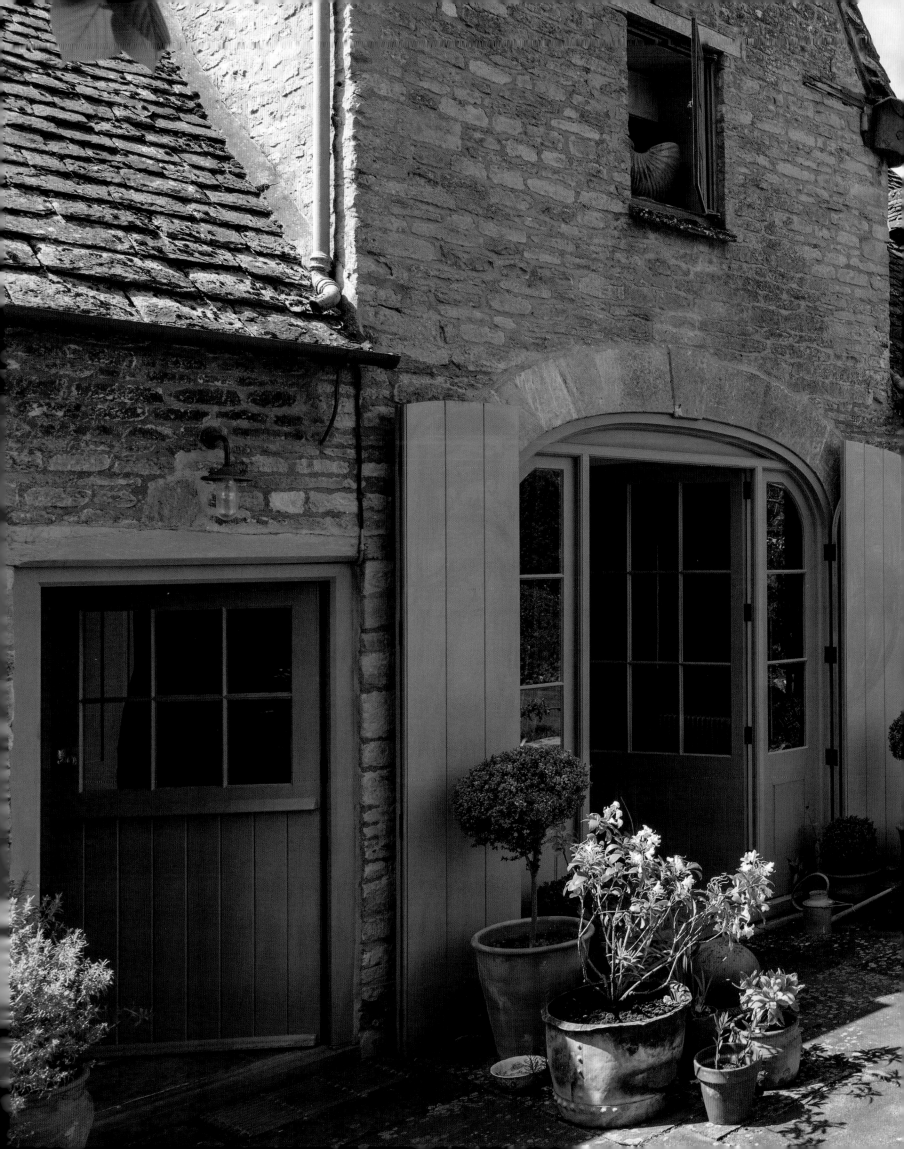

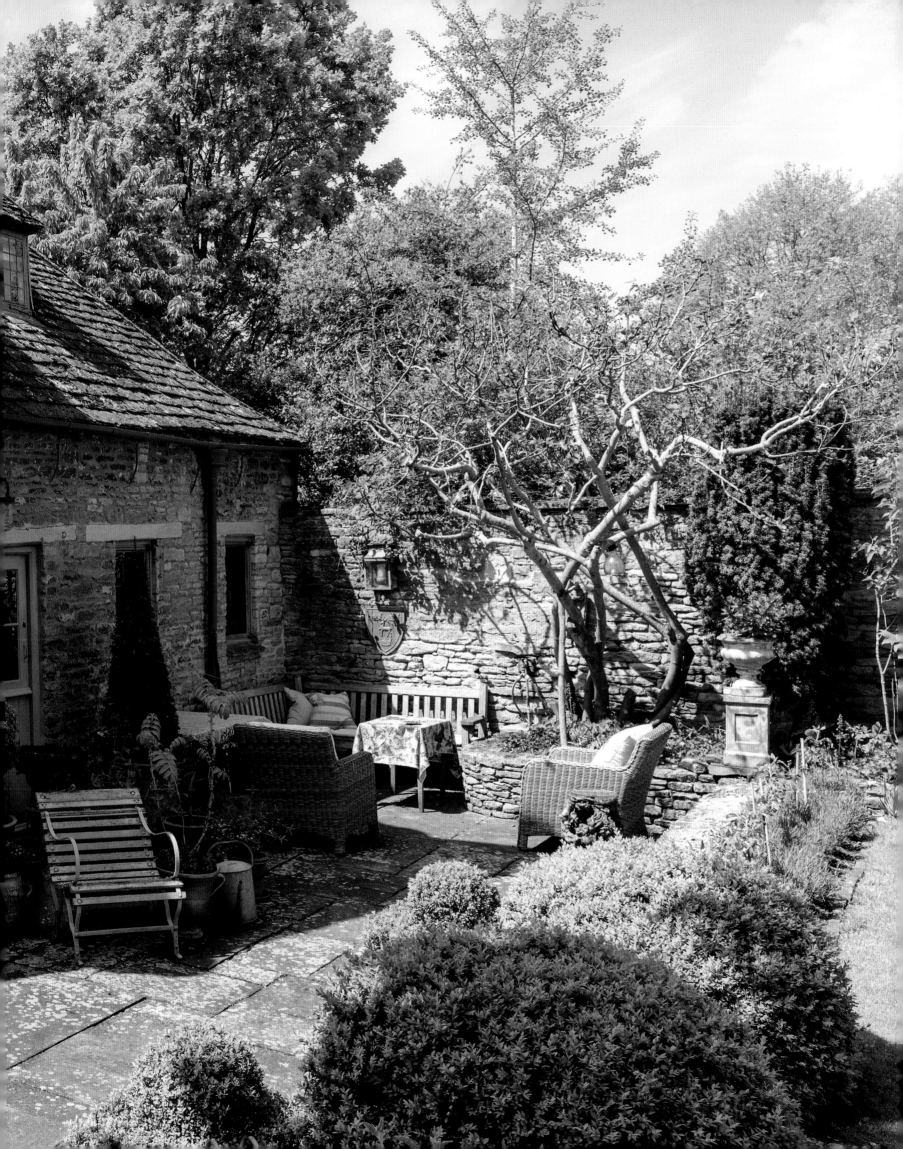

This page. The table is set with 'Blue Italian' Spode and surrounded by East Anglian ball back chairs with Antıco Setıfıcıo Fiorentino striped fabric, used horizontally, for the seating.

Opposite, clockwise from top left. A wooden spoon rack, a gift from a client, and an old school clock are set among artwork in a corner of the kitchen; the long sign above the window is a leftover from a TV commercial made by Emma's late partner, Menno Ziessen; beside the kitchen china cupboard, the top two paintings, one of which is of Emma's great-great-grandmother, are by Emma's great-great-uncle, and the bottom one is of a pug ancestor; Paris lights from Robert Kime are a pretty addition to the kitchen.

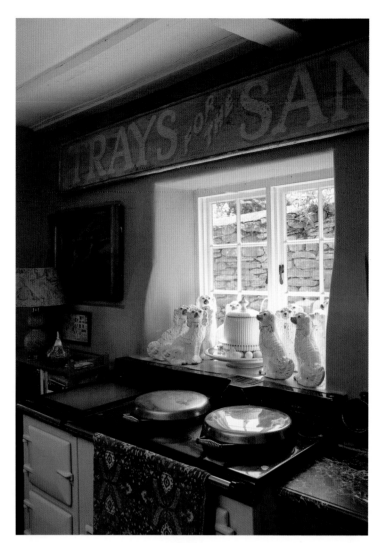
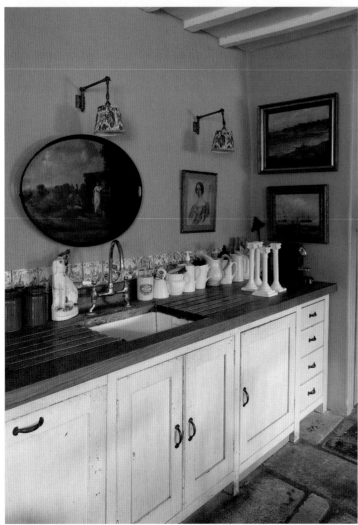

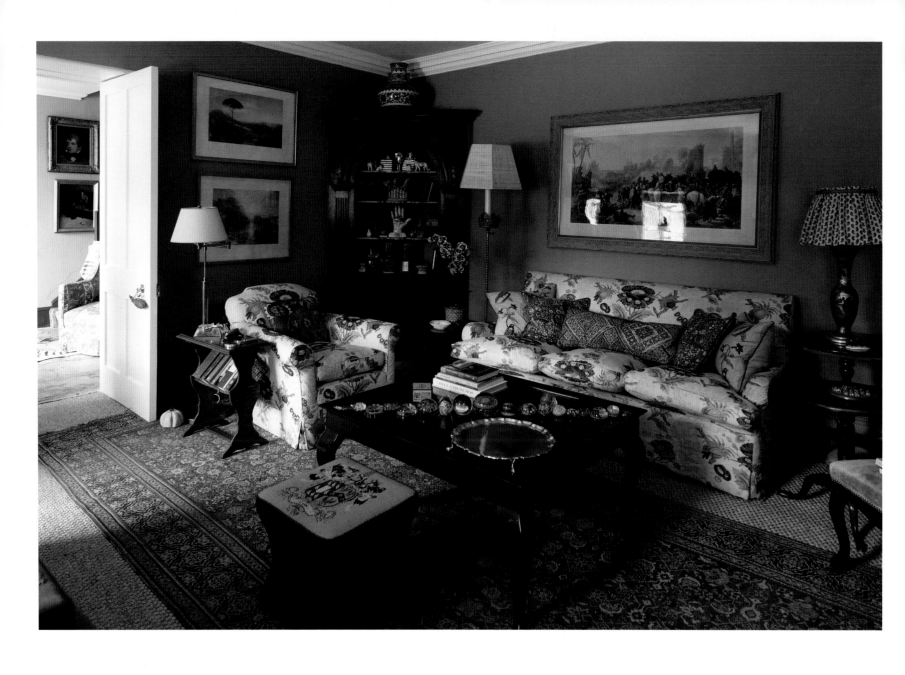

This page. The corner cupboard in the drawing room is one that Emma's mother wouldn't have in the house as she believed it to be haunted. A pair of engravings by Turner, next to the cupboard, were bought at the West Wycombe Park sale in 1998. The large engraving over the sofa is of the relief of Lucknow.

Opposite, clockwise from top. The old stone barn has been converted into a library, and original bricks from the house used to pave around the outside; the vibrant suzani and antique screen help create a cosy corner in the barn bedroom; a hidden door in the bookcases opens to reveal the bathroom.

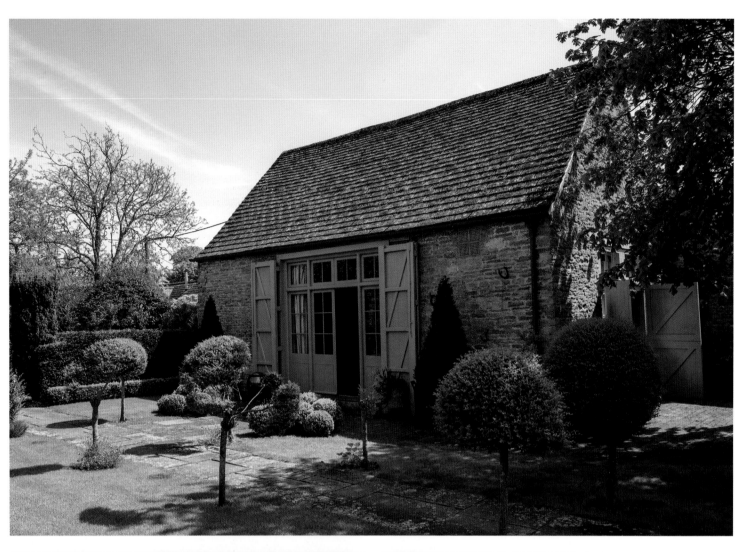

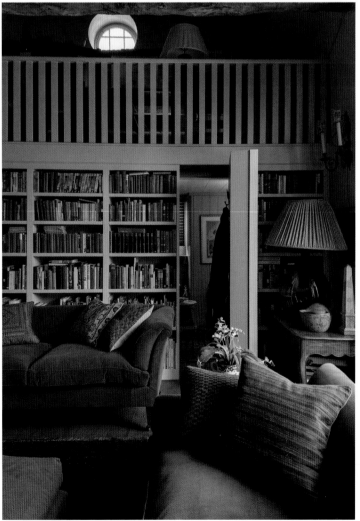

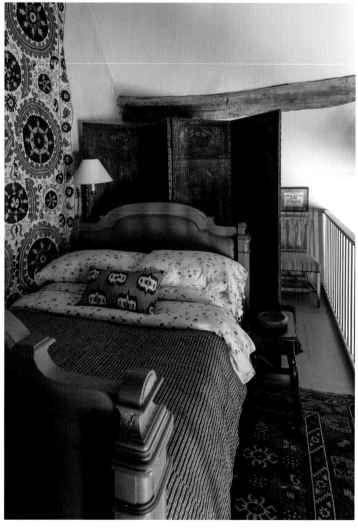

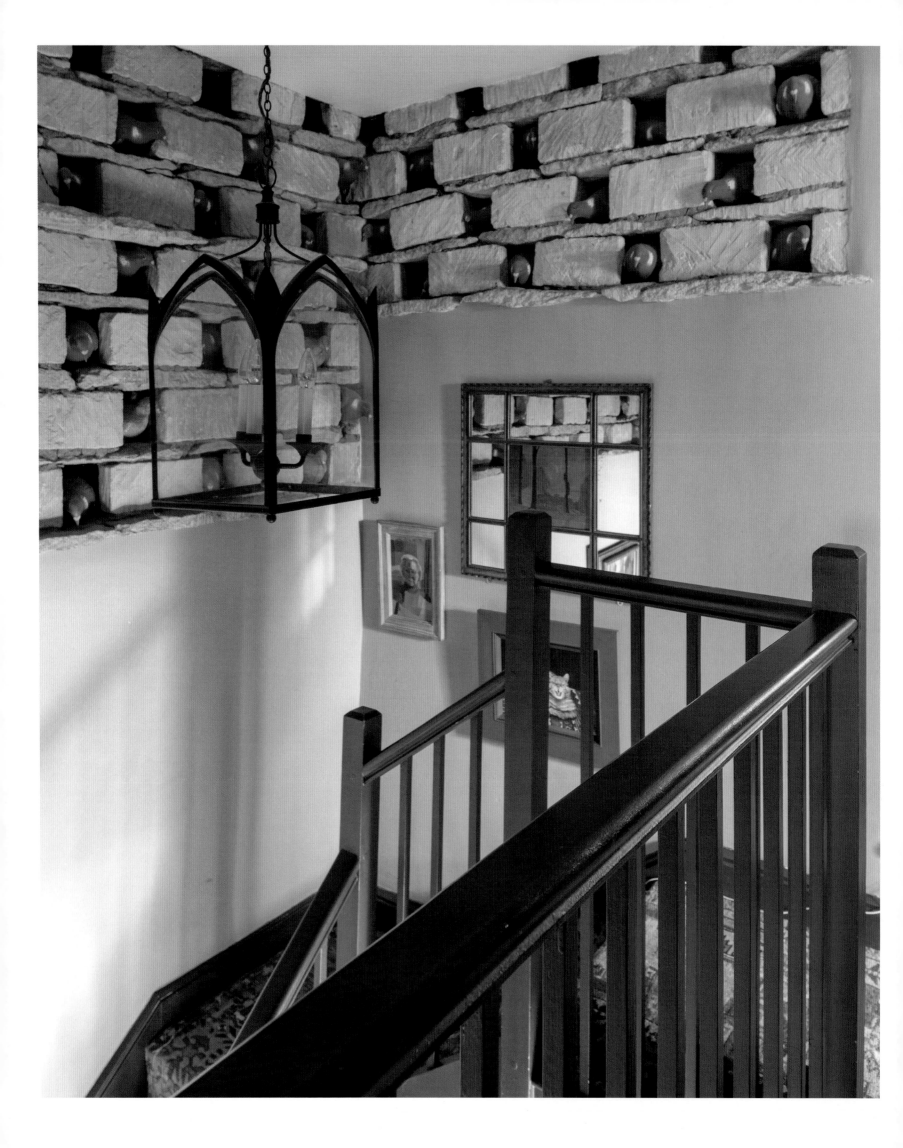

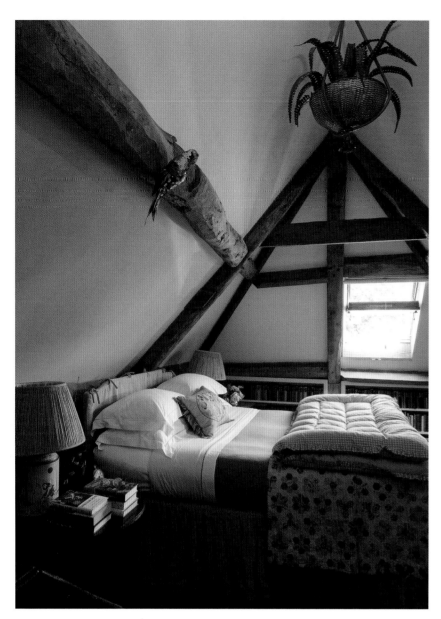

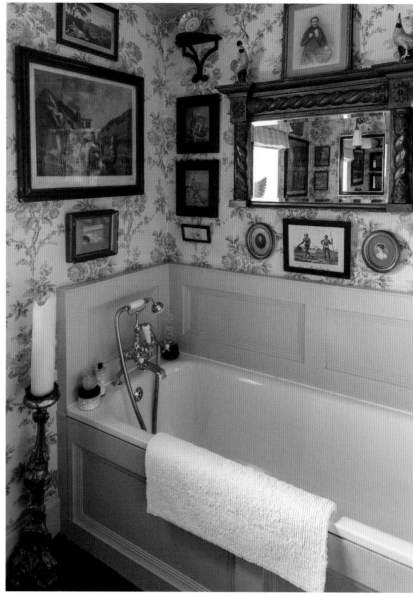

Opposite. Decoy pigeons live in the old dovecote at the top of the stairs.

This page, left. In a bedroom in the eaves of the house, an eiderdown covered in Robert Kime 'Devon' chintz is used with an antique patchwork quilt on the bed.

This page, right. The main bathroom walls, papered in Colefax and Fowler 'Rameau Fleurie', now discontinued, are decorated in an ever-growing collection of engravings and prints.

Q&A

What's your idea of home?

The best place to be.

Who are your design heroes?

David Hicks – I love his considered table arrangements, and Roger Banks-Pye for his obsession with all things blue and white.

What book do you always reach for?

John Stefanidis' *Living by Design*.

Is there any advice that has particularly resonated with you?

'Suitability, suitability, suitability.'

What would you have been if you weren't a designer?

A detective!

What's your favourite room to design?

I love organising space, so a bathroom or kitchen is always pleasing – solving the problem of fitting in everything that's needed. But my favourite room to design must be a library.

What's your favourite season in your house?

Winter – I love having the fires lit, and the low light is so beautiful.

Do you collect anything?

I've collected stuff all my life, and I didn't think I'd ever say it, and perhaps it's not 100 per cent true, but things don't seem as important to me as they used to. Now, I prefer to collect plants.

What's your idea of luxury?

Wasting time.

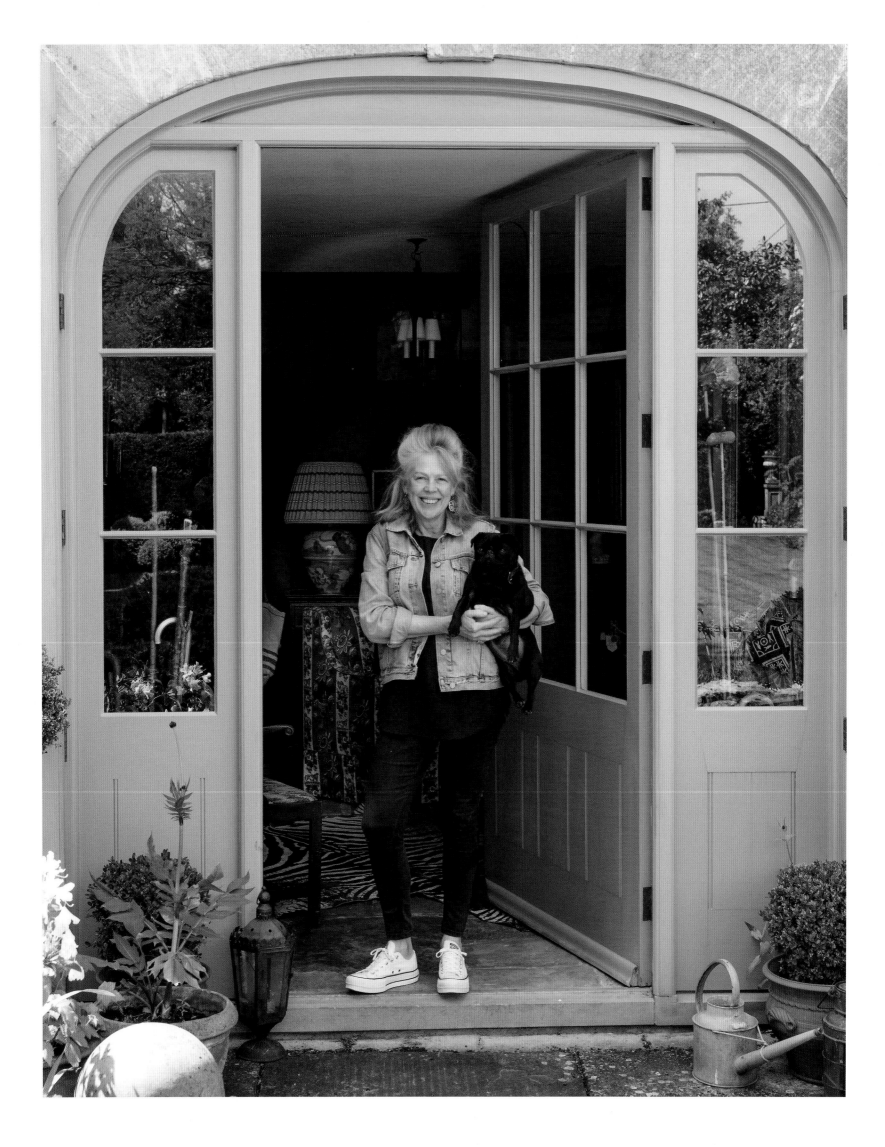

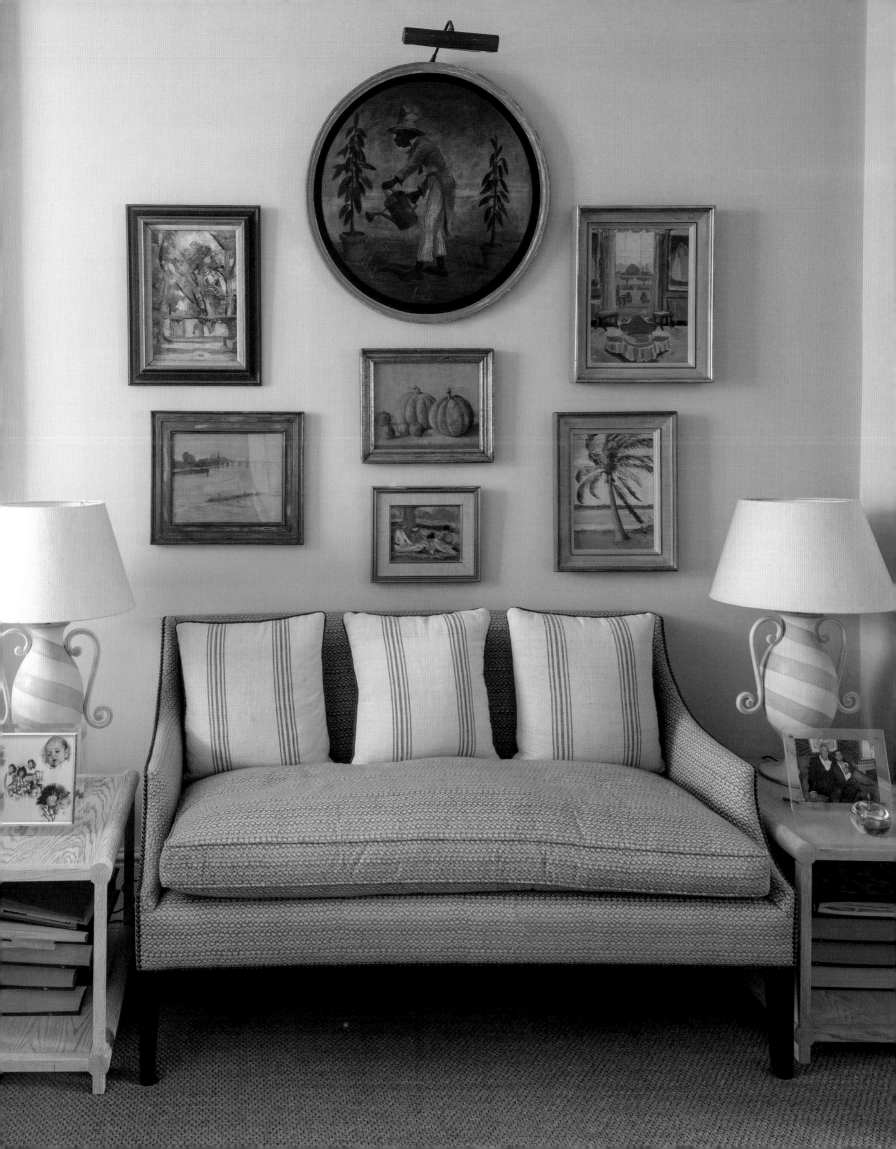

JANE CHURCHILL

Jane Churchill has used a subtle polished plaster in a horizontal striped pattern in the hall of her house. 'The reason I did this was to make it look wider,' she says. 'Stripes make anyone look wider! I have a hall fetish, and wish it could have been larger, but you don't get a large hall in a small London house.'

Immediately, there's the sense that there's something matter of fact and practical about Jane – it comes as no surprise to discover that she'll often find herself crawling up ladders on a building site, or that she believes that being 'incredibly organised' is the key to a successful business.

She moved into her house, just off the King's Road in Chelsea, about seven years ago, from a much larger one in Belgravia. She liked the fact that her new home had high ceilings – a bonus in a relatively small place. It wasn't in bad condition, she says, as it had been renovated by a property developer – 'so guess what, it was grey from top to toe!' However, the cornice in the drawing room was coming down, so she had it copied and reinstated. 'People don't often realise how important these details are,' she says.

Some changes had already been made by the developer, including the 'incredibly lucky' addition of the conservatory, added to the back of the drawing room, which helps makes the house feel light and sunny. It looks out to a courtyard, the far wall of which Jane has mirrored from top to bottom, with trellis over the top. This creates a spectacular effect at night when lit from above and below. She also installed a fireplace in the drawing room, converted a bathroom to a walk-in dressing room and put in a new kitchen. Above the garage, accessed from the road behind, is a bedroom and bathroom, which Jane lets out. She never uses the garage, she says. 'Needless to say, my children dump all their furniture in it, but I suppose it's better than putting it into storage and forgetting about it.'

It was almost inevitable that Jane would end up in the design world. Her great aunt – her grandmother's sister – was Nancy Lancaster. 'My grandmother was also incredibly talented and could draw beautifully,' she says. 'She designed an amazing house in Portugal, and drew it all up without an architect. Every house she had was always so stylish and clever and rather ahead of what was being done at the time.' Nancy Lancaster's houses, by contrast, were 'much grander, but also extraordinarily "lived in" and that was what was so wonderful – they were proper homes'.

Nancy Astor, the first female MP, was another aunt. 'I came from this line of very strong women who got on with what they wanted to do,' she says. 'I suppose I inherited some sort of gene.' Her mother's sister was a successful interior designer with her own business as well. 'So we were absolutely enveloped by design; but not in an annoying way, it was always just there,' she says. 'As a child growing up, I probably didn't really think about interiors, but it was obviously in the background. Houses, gardens and food were the three main topics of our childhood.'

Opposite. The sofa was made especially for the space, as it had to be narrow. The round painting used to belong to Jane's great aunt, Nancy Lancaster. 'I love round pictures in a hang,' says Jane. The two on the right, of the drawing room at Haseley and a Nassau scene, were painted by her grandmother.

Jane had no formal training in design, but 'learnt on the hoof'. In her early twenties, she opened a gift shop, Treasure Island, selling imported homewares on the Pimlico Road; after 10 years, this morphed into a design business and she started designing friends' houses. 'I still work full time,' she says. 'I'm the oldest bag in the Pimlico Road.' She employs four people full time, along with an accountant, all of whom have been with her for years.

When we visited, she was just finishing a project in Russia, '200 kilometres from Chechnya. We took our Irish builders there, as the local builders were not up to delivering the standard required.' She was also working on a commission in Norway. 'I've worked in Australia, the Caribbean, New York – I love travelling,' she says. 'Last year, I did some rooms in St Barts, and after the hurricane thought, "Lucky me, they will have to be redone", but the house looked as though I had just puffed up the cushions. You've got to know all about climate and termites in those places!' She's also worked for an 'amazing cross-section of people', she says, including Bill Wyman from The Rolling Stones.

The furniture, artwork and other items in her own home are essentially a mix of family heirlooms, pieces she has collected over the years and furniture she has had custom made. Jane also loves contemporary design, which becomes clear as soon as you step into the striped hallway, where she installed an enormous star-shaped mirror which she bought when she moved in. 'Apart from my fixation with hallways, my other fixation is scale,' she says. 'I can't stand anything too small.'

The fabric, found in Istanbul, on a pair of slipper chairs in the drawing room was the starting point for the decoration of the room, with Jane designing most of the sofas and chairs. 'They had to be pygmy-sized for tall people,' she says. 'Because the men in my family are all so tall, I designed narrow backs and deep seats.'

In the book-lined basement – 'I've got so many books, basically I've used them as wallpaper!' – is Jane's collection of blue and white grasshopper pots, of varying heights, all set out on a circular table. 'I pick them up everywhere, as no-one knows what to do with them,' she says. 'I light candles in them at night and it looks lovely.'

Every now and then, she slightly shifts things around in the house and changes some cushions or lampshades, but nothing too major. 'The thing is, it's important to update things from time to time.'

She is loath to say if she'll be in the house forever, but with family close by, she expects to always be in London. She certainly intends to be working for as long as she's able, walking to work as she always does. 'The other day, my curtain maker said he was going to retire, and I said, "But if you do, you'll drop dead!" And guess what, he's still working.'

'I CAME FROM THIS LINE OF VERY STRONG WOMEN WHO GOT ON WITH WHAT THEY WANTED TO DO. I SUPPOSE I INHERITED SOME SORT OF GENE.'

Opposite. The tablecloth in the conservatory is 18th-century Hanoverian. It used to belong to Jane's grandmother, and Jane had it restored. Her grandmother bought the candlesticks in Beauchamp Place for £30 before the war.

Overleaf. The ikat, found in Istanbul, on the small chairs under the window provided the starting point for the decoration of the drawing room.

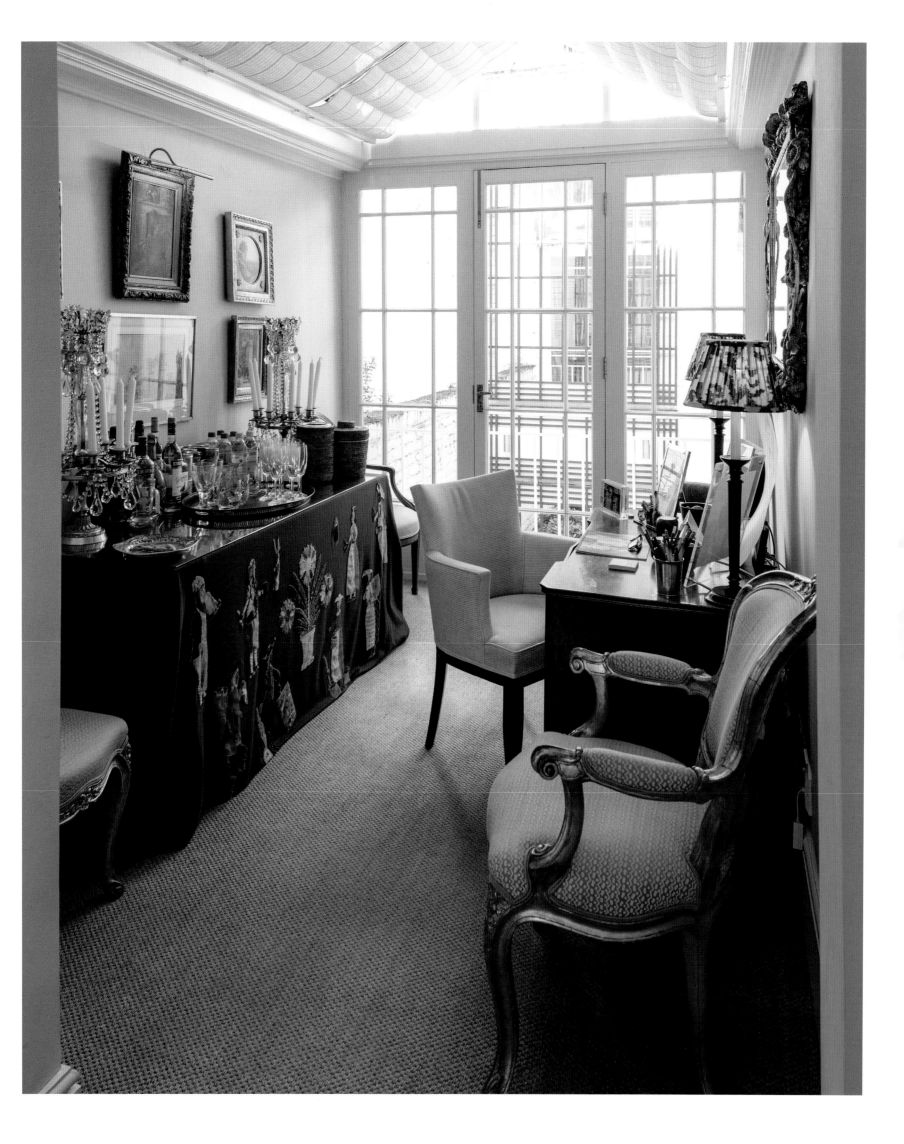

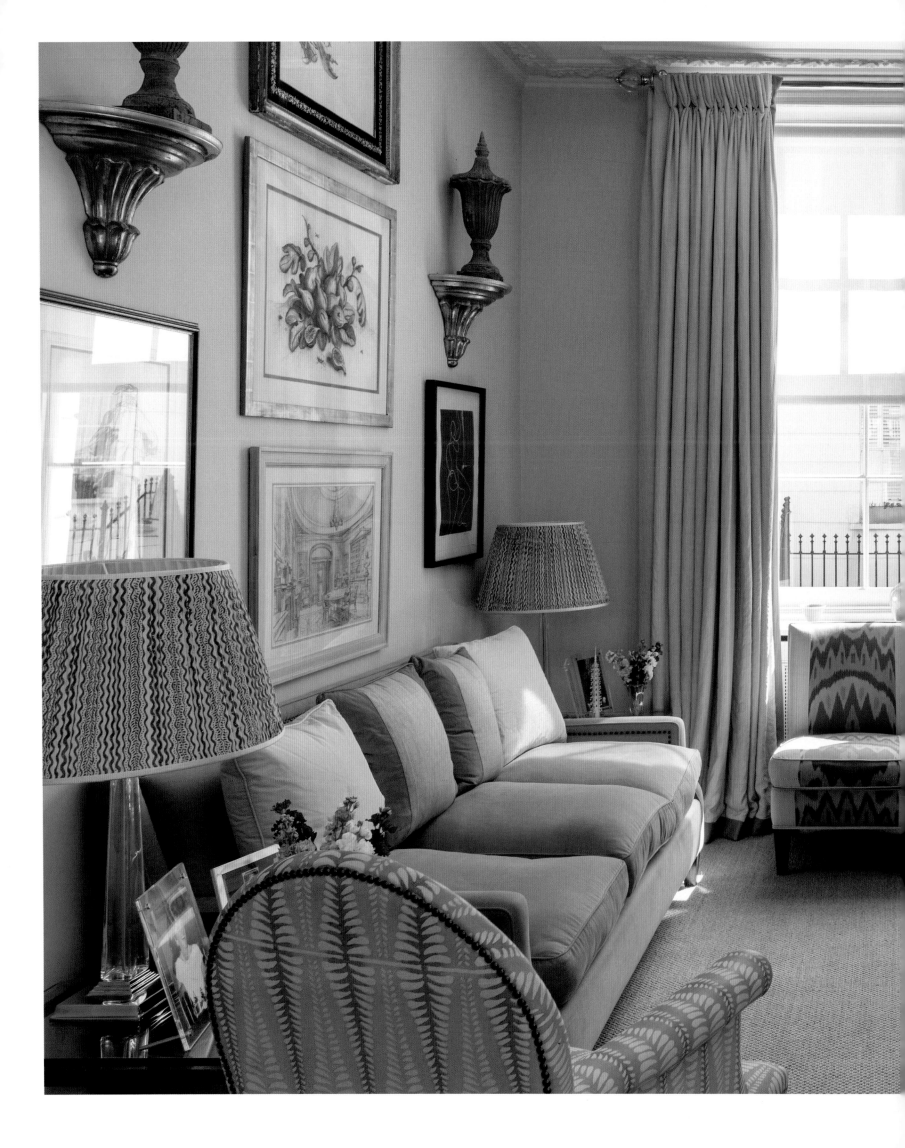

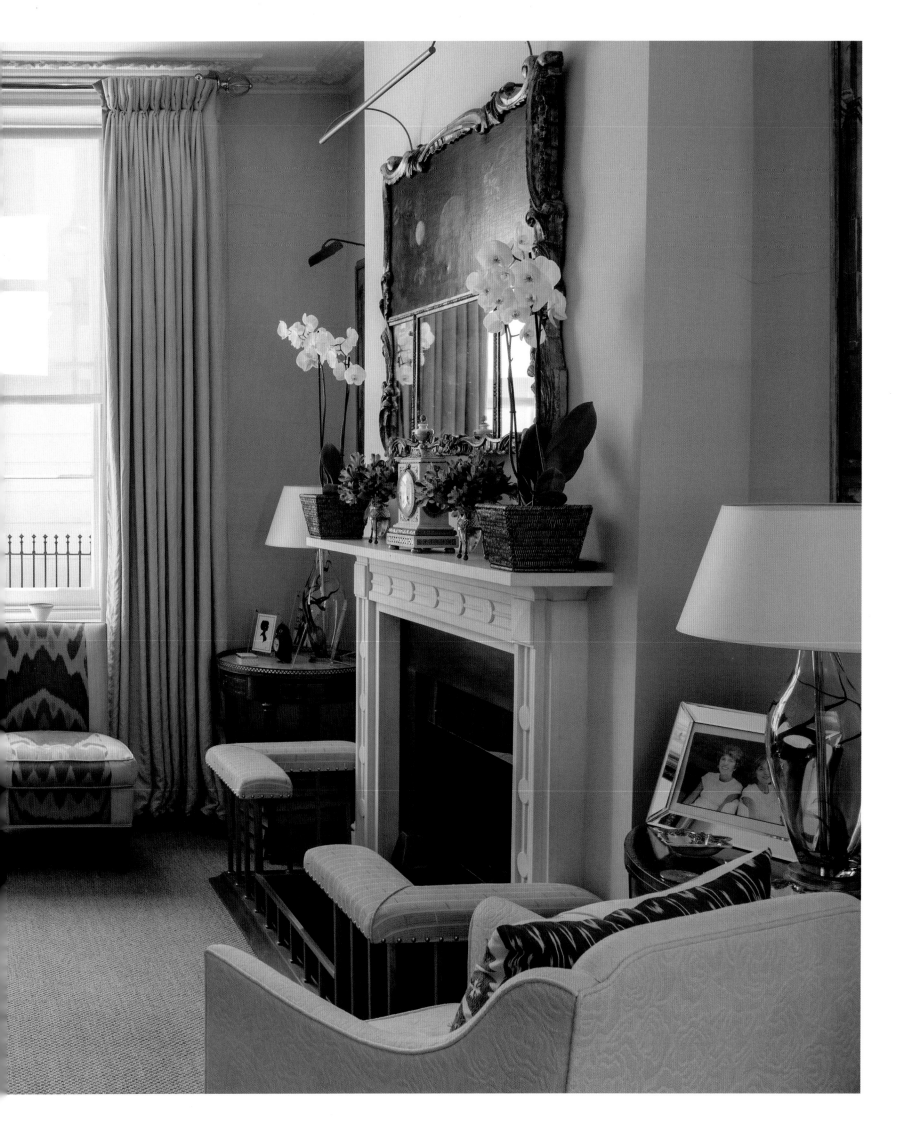

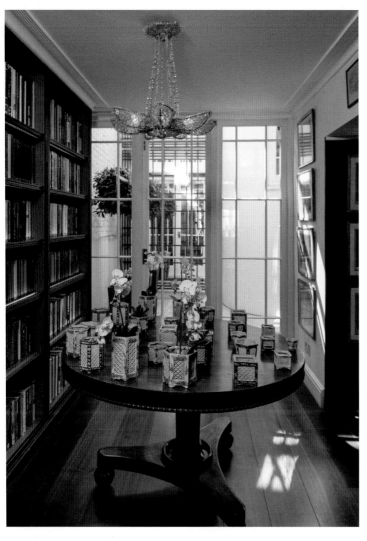
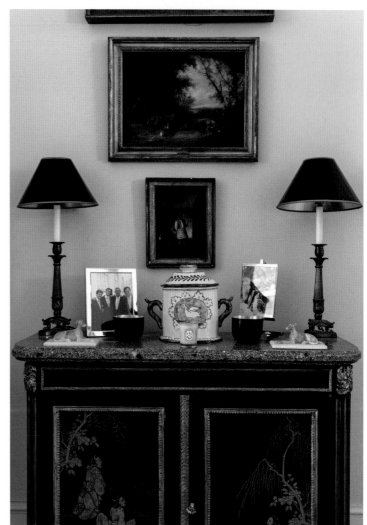

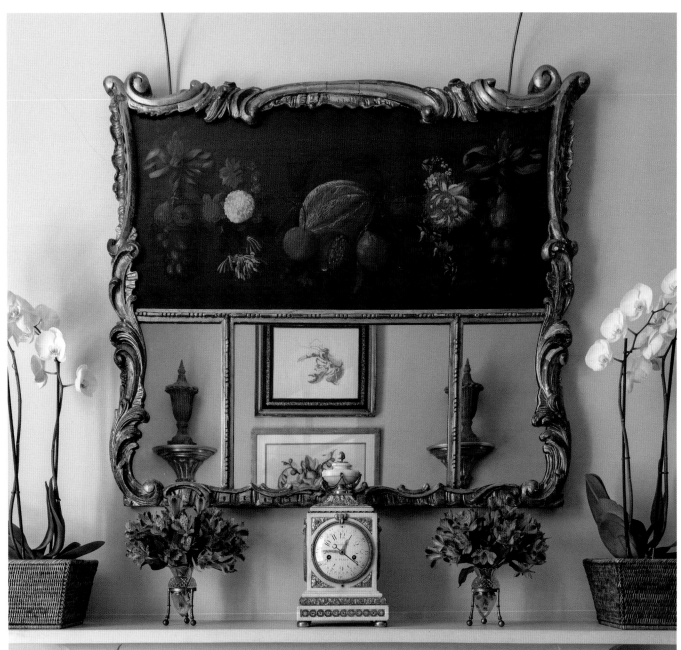

Opposite, clockwise from top left.
Grasshopper pots are displayed on a round table which, over the years, has moved with Jane between various houses; the Chinoiserie commode belonged to Jane's husband; the mirror on her dressing table was once Nancy Lancaster's and is exactly like the one in the oil painting of Queen Charlotte at Windsor Castle; Jane found the old French linen with her initials on it at an antique fair.

This page. Jane bought the drawing room mirror years ago from an antique shop in the New Kings Road. The fireplace is from Chesneys.

Q&A

What does home mean to you?

Comfort. I like to walk into a room and feel my shoulders drop and think, 'This is heaven.' I hate walking into a room where the sofas are uncomfortable or the cushions have golf balls inside them! I think the Americans know about comfort, and they were the first to do really good bathrooms. My great aunt Nancy Lancaster made bathrooms look like drawing rooms – and that was in the Fifties, a real innovator!

What's your idea of luxury?

A five-star hotel with my finger on the bell!

What can't you live without?

A comfortable bed. I take my pillow everywhere with me.

Sheets and blankets or duvets?

Sheets and blankets. I hate duvets – in summer, they're too hot, and in winter, they're not warm enough.

If there was a fire, what would you grab?

The mirror Nancy Lancaster gave me, on my dressing table. I was quite old when she died. We spent a lot of time with her, and she was so entertaining. She used to enthral my children, too. Food there was always delicious – we would look forward to every meal. She was a brilliant gardener and was in the garden until she was well over 90.

Who has inspired you in your career?

My family and obviously my great aunt and grandmother. I think Kit Kemp is brilliant – very original and clever. She stands out – so many don't stand out anymore.

What do you like to use for layering?

It depends on the scheme, and more often than not, you've got to use what people have. You might not have planned to incorporate it, but it's how you use it that counts.

How do you entertain?

I usually have eight or 10 people for dinner. If it's eight, I can usually organise it myself, and if it's 10, I usually get someone in to do it. People help themselves, and it's very easy.

Flowers or foliage?

Flowers with foliage!

Fiction or non-fiction?

I don't read as much as I should, but when I do, I prefer non-fiction. I usually feel exhausted in the evenings, and it's often easier to watch some rubbish on television. I actually love travel programs and documentaries, but never a soap.

Do you think antiques still have a place in interiors?

I think I know how to use them, but many people don't, and panic and say they don't like brown furniture. My younger clients certainly don't want brown furniture, but would be open to painted French stuff. I love going to the antique fairs to see who's there – there do seem to be more 30- and 40-year-olds now.

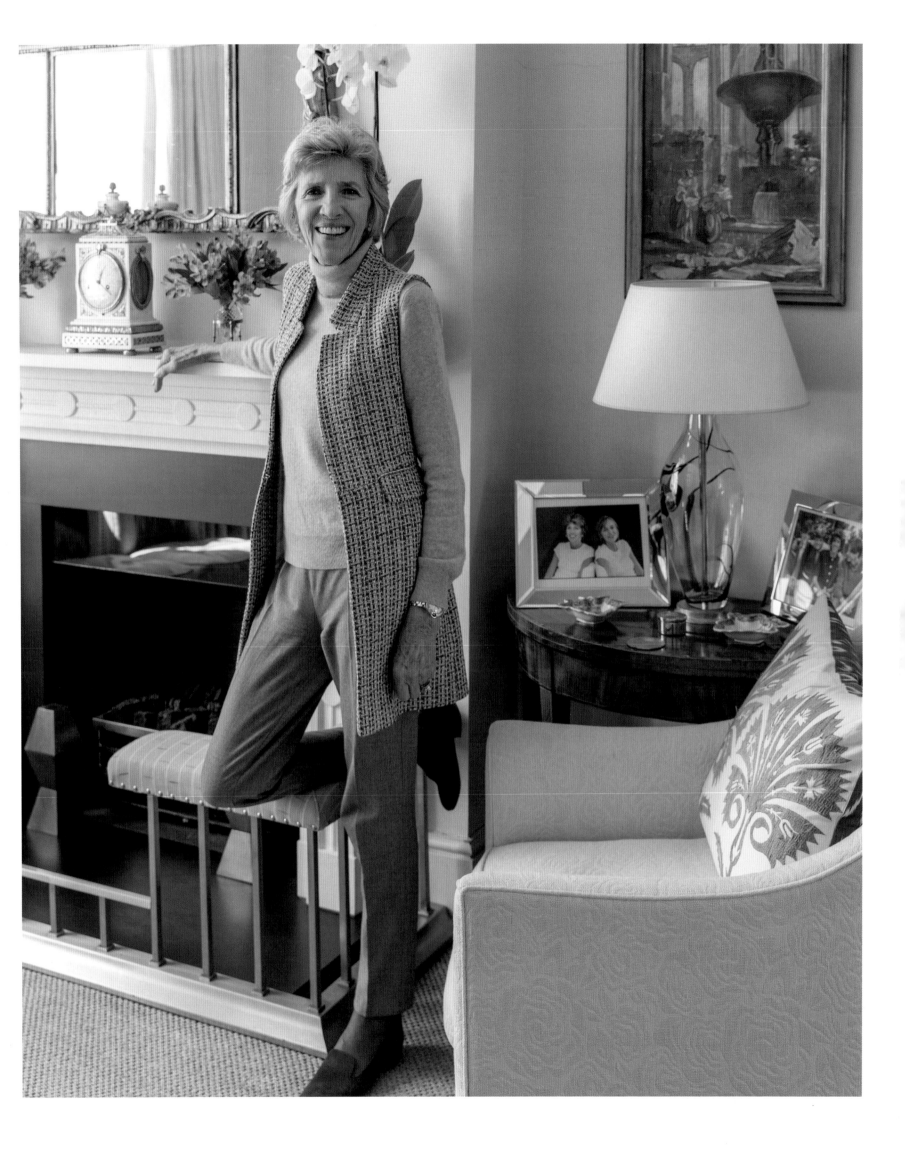

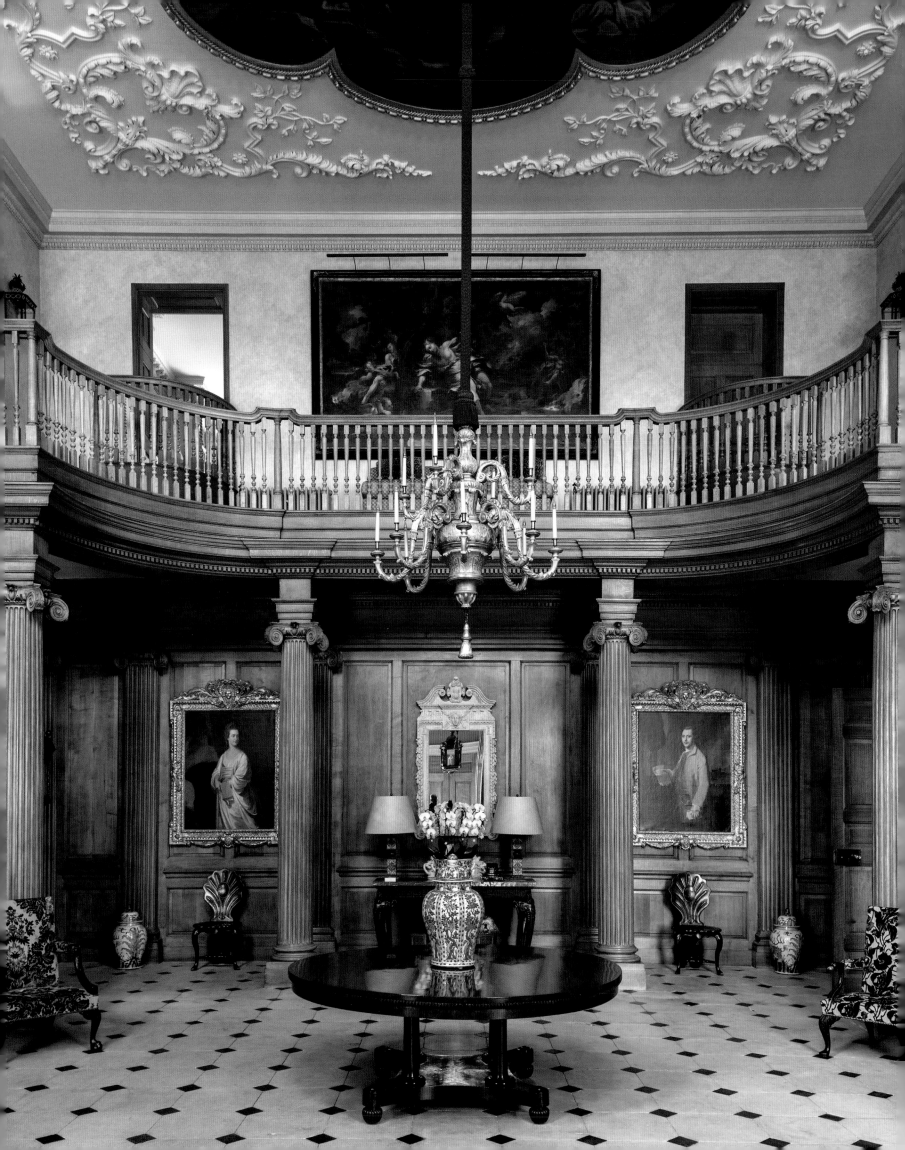

MIKE FISHER

Mike Fisher is no stranger to extravagant projects – his practice, Studio Indigo, specialises in high-end architecture and design. But when it came to deciding how to approach his own house in Somerset, he found it a challenge.

Ven House, designed by Nathaniel Ireson in the early 18th century, was reconfigured 100 years later by Decimus Burton, architect of two of the historic glasshouses at Kew Gardens. At Ven House, Burton rebuilt a staircase and added a drawing room, orangery and conservatory. The Medlycott family, who had lived in the house for several generations, eventually sold it in 1957. Since then, it has had a number of owners including American decorator Tommy Kyle and, later, Jasper Conran, who held onto it for eight years before Mike and his husband, Charles, bought it in 2015.

Apart from being difficult to decorate because 'the architecture is so strong, Jasper's style was so amazing that, to begin with, we found the idea of redecorating such a huge house quite intimidating,' says Mike. First, he tried a few modern pieces, but those didn't work. 'We have a very contemporary house in London,' he says. 'We also had a lot of antique furniture from earlier houses we had lived in.' In their almost 30 years together, the couple have moved more than 20 times. Among the antiques was a lot of Russian furniture, but while Mike is very interested in Russian decorative arts, they didn't work here either, he says.

Edward Hurst, who Mike describes as 'one of the best antique dealers in the UK', had collaborated with Jasper Conran on the house and knew it well. So Mike started working with Hurst, 'and he helped source a lot of the furniture you see here today. I have found that period furniture works better in the house, but you can get away with a lot of contemporary art, strangely enough.'

Much of the work Mike has done to the house involved restoration and repair – dealing with the plumbing and electrics, repairing the roof and reinstating missing bits of architecture. 'Often it was a question of, "Where does one stop?" Edward Hurst describes a well-restored house as "a lovely sleepy house". When houses are over-restored, he says you have to put them back to sleep. So I really hope that this is a sleepy house!'

When restoring it, Mike returned to Burton's original floor plans. One thing he particularly likes is the enfilade formed as the morning room leads to the drawing room, the music room and into the orangery. 'It's a grand house, and the challenge has been to turn it into a home,' he says. 'The rooms aren't too big, which helps.'

It helps, too, that the couple uses the house fully, starting the day in the breakfast room, then disappearing to their studies or the library before meeting up for lunch in the morning room. 'We spend the afternoon and early evening in the drawing room. If it's just the two of us, we have supper in the kitchen, or if there are more of us, dinner in the dining room. We come up to the library after supper.'

Opposite. A large ceiling painting, *Time Bearing Naked Truth Skyward Away from Anger and Envy* by G.B. Cipriani (1727-1787), after Poussin, is framed by rococo scrolls in the entrance hall at Ven House.

While Mike describes Jasper Conran's style as 'amazing', he, of course, had his own ideas for Ven House. The drawing room, formerly bright yellow, is now salmon pink and the gilding has been restored. The morning room, once dark green, is now a more sunny yellow. Wallpaper by de Gournay is used in a guest suite; in the master suite, the walls are upholstered in a blue-grey wool.

In furnishing the house, Mike has chosen pieces from different eras and different places. 'I didn't want it to be too pure or too much like a museum,' he says. The chandeliers are mainly Russian and are quite rare, as many did not survive the revolution. In the drawing room, French and English chairs mingle with Italian painted furniture; elaborate sconces above the fireplace are from Sweden.

The walls of the drawing room are hung with portraits by the contemporary artist Diarmuid Kelly, who Mike has been collecting for years. It's his nod towards the type of ancestral portraits usually found in such a house. Although he doesn't particularly like portraits in a traditional sense, there are a few in the entrance hall, painted at about the same time the house was built. 'I think it's great to walk into the hallway and experience a sense of history, even if it isn't my own,' he says. The formal dining room, which was once the entrance hall, is 'again a mix of everything'. A 1930s French rock crystal chandelier hangs above the table, while on the walls are Russian watercolours of St Petersburg. Mike and Charles' collection of Georgian silver, particularly the work of Hester Bateman, is also found in the room.

Upstairs, the master suite has been created from what were once three bedrooms; Mike's favourite views from the house are of the cedar of Lebanon trees from the dressing room and the formal garden from the bedroom – 'whether it's covered in frost or snow, or when the wind is howling'. One of the guest rooms is known as the 'Catherine the Great room', as a portrait of the Russian empress hangs on the wall. 'What's wonderful about this house is that the bedrooms are so comfortable and inviting and warm,' says Mike.

Mike's love of Russia dates back to his childhood – he comes from a military family which was based in Germany until he was 18. 'German and Russian were my first languages,' he says. Around the age of four, he was given a set of Lego and, from then on, built with whatever materials he came across. It was only natural that he would study architecture, but he found himself an oddball on the course with his additional interest in interior design. He then went on to do a masters degree in urban design, but eventually wanted to get back to building and creating himself. And so Studio Indigo was established, and Mike now employs around 50 people.

With high-powered business lives, you could forgive Mike and Charles for hibernating at Ven House, but instead they often find themselves staging elaborate lunches or dinners for up to 60 people. 'Houses like this were made for entertaining,' says Mike. 'We might have a long table in the orangery, or lunch in the entrance hall or out on the terrace. Entertaining is about creating memories – that's something Charles has taught me.'

When they're alone, though, Mike likes to crawl away to his library and get lost in his books about Russian history, arts and architecture – 'an extraordinary world that got swept away by a revolution. I've spent 30 or 40 years reading those books, and love returning to them.' In everything, it's all about memories.

'HOUSES LIKE THIS WERE MADE FOR ENTERTAINING. WE MIGHT HAVE A LONG TABLE IN THE ORANGERY OR LUNCH IN THE ENTRANCE HALL OR OUT ON THE TERRACE. ENTERTAINING IS ABOUT CREATING MEMORIES.'

Opposite. The library looks out towards the formal parterre.

Overleaf. A view of the house from the south garden, with the formal garden in the foreground. To the left is the orangery, added by Decimus Burton in 1837.

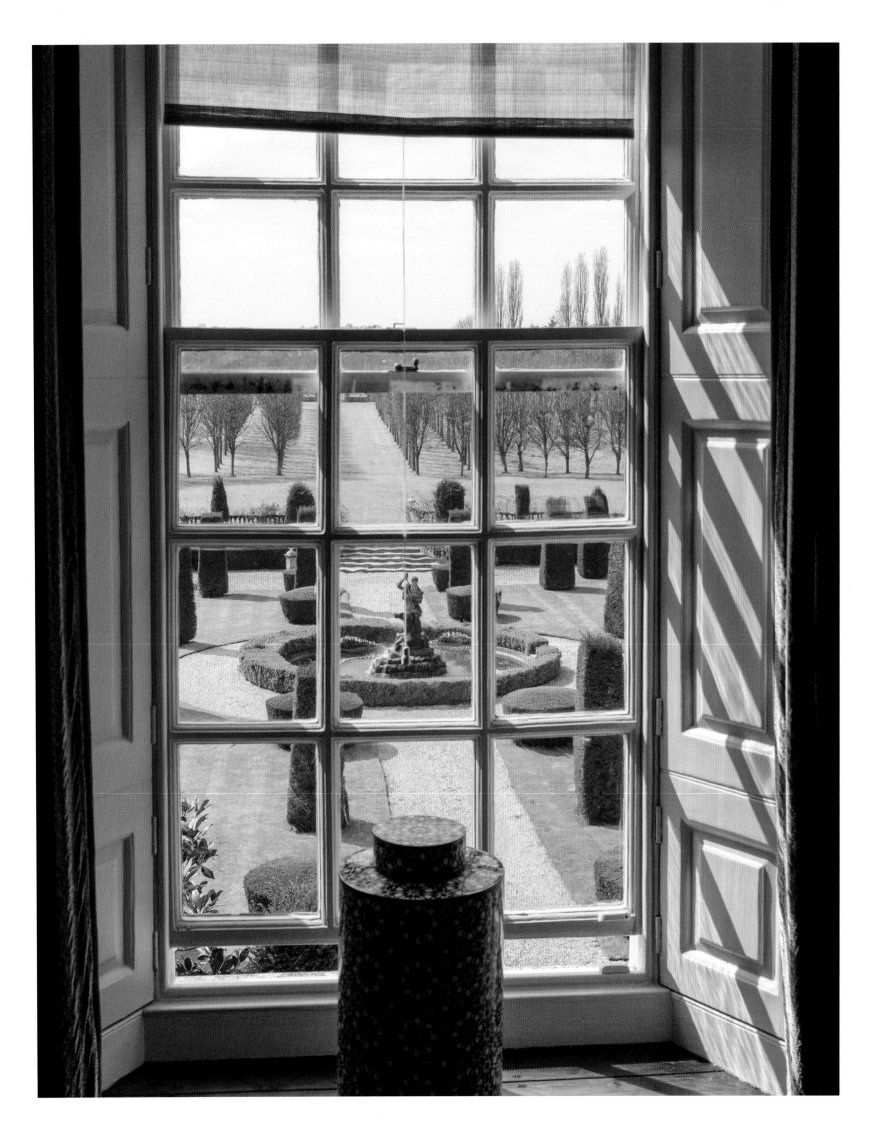

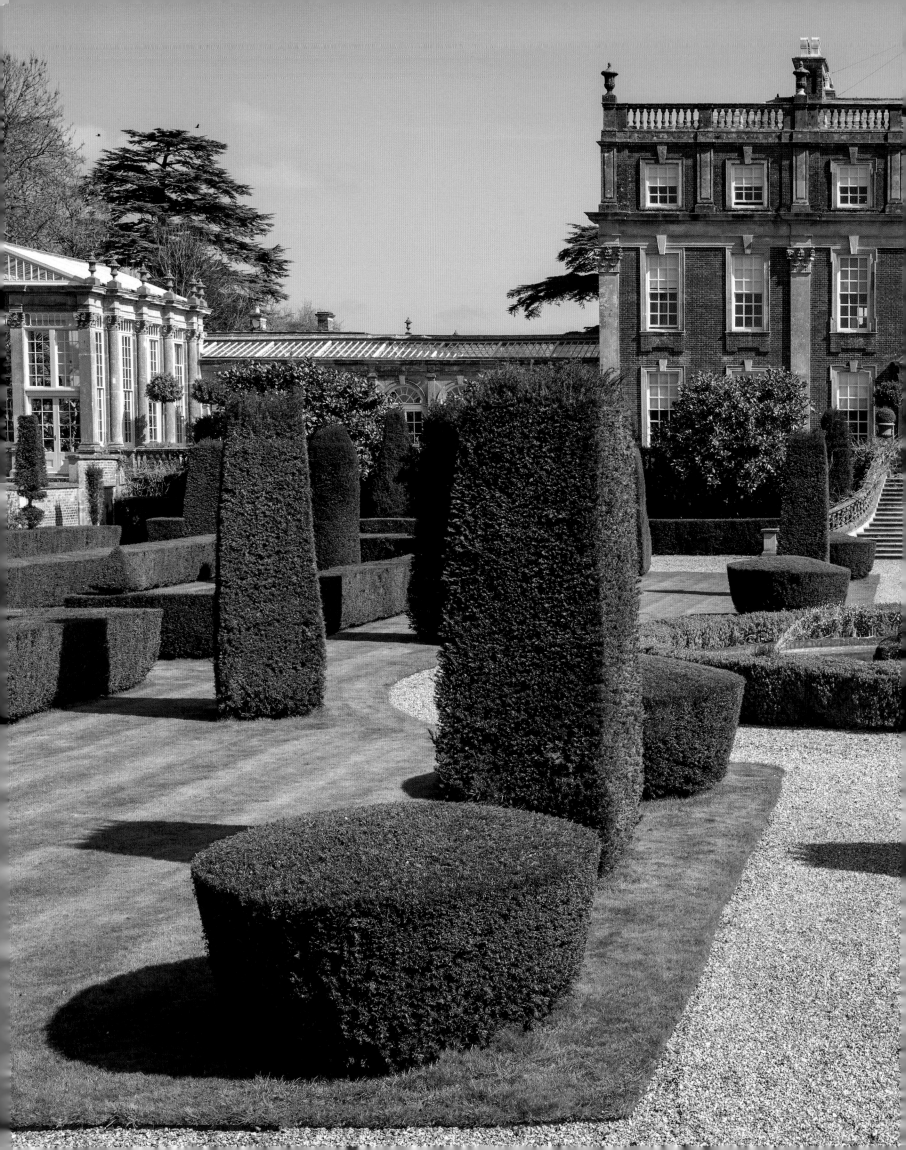

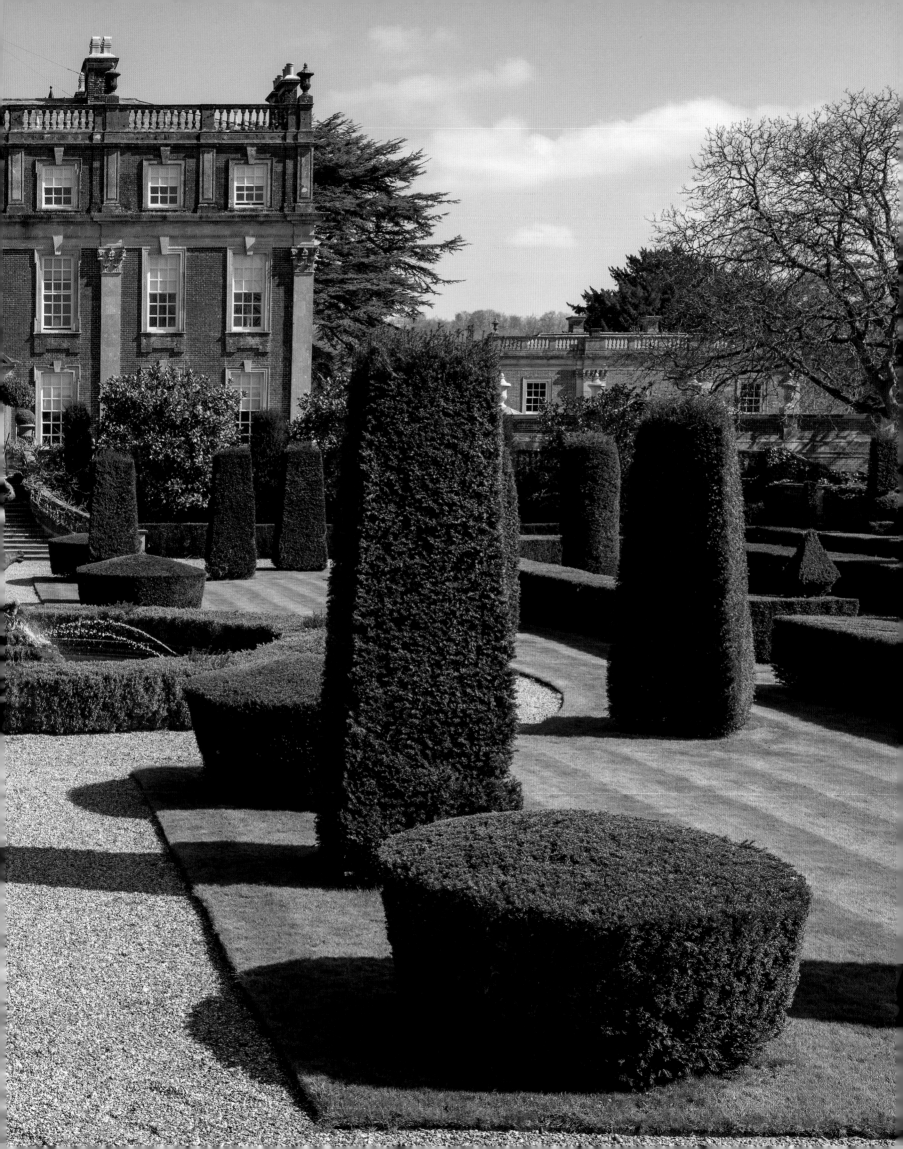

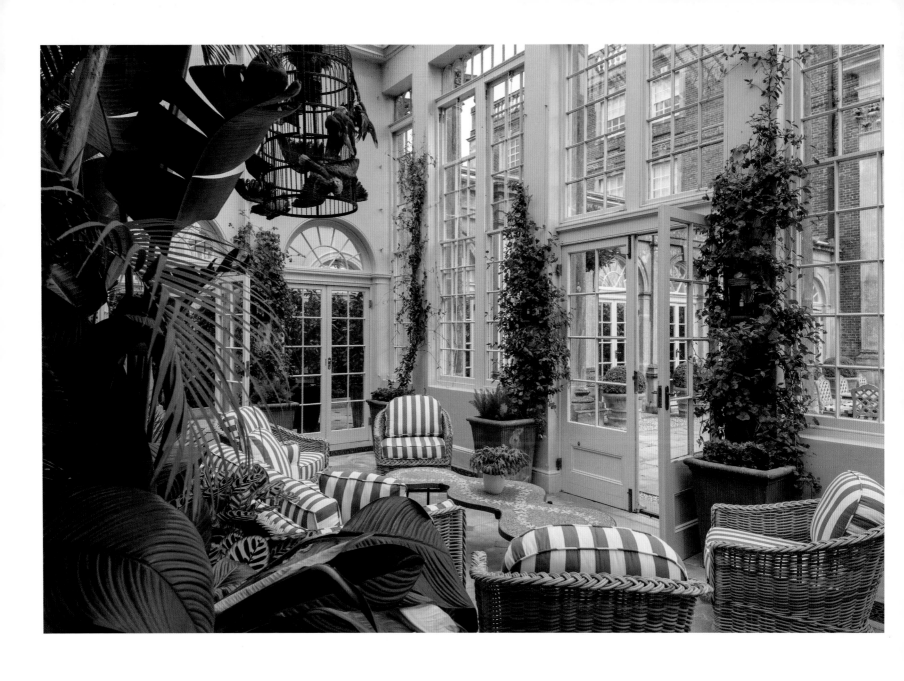

This page. The 19th-century orangery is given a contemporary twist with the wicker furniture and freeform mosaic table.

Opposite. Soane 'Tulips and Butterflies', used for the seat pads on the painted French-style chairs in the kitchen, complements the Pierre Frey 'Macao' roman blind.

162

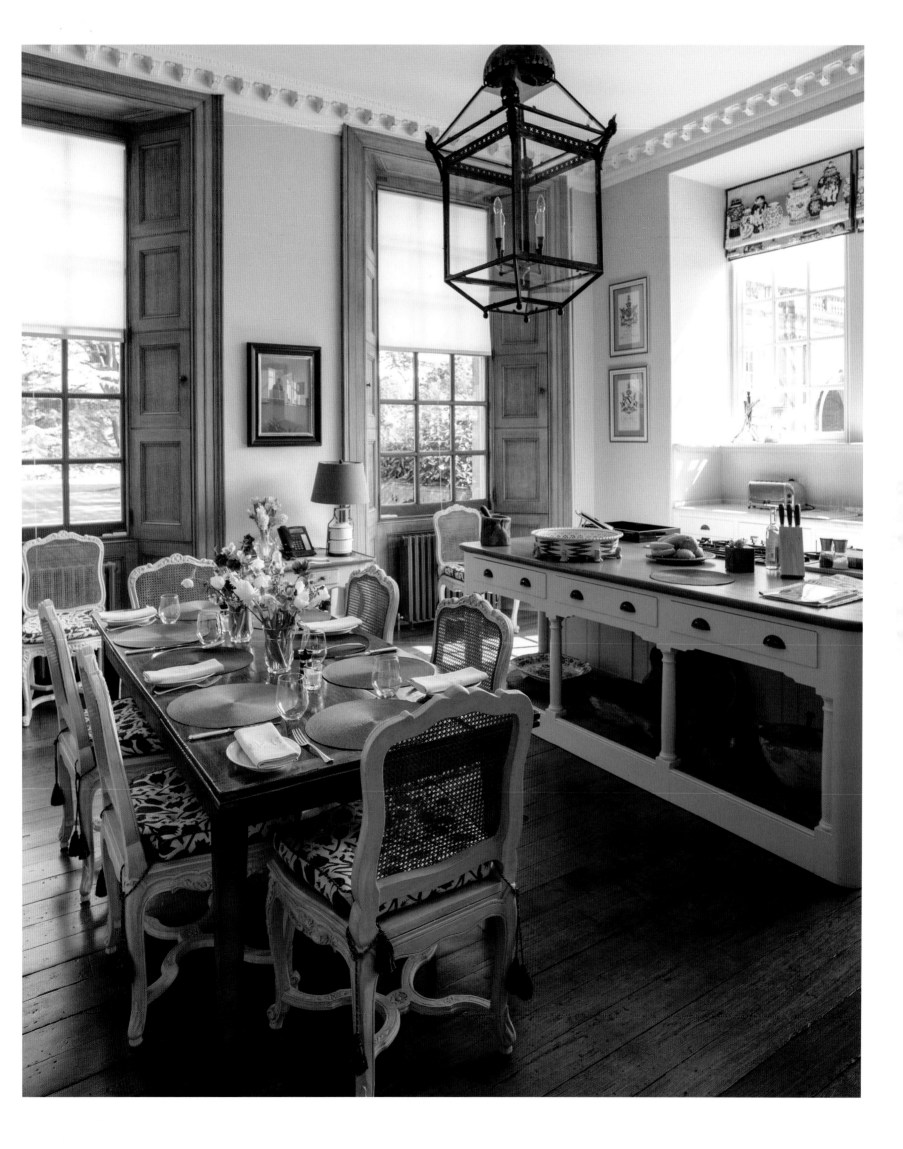

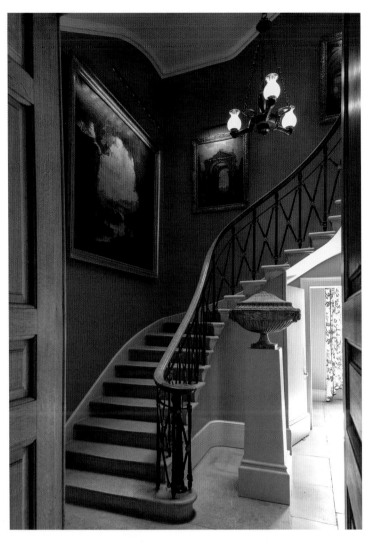

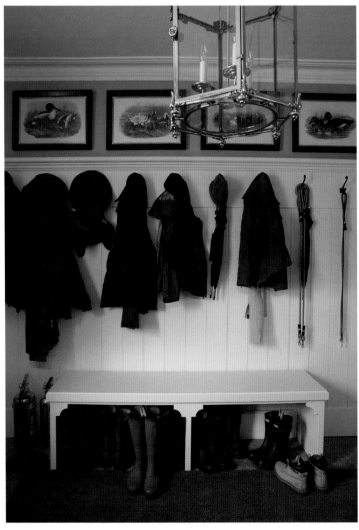
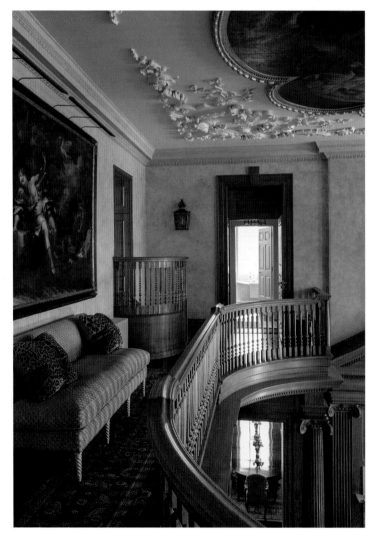

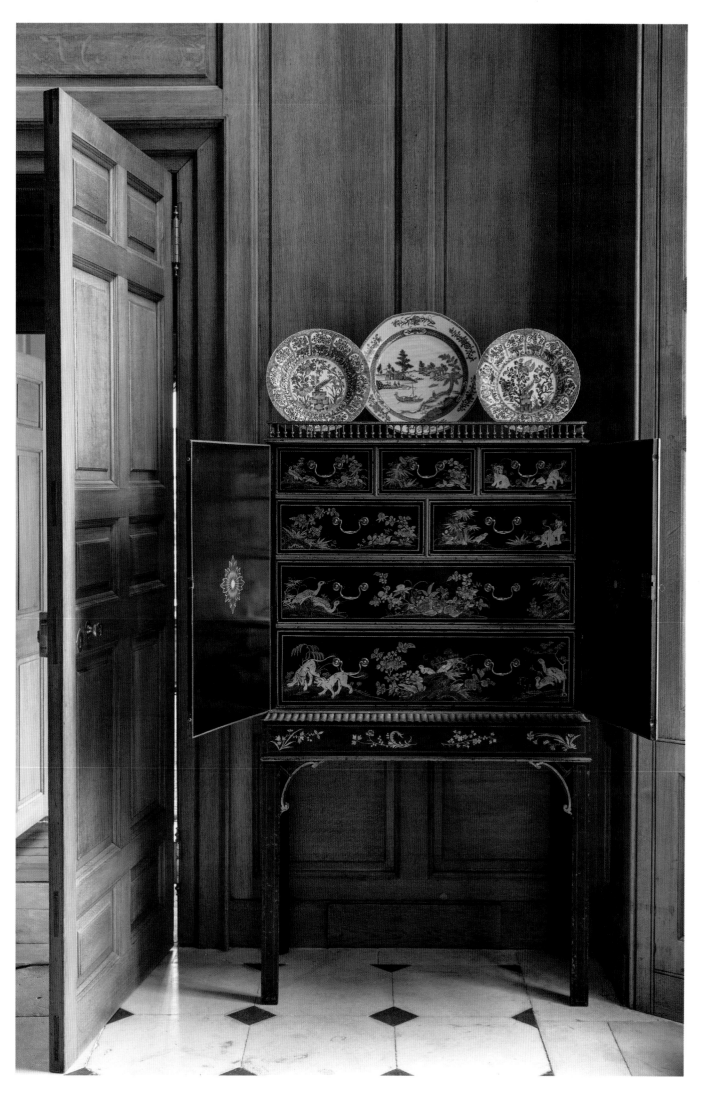

Opposite, clockwise from top left.
The main staircase was previously
the back stairs before the Decimus
Burton alterations; the servants'
bells are connected through
a complex series of wires and
pulleys throughout the house; the
upper gallery has been painted in
a specialist colour to match the
fireplace stone; a 19th-century
brass hall lantern hangs in the
boot room.

This page. A collection of Chinese
porcelain sits on a George III
Japanese cabinet, circa 1760,
in the entrance hall.

Overleaf. Decimus Burton removed
the main staircase to form the
drawing room, which looks through
to the music room. The paint colour
on the walls was mixed especially
for the room. All the portraits are
by Diarmuid Kelley.

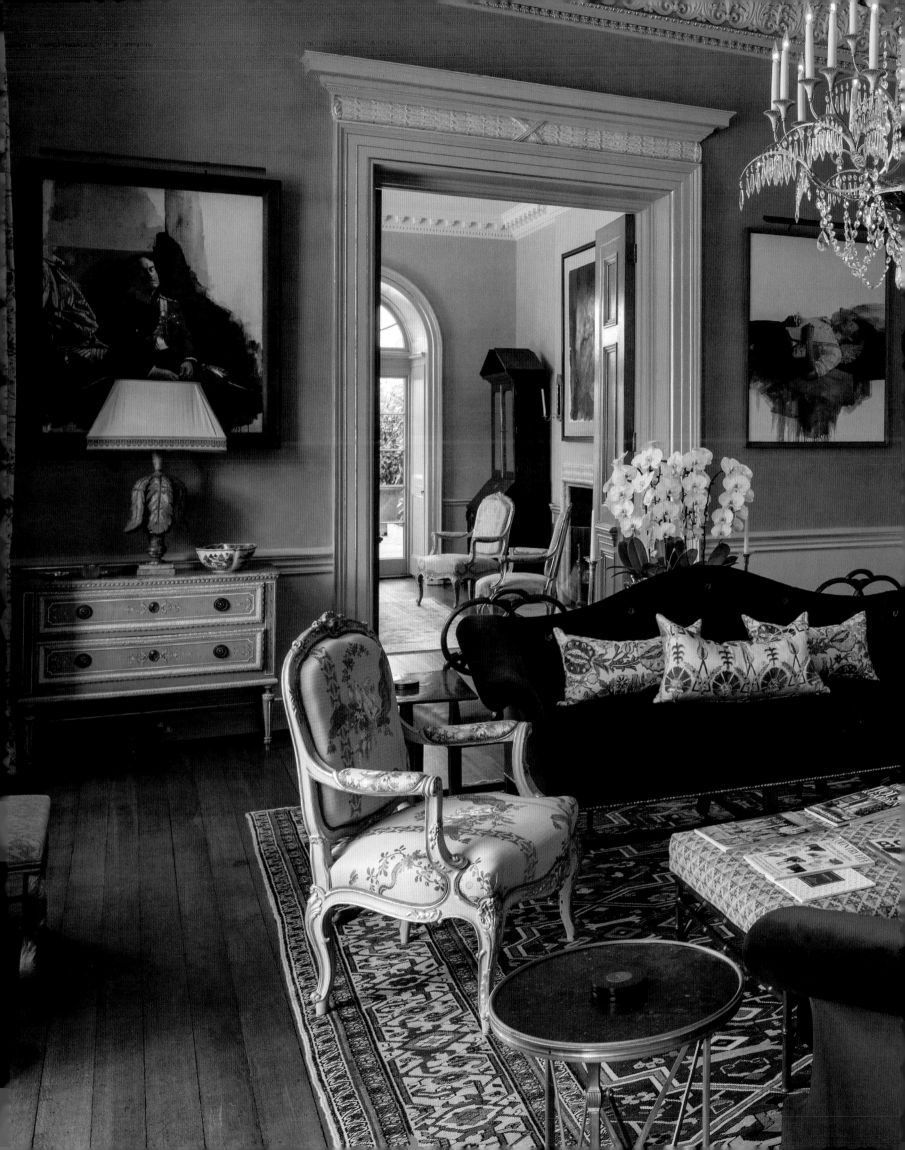

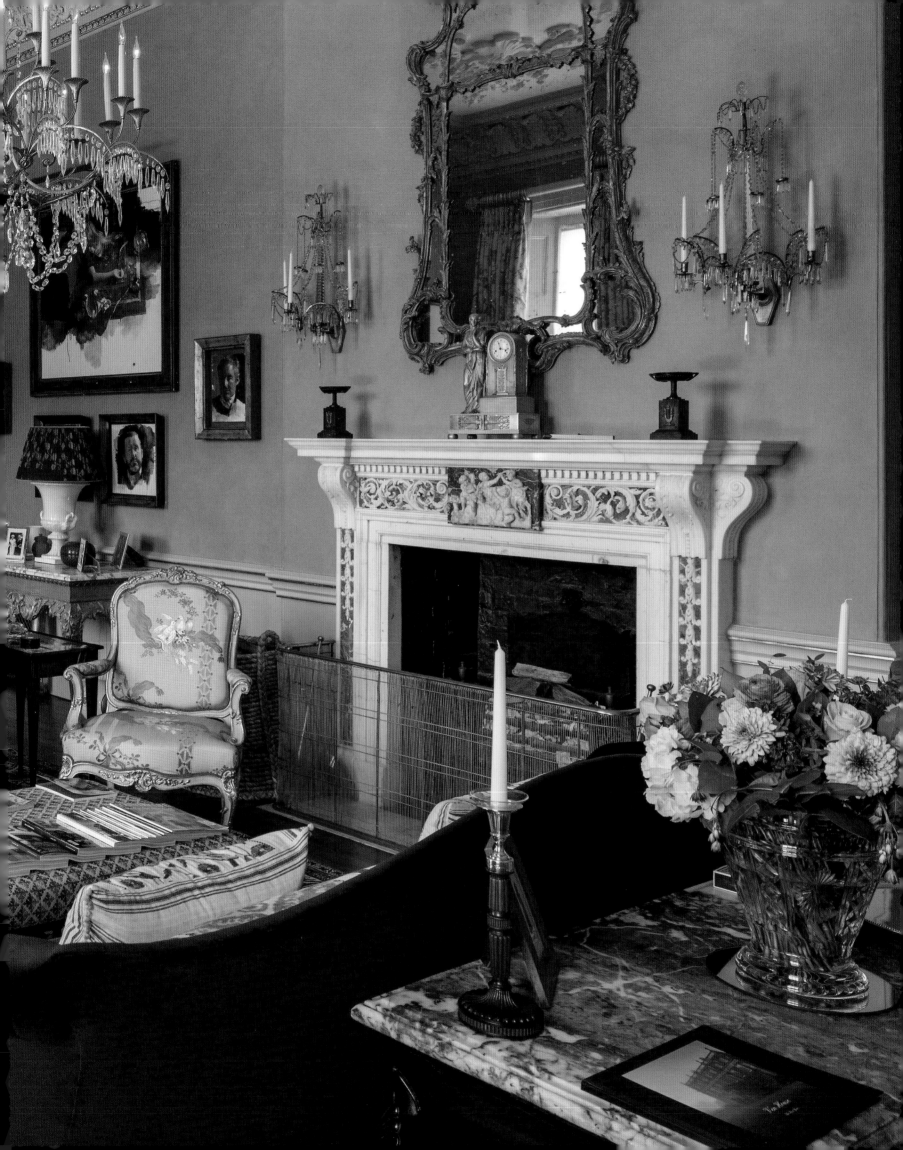

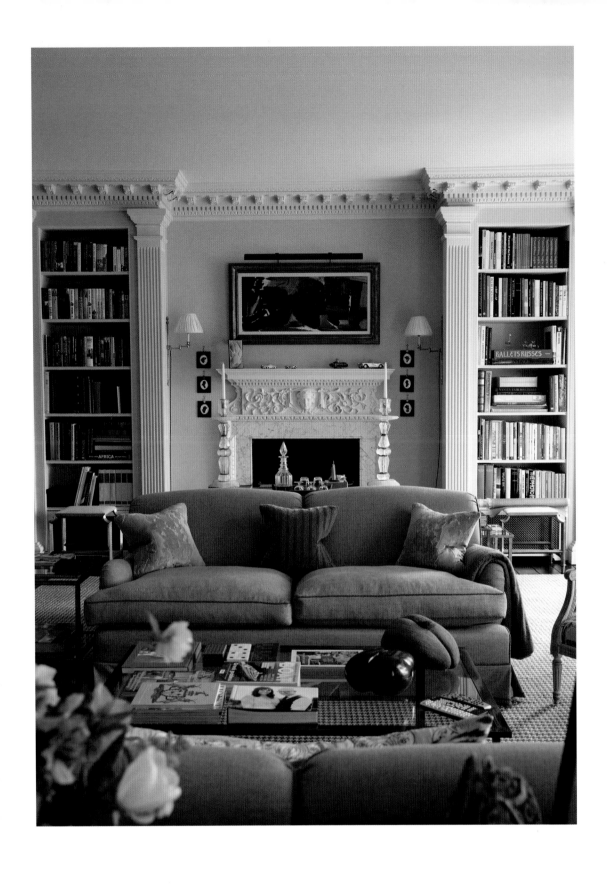

This page. The library was created from the original double staircase at the upper level.

Opposite. A Russian chandelier, circa 1820, hangs above the Georgian-style dining table in the morning room.

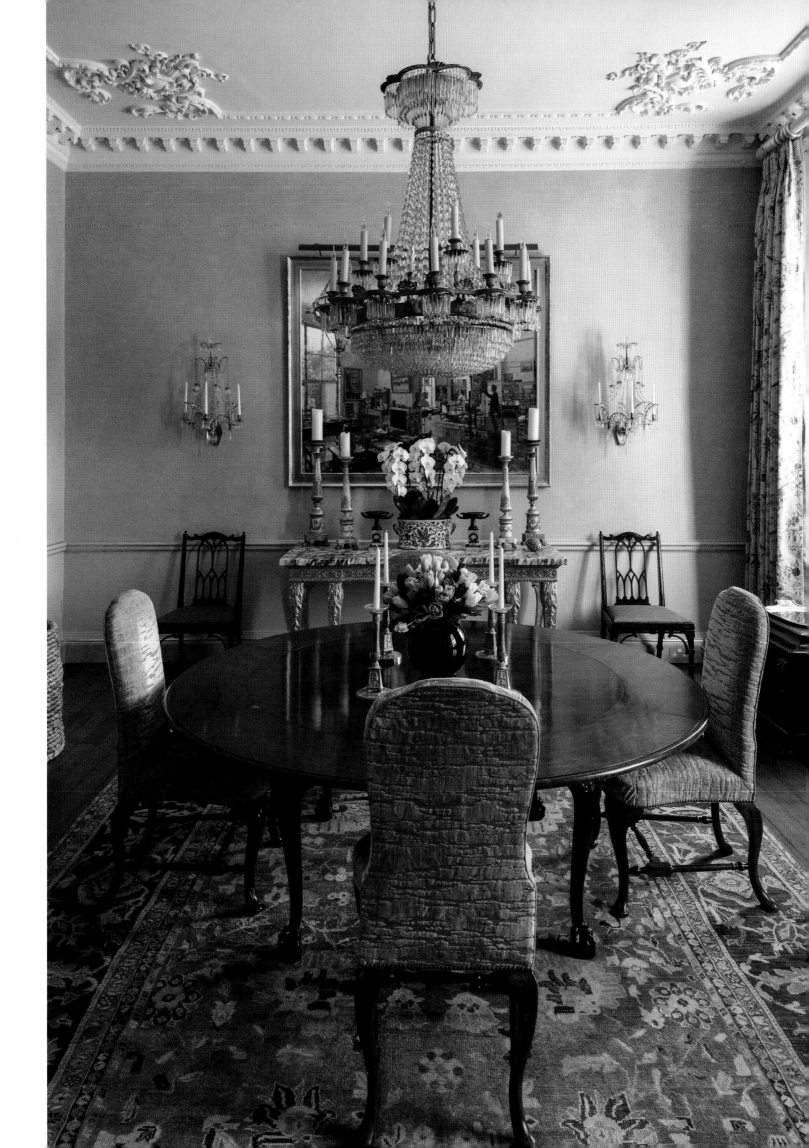

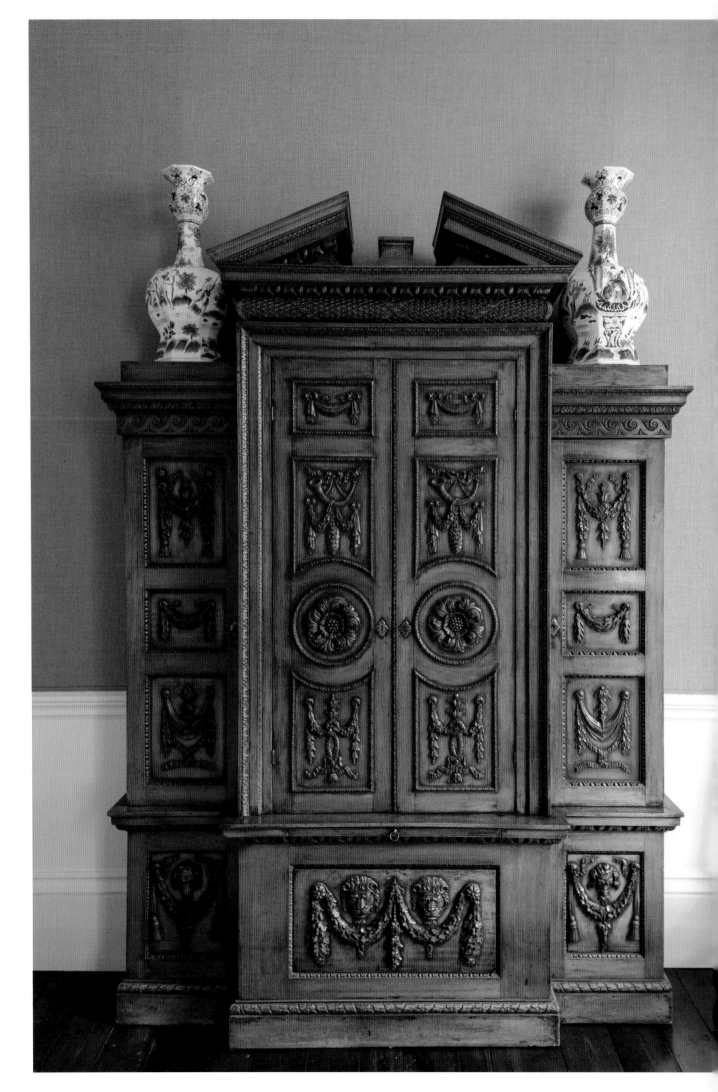

This page. An unusual George II architectural breakfront cabinet, circa 1740, in the master bedroom, was probably made in Barbados from manchineel wood. A pair of Delft vases sits on top of it.

Opposite, clockwise from top left. The walls of the Catherine the Great sitting room are hung with wallpaper by de Gournay; an antique bath in the master bathroom is flanked by klismos chairs; an 18th-century portrait of Catherine the Great hangs on the wall in the guest bedroom named after her.

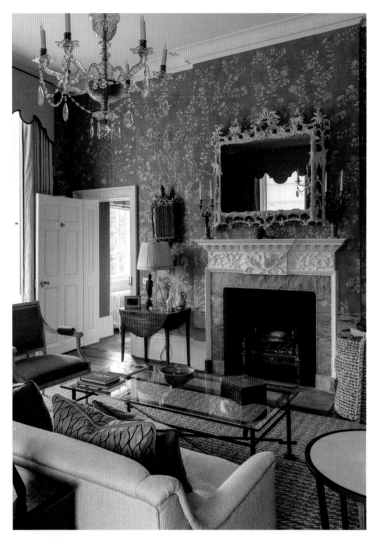

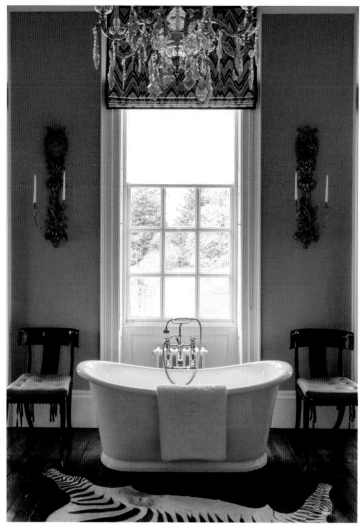

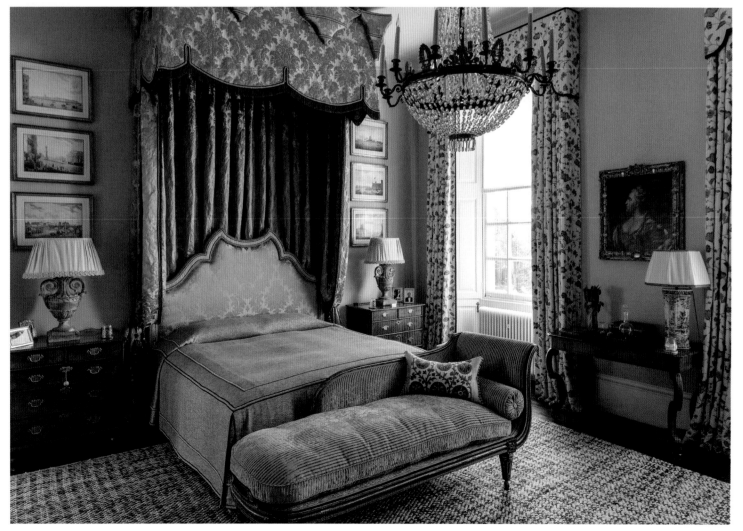

Q&A

What does home mean to you?

Home is like *Heimat* – it's where you belong. Home and a sense of place are vitally important. Ven is the most extraordinarily calming place because it's so beautiful – there's the countryside, the wildlife, that sense of coming home when you come through the gates. It's being surrounded by all the beautiful objects I've collected over my lifetime.

Is there anyone who's influenced you in your life?

Apart from my parents, there are three others. Barry Heathcote, my design lecturer at the University of Dundee, taught me how to solve problems through design – the more difficult the problem the more interesting the design solution. Barry taught me how to design my way out of a paper bag, and I endeavour to pass this on to my office. The second most important person would be Ngila Boyd, an interior designer with whom I teamed up when I set up Indigo in 2005. She has an amazing sense of colour and style and is very understated. And then Charles, he has taught me everything. He's a businessman and also one of the best problem solvers I know.

What does luxury mean to you?

The biggest luxury in the world is to be with Charles and the dogs. We always say, even if we have nothing, we have each other.

How would you describe your design aesthetic?

Varied, I suppose, and very disciplined, which comes from my architectural background. I like Georgian and Irish furniture, because they never got it quite right, which made it slightly quirky and interesting. I suppose that's how I like my interiors.

Are there particular rooms you like to design?

Staircases! Because they are architectural spaces, and I love the celebration of linking spaces. They're the most complex of designs, and I always want them to be more than utilitarian. I also love that sense of arrival as you come down the stairs.

Having lived in more than 20 houses, do you expect to be here long?

I'm going to be buried in the garden! We haven't been here long, but there's a sense of community here that's so important to us. My parents live here and close family all live nearby. The house is always full of people, which we like.

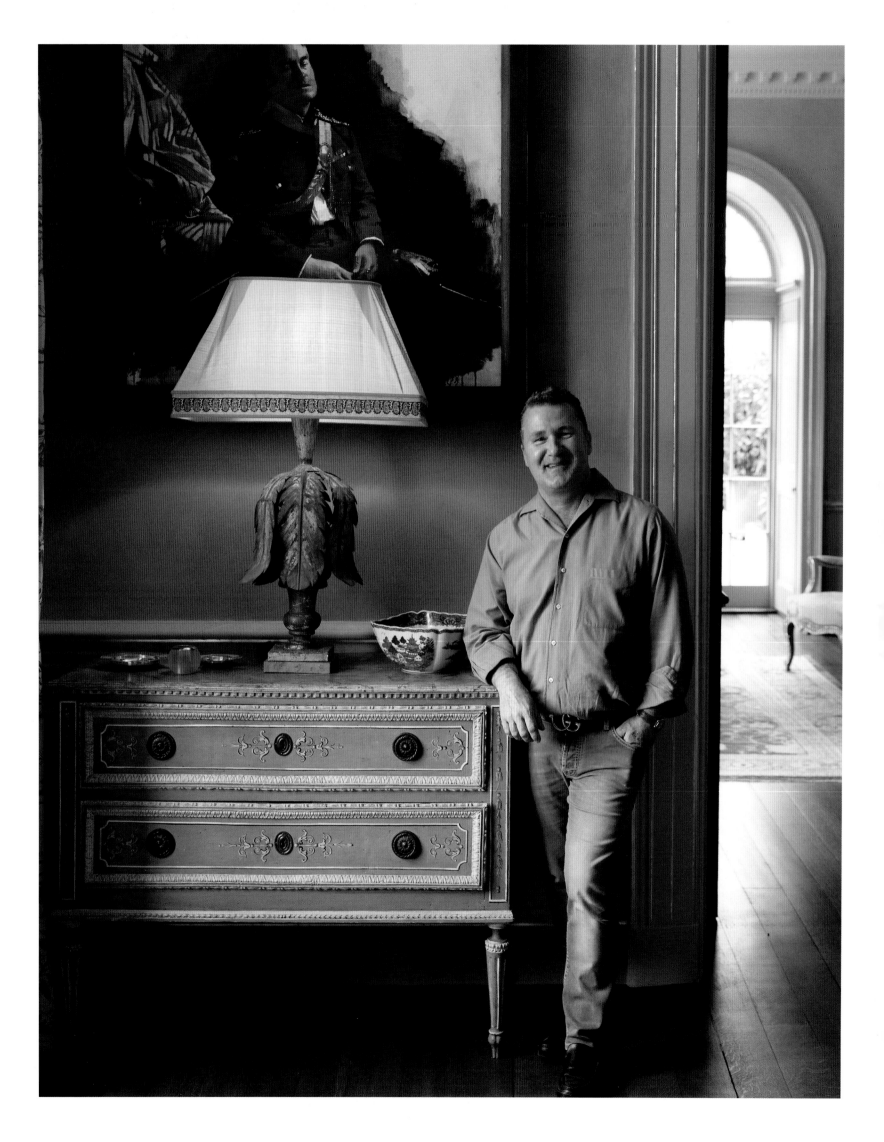

SARAH VANRENEN

arah Vanrenen's approach to the renovation of her family's Wiltshire farmhouse has been to take things slowly. 'It's been done on a shoestring budget, because we were also doing our house in London at the same time,' she says. The 300-year-old house, made up of three cottages and set in 1000 acres of farmland, used to belong to her husband Grant's grandmother, and he has been associated with it, in one way or another, for his entire life. Two of his siblings still live close by.

The couple move back and forth between London and the country each week, though Sarah has set up her design practice in Hungerford, about half an hour's drive from the farm. 'I love my London house a lot, but I'm happiest here, and it's a wonderful place to bring up a child,' she says. She's in business with a close friend, Louisa Greville Williams, and has projects nearby and in London. She has also worked on projects in the Caribbean, and has her own fabric range, which she sells under her mother Penny Morrison's umbrella.

After Sarah finished school, she went to art school in Florence for a year – 'I was always visually inspired' – then got a job in the picture department at Christie's. 'I learnt so much there,' she says. 'It was a wonderful environment to work in.' Coming to the gradual realisation, however, that she would never be an art specialist, she left after five years and started out on her own in design. 'I learnt the hard way, through experience.' Initially working out of her flat in South Kensington, she started picking up jobs.

'Mum and I have very similar tastes, and she helped me a lot – I was always ringing her up to ask for advice,' says Sarah. 'I knew what I wanted to do instinctively, and luckily had a brilliant builder, who understood exactly what I wanted. I had to figure everything out along the way; it was a massive learning curve, but there was quality from the beginning.'

Joining forces with Louisa Greville Williams, who has had many years of experience in design, allows the pair to do 'so much more as a team. Plus it's also a lot more fun,' says Sarah. With the company expanding gradually, she also has plans to take her fabric business in-house. 'I'd love to run it from home in the outbuildings – that's the dream.'

Those buildings would need work, and Sarah's attention, until now, has been on the main house, which was fairly rundown when she moved in. It had been added to over the years, without any real sense of planning.

One room that desperately needed attention was the kitchen, which was small and with no link to the outside, apart from a sliver of view through a tiny window. With the help of an architect, it was enlarged significantly to include a casual dining and living area, with bi-fold doors providing direct access to the garden. Part of the reconfiguration also included incorporating a new entrance hall with skylight, adding two more bedrooms to make a total of seven, and converting a passageway

into a boot room – one of Sarah's favourite parts of the house. With the addition of antique paintings and the odd bit of taxidermy, along with old French fruit boxes for storage, it is as individual as it is functional.

Sarah's idiosyncratic approach to design, as well as her trademark love of bright colour – 'On these rainy days, one needs a bit of cheering up!' – can clearly be seen in the kitchen area, with its flashes of teal, exuberant mix of fabrics and mismatched chairs around the breakfast table. As in the rest of the house, there's also an assortment of oversized lamps – two perching on the dresser dwarf objects around them. 'I love big lamps, as you might notice – they're surprisingly hard to find,' she says. On a tight budget, she adds, lamps can make an enormous difference to a room.

The dining room, previously a dreary dark burgundy, is now painted in a shade of chartreuse. A sideboard in the room came from Grant's father, and Sarah's mother 'donated the fabric for the curtains – when I moved in here, she gave me lots of fabric for upholstery'. In the drawing room, the curtains came from Penny Morrison's old flat, and Sarah rejigged them by adding the borders.

Upstairs, the bedrooms and bathrooms are equally colourful and eclectic, each with its own highly individual scheme and mix of old and new. The main bedroom is airy in feel, with its vaulted, beamed ceiling. It's a pretty space with a tasselled half-tester bed hung with antique lace and a suzani bedhead, Penny Morrison linen curtains and walls covered in numerous small artworks. The en suite bathroom is papered with a bold wallpaper, also one of Penny's designs.

Since gardening has become Sarah's new passion, she's now concentrating more on what lies outdoors than inside. However, at the time of writing, she was in the process of redecorating one of the guest bedrooms, using her own wallpaper, 'Dahlia', and an old French linen sheet to make curtains, and was making plans to liven up one of the bathrooms.

'I LOVE MY LONDON HOUSE A LOT, BUT I'M HAPPIEST HERE, AND IT'S A WONDERFUL PLACE TO BRING UP A CHILD.'

Opposite. The 'not-so-serious' lime green walls provide a counterpoint to the portraits of Sarah's husband's ancestors. The removable linen chair covers are practical, but also fairly relaxed, says the designer.

Overleaf. The scalloped rug, by Vanrenen GW Designs, is laid over the encaustic tiles from Morocco. The boxes for shoes, boots and outdoor kit are old fruit crates from France, and the hats all sit on antlers. The portrait was an unsold lot in a local auction and 'filled a space', says Sarah. The owl came from a French antique market.

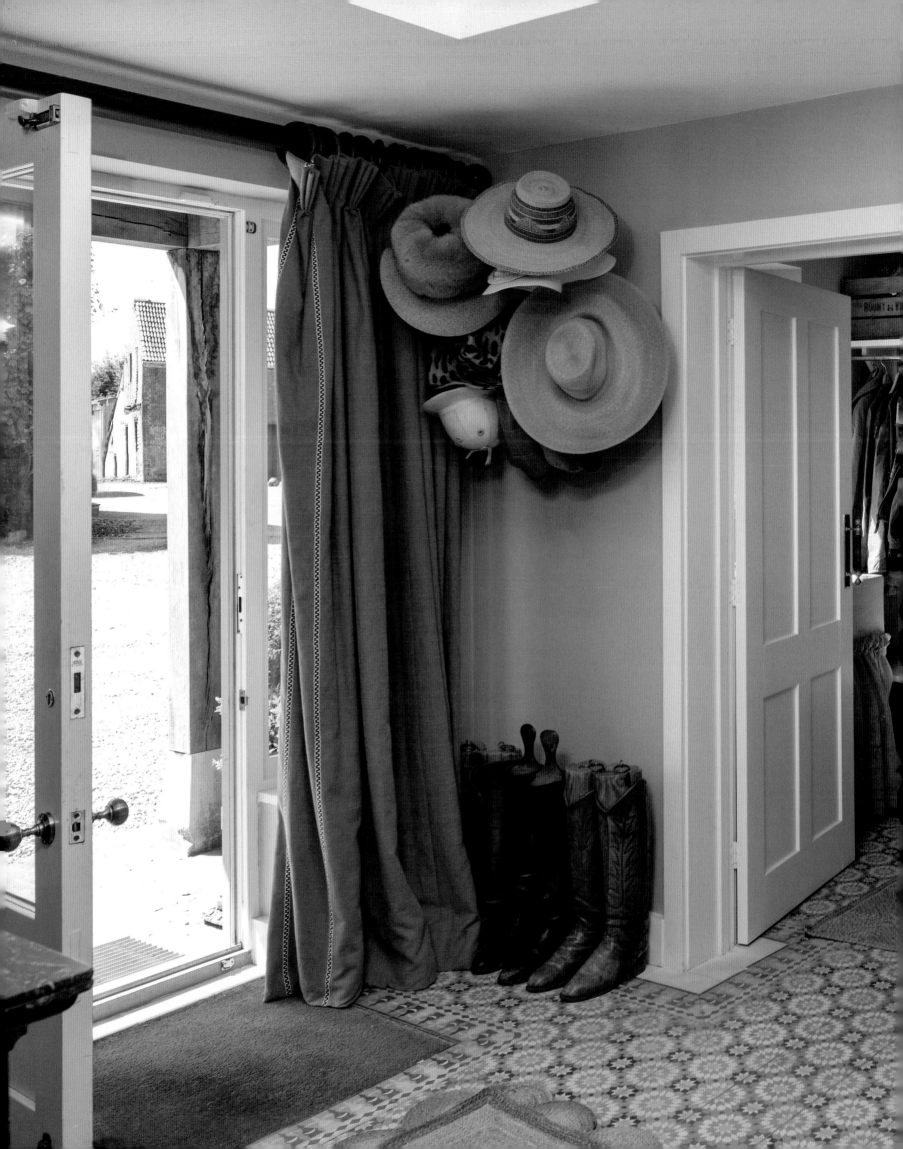

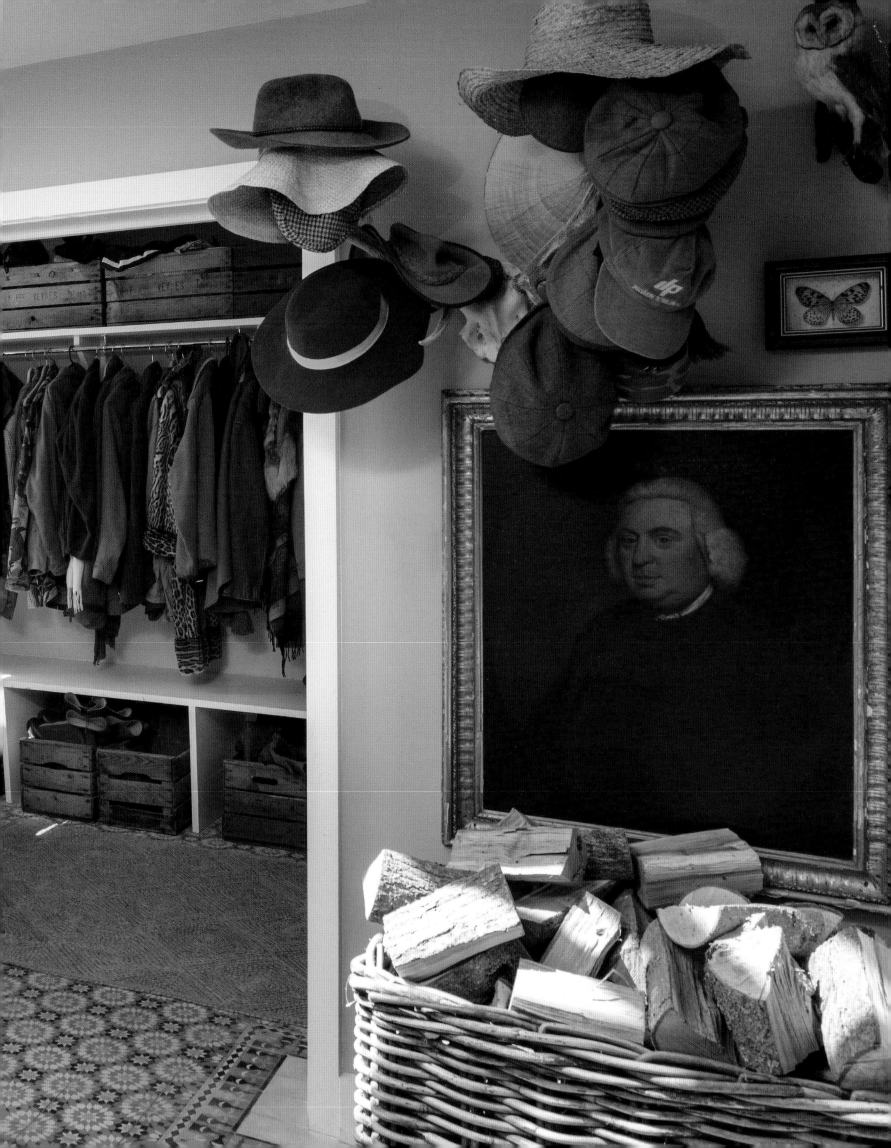

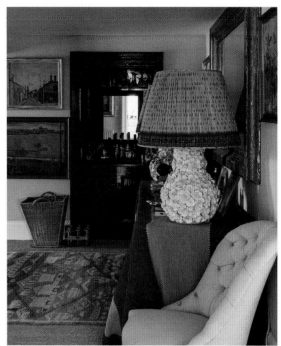
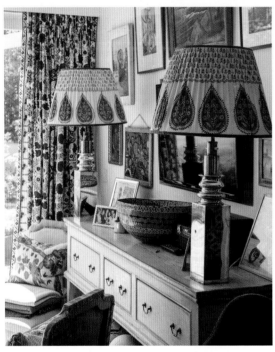
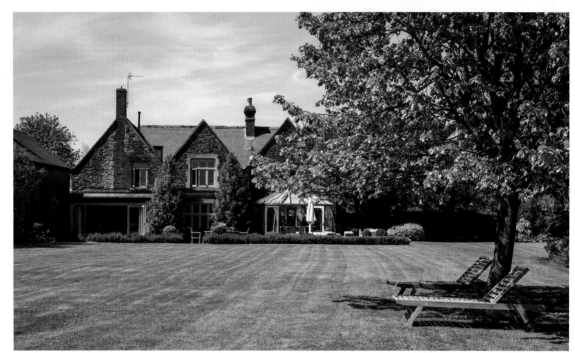
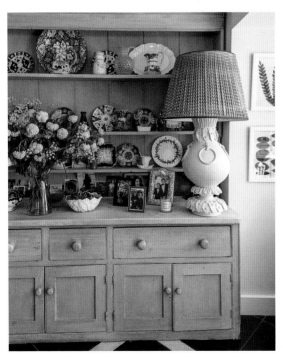
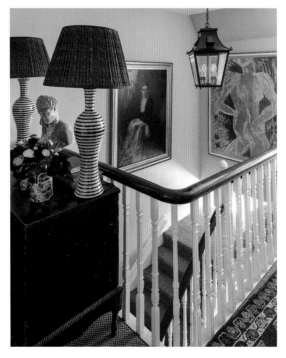
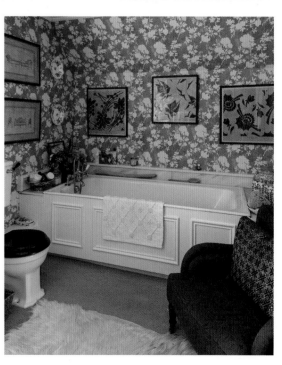

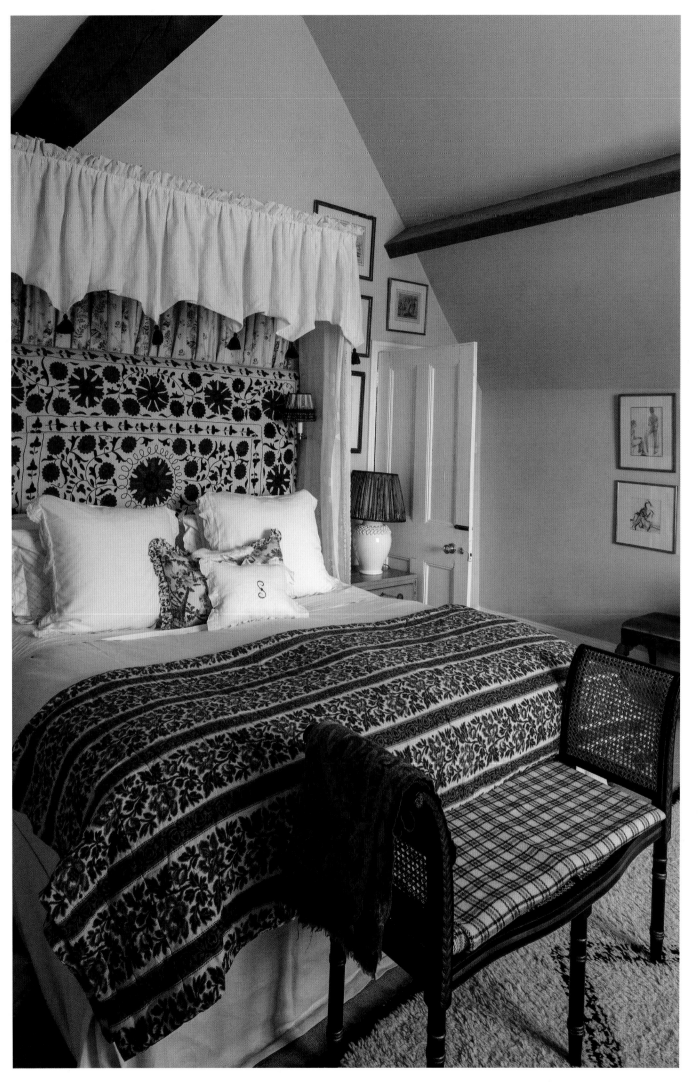

Opposite, clockwise from top left. Shades on the American lamp bases were made from saris; recycled sleepers were used for the kitchen table; a red cupboard, transformed into a bar, brightens up the inner hall; the house is made up of a series of cottages; Sarah had old textile designs framed and has hung them against the Penny Morrison 'Flowerberry' wallpaper; Sarah likes to 'mix it up', as with the modern print alongside her husband's great-great-grand-mother's portrait; ceramics from markets are displayed on the lime-washed dresser; Sarah chose 'Arabella', her favourite fabric by her mother, Penny Morrison, for the curtains in the living area of the kitchen.

This page. In the main bedroom, an old suzani has been made into the headboard, and is surrounded by panels of old lace found in a market and a canopy of Chelsea Textiles linen. The antique quilt was found in a French market.

Q&A

What does home mean to you?

Home is the place you feel most comfortable, and are glad to get back to after a long day at work or even after a trip abroad. It is the place where your bed should swallow you up, and everything around you gives you pleasure.

What's your idea of luxury?

Luxury is deep, feather-cushioned sofas and comfortable bedrooms and bathrooms, always with enormous, fluffy white towels. Big log fires and low-level, soft ambient lighting.

How would you describe your aesthetic?

My husband would say cluttered! I suppose it's eclectic – one has to stop somewhere, so my husband has a policy of 'one thing in, one thing out'! I love candles and flowers everywhere – we always have candlelit dinners together. Eating in the right light is very important. This house looks really pretty at night with all the lamps on.

Do you enjoy entertaining?

Yes, I do when I have time. There's a lovely shoot on the farm that my husband shares with his siblings and two other friends – it's really fun sharing it, as it means we don't always have to have eight people to stay and feed. It's lovely having these country pursuits.

Do you like cooking?

Yes, but again, I do have to have time. We have large dinner parties during the winter in the shooting season and big barbecues in the summer – it's quite a social area. We often go to my sister-in-law's, who also lives on the farm, and is quite wonderful; or her family comes up here. I love having Christmas here – and we often get snow.

Do you collect anything in particular?

I will always collect paintings, I think. I love going to the local auctions, and particularly love street scenes. Also, I have to stop myself from buying pretty china as we have just run out of room! I often buy for clients, as pretty plates look so lovely on bathroom walls.

How do you start designing a room?

As soon as I walk into a room, I seem to see a colour. I often go into a room and rearrange all the furniture in my head.

What would you grab if there was a fire?

I would probably take as much of my artwork in one armful as I could. It has taken me quite a few years to collect, and it all has a story. A house without paintings and pictures is not a home, in my view.

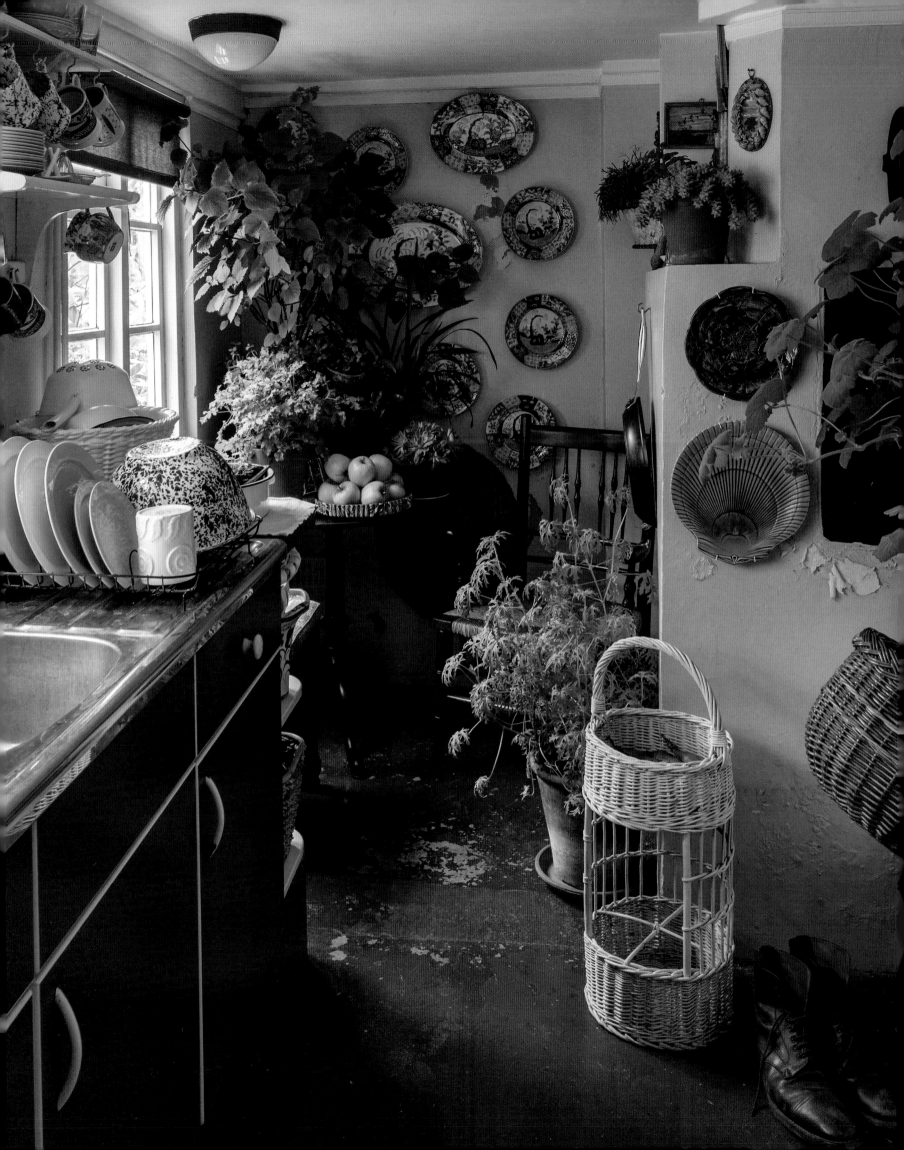

DANIEL SLOWIK

I n the cottage on an island in the River Stour on the Essex-Suffolk border where Daniel Slowik and Benedict Foley spend their weekends, the rooms are enjoyably full. It's as if, says Daniel, 'some dowager had decanted from a much larger house'. In truth, the couple had moved from Benedict's similarly full loft apartment in London's Notting Hill to Daniel's small flat in Hackney; not all their belongings would fit, so they were put into storage until the couple found a spot in the country for them.

A taxidermied coyote or feltwork cushion of Bette Davis here, a slightly grotesque mirror or 'the worst copies ever' of the Marly Horses there – it's a combination Daniel cheerfully refers to as 'horror charm', a mishmash of pieces you wouldn't expect to see together. 'Our flat in London is decorated much more formally, and it's quite nice being able to escape all that,' he says. 'This kind of informality is actually how we like to live.'

The rented cottage, Daniel adds, is a complete reflection of the couple's collecting habits. 'I have always collected, and Benedict, although younger than me, has been collecting since he was a child, so has a strong showing, too.' When the time came to move in, however, they may have regretted accumulating so many large belongings, or choosing such a charmingly small cottage with two very tight staircases. 'Getting furniture upstairs was literally impossible, so everything had to be brought through the one large upstairs window that opened to the floor,' says Daniel. 'It was a complete godsend; we spent many weekends tossing oversized wardrobes and chests of drawers up through it from the terrace below. Any friends who were staying were roped into helping immediately!'

One piece that gave them a huge amount of bother was a part 17th-century tester bed in Benedict's room, which was designed by Syrie Maugham for Cecil Beaton, and painted peacock blue by Daniel and Benedict. To get it into the house in the first place, they had to take it to pieces, then cut it down to make it fit into the room – and it still scrapes the ceiling. 'I like the idea of overscaling in a small space,' says Daniel. 'I remember Tom Parr always saying a big piece of furniture in a small room makes the room look bigger.'

The couple found the house, two mill workers' dwellings pulled together to make one cottage, about five years ago on the internet, and were attracted to it mainly because of the flamboyant block-printed 1960s wallpapers in the upstairs rooms. The decorating scheme was devised by the owner, who lived in the mill house next door. As well as the wallpapers, she had installed fireplaces with surrounds in the rooms downstairs to replace the cooking ranges, and put in a silver cabinet – not the sorts of things you would expect to find in such a modest dwelling. The agents had a hard time letting it, and advised the owner to paint over all the wallpaper. By the time Daniel and Benedict saw it, those rooms were all decorated in the standard creamy colour, 'Magnolia'. 'It was very disappointing,' says Daniel.

Opposite. The kitchen, which escaped the estate agent's 'Magnolia' paint, retains its original bold colour scheme. A collection of Imari ironstone plates hangs on the end wall, the unusable broken parts of a large service that came from a country house in Scotland.

The only solution was to repaint – the duo decided on a powdery blue for Daniel's bedroom, 'partly because of the Bennison curtains we had been given by one of Benedict's clients'. One curtain has been repurposed and now hangs behind the bed. With Daniel and Benedict's belongings in place, and their approach to design, there's no risk of a middle-of-the-road result. Above the fireplace in Daniel's bedroom, for instance, is a mirror that used to belong to Nancy Lancaster that Benedict found in an antique dealer's in London. The patterned linen on the bed, on the other hand, came from 'over the road when they had a garage sale – I love the combination of blue, orange and red, it's really rich'.

In the passage outside the bedroom, the walls are covered in an ever-changing hang of paintings, which mainly belong to Benedict, an art dealer in 20th-century British art. The landing has been turned into a study area, with stacks of books lined up along the corridor. 'This is our library, but there's a problem if you want to get to a book at the bottom of the pile!' says Daniel.

In the dining room, the ivy-patterned curtains, as well as the William IV buffet, and a Georgian linen press that had been adapted into a bar in the 1970s, came with the house. Daniel and Benedict painted the hanging shelves above the buffet, and removed the orange Formica top, painting the wood beneath white.

Throughout the house, almost everything is inherited, bought from junk shops or auctions, or has been given to the couple second-hand. 'Because the cottage is rented, it hasn't really been "finished" – it's a moveable feast really,' says Daniel. 'I love the rusticity of it.' He also loves the fact that he can leave work behind in London when he comes here. 'I find it's much better that way – I'm then in the right state of mind to deal with work during the week.'

Daniel's interest in design dates back to his early childhood. 'My mother said my first word was "church" – one idea I had was to become a vicar, because you get to live in a nice house!' He used to play with his great-grandmother's very grand doll's house, and made model houses, including a detailed one of Château de Chillon on Lake Geneva. He also spent a lot of time drawing with his father, a graphic designer. 'I'd draw things like furniture and fireplaces, and the exteriors of houses.' His first book, when he was about five, was *English Country Houses* by Christopher Hussey. 'I can still smell the pages now – I used to sit there for hours looking at it.'

While studying history of art and design at university, Daniel worked as a porter at Sotheby's, before getting a permanent job there, moving between departments. 'I realised objects weren't particularly interesting in isolation – it's a bit like going into a white box art gallery and seeing a work of art in a sterile environment instead of in an interior.' He learnt that it's 'really very important to consider the interior when buying artworks, and having utilitarian objects adds to the whole look'.

For a few months, Daniel was a guide at Kensington Palace, during the time in which Princess Diana died. Then he found his way into the antiques department of Sibyl Colefax & John Fowler. About five years ago, he started his own decorating team at Colefax, in addition to his previous role. 'It just naturally evolved,' he says. 'I'm interested not just in antiques but, rather, antiques in interiors.'

He's interested in context, in how things fit together, and it's not a coincidence that he points out a little bridge just near the cottage. In this bucolic setting, with cows in a field across the road, and a lazy river that Daniel and Benedict punt along when they're going to see their friend Veere Grenney, the steel bridge introduces a jarring note. 'There are loads of airfields nearby, and the reason it's made from steel is that, during the war, tanks needed to be able to drive over it,' says Daniel. 'It's difficult to imagine the whole area being given over to war.'

'BECAUSE THE COTTAGE IS RENTED, IT HASN'T REALLY BEEN "FINISHED" – IT'S A MOVEABLE FEAST REALLY. I LOVE THE RUSTICITY OF IT.'

Opposite. Daniel and Benedict often punt along the river when visiting friends nearby.

Overleaf. The chairs around the table are a mixture of Georgian models – three finely carved unusual Scottish examples with seats in a Claremont damask and a provincial 'Chippendale' chair with bargello work seat.

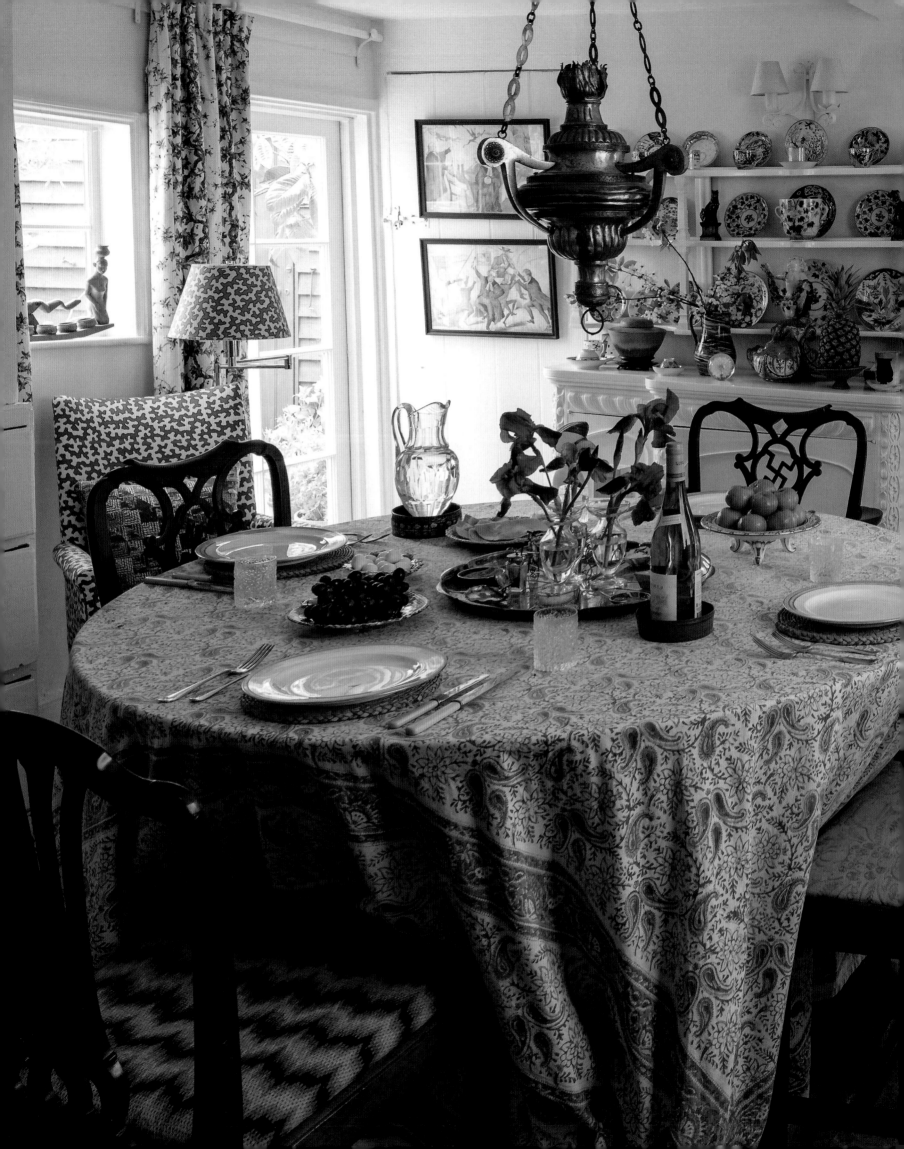

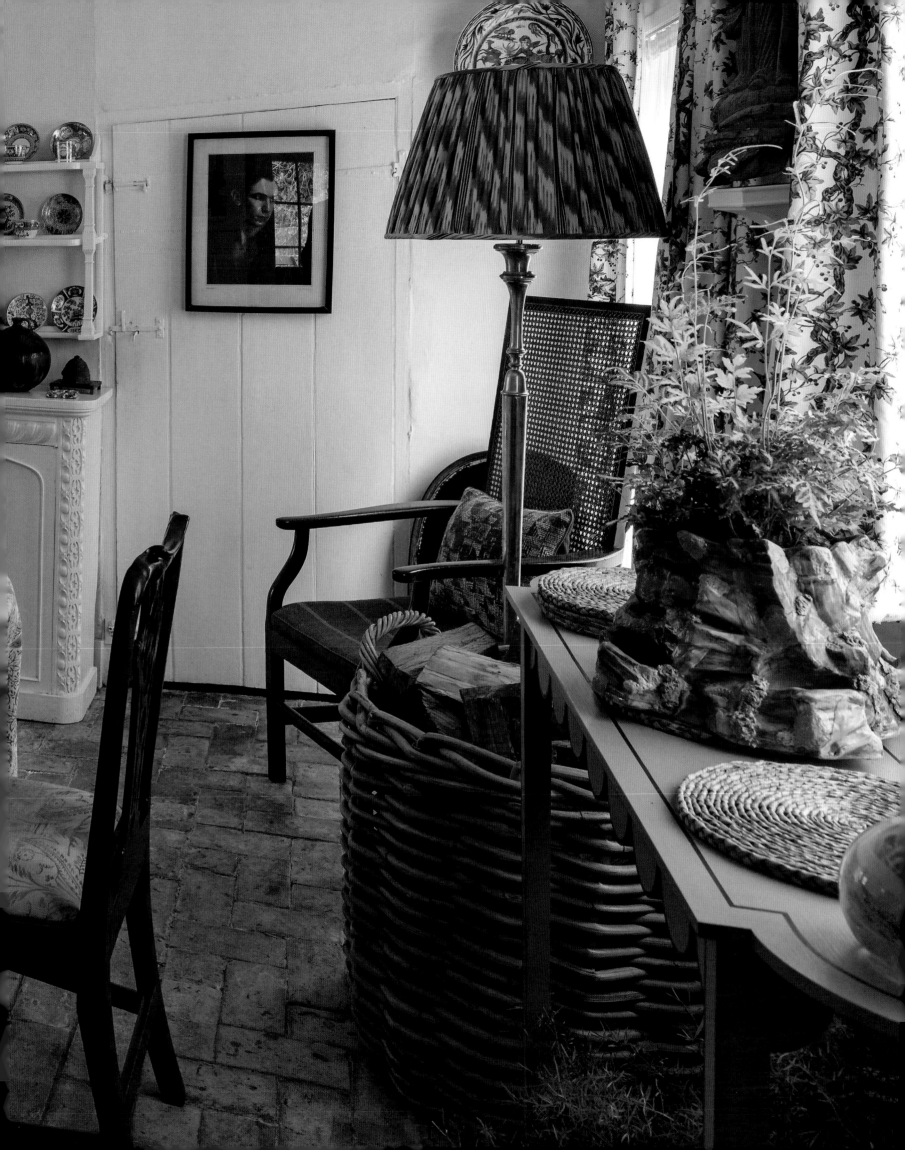

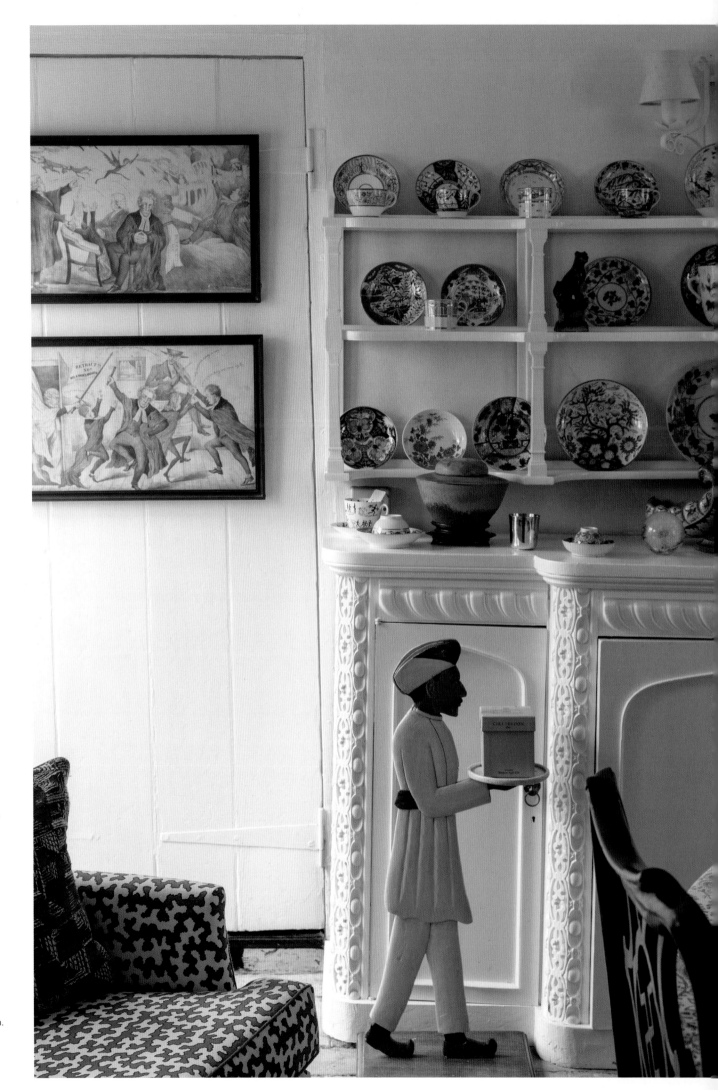

This page. A collection of late 18th- and early 19th-century English Imari palette porcelain, collected by Benedict for more than a decade, is displayed on the painted William IV buffet with other ceramic pieces.

Opposite, clockwise from top. The sitting room contains a collection of disparate, comfortable hand-me-down furniture; upstairs in the 'library', books piled high on the floor are ordered into subject; vintage ivy pattern chintz curtains were the starting point for the green and white scheme of the dining room.

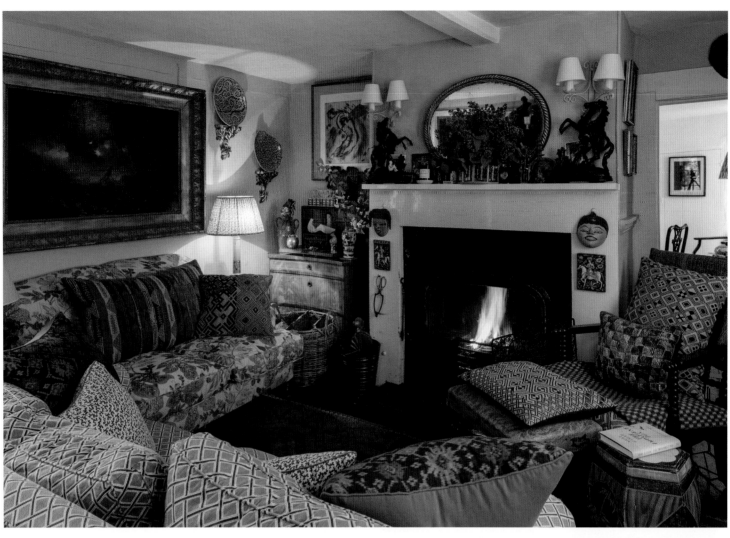

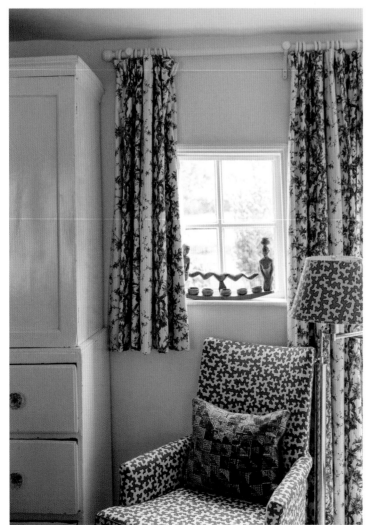

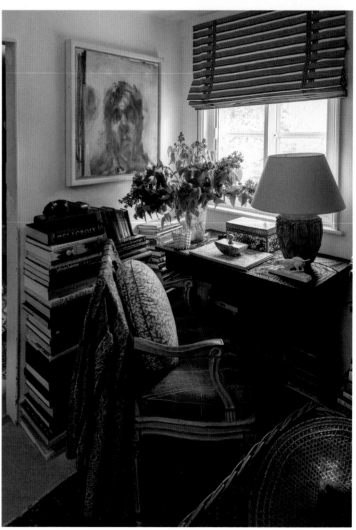

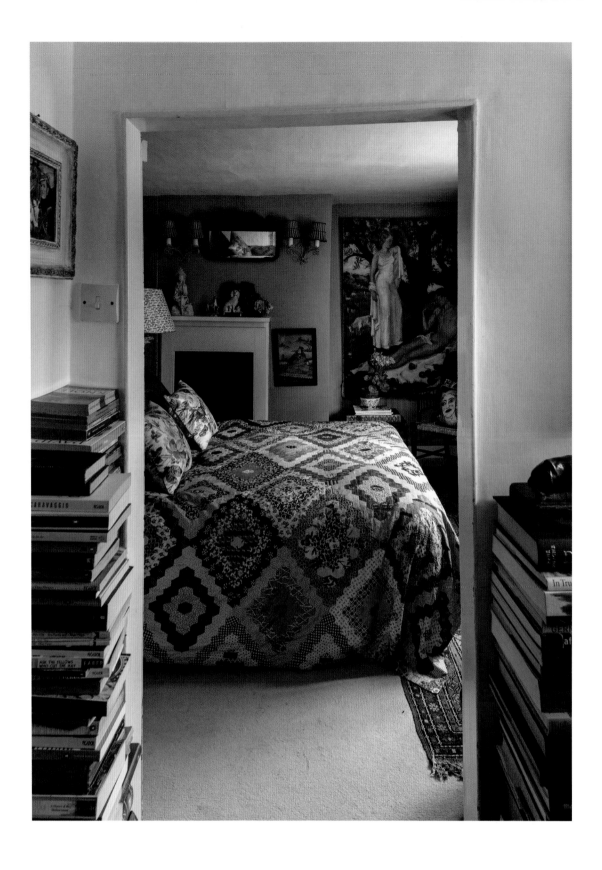

This page. Walls of the guest bedroom are painted in gloss lilac, and the 19th-century quilt matches the curtains. The split bamboo lampshades on either side of the George III fret-cut mirror cost $7 each from Walmart in the US. 'Getting them back to the UK was the most expensive thing about them!' says Daniel.

Opposite. A view along the upstairs corridor. Benedict runs London-based gallery A.Prin Art, specialising in 20th-century art, and the hang here constantly changes as new works come in and go out. Relatively little-known artists might be found alongside the likes of John Minton, Otto Dix, Cecil Beaton and Roger Hilton.

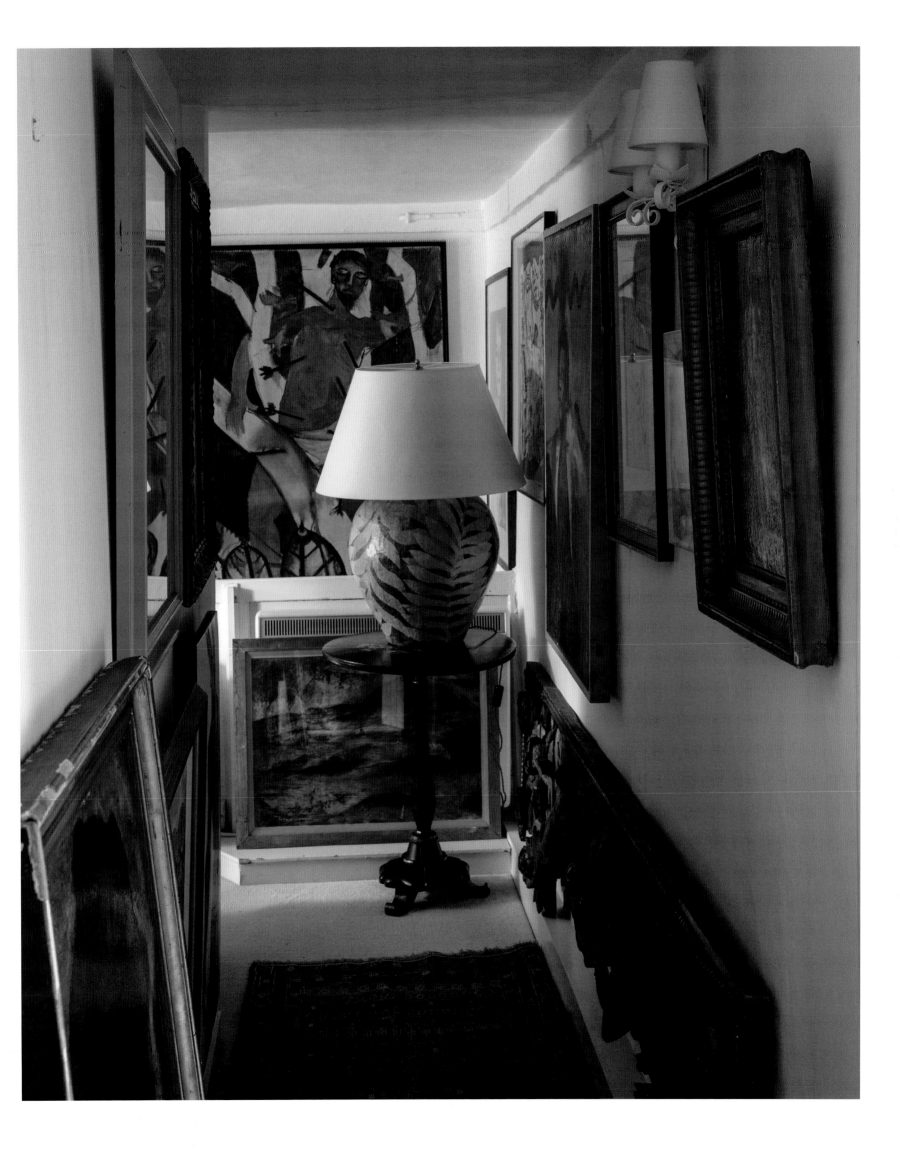

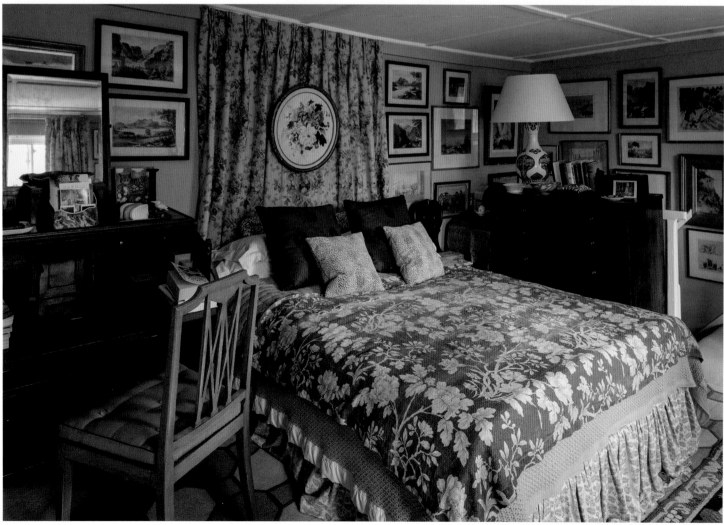

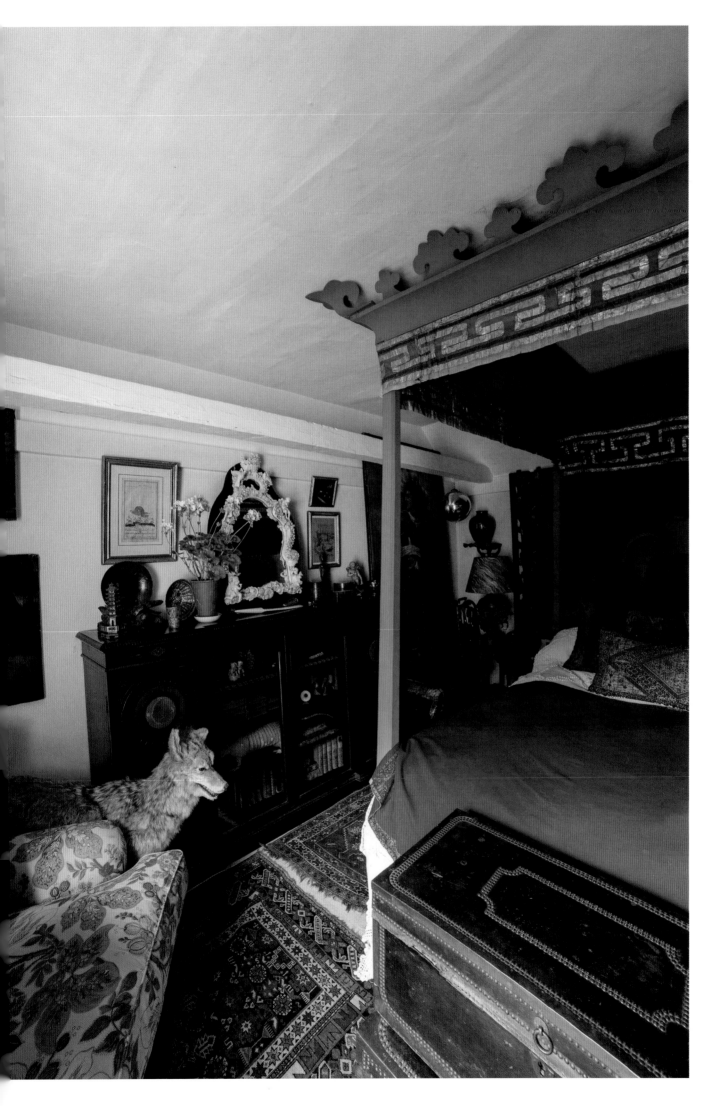

Opposite, clockwise from top left.
A 19th-century Scottish thistle
design mirror, previously used by
Nancy Lancaster as a dressing
mirror at Haseley Court, only
just fits above the fireplace in
a bedroom; two prints from
Hogarth's series 'The Rake's
Progress' contrast with a Kashmiri
kashkul bowl; a yellow painted
chair from Sibyl Colefax Antiques
sits in front of a bureau chest
bought at a local auction for a song.

This page. A part 17th-century
bed, remade by Syrie Maugham for
Cecil Beaton, is painted the same
blue as in the large painting of a
cavalier that can be glimpsed in the
back corner of the room. Fabrics
include vintage Bennison 'Wheat
Flower' on the armchair, early
19th-century Portuguese
embroideries on the bed canopy
and Swat Valley embroideries
made into cushions. A stuffed
coyote completes the scene.

Q&A

What does home mean to you?

Being surrounded by all your things – you kind of feel it's permanent. It's funny because this house is rented, but feels more permanent, somehow. It feels settled.

Who has inspired you?

John Fowler, specifically. He was incredibly groundbreaking – and so imaginative and innovative. I'm obsessed with Cornbury Park, which he did in the Sixties.

What's your favourite room to design?

Probably a drawing room – I like to start with the rug, taking colour inspiration from a really good piece and selecting fabrics that work with that rug. It's so important that the client is happy and consulted. From really early on, you've got to gauge what they want. I don't like pin-point designing everything from the beginning, but prefer allowing schemes to evolve as we go along. This gives a more natural and cohesive result.

With all the new collections that come out, are you often tempted to change things?

Once a decision is made, you have to stick to it. If it's good, it will stand the test of time.

Do you collect anything?

I used to collect chairs. Benedict and I have that in common.

What's your idea of luxury?

A nice hot bath on a Saturday night, having a sofa supper and watching a film.

Fiction or non-fiction?

I like reading trashy, gossipy biographies and books about demolished country houses.

What's your favourite design book?

The old Colefax books – Roger Banks-Pye is a huge favourite.

What can't you live without?

Benedict.

If there was a fire, what would you grab?

The stuffed coyote, I think. And definitely the Cecil Beaton bed, although it would be hell taking it all down.

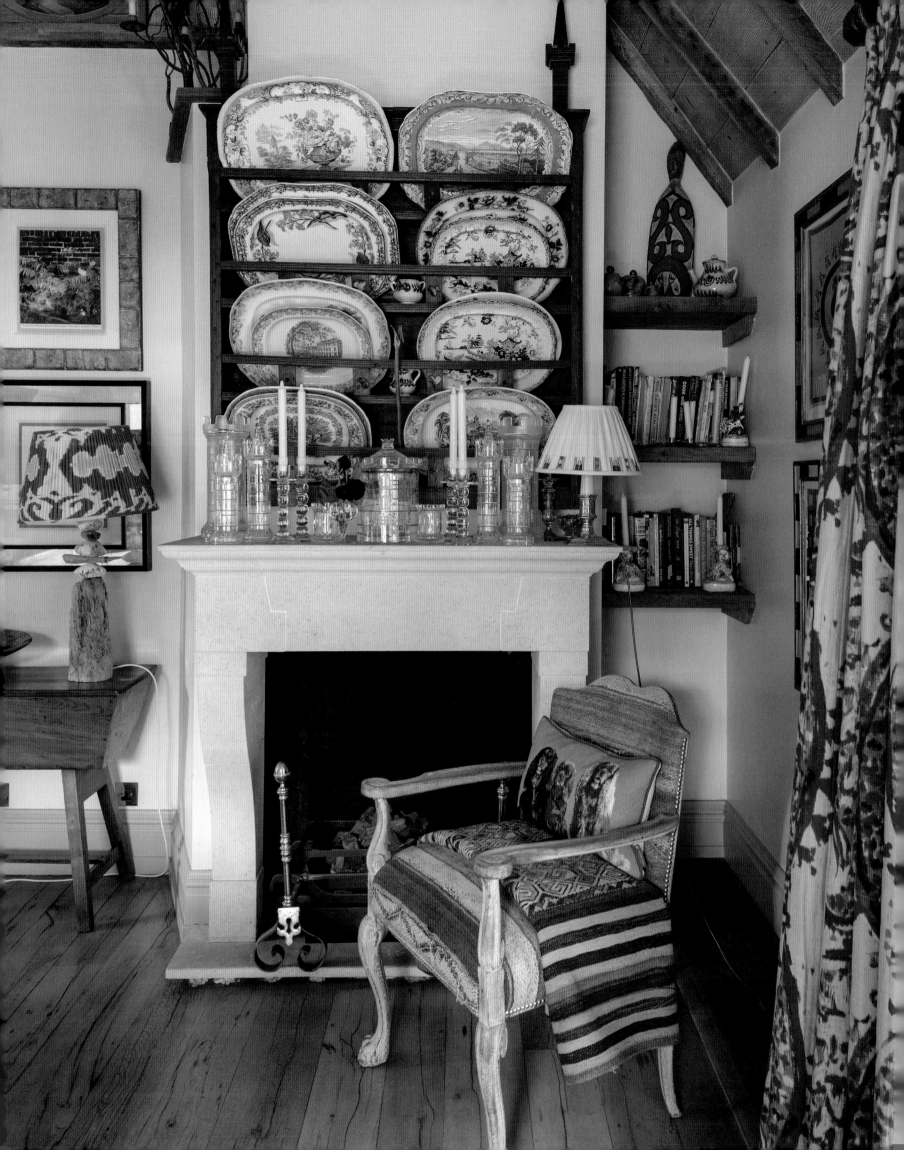

KIT KEMP

Across the arm of a sofa in the sitting room of Kit Kemp's house in the New Forest is a colourful cloth she found in a second-hand clothes shop in Covent Garden. It provided the inspiration for 'Mythical Creatures', the range of china she designed for Wedgwood. Kit finds inspiration everywhere, and has also collaborated on textiles, wallpapers and rugs. But, in the design world, she is known, more than anything, for her individual take on hotel interiors. More than 30 years ago, Kit and her husband, Tim, opened the Dorset Square Hotel in Marylebone, and since then they have established a string of others, in both London and New York. As well as the hotels, they have their own commercial laundry and a small in-house hospitality school and bakery.

Each property is unique, but what ties them together is Kit's unpredictable, and often playful, approach to design. Her world is colourful and full of pattern and texture. It's infused with contemporary art but, equally, presents more mundane objects in a new light. Her interiors are calm and comfortable, yet exciting at the same time. She has an ability to create environments that, while highly distinctive, are always sensitive to their surroundings.

Her father's family was artistic, so even as a child art was there in the background. 'I've always loved colour,' she says. Kit grew up in the country, just across the river from where her family house is now. 'I was a tomboy and spent a lot of time outside – we lived a very rural life, without any neighbours.' As far as interiors went, she was also practical. 'I knew how to upholster a sofa and wallpaper a hallway.'

When she left school, one of her first jobs, which she thoroughly enjoyed, was with an auctioneer. She then worked for a shipping company for a while before moving up to London, where she got a job with a Polish architect, Leszek Nowicki, who would often take her to exhibitions. 'I learnt to get a very good feel for dimensions and space,' she says. 'My boss had a very "crafty" aesthetic – very simple. He much preferred pottery to fine china. I gained great experience there.'

After a few years, she started her own small company, again in shipping, and later joined Tim in a business that specialised in student accommodation. 'When he managed to get the freehold for one of the buildings, he had plans to upgrade it,' she says. He'd already been using a decorator, but Kit figured out she could do it instead. 'So that's what happened – if I decide to do something, I'm pretty determined. I never give up.'

That was in the mid-Eighties, and the upgraded hostel became the Dorset Square Hotel. 'I remember *Country Life* calling it the first country house hotel in London,' she says. 'It's a Regency building, and we still have it in the group.' From then, she says, 'the interiors of the hotels became my world.'

Their country house, set on four-and-a-half acres near the Hampshire coast with a garden running down to the water's edge, certainly needed Kit's clever approach

Opposite. Part of Kit's collection of meat platters adorns the area above the kitchen fireplace. She has more of them at The Whitby Hotel in New York, believing that collections of objects make them more fascinating.

to design when she and Tim found it in 1999. 'It was built in the 1930s and wasn't a very attractive house, really,' she says. 'It had been on the market for ages, and we thought we could do something with it because of the position.'

About 10 years ago, they completely refurbished it, adding the orangery – or dining room – as well as an extra bedroom, new entrance hall and stairway. The house is decorated in quintessential Kit Kemp style, with plenty of bold colour and pattern, in wallpaper, upholstery fabric and rugs; an abundance of artwork, including oversized contemporary sculptures and paintings; and a mix of furniture, from the rustic to the more refined. Clearly, pieces have been collected from all over the world – in a bedroom, for instance, a traditional hunting scene hangs above ornate Indian side tables. In Kit's capable hands, elements that, in other settings, might not sit together comfortably make perfect sense.

Kit's ability to create entire worlds is also in evidence outside. Apart from the topiary animals that frolic across the lawn or stand among flower beds, there are three enchanting additions – a shepherd's hut, a gypsy caravan and a thatched summerhouse. The hut had once belonged to a friend, John Harman, who had built it and used it as an office. It has since undergone a significant transformation. 'As he's a thatcher, I asked him to thatch it,' says Kit. 'There was a boiler in the corner, which we stripped out, and then I asked Melissa to do her magic.' Melissa White, who worked with Kit on a fabric and wallpaper collection, filled the interior walls with scenes and motifs you're more likely to find in a storybook, all sitting under a stylised starry sky. The hut provides a quiet working spot for Kit, or just somewhere to retreat to. It's decorated with all sorts of bits and pieces she has collected over the years, which look all the better for being mismatched.

John also built the summerhouse, otherwise known as 'the hobbit's hut'. The gypsy caravan, says Kit, is an authentic one they found in Dorset. 'Whole families of gypsies would roam the countryside in these caravans. There's a stove and a pull-out bed in it, and children are completely entranced by it. We have afternoon tea inside and pretend to tell people's fortunes.'

Every weekend Kit and Tim, who live in London during the week, come down to the house, which is also home to their three generations of King Charles spaniels, and Kit and Tim's family when they visit. Even before they found it, they'd been renting a little farmhouse about half a mile away, partly as a way of getting their three daughters out of London and attuned to a more rural lifestyle. 'At first they'd almost hated it, but very quickly they decided they quite liked it, with all the horse riding,' she says. 'I loved the farmhouse – it was really rustic and the children could ride their bikes all around the ground floor!'

These days, Kit usually rides on weekends, and does 'Sunday lunch for waifs and strays – I don't mind cooking, but don't enjoy the washing up'. In summer, the family spend a lot of time on the terrace, but Kit says the garden has a lot to offer all year round. 'I'm no great gardener, but I love gardens,' she says. 'When you shut the door of a room, it dies, whereas the garden just goes on and on.' She has plans to do more in the garden. 'And we have an old boathouse which I would love to redo.'

'I WAS A TOMBOY AND SPENT A LOT OF TIME OUTSIDE – WE LIVED A VERY RURAL LIFE, WITHOUT ANY NEIGHBOURS.'

Opposite. The hand-embroidered cushions by Fine Cell Work in Kit's design, 'Heart of Oak', sit on a pair of oversized armchairs.

Overleaf. Reclaimed oak floors and a raised stone fireplace from France feature in the green room. The Pippa sofas were designed and made to Kit's specifications, with hand embroidery and embellishments.

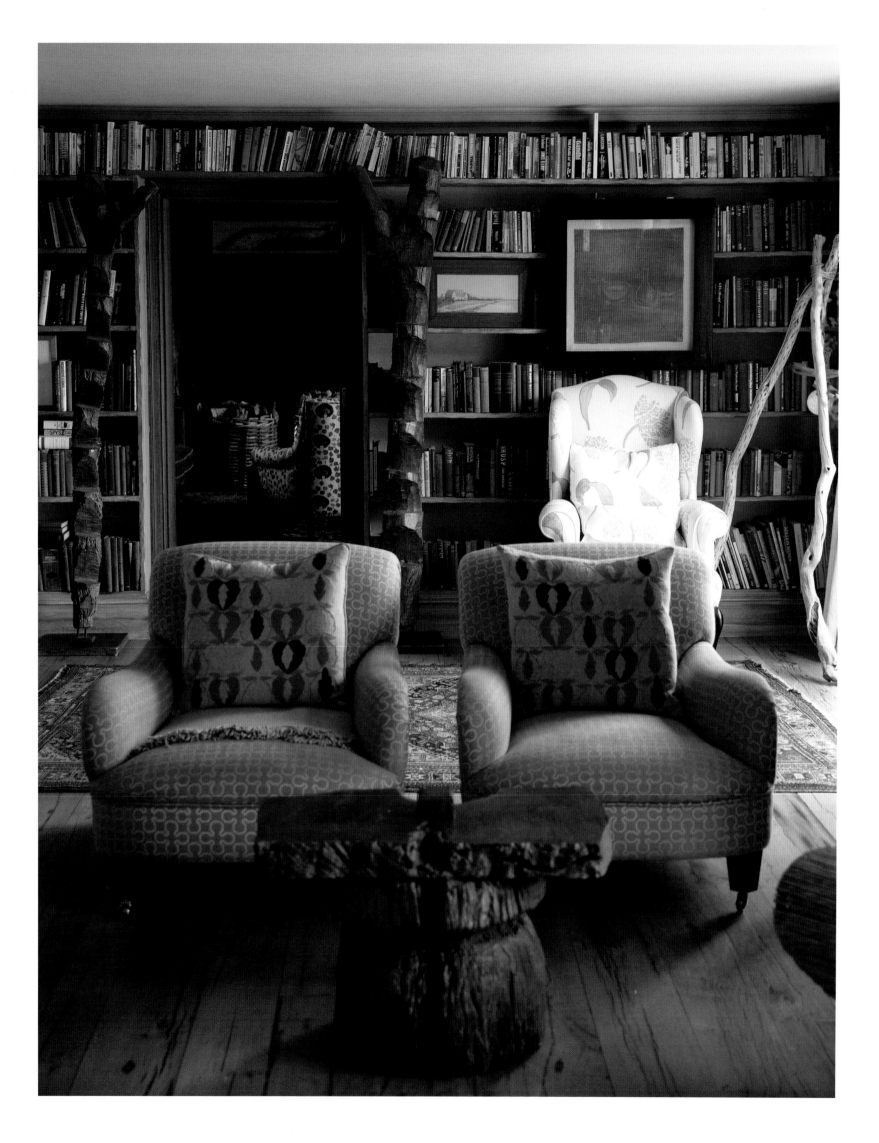

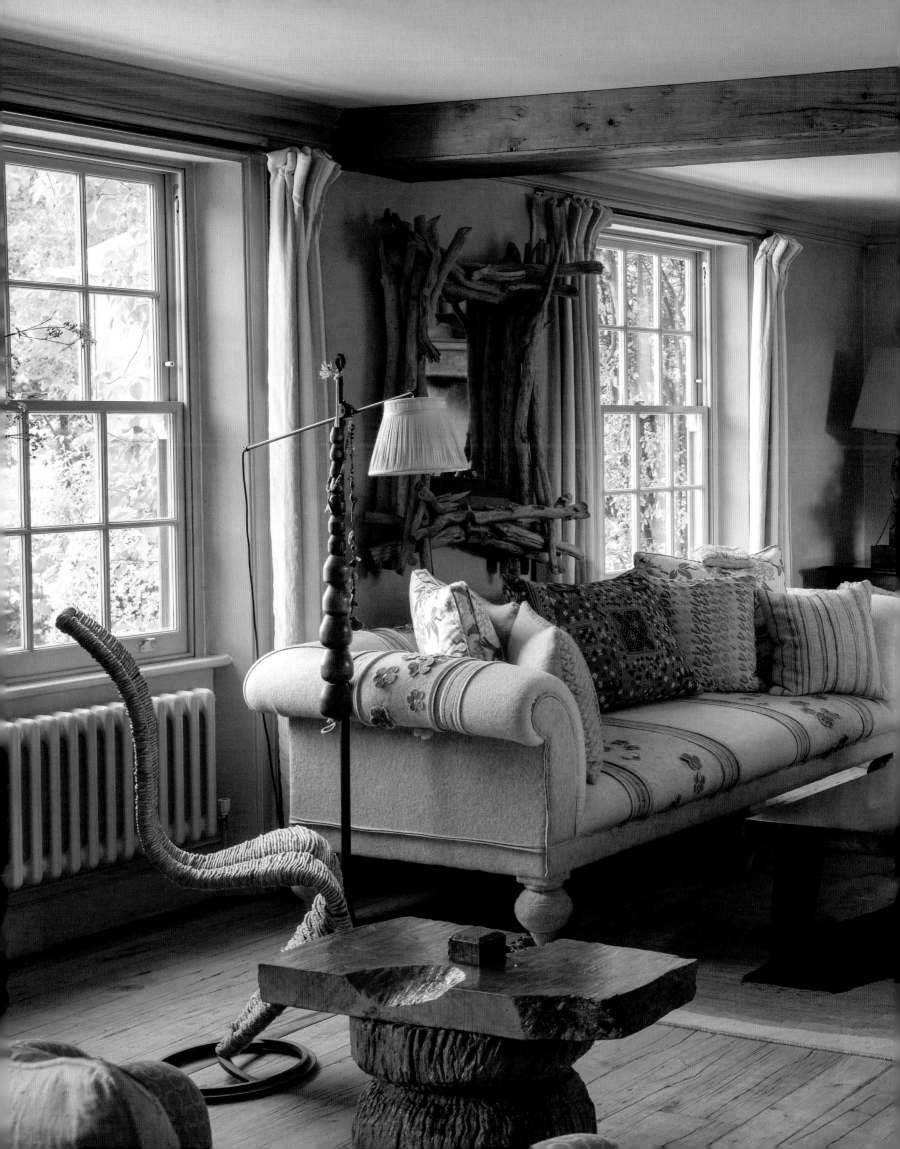

This page. The blue room – Kit's daughter Minnie's bedroom – is part of a new extension facing the river, and lends itself to a nautical theme. Its ceiling is tall enough to have a boat suspended between the oak beams.

Opposite, above. Kit loves bright colours, and has used South American blankets to upholster the chairs in the dining room. The rug is Moroccan, and a mobile of swimming fish is suspended from the chandelier.

Opposite, below. When Kit rebuilt the house in the 1980s, she added the panelling, along with the inglenook fireplace, to the wood room. The sofas are upholstered in a Dominique Kieffer corduroy.

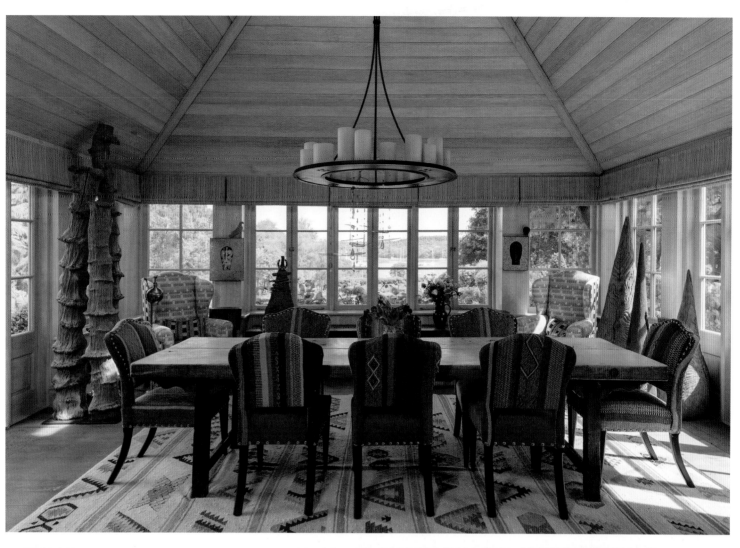
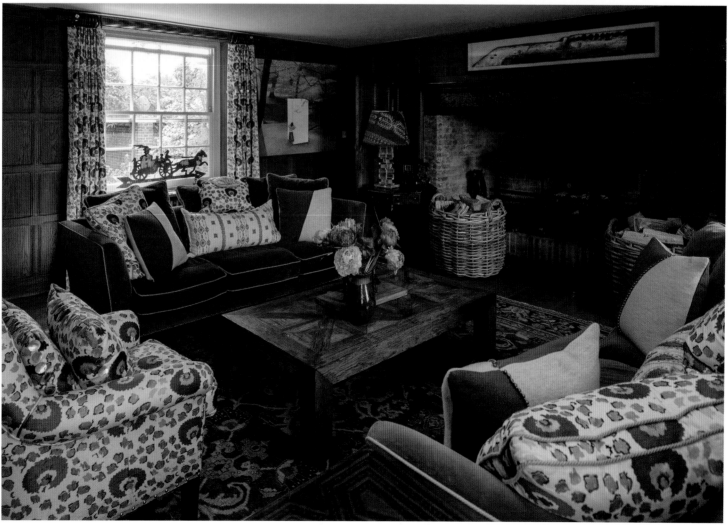

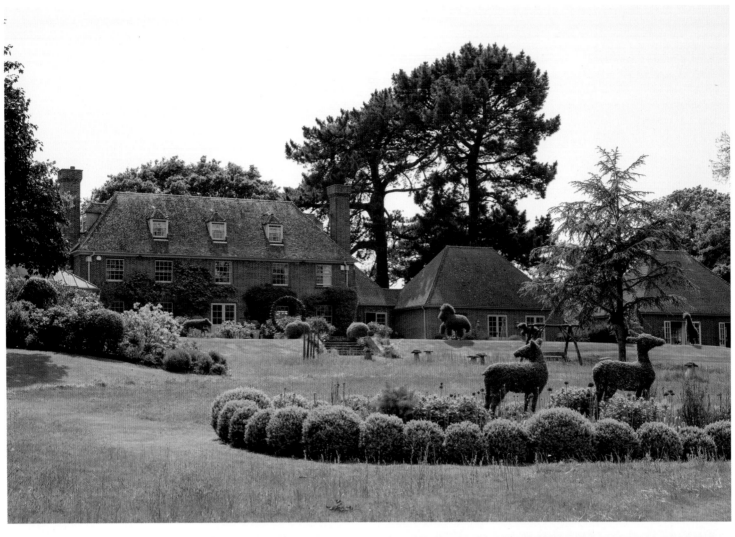

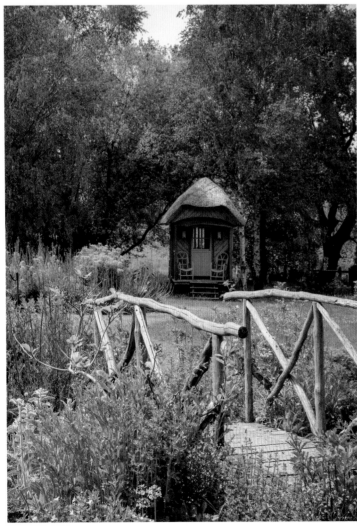

Opposite, clockwise from top. Topiary animals inhabit the garden; the gypsy caravan was found in Dorset; when the shepherd's house was moved to the garden, Kit had it thatched.

This page. Under the starry sky of the ceiling, Melissa White's hand-painted scenes of a mythical landscape decorate the walls of the shepherd's hut.

207

This page. Two large armchairs covered in Kit Kemp's 'Ikat Weave' frame the fireplace in the main bedroom.

Opposite, clockwise from top left. 'Scattered Flowers' by Kit Kemp is used to paper the walls of the main bathroom; an antique settee, covered in Kit Kemp's 'Friendly Folk' fabric for Andrew Martin, is set at the end of the bed in the main bedroom; wild flowers from the garden are arranged in an old French jug in the dining room; cushions in hand-embroidered Chelsea Textiles fabric rest on a quilt in the same fabric.

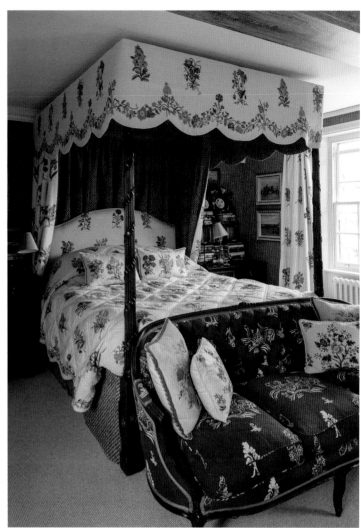

Q&A

How do you like to entertain?

Now that we have redone the house in London, I really would like to have people around in a very simple way. And, actually, I owe people!

How do you relax?

I go riding and walk the dogs. I have a few good friends down here, and we will meet for a coffee. I also love picking flowers on a Friday evening – sometimes I get tense about work, but whenever I start putting the flowers together, I begin to feel so relaxed. I'm really lucky to have that balance.

What's your idea of luxury?

Going around the garden in the early morning in my nightie, and swimming in the nude.

Is there any piece of advice that has stuck with you?

I think it really is about self-belief, sticking to your guns and not doubting yourself.

Are there any design books you particularly love?

I buy a lot of them – I'm not totally digital. I still love a scrapbook – it means more to me than scrolling through Pinterest. I love Chester Jones' book, and also love Robert Kime's work. And Axel Vervoordt's, too.

What are your favourite holiday destinations?

We always spend summers at home near the coast in Hampshire and Christmas on Barbados. We've got lazy about going anywhere new – at least we know that when we go to Barbados everything is organised, so we can just plonk! I'd love to go to India again – I want to look at some designs and furniture – and I should go to the Far East as well.

Do you collect anything?

Many things, such as plates, and then they hang in a group. We also collected bowling shoes – so, peculiar things, which we then make into an art piece. I love using the tops of weather vanes, and door stops. I also collect French pottery – Cluny jugs.

What would you grab if there was a fire?

It's so difficult with so many memories, but I think I would take the wooden sculpted lion's head on the console in the green room. He has the friendliest face and the kindest eyes.

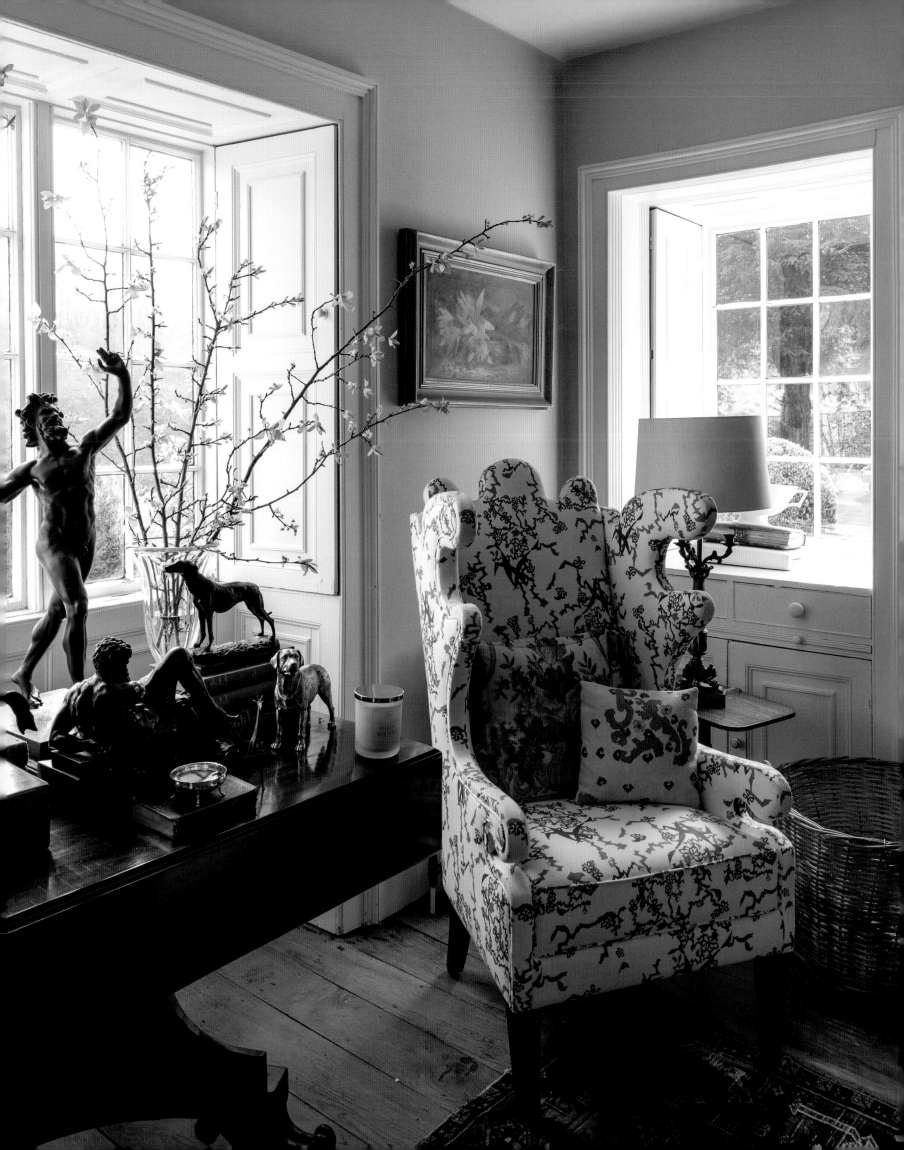

JUSTIN VAN BREDA

The importance and love of family is apparent throughout Justin van Breda and his husband Alastair Matchett's house in the southern Cotswolds. In the sitting room, a portrait of Alastair's mother hangs above the fireplace; a George III table in the bay window once belonged to Justin's father. The furniture in the main bedroom once sat in the home of Alastair's grandmother; and the chairs at the end of a bed in another room belonged to his mother.

A focused dose of family history can be found in the downstairs cloakroom, where the walls are hung with black and white photos of Justin and Alastair's parents and grandparents. There's also a framed British flag that Alastair waved at the Queen's Silver Jubilee in 1977. Even their yellow labradors are part of the story. 'Margot had her eight puppies in the cloakroom, and they lived in there for three months,' says Justin. 'Maudie, one of her puppies, is named after my grandmother.' And so, quite apart from the history of the house itself, there is a sense of layers, and of a narrative.

With such careful custodianship of their own heritage, it is unsurprising that the couple have been sensitive towards work carried out on the house, which Alastair has owned since 2000. In the hallway, among a host of paintings, hang the original parchment title deeds, dated 1636, and further title deeds can be found upstairs. In renovating the house, nothing was dramatically changed. 'A scullery was added behind the kitchen, and the laundry used to be the carriage house,' says Justin. 'We still have the original carriage – a Georgian trap – it's in the garage.'

The kitchen is Justin's favourite room: 'We have every meal in there.' When Alastair bought the property, the kitchen was elsewhere in the house. He created the new one out of six small rooms, including a coal store. A huge wooden cider press, original to the property and dated 1814, stands in a corner of the room, and the dresser, with the paintwork unchanged from the day it was built, is also original to the house. The scalloped shelving detail has been carried through to other rooms.

The sitting room has all its original features, including the fireplace, doors, windows and floors. Along with the family objects and Alastair's collection of bronzes are two pieces of furniture that Justin has designed – the Augustus wingback chair, sitting in the corner between the windows, and the Blythe sofa. 'The Georgians did a lot of crazy shapes; I went even crazier!' he says to explain their flamboyant forms. Both are upholstered in textiles from his first fabric collection – 'Pavilion Plasterwork' for the sofa and Burnt Summer 'Trailing Hawthorne' for the chair.

It's in the dining room, however, that Justin's design input is particularly apparent – not only are the table and sideboard from his collection, the room is papered in a print he devised. 'I adore Constable's *Wivenhoe Park* painting, so had it specially printed for here. I plotted the canvas, and manipulated it so that the mansion house was in the centre, to work across the three walls.' Alastair wasn't

Opposite. The Augustus chair by Justin van Breda, upholstered in his Burnt Summer 'Trailing Hawthorne' fabric, sits next to his father's George III table in a corner of the sitting room.

so keen on the idea of wallpaper, but made a concession for this room. He loves it now, as the scenic setting feels as if you are dining in the park.

Altogether there are seven bedrooms in the house, including the main one, which was once a series of tack rooms. The others are styled, to some degree – one is the Victorian room, another is the Chinese. Justin's favourite bedroom is the Africa room, which contains all his favourite things from South Africa, which is where he grew up.

As a child he had a yellow and white bedroom: 'It was the first colour choice I made,' he says. 'I remember moving my room around and pushing the bed up to the window and pulling the curtains over it to make a tent.'

After studying English and politics at university, and design in Cape Town, he took a gap year in London, having just enough money not to work for a month. 'I was very precocious and wrote to a whole lot of designers,' he says. Justin happened to approach Nicholas Haslam at exactly the right moment. 'He had just landed a huge job in Belgium, and knew it would be useful to have someone who could speak Flemish, which is so similar to Afrikaans.'

Justin's 'first real big job' with Nicholas Haslam was to work on a pop star's house. 'It was a baptism of fire, managing the curtain makers, specialist painters, tailors and furniture restorers,' he says. 'I spent three weeks commuting up and down, finishing off the installation. At the end of that year, Nicky offered me the job of creative director – I was 25 years old!'

After three years, Justin decided to branch out on his own, and opened a shop on Pimlico Road in 2002. The following year he launched his first furniture collection, which received an award at Decorex. Since then the line has expanded to include bespoke and customisable pieces. At the time of writing, he was being represented by eight showrooms in the States. 'My furniture takes references from design history, focusing on proportion, line and finish,' he says. 'What's fascinating to me is the different regional aesthetics – what they buy in New York is not what they buy in Atlanta or London.'

In 2015, Justin launched his first fabric collection, and has opened a space, The Fabric Room, adjacent to his furniture studio, where he sells his own textiles as well as those of a number of other designers, including two from South Africa.

He and Alastair live in London during the week, and go to the house in the Cotswolds for weekends. Even in the garden, their strong sense of family is apparent. A mound, which used to be a Georgian ice house, is covered in bulbs. 'When Alastair's mum died, we planted 1000 daffodils there,' says Justin. The couple's fathers both died within a short time of each other, and a friend gave them a pair of oak trees in memory of them.

What Justin loves most about the house, he says, 'is that nothing's too precious, it's just a working house'. He and Alastair are thinking of doing more to it, however. They have plans to build a Bannerman-esque, neo-classical, rough-hewn timber folly, using tree trunks as columns. 'We'll install a fireplace in there and watch the last rays of sunshine in the evenings.'

'MY FURNITURE TAKES REFERENCES FROM DESIGN HISTORY, FOCUSING ON PROPORTION, LINE AND FINISH. WHAT'S FASCINATING TO ME IS THE DIFFERENT REGIONAL AESTHETICS – WHAT THEY BUY IN NEW YORK IS NOT WHAT THEY BUY IN ATLANTA OR LONDON.'

Opposite. The dresser in the kitchen contains Justin's collection of teapots and Wedgwood.

Overleaf. Justin, with Margot and Maudie in the front garden, 'in search of weeds', according to the designer.

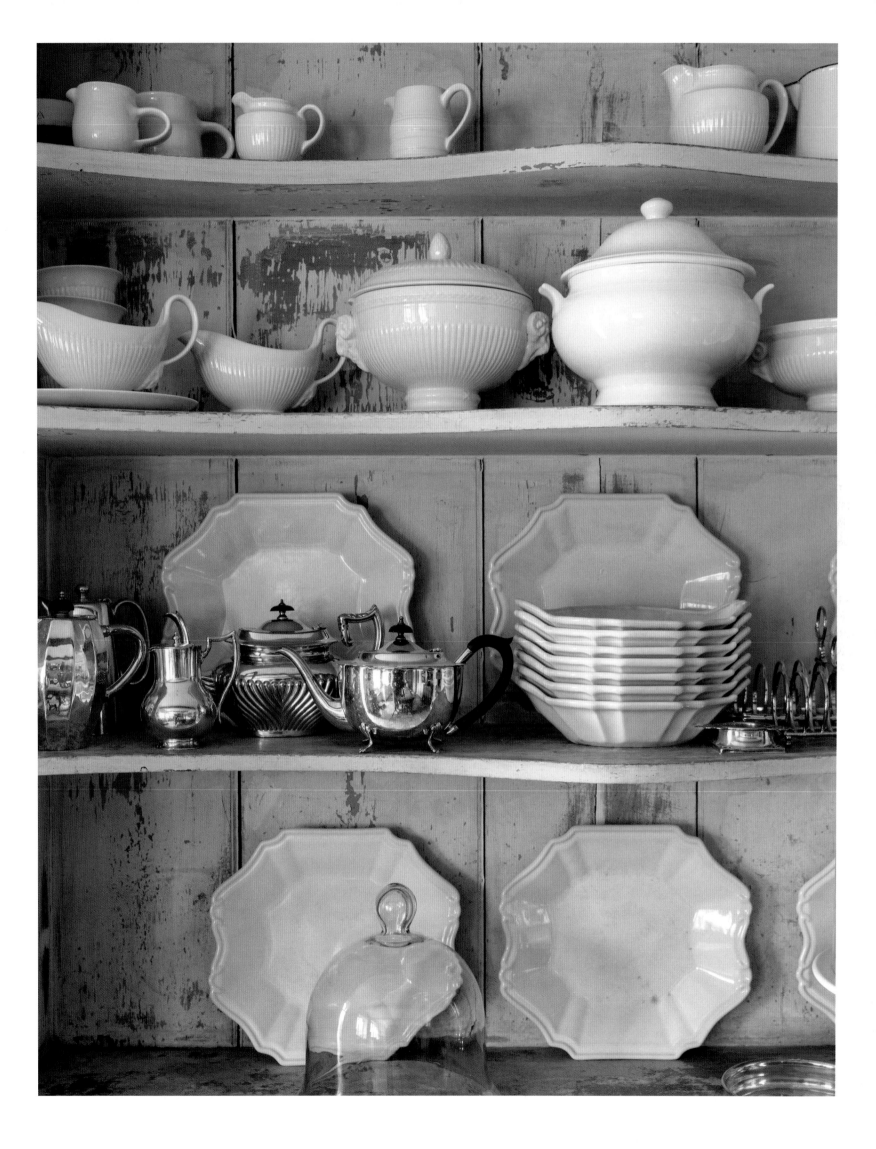

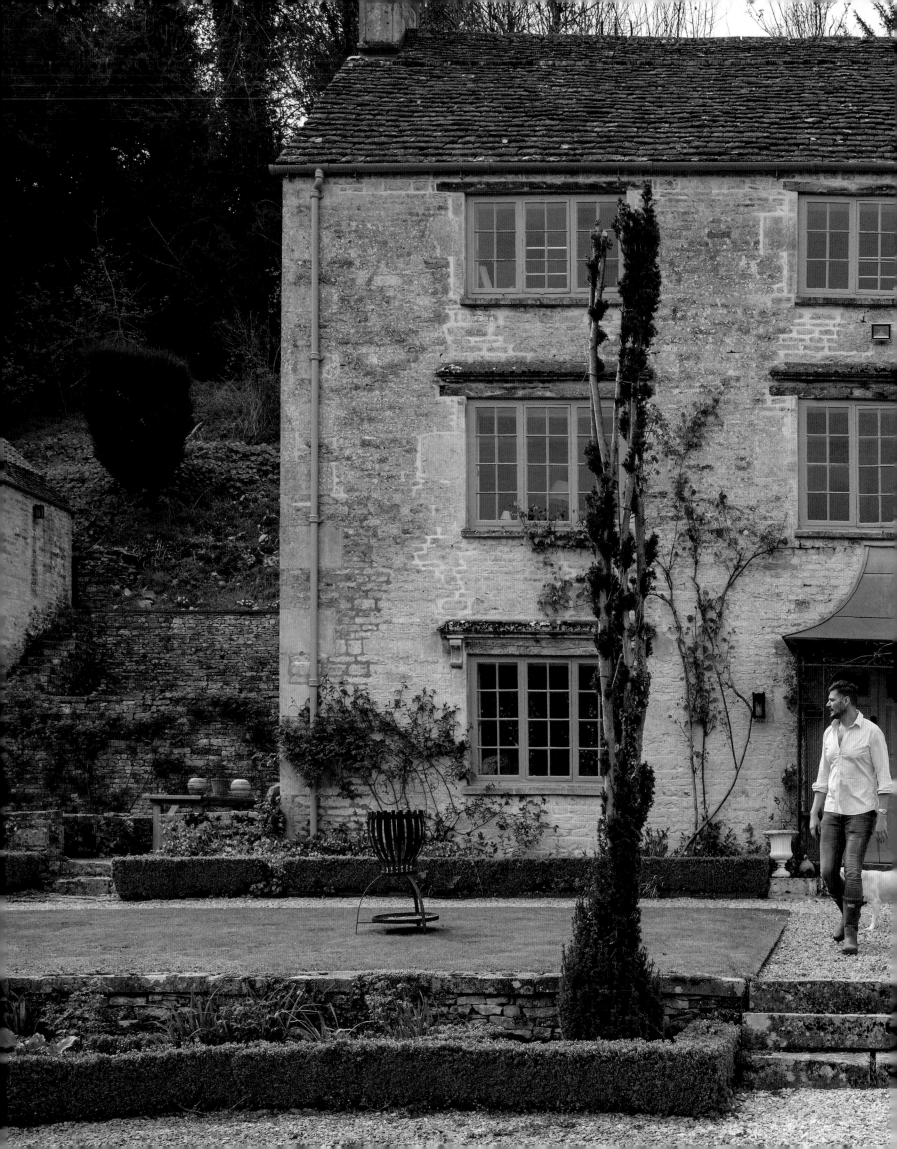

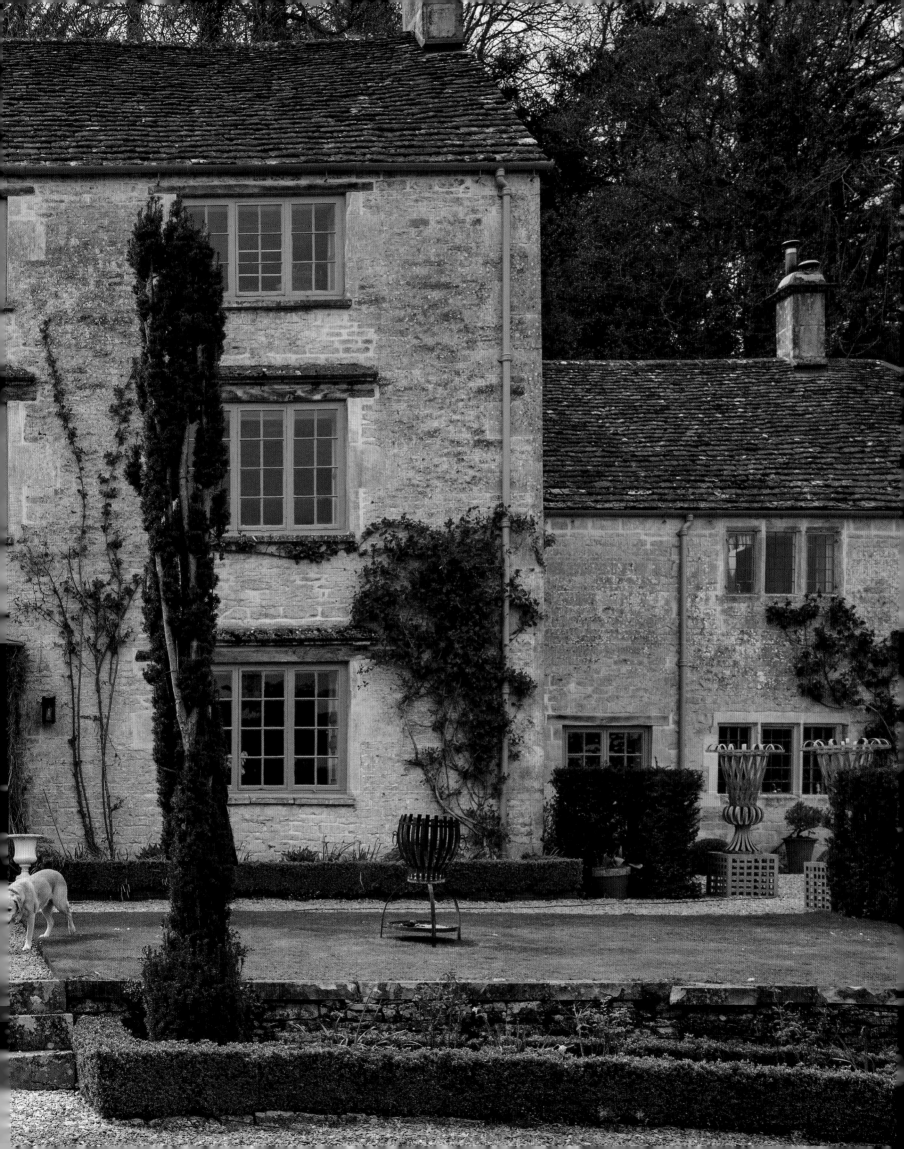

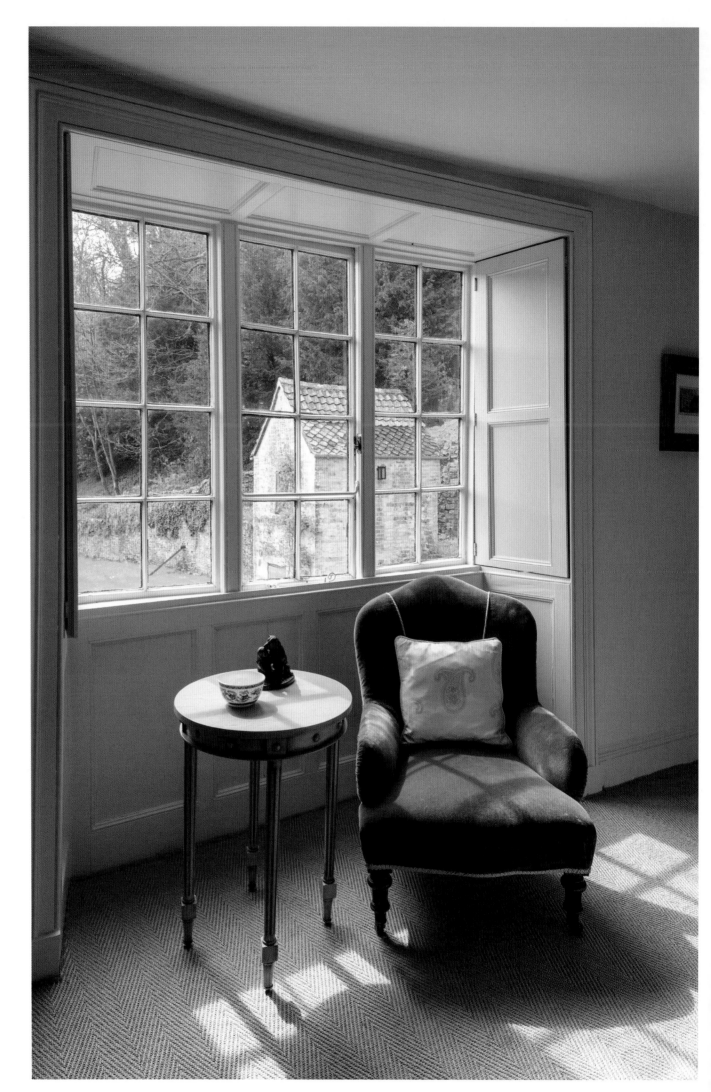

This page. The velvet chair in a guest bedroom used to belong to Alastair's mother. The limed oak Thomas coffee table is from Justin van Breda's collection. The summer house, outside the window, was built to house Roman archaeological finds.

Opposite, clockwise from top. A copy of Constable's *Wivenhoe Park, Essex*, a favourite painting of Justin's, covers three walls of the dining room; the mirrors and etchings behind his Blythe sofa are from Les Puces in Paris; photos of Justin and Alastair's families are an integral part of the cloakroom.

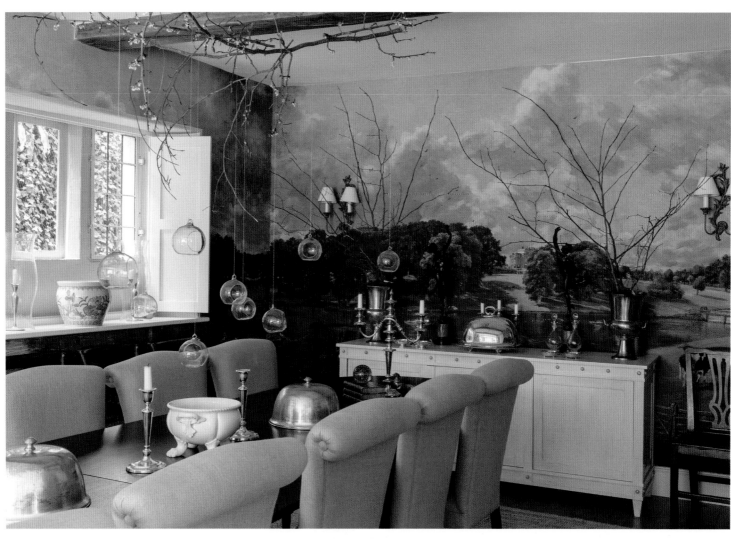

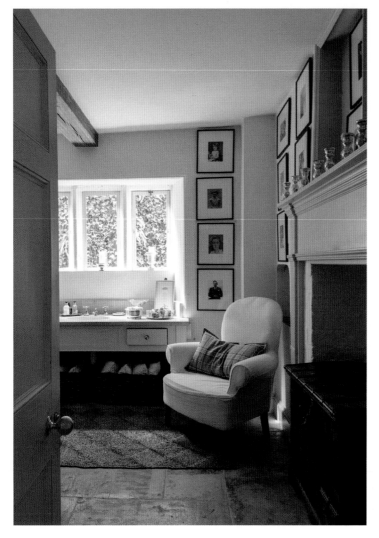

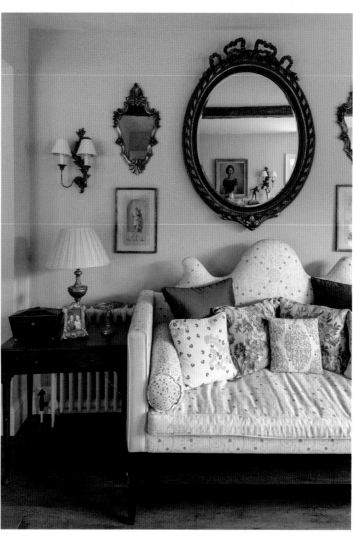

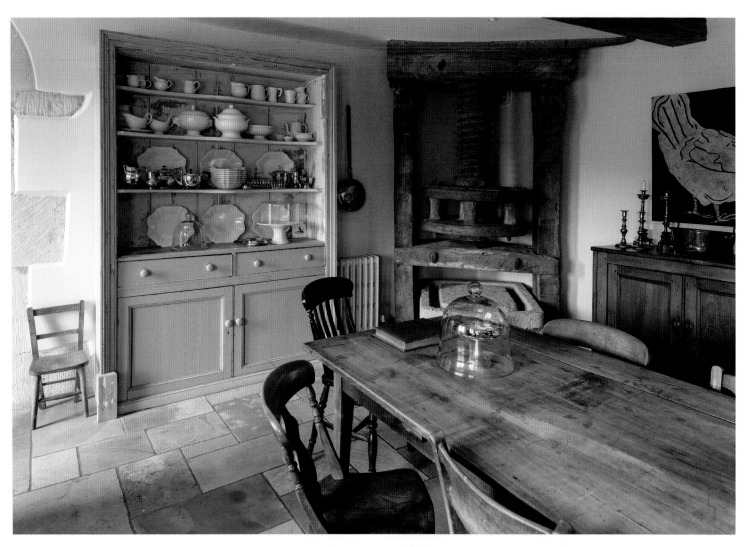

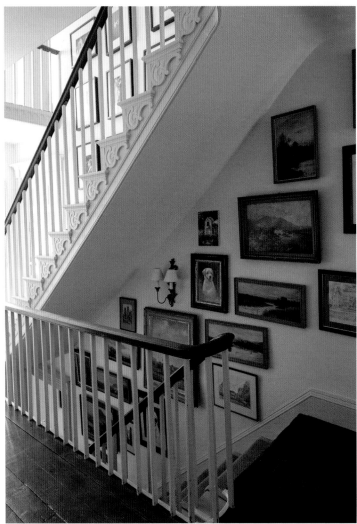

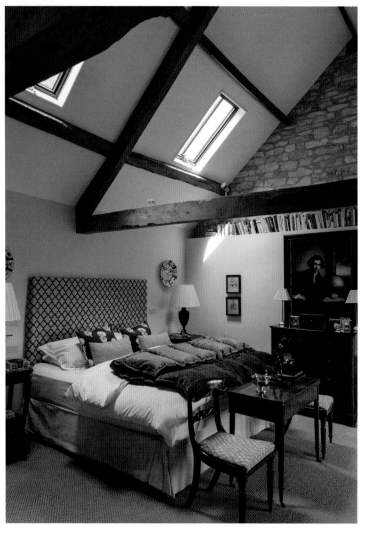

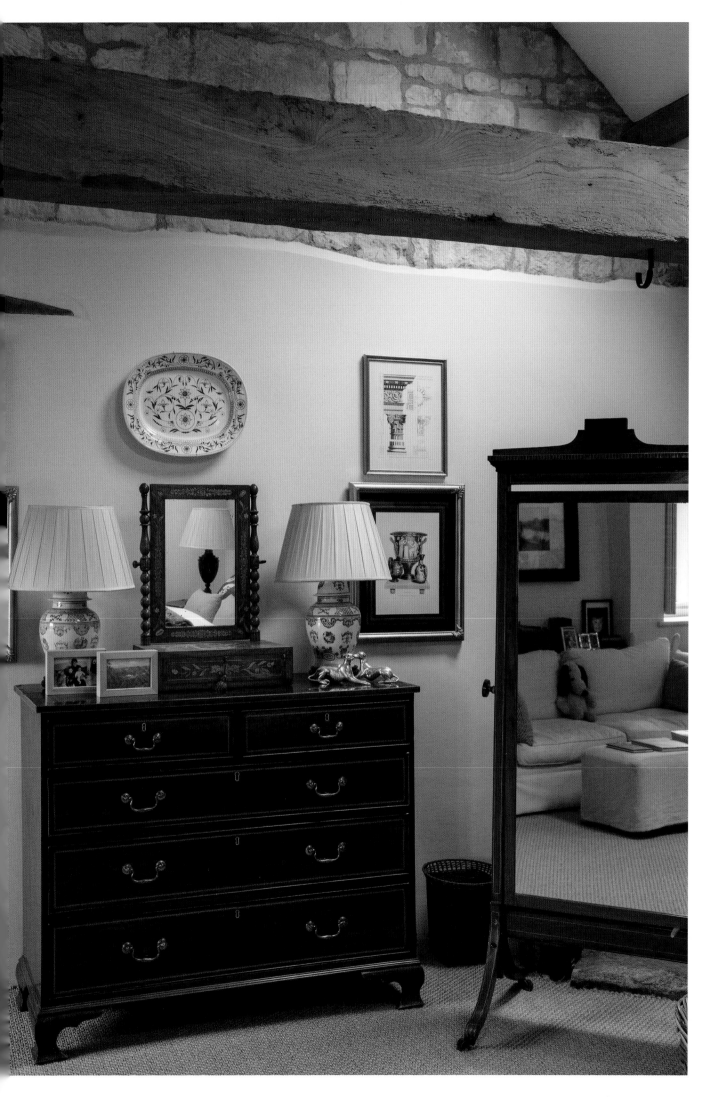

Opposite, clockwise from top. The dresser, original to the house, and the 1814 cider press are a feature of the kitchen; the chest of drawers in the main bedroom is one of the first pieces of furniture Justin ever bought – he painted it dusky pink before restoring it to 'a more grown-up French polish'; the stairway from the hallway up to the first floor is lined with an assortment of paintings, mainly of dogs and landscapes, that Justin and Alastair garnered from their parents' homes.

This page. A corner of the bedroom contains Alastair's grandmother's furniture, including a cheval mirror. On the walls are architectural engravings and blue and white Danish china. Completing the scene are Chinese export lamps.

221

Q&A

What does home mean to you?

A day with people, food and laughter! It's very much about a feeling. And living with things around you that tell a story.

Who has been your mentor?

Nicky Haslam, without question. Even today, when I work out the layout for a room, I revert back to what he taught me. Working with him was a very special time in my life.

Do you find yourself wanting to change things constantly?

Yes, but I restrain myself as Alastair likes home to remain constant.

How do you relax?

I sleep very well, and on weekends I garden. I look after the kitchen garden and the rose garden. My father taught me how to prune roses. When we got married, I asked for no wedding gifts except for David Austin roses, which became the circular rose garden on the terrace where we were married.

Flowers or foliage?

Both. I bring flowers into the house, and never buy anything, so whatever is in the garden. I love a seasonal garden frond. At Easter, the whole house is full of daffodils; in winter it is filled with grasses and rosehips.

What's your favourite season?

I love winter. The English countryside in June is spectacular, but I came here for the first time in November, and woke up in the morning and the whole valley was covered in snow.

Do you like reading?

I'm an avid reader, and have recently begun listening to books while I'm driving – I'm now listening to all the Wilbur Smith novels that take me right back to Africa, *Chanel's Riviera* by Anne de Courcy and Anne Glenconner's hilarious and poignant *Lady in Waiting*. I also love historical biographies.

Do you collect anything in particular?

I love Wedgwood, silver candlesticks, teapots and rose bowls.

Do you like entertaining?

We entertain a lot – in London, and here over the weekends. I love having people to our home. In the country, it's kitchen suppers mostly, and the odd more formal dinner – I love a tablescape filled with bronzes, flowers, silver and books. In the summer we eat outside as much as we can, pretending we're in France!

If there was a fire, what would you grab?

Alastair and the dogs.

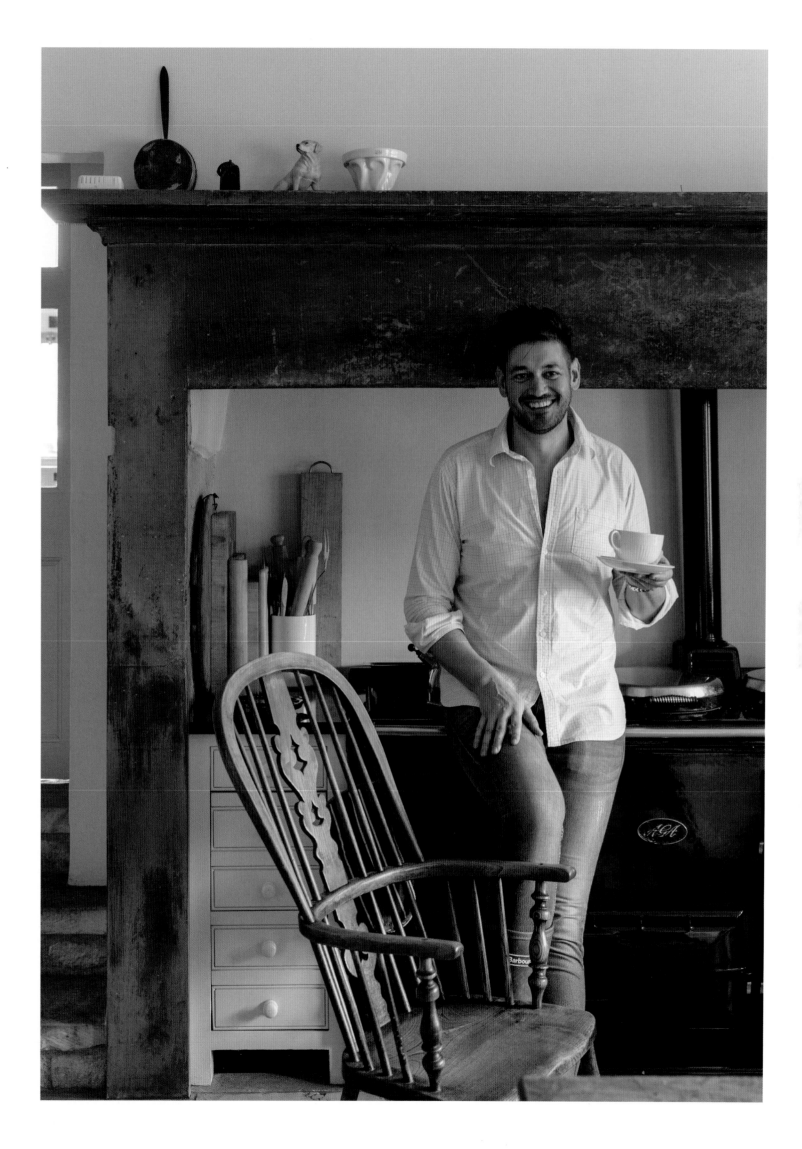

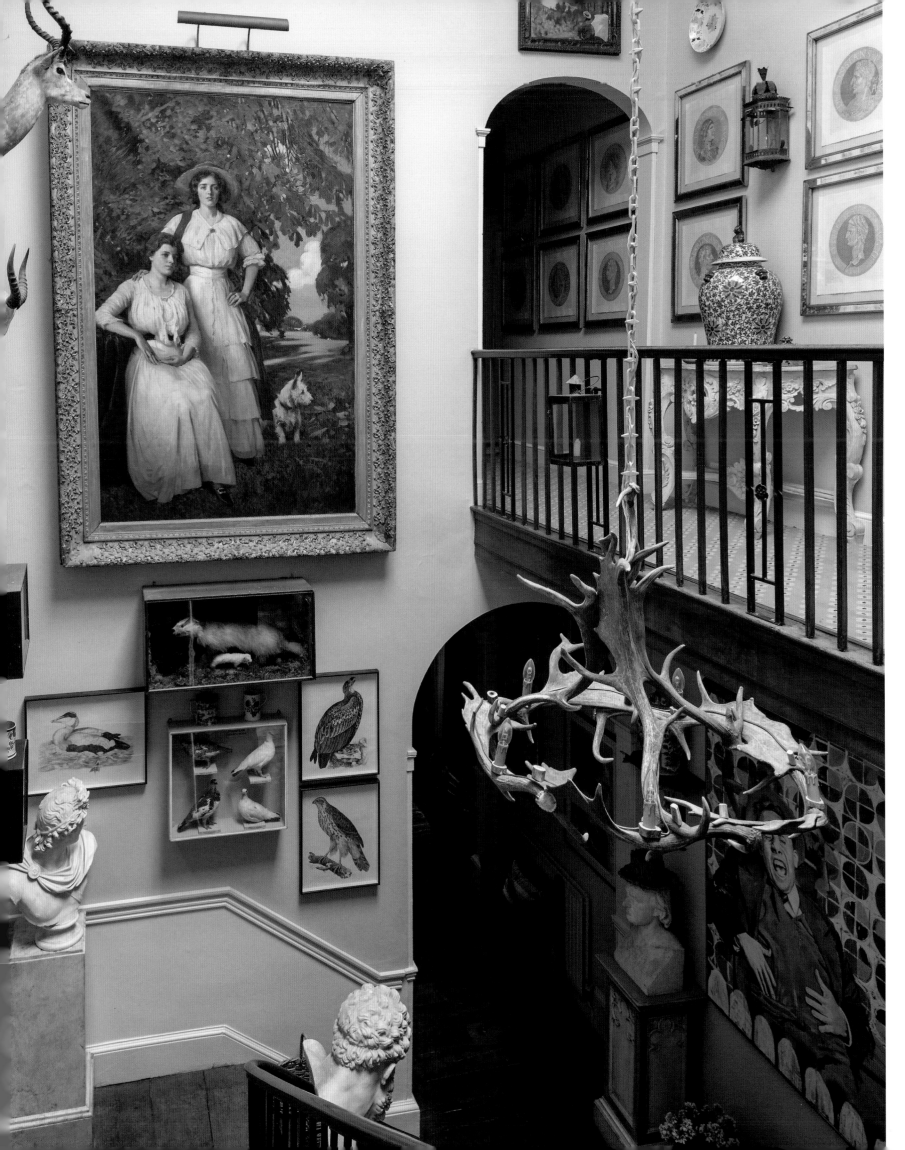

PENNY MORRISON

T here's a fearlessness to Penny Morrison, and it's apparent in her life story. Until she moved to an 18th-century house in Wales 30 years ago, she had never lived anywhere for more than two years in her adult life. Born and raised in South Africa, she arrived in London as a young woman with her three-year-old daughter, Sarah, and no particular plans. 'I had no money, either.' During those early years in the UK, she was a 'jack of all trades, cooking directors' lunches, selling houses and doing all sorts of things'. In the 1980s, she spent a couple of years in the States, again living on her wits.

When Penny returned to London, she met her husband, art dealer Guy Morrison, at a wedding, and the pair eventually got together. 'I then started buying property in London and selling it on,' she says. 'That's where I learnt about decorating. I've never worked for anyone; I'm completely self-taught.'

Penny and Guy got married in 1988 and, at the time, were living in a rented farmhouse in Leicestershire. They were looking to buy something in the country for themselves and, while staying with friends for the weekend, came across what is now their house in Wales. 'It was in *Country Life*, and looked like a Scottish hunting lodge,' says Penny. 'We all drove over in three or four carloads, and it was literally falling to pieces, with plants growing through the roof and radiators falling off the walls. It hadn't been touched since 1900, and had only ever been lived in by three families. I fell in love with it.'

It took about a year to do up – during which time their son Ted, who now works with Penny, was born. The house was full of dry rot; as well as replacing floors and other damaged timbers, the couple had the house completely rewired, and installed a new roof and new windows. They raised the ceiling above the stairwell in the hall and put in a huge skylight, and added fireplaces to some of the rooms. 'I wanted to keep it feeling like an old Scottish hunting lodge,' she says. 'When we moved in, we had very little and it has evolved over the years, with me being a sort of manic junk-shopper and Guy an art dealer. We've just filled it up – there's not another inch left for pictures!'

Penny's way of working is often unconventional, or 'untrained and very erratic', as she describes it. 'Everything I do is in my head. I just drew the bookcases on the wall with pencil, and got a local man to build them,' she says. 'In this area, there is always someone who can make something.'

This is a house that's so very much part of its setting, which is clear even from inside. 'I always wanted a house where you would walk through the front door and see through to the garden,' says the designer. Set in 150 acres of land, the landscape is Guy's responsibility, while the garden is Penny's. A few years ago, they 'gave each other a greenhouse', specifically so she could grow plants and flowers for the house.

The hallway immediately creates the impression of a hunting lodge, with its walls hung with trophies, along with taxidermied creatures in box frames. 'Quite

a few of the trophies were already here, and Guy and I have added to them over the years,' says Penny. It's true that, even here, there's scarcely a bare spot on the walls, with antique plates jostling for space with a variety of artworks, ranging from the traditional to the contemporary. Classical busts, a couple wearing jaunty hats, sit on pedestals – nothing is taken too seriously.

The drawing room, as is true for the rest of the house, is also crammed with artworks, many of them large in scale. 'You really need big pictures and big bits of furniture to make a room look good – there is nothing I loathe more than a room with pictures the size of postage stamps. The walls have to be covered in a relaxed way,' says Penny.

Her approach to decorating in general is anything but stitched up. When an ottoman in the room needed recovering, 'I just flung a piece of fabric I love over it – it makes the whole room look more relaxed,' she says. The curtains were made up of green and coffee taffetas that are sewn together. The dining room floors, riddled with dry rot, were replaced with plywood, 'which we had painted to look like a floor. It was all mend and make do.'

One of the most intimate rooms in the house is the morning room, created from what was once the laundry. Penny installed the scallop-topped shelves and fireplace, and painted them, and also the heaters and mirror frame above the mantelpiece, the same colour as the walls. 'I love everything painted in the same colour – it makes the room look more cohesive.'

The library, painted bright turquoise, is Penny's favourite room. Antique Turkish fabrics used on cushions complement the linen curtains from her own label. In some of the bedrooms, she has again used her own fabric and wallpaper, often mixed with vintage textiles. As with much of her career, designing fabrics came about quite unexpectedly. 'I was doing a hotel in St Barth's in 2006, and I struggled to find the right fabrics, so I thought I'd start making my own. I was lucky it worked, because I knew nothing about fabrics when I started.'

She has had a lifelong interest in design. 'Our houses always looked beautiful – my mother would make curtains out of dress fabrics, so I was brought up like that. I'm always on the lookout for something that catches my eye, and might then decide to incorporate it into a new fabric design.'

Penny's accessories range includes lamps and shades, tableware and vases. Her fabric business is based at her property in Wales, while her shop is on Langton Street in London. Her clients include some high-profile names, who often commission her to do several houses, both in the UK and internationally.

For someone who used to move constantly, Penny seems remarkably settled in Wales. Every time she goes away and comes back, 'Guy has rearranged the furniture and rehung the pictures.' He has plans to build a granny flat in the stables, she says, 'but I don't want to. I said it would have to be a grandpa flat! I'm happy with everything as it is.'

'IT WAS LITERALLY FALLING TO PIECES, WITH PLANTS GROWING THROUGH THE ROOF AND RADIATORS FALLING OFF THE WALLS. IT HADN'T BEEN TOUCHED SINCE 1900, AND HAD ONLY EVER BEEN LIVED IN BY THREE FAMILIES. I FELL IN LOVE WITH IT.'

Opposite. A portrait of a mother and children by the Scottish painter Robert Brough hangs above Penny's collection of blue and white china in the drawing room. The sofa is covered in Jean Monro 'Hydrangea & Rose'.

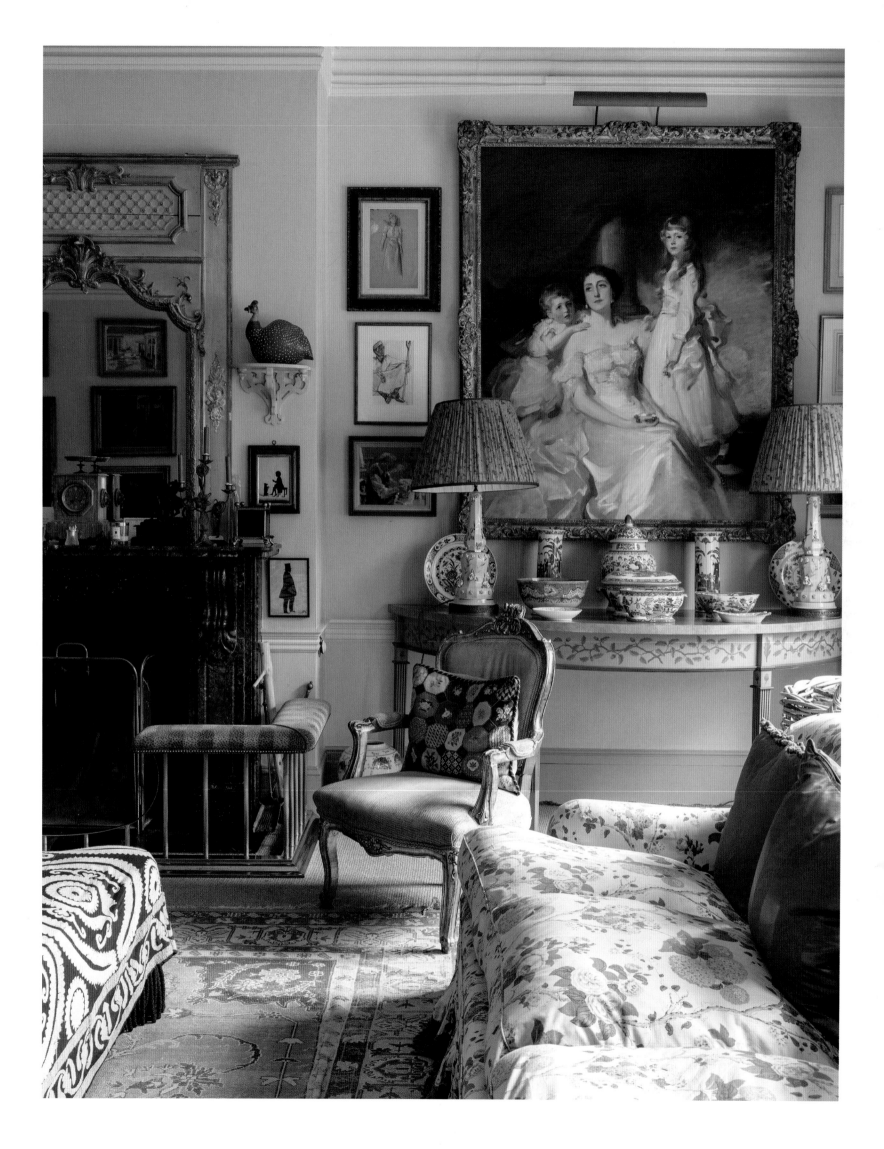

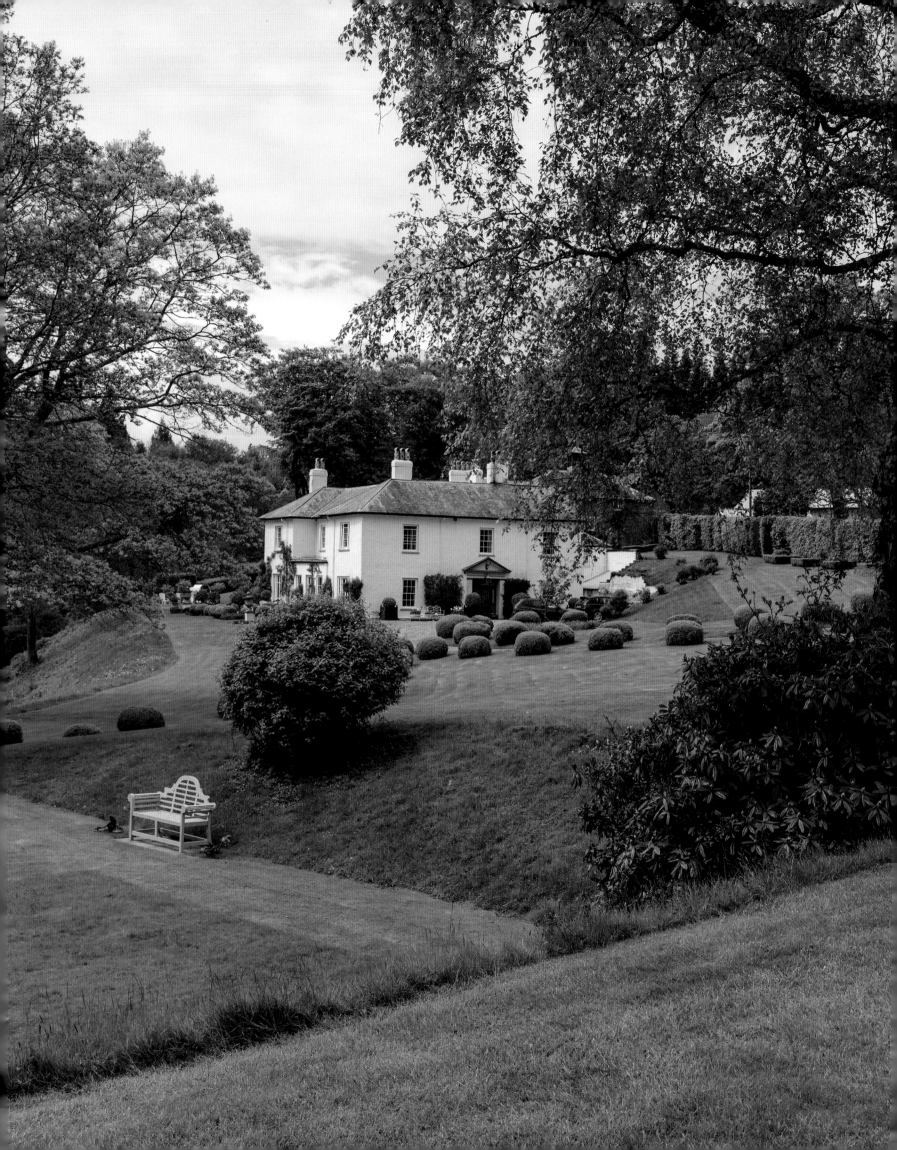

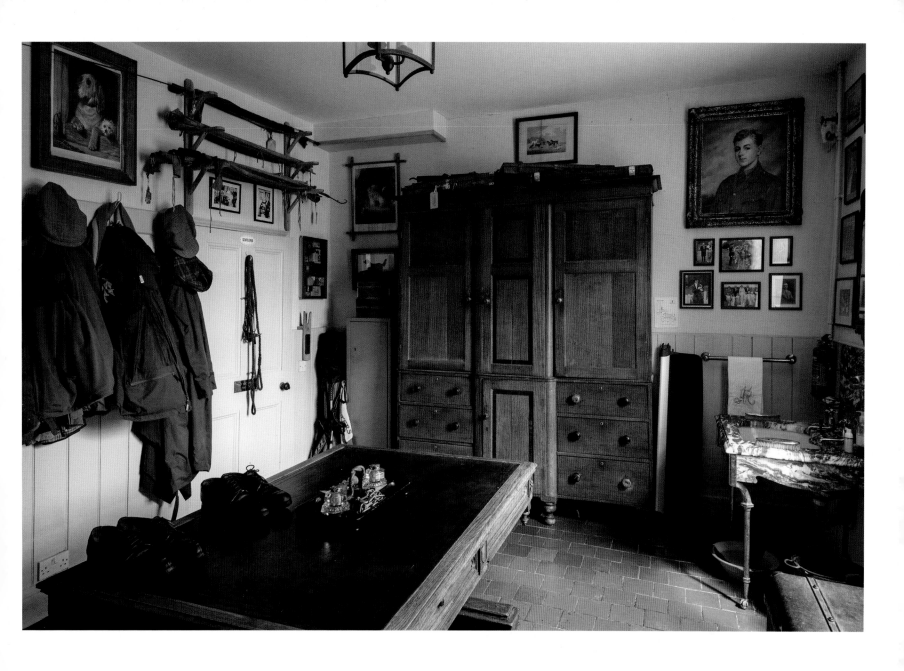

Opposite. When Penny first saw the house in Wales she thought it looked like a Scottish hunting lodge.

This page. A posthumous portrait of Penny's great uncle is a dominant feature of the utility room. The cupboard came from a local auction house, and the marble basin from a reclamation yard in Hereford.

Overleaf. The walls of the well-used library are hung with a selection of 19th-century watercolours by Thorburn, Lodge, Wallace and Harrison. Penny Morrison 'Arabella' fabric is used for the curtains, 'Blue Stripe' for the armchairs and the ottoman is covered in a kente cloth.

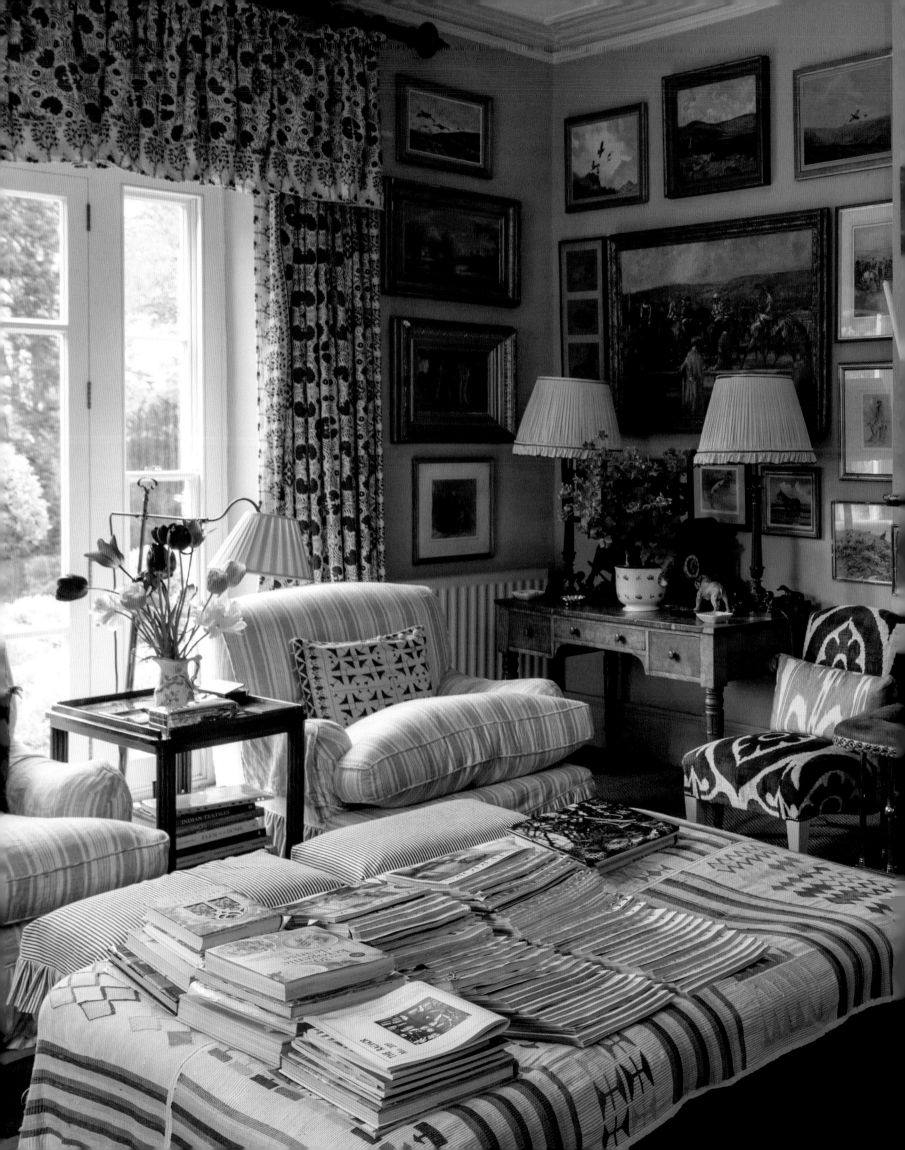

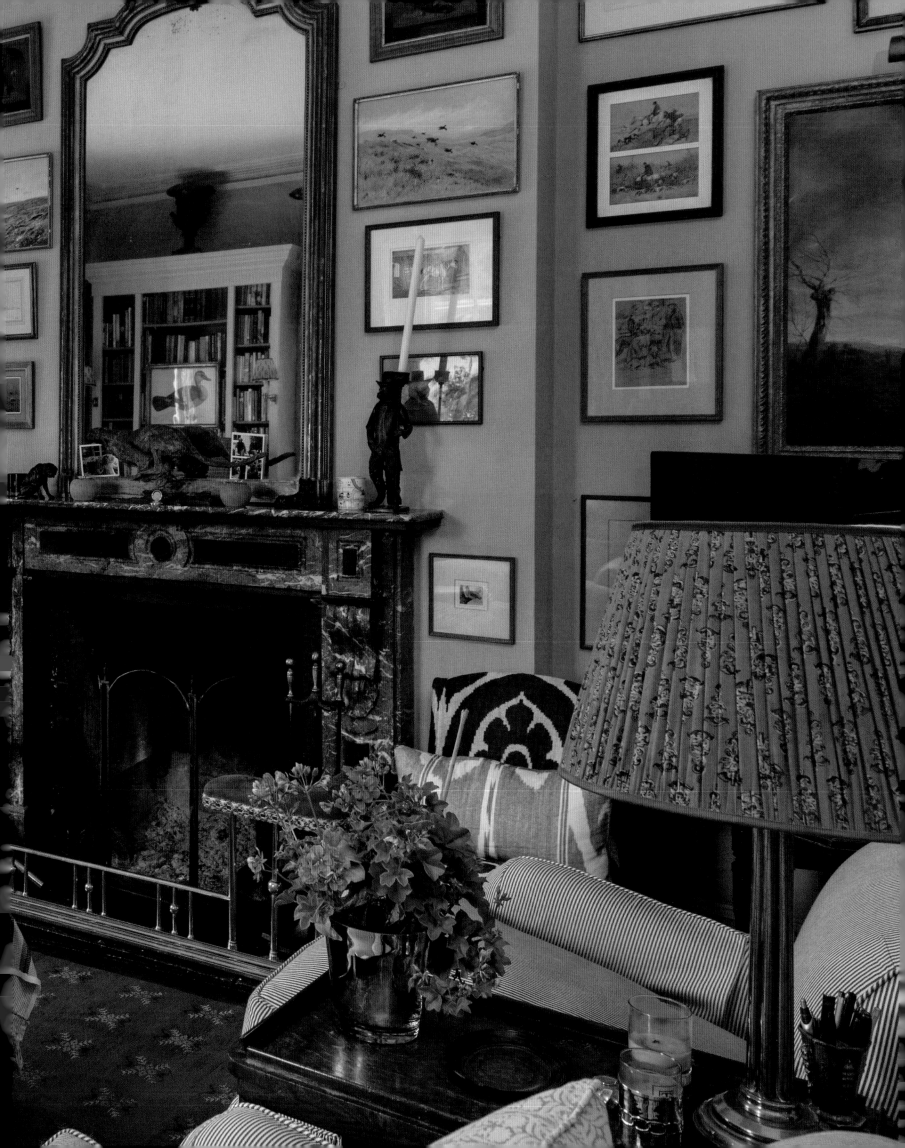

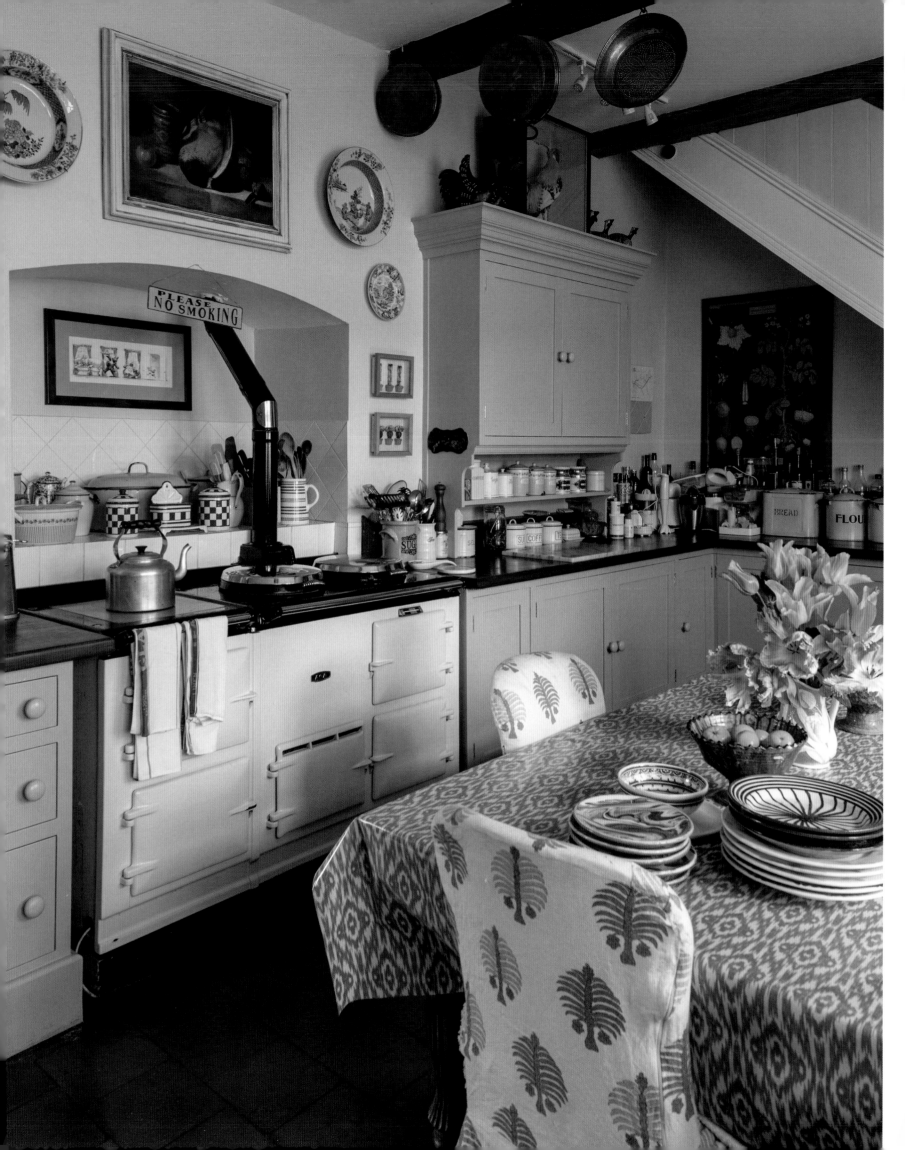

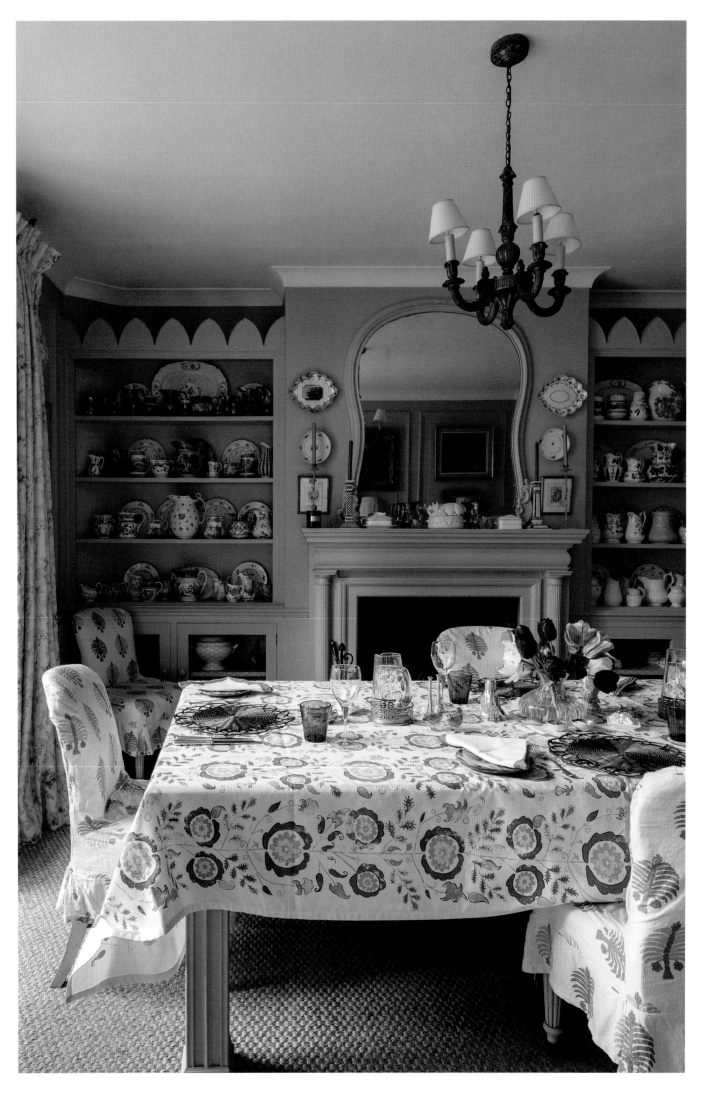

Opposite. Penny Morrison 'Gobi' was used for the loose covers on the chairs in the kitchen, as well as those in the morning room. The plates on the table are from Penny's accessories collection.

This page. The morning room used to be the laundry. Penny installed the shelves and fireplace, painting everything the same colour to make it look cohesive. The tablecloth is in her 'Simla' fabric.

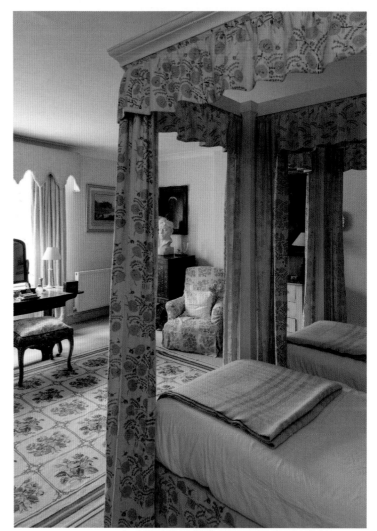
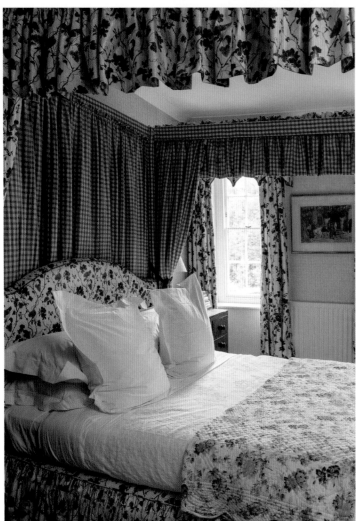
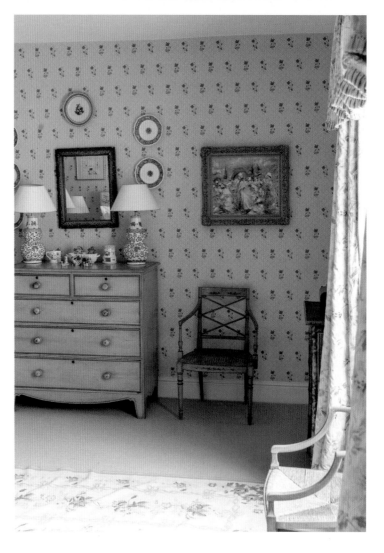

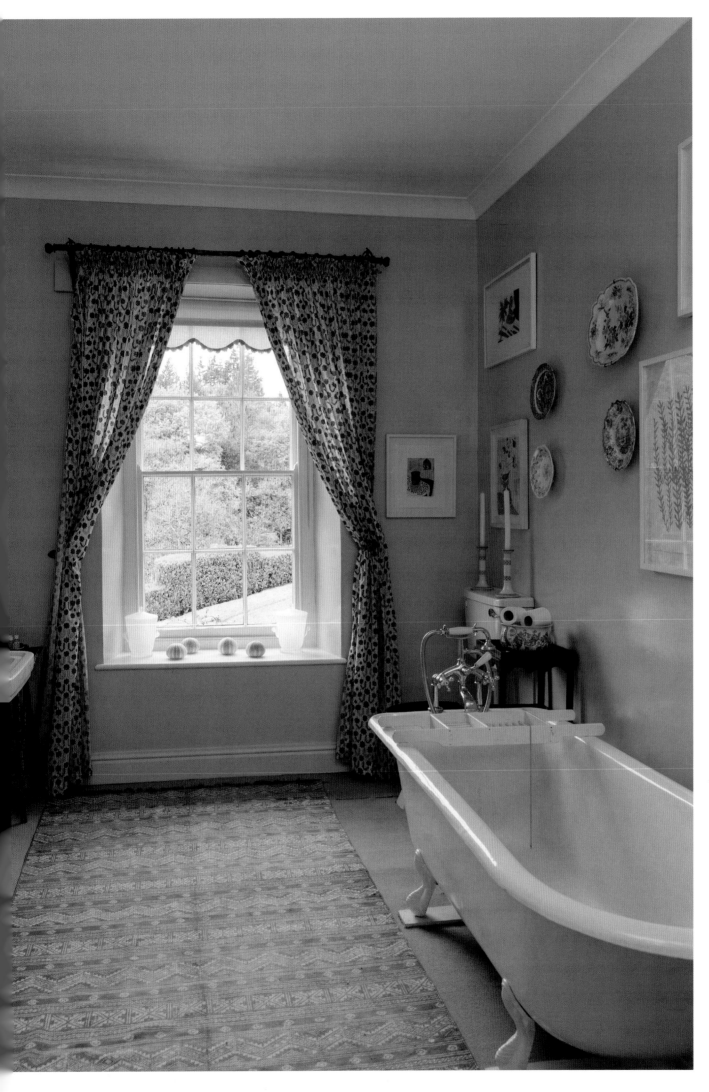

Opposite, clockwise from top left. A striped wallpaper, now discontinued, by Nina Campbell is used in an upstairs hallway; a large rug by Vaughan Designs complements Penny Morrison's 'Pasha Adam Linen' used for bed curtains and chair; painted furniture and blue and white porcelain is used to effect in one of the bedrooms; Penny used a favourite fabric, 'Climbing Geranium' by Colefax and Fowler, now discontinued, for the bed curtains, and lined them in gingham.

This page. A bathroom, with original cast iron bath, features a pair of old French cotton curtains, bought at a flea market and hung on a faux bamboo pole. Penny had the rug made in India.

235

Q&A

What's your idea of home?

It's a feeling of being happy and secure and cosy in your own space. Cats, dogs and a fire, and not having to do or be everywhere or with everyone.

How would you describe your aesthetic?

Eclectic – all about things telling a story. I love old and new and surprising things. I have always had a fascination with old textiles – and colour. I believe every house has to have furniture where you can put your feet up and have a snooze. I don't like things that look too perfect.

What can't you live without?

Jugs of garden flowers.

How do you relax?

By sitting in my favourite chair in the library. I love well-written fiction – Michael Ondaatje, Scandinavian novels such as *The Girl with the Dragon Tattoo*.

What's your idea of luxury?

Going on a private jet or sleeping in my own bed! The only reason I'd like to be very rich is to have our own jet – I loathe airports.

Who are you inspired by?

Geoffrey Bennison – he just had the comfortable old country house look, where you would get lost in the feeling of it, mixing the old with the new.

The best advice you've been given?

When in doubt, overscale.

What would you be if you weren't an interior designer?

Probably an events planner, or a party planner.

Do you have any favourite design books?

One Man's Folly: The Exceptional Houses of Furlow Gatewood, and Bunny Williams' *An Affair with a House*.

What would you grab if there was a fire?

My dogs, and pictures of my children – past photographs are irreplaceable.

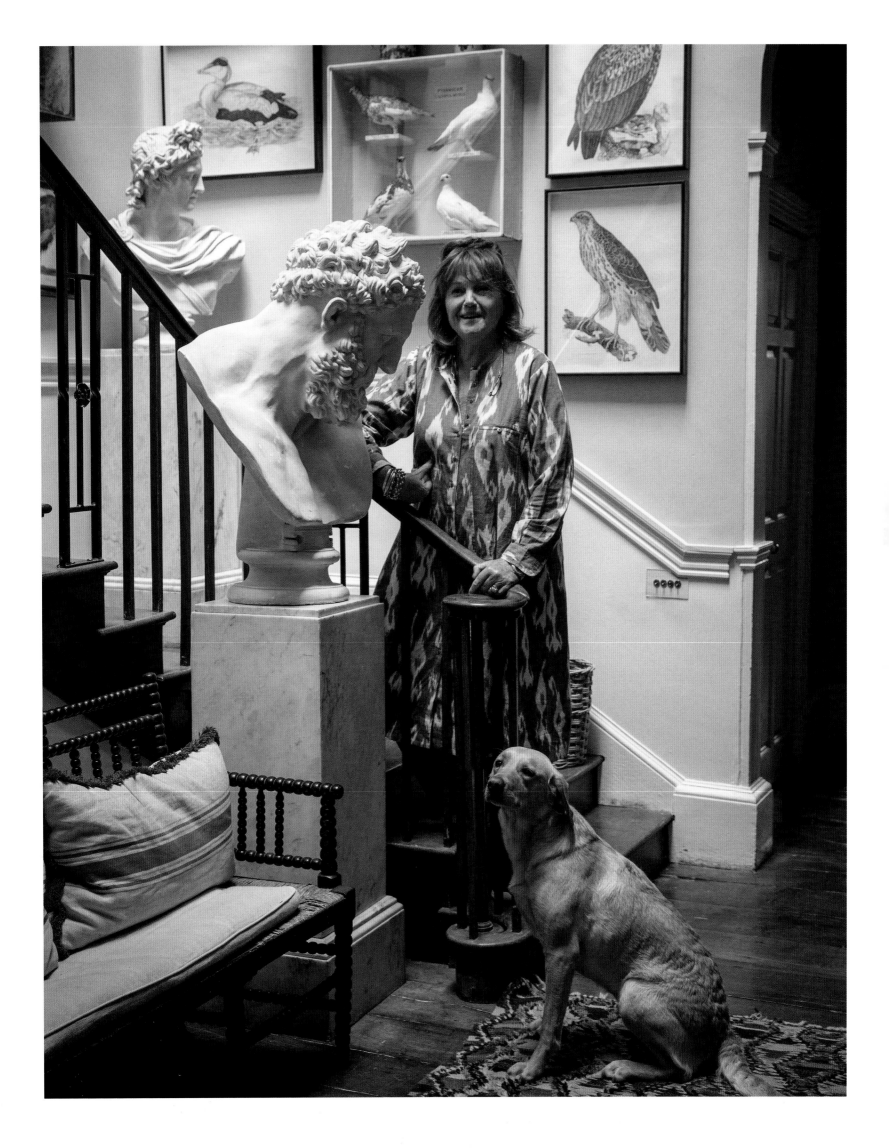

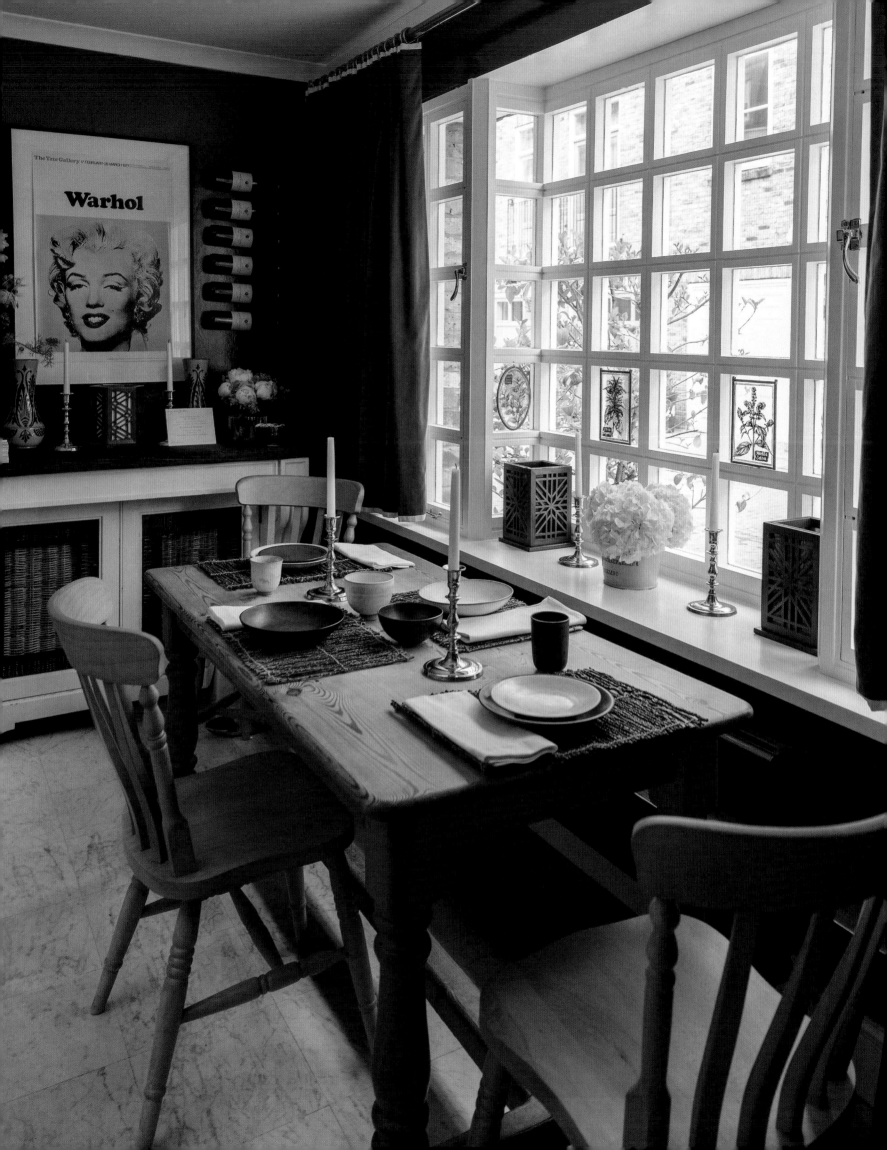

GUY OLIVER

Guy Oliver's favourite design projects involve yachts. It's the limitations of the space, and the problem-solving, he particularly likes. 'Every single inch has to be bespoke, and I love the challenge of that, so it all fits together like a jigsaw puzzle,' he says. The mews house where he lives in central London is compact in form, and his love of the sea, as well as his own maritime story, is plainly evident.

There's the model of a yacht sitting in the porthole window, the cabin-like proportions of his bedroom, and the painting of a sailing ship – *The Thermopylae Leaving Foochow* by Montague Dawson – above the sofa in the living room. 'It used to hang in my bedroom when I was a child,' says Guy, 'and is probably the reason I joined the Royal Navy.'

He enlisted as an officer cadet at 16, and it was one way of seeing the world. After two years, the navy sent him to the University of Edinburgh to study geography and cartography, but he realised he was drawn to other pursuits, and took courses in the history of architecture, art and design, at the same time working leave periods at sea in different parts of the world.

As a child, he spent a lot of time in museums, studied books on the decorative arts, and loved to draw as well as sketch out plans and layouts. 'My mother had an antiques business, and she was always buying and selling,' he says. 'I would go to the markets with her, and got into that. I learnt from an early age that if I bought a spoon from the rummage bin, I could research the hallmark, polish it up and sell it on for a bit more.'

'Aberdeenshire was always a constant in my life, and what I would regard as "home",' says Guy, though his parents moved every 18 months or so. His father was in the police force – each time he was promoted, the family would have to live in different parts of the country.

Guy's first job after university was with interior designer Sylvia Lawson Johnston in Aberdeenshire. He then went on to work at Colefax and Fowler under Imogen Taylor, before continuing his studies at the Prince of Wales's Institute of Architecture. To support himself while on the course, Guy went freelance, and picked up projects with the likes of Paul Dyson, designing exhibitions and events. He eventually met David Laws, who was responsible for the interiors of the state rooms at 10 Downing Street for Margaret Thatcher, and was looking for someone to take over his business when he retired. For seven years, the pair ran the business together until Guy eventually took it on alone.

Since then, his portfolio has built to include high-profile projects – the redesign of London's Connaught hotel and the award-winning upgrade of Claridge's – as well as exhibition and event design at the Louvre and Versailles, residential interiors, shops, clubs, restaurants, private aircraft and yachts. He also acted as a consultant to the US hotelier André Balazs. At the time of writing, his projects included

Opposite. The walnut and cobalt glass lantern on the kitchen windowsill was designed by Guy for Turquoise Mountain Foundation, a charity focused on preserving and reviving the culture and traditional crafts of countries such as Afghanistan. Painted glass panels of herbs hanging in the window are by Helen Whittaker.

a Grade 1 listed house, a hotel in Florence, a large yacht and an ongoing job in Ireland. 'There are six people in the office, plus I have freelance draftsmen and others who work on gathering and sourcing samples and furniture,' he says. 'We work alongside project architects, which enables us to "punch above our weight". We are a small team doing big jobs.'

Philanthropy has always been an important part of Guy's working life – while he supports many initiatives in the UK, he has also been heavily involved in the Turquoise Mountain Foundation, an initiative by the Prince of Wales to revive traditional crafts, which started in Afghanistan. Guy integrated this craftsmanship into a special suite at The Connaught.

Some of the craftsmanship is also on display in his home – sitting on the windowsill in the kitchen are two blue glass lanterns he designed and had made in Kabul. 'I still go to Afghanistan frequently,' he says. 'I've been there 20 times.' And hanging above those lanterns, against the window, are hand-painted glass squares he commissioned for a Jo Malone perfume launch.

The mews house is full of an eclectic mix of furniture and pieces Guy has picked up on his travels, or ones that have special meaning for him. A case in point – a bowl of 'eggs' in the living room come from Zimbabwe, where his parents spend half the year. 'My mother would give me a stone egg each Easter,' he says. Sitting on a chest of drawers is a wooden Japanese temple, which he bought with money his mother had given him for his birthday. 'I was in Japan doing an installation and found it in a flea market.' Working in Russia, he bought a number of Soviet porcelain pieces – busts of Lenin and Stalin sit on the kitchen shelf. 'I always thought it was ironic that when I was in the navy, we would track Soviet warships, and then literally five years later, I was sitting in the Kremlin discussing decoration.'

During the time that Guy has lived in the mews, he has had to do very little to the bones of the place. The kitchen is 30 years old, 'and it's in amazingly good nick. I painted the walls a deep blue.' Apart from that, 'the floors and the carpet runner up the stairs are new. There used to be a Sixties fireplace halfway up the wall in the sitting room, which was incongruous, so I replaced it with the marble one.' Here and there, there are surprising elements, such as the caricatures from the 1920s by Mexican Miguel Covarrubias set into the back of the front door.

There are still things to do, but Guy is in no hurry. 'The carpenter's door is always broken,' he says. This is where he retreats from an exceptionally hectic life, and he cannot imagine moving. 'It's central and it's quiet, and it is unusual to find sanctuary like that in London.'

'I LEARNT FROM AN EARLY AGE THAT IF I BOUGHT A SPOON FROM THE RUMMAGE BIN, I COULD RESEARCH THE HALLMARK, POLISH IT UP AND SELL IT ON FOR A BIT MORE.'

Opposite. An 18th-century portrait of a Levantine merchant hangs above the mantelpiece in the sitting room. Flanking the fireplace are black lacquer Chinoiserie cabinets, with watercolour studies above of The Frick Collection in New York by artist and friend Alexander Creswell. The artworks date from a period when Guy lived in Manhattan.

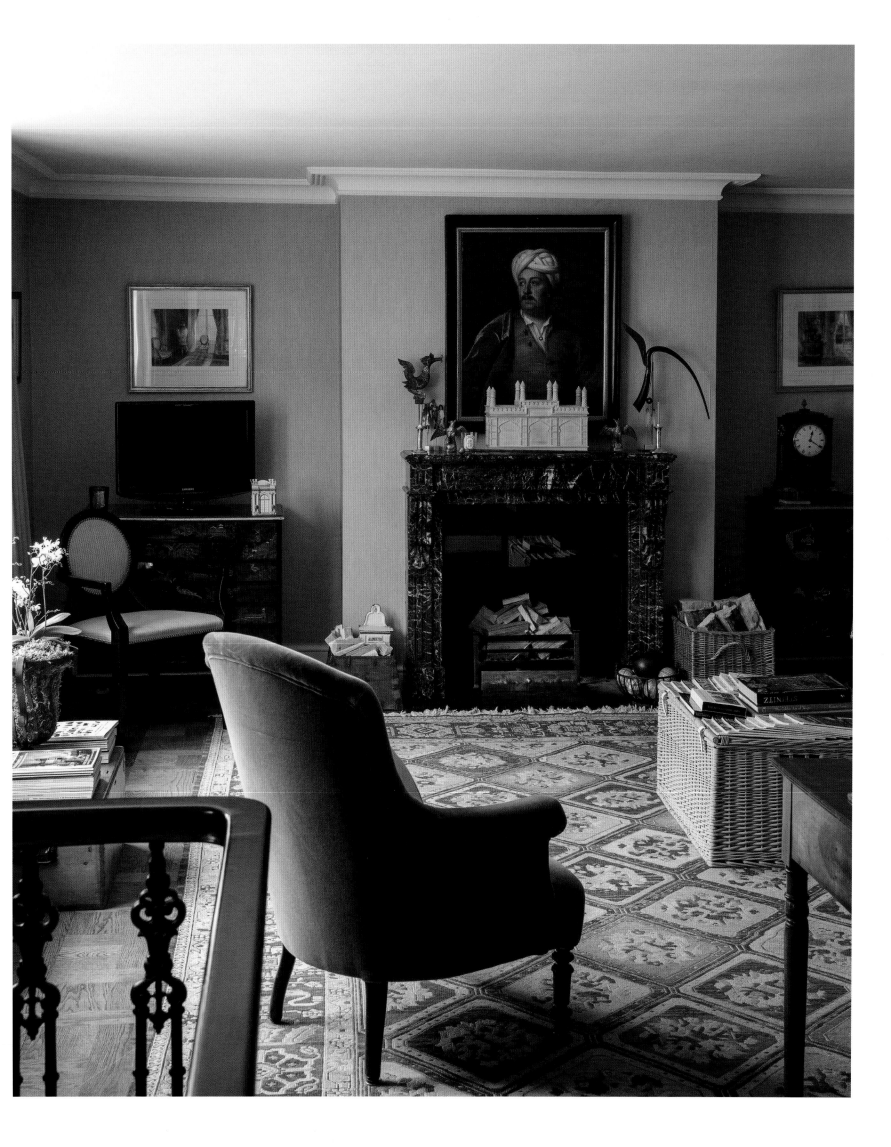

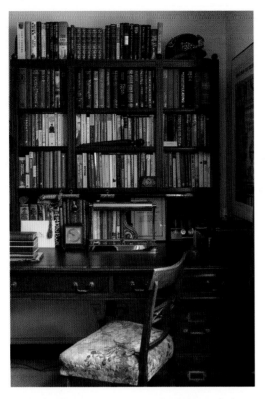

This page, clockwise from top left. Guy's naval sword is suspended in front of the bookshelves in his study; caricatures by Miguel Covarrubias are set into panels in the front door; an Arabic ghutrah from Jeddah is used for the tablecloth in the sitting room; a cushion by Fine Cell Work sits on an antique chair covered in cornflower blue mohair velvet; the 1930s pond yacht was a gift to Guy from his grandfather; a life study by Lucian Freud is juxtaposed against a glass bowl by Marianne Buus, which sits on a lacquered cabinet designed by Guy.

Opposite. An antique temple, bought by Guy on a working trip to Japan, has a prominent position in the yellow bedroom.

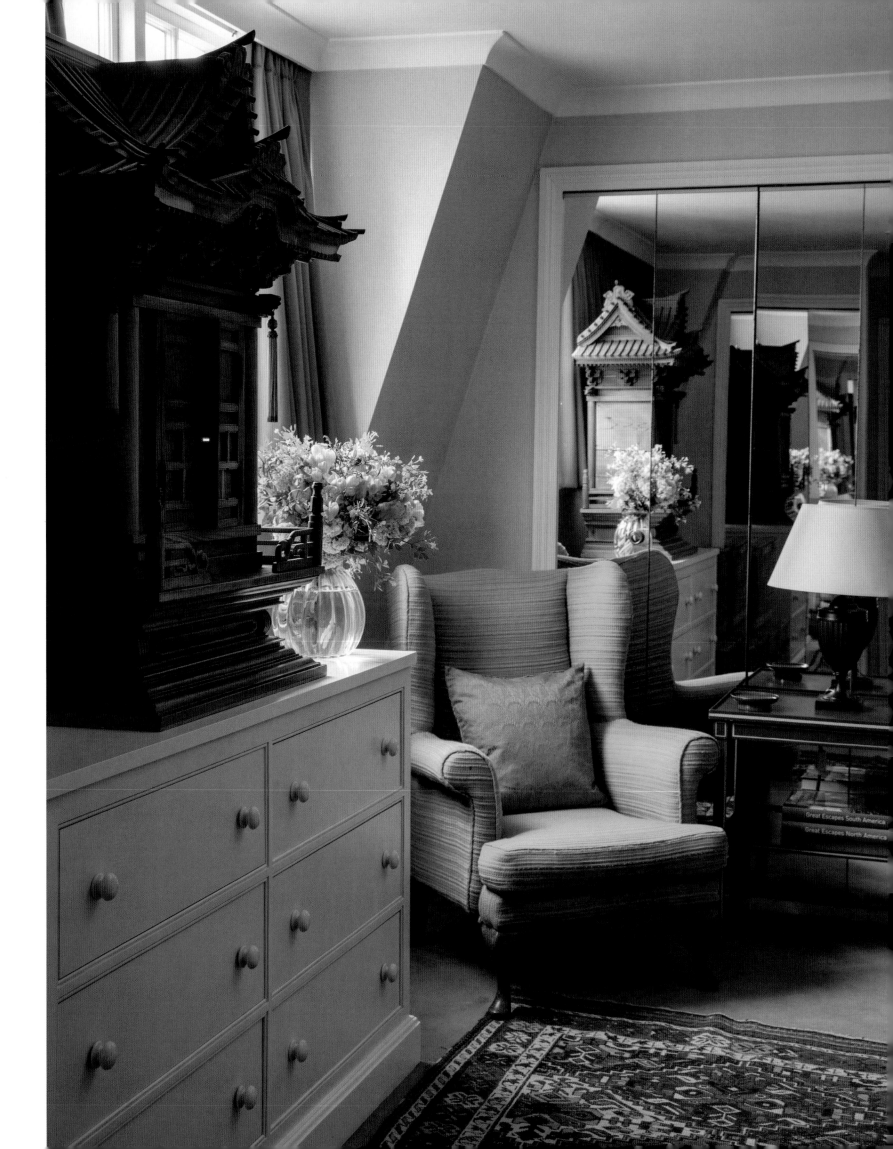

Q&A

How do you relax?

I love what I do – it's my work and my hobby, so it depends on how you define relaxation. I am constantly looking, referencing, absorbing, sketching or photographing. I don't seem to be able to switch that off completely. However, I do love to swim and exercise, I meditate, and recently have been taking time to write. Once a year I take a two-week adventure trip somewhere remote.

What kind of books do you like reading?

Biographies, classic or contemporary fiction and history – I like everything, really, and it's the same with music. It depends on my mood.

Are you into cooking?

Yes, other people's cooking. I know a lot of chefs and love tasting what they create, and then (sometimes), trying to do it for others. Generally, I won't cook if I am alone, but I will for guests. For breakfast, I eat on the go – I grab fresh orange juice on the way to work and, weirdly, a chicken or salmon teriyaki stick, and lemon and ginger tea. I love cheese, houmous, the taste and smell of organic tomatoes – the list goes on.

What about entertaining?

I regularly bring friends together in favourite neighbourhood restaurants in different parts of London. When I do entertain at home, I like to do it 'big', and bring people together from different parts of my life, young and old. I can fit three tables of 12 in the garage, I hang the walls with fabric, and dress it with greenery and flowers. A chef friend will make a large pâté and a beef Wellington. I make lobster bisque and serve cheese and pudding (tarte tatin is a favourite in the winter). Once or twice a year, I help organise charity fundraising events.

What is your method of working?

No set rules. Generally I do the layouts first, after discussing how the space is to be used. Then the theme or concept is decided, and we go into furniture choices and colours after that. I love finding solutions to whatever the challenge may be, thinking about textures and finding or commissioning special and unique things, and ultimately creating a place that reflects the personality and culture of the client.

What's your idea of luxury?

Meditation. Taking time to reflect and energise in a beautiful place.

What would you grab if there was a fire?

Whoever else was in the house at the time! I am not overly attached to objects, but if I thought about it, a painting by an old friend and the sword that my parents saved up to buy for me when I graduated from naval college.

EDWARD BULMER

Court of Noke, in Herefordshire, is Edward Bulmer's world. The 200 acres of farmland contains not only the family home he shares with his wife, Emma, and their three daughters (as well as Molly the lurcher and Lenny the dachshund), his natural paint company and interior design business are housed in the farm's outbuildings. Edward and Emma work together, with Emma taking care of the marketing and finance for the paint company – so the divide between family and work life is almost non-existent.

The Bulmers have lived in the house since 1995, when they found it in a quietly neglected state. With its dovecote, walled garden and water garden, it had originally been a gentleman farmer's residence, but over the years the Queen Anne house, built around 1700, had been altered quite significantly. A wing of offices had been added in the 19th century and a number of windows had been bricked up. 'Without the windows on the façade,' says Edward, 'it looked quite forlorn.'

He had plenty of experience in design to tackle such a project, starting with his childhood in a Georgian rectory nearby, which his parents had meticulously restored. 'I can't even remember a time of not having builders at home,' he says. His father brought in David Mlinaric to help with the interiors. 'Ours was the first country house he decorated,' says Edward. 'I was about eight at the time, and was asked what colour I wanted in my bedroom. I said purple.'

While studying history of art at university, 'it all fell into place, and I realised how much I loved country houses,' he says. After working in advertising for a year, he took a job with David Mlinaric. 'One of the first things I did was to draw up a library for Jacob Rothschild's house in Maida Vale.' Rothschild had also taken over the lease of Spencer House, a neoclassical mansion in St James's, London, and Edward was given the task of 'going there and researching and drawing up details. I just loved being in this beautiful empty house.'

He went on to work with architectural historian Gervase Jackson-Stops and, later, with picture restorer Alec Cobbe. 'I was assisting him with all the low-level stuff – re-stretching artworks and preparing the palette,' says Edward. 'There I was quietly learning about tonality and pigments without realising I would be making my own natural paint one day.' He eventually went out on his own, and when Charles Spencer inherited Althorp, Emma encouraged Edward to contact him to offer his services and put the house to right after some insensitive renovations.

'That was a really lovely job that went on for two or three years,' says Edward. 'I rehung all the pictures, and bought four sofas and nothing else. Everything else had been in storage, and I used it all. I remade curtains from stored silks and curtain boxes from all the old mouldings that had been taken from Spencer House.'

The paint company came about when Edward worked on an interiors project at Goodwood House in West Sussex, and was asked to ensure that all the paints he planned to use were environmentally sound. Once he started investigating the

possibilities, he realised the best solution was to endeavour to make his own, which proved to be no easy task.

It was around this time that the family moved into the Herefordshire house, camping at first before the restoration began. The office wing was replaced by a new wing, which faces the walled garden. A garden hall and dining room were added, and the kitchen enlarged. Many of the windows were unblocked and dormer windows installed.

The garden hall, painted turquoise, creates a link between the dining room on one side and kitchen on the other. The walls of an adjoining cloakroom are lined in a now discontinued Rubelli fabric. 'We first saw it in a chateau in France, and this was as much as we could afford!' says Edward. The dining room, which he describes as the most traditional room in the house, contains antiques and paintings collected during his early days as a decorator. 'The curtains are a Watts of Westminster wallpaper border design that we printed repeatedly as a fabric,' he says. 'What we were trying to do was relax the room a bit.' The kitchen is informal and light filled, made even more casual by the use of clapboard panelling on the walls.

From the front door of the house, a wide hallway opens to a family room and music room. Given Edward's background in design, it might be tempting to think he would be inclined towards historical accuracy, but that's not the case. He describes the family room as being 'the only actual 18th-century room as such – the panelling dates back to the 1750s. Oddly, we've furnished it in a modern style.' Many of those pieces have been designed by Edward, and walls are hung with artworks by family and friends.

The music room was created out of two rooms, with oak panelling installed from floor to ceiling and painted a delicate green (naturally, all paint used is from his range). 'Of all the rooms in the house, I love this one most of all,' says Edward. 'It's where the socialising mainly happens.' Again, he designed some of the furniture, including the sofa, and also did the paintings of the Taj Mahal. The fireplace came from a salvage company, and the pretty curtains were made from Indian bedspreads.

The bedrooms have been decorated in an equally eclectic style. The Chinese wallpaper in the main bedroom was originally used by David Mlinaric in the house that Edward grew up in. 'It was an enormous effort to get it off the walls,' he says. The original plan had been to reuse it in the dining room, but there wasn't enough. Instead, Edward designed the bed to work in with the wallpaper. In the adjoining bathroom, the walls are covered in paintings, including nudes by Edward. In a guest room, created from two rooms, the walls are lined with fabric, the curtains are made from old saris, and the bed is by Chippendale.

When Edward and Emma bought their house, the previous owner made two stipulations – a fitted kitchen was not permitted, and Laura Ashley wallpaper was not to be used. Her conditions have been more than adequately fulfilled!

'THERE I WAS QUIETLY LEARNING ABOUT TONALITY AND PIGMENTS WITHOUT REALISING I WOULD BE MAKING MY OWN NATURAL PAINT ONE DAY.'

Opposite. A large landscape with a fortified town, by Isaac de Moucheron, and a view of Downton Castle by William Ward Gill are set against a wall painted in Edward Bulmer's 'Aquatic'. The commode is by Edward Bulmer Ltd, after a design by Henry Holland. The curtains are bespoke printed cotton by Watts of Westminster.

Overleaf. The music room is Edward's favourite room in the house, 'because it's where all the socialising happens'. The walls of home-made oak panelling are painted in 'Pomona', also by Edward Bulmer Natural Paint.

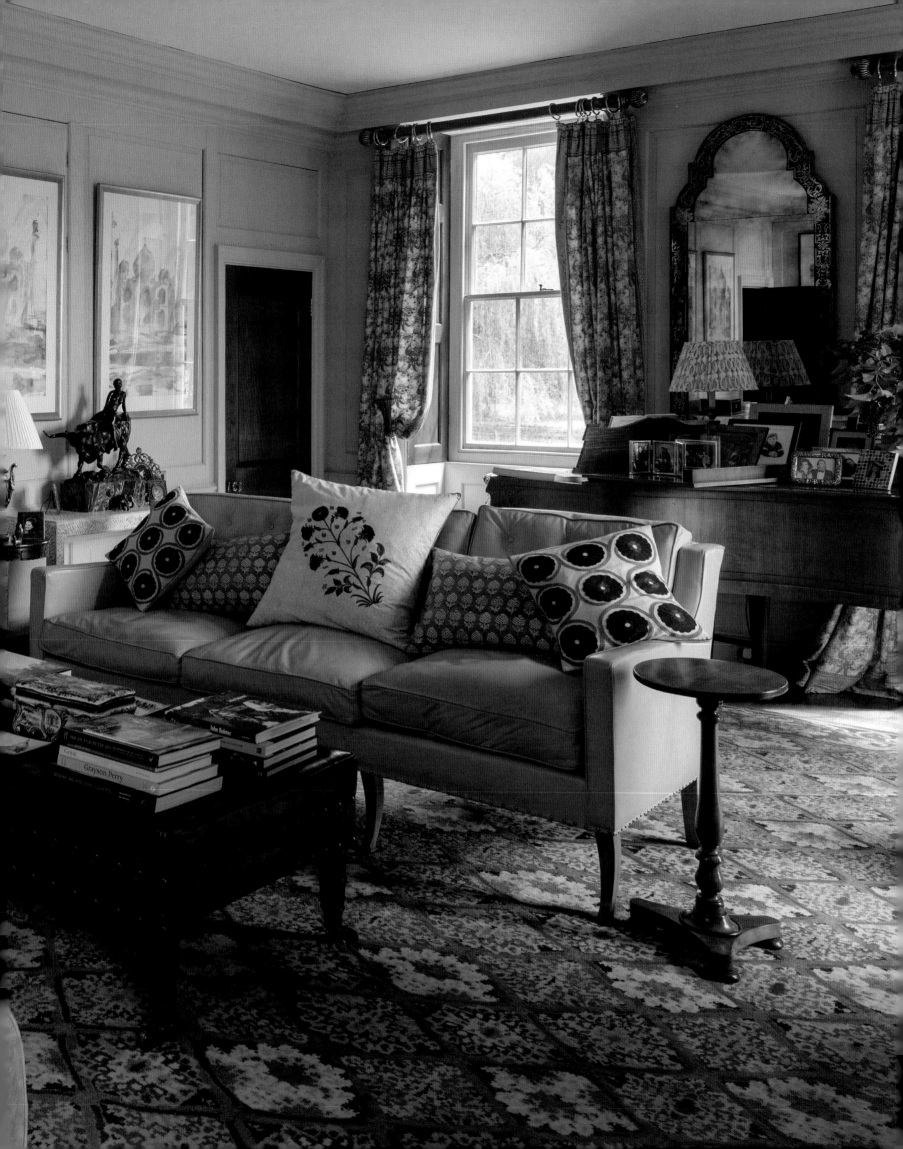

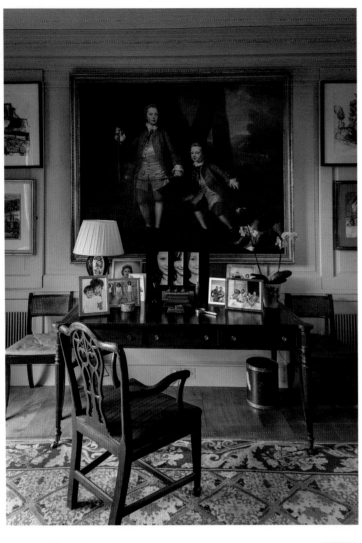

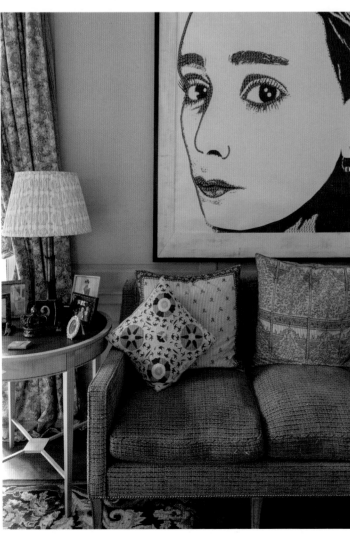

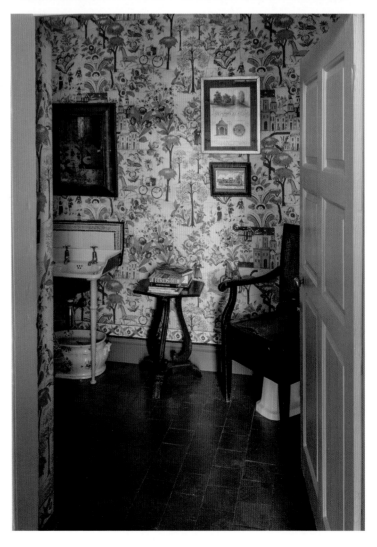

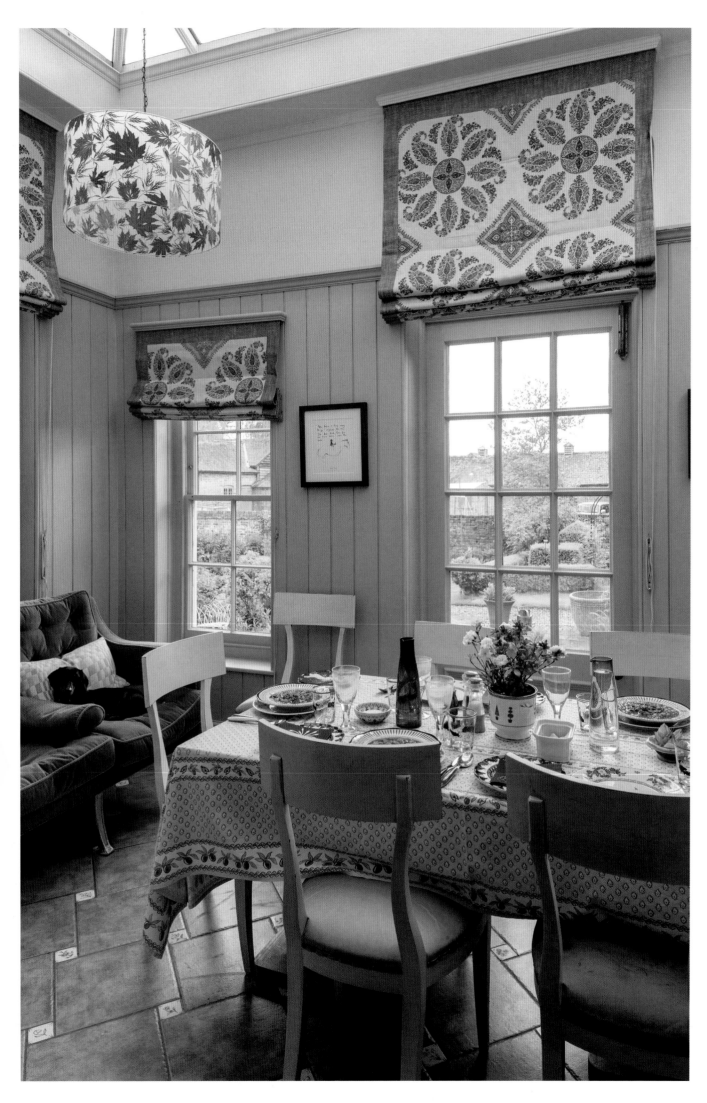

Opposite, clockwise from top left. A portrait of Thomas and Henry Arundell by George Knapton hangs behind the desk in the music room; reused stone flagging has been laid as flooring in the garden hall; the cloakroom is lined with an extravagant Rubelli fabric; a portrait of Edward's daughter Evie, by his daughter Isabella, has a prominent position in the music room.

This page. The light-filled eating area, part of the kitchen, is in the newly built wing of the house.

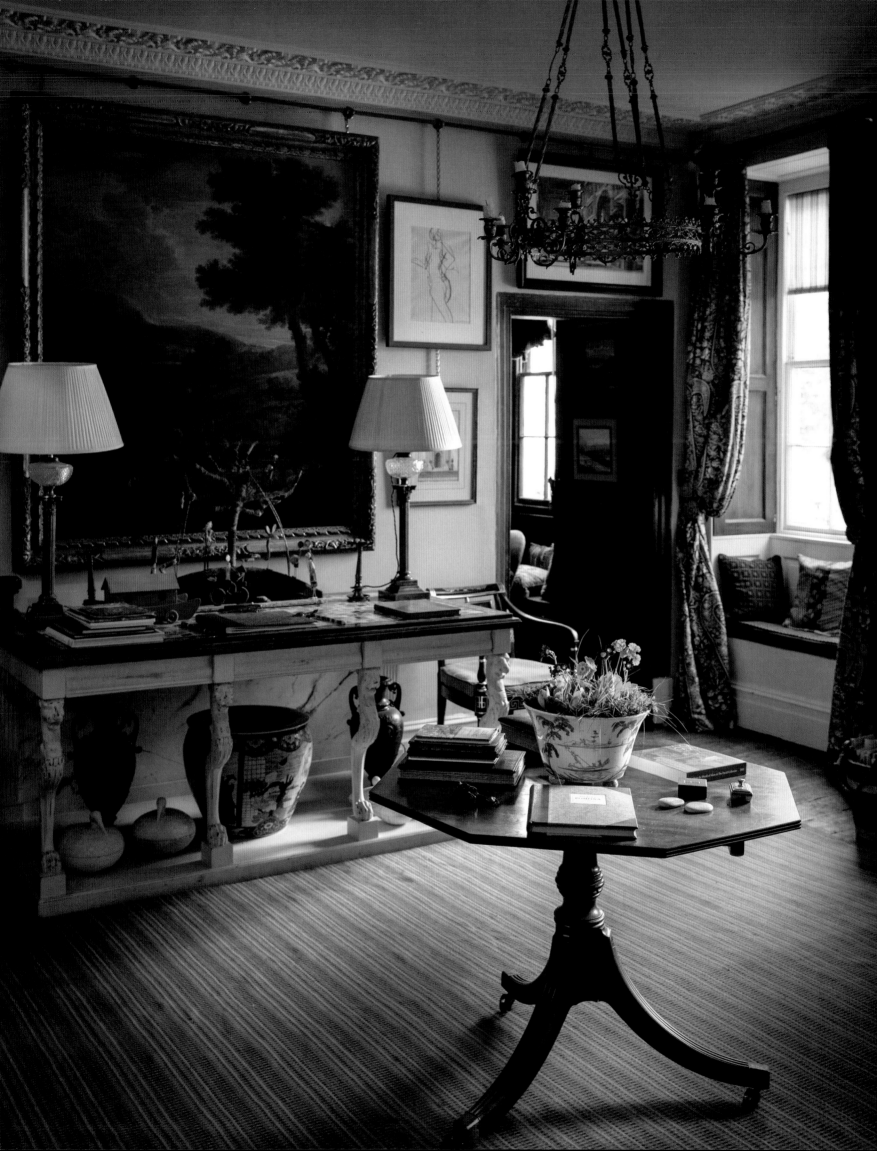

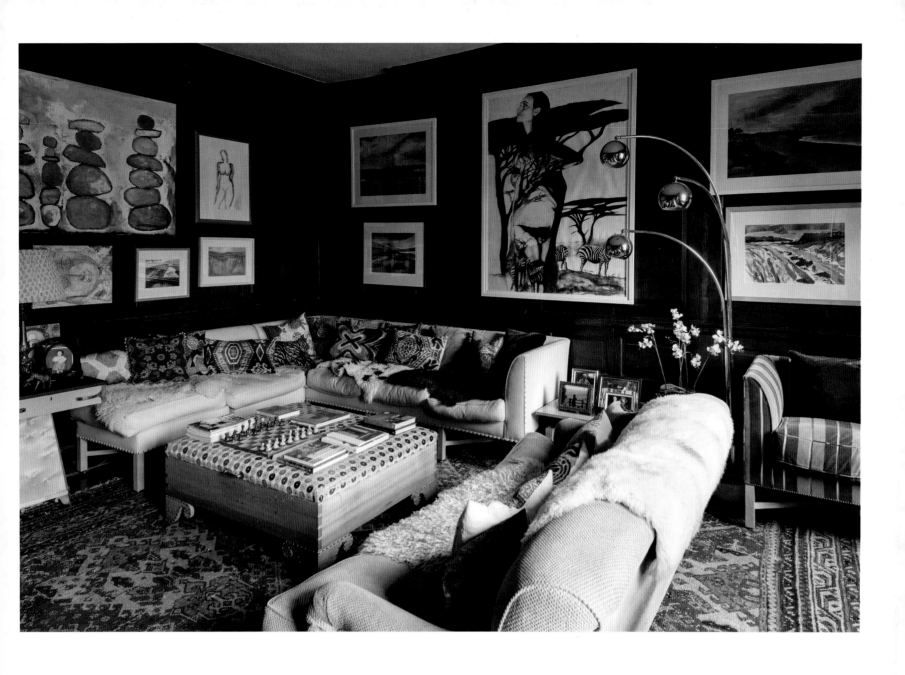

Opposite. A table designed by Edward, with variegated marble top from Udaipur, sits in the hall beneath a landscape with hunting party, by John Wootton.

This page. Pictures, mainly by Edward and his three daughters, decorate the walls of the family room, which has oak panelling dating back to around 1750.

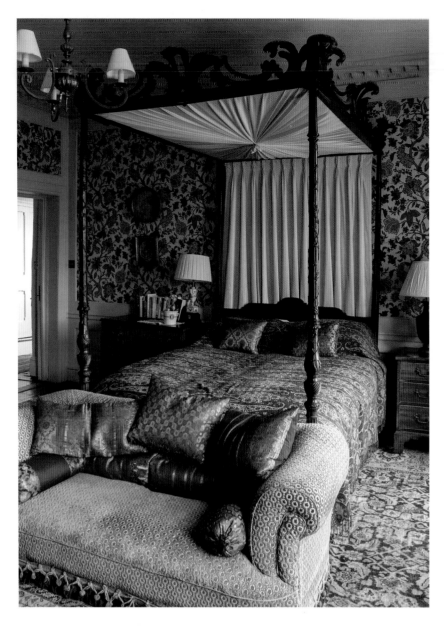

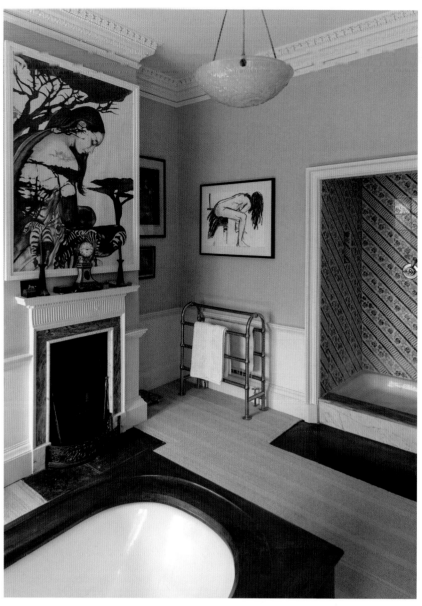

This page, left. The walls in a guest bedroom are decorated with Pierre Frey 'Tree of Life', and the bed has cornices and posts in the manner of Thomas Chippendale.

This page, right. The bathroom is treated like any other room in the house, its walls hung with drawings by Edward and his daughter Isabella.

Opposite. The early 19th-century Chinese export wallpaper in the main bedroom came from Lambton Castle in County Durham.

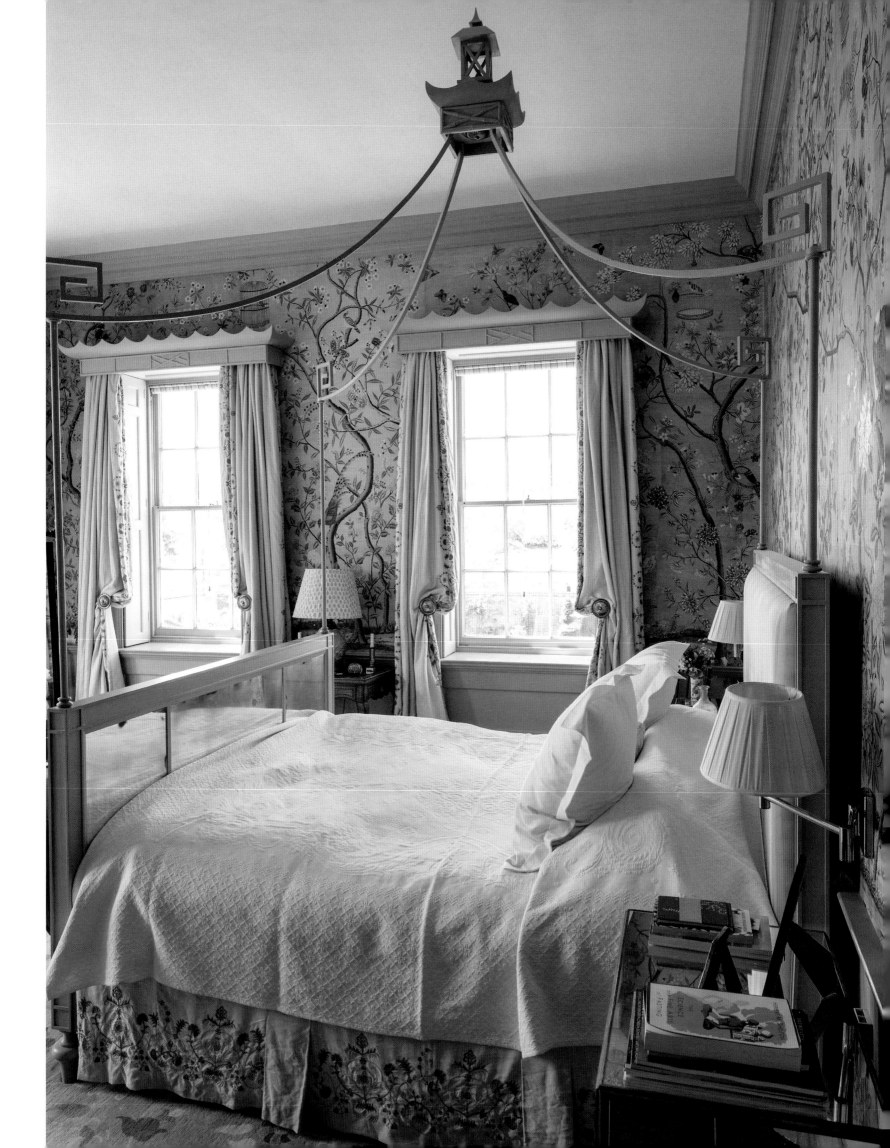

Q&A

How do you relax?

I love my work, so I'm constantly thinking about what I need to do next. Even if I'm thinking about work, it's still relaxing.

Do you turn away jobs that aren't historical houses?

I get offered buildings that don't exist, and end up designing them. But I have started turning away jobs that I sense early on just aren't right for me.

Who has been your greatest influence?

It would have to be Alec Cobbe – the five years I spent with him were the most informative I've had. But the person I would thank the most would be Janet, Duchess of Richmond of Goodwood. She managed to link for me my love of historical conservation, old buildings and overriding concern for our planetary stewardship. We wouldn't be where we are today without her, so I'm very grateful. I'm very burdened by the state of our planet.

What's your favourite room to design?

Probably a library, because there's so much architecture involved.

What's your idea of home?

Where my family is. A house is eye candy for me, but it is nothing if it is not the backdrop to munching, chatting, drinking, laughing, family life!

What's your idea of luxury?

Eating home-grown vegetables.

What would you grab if there was a fire?

My wife, children and dogs, obviously!

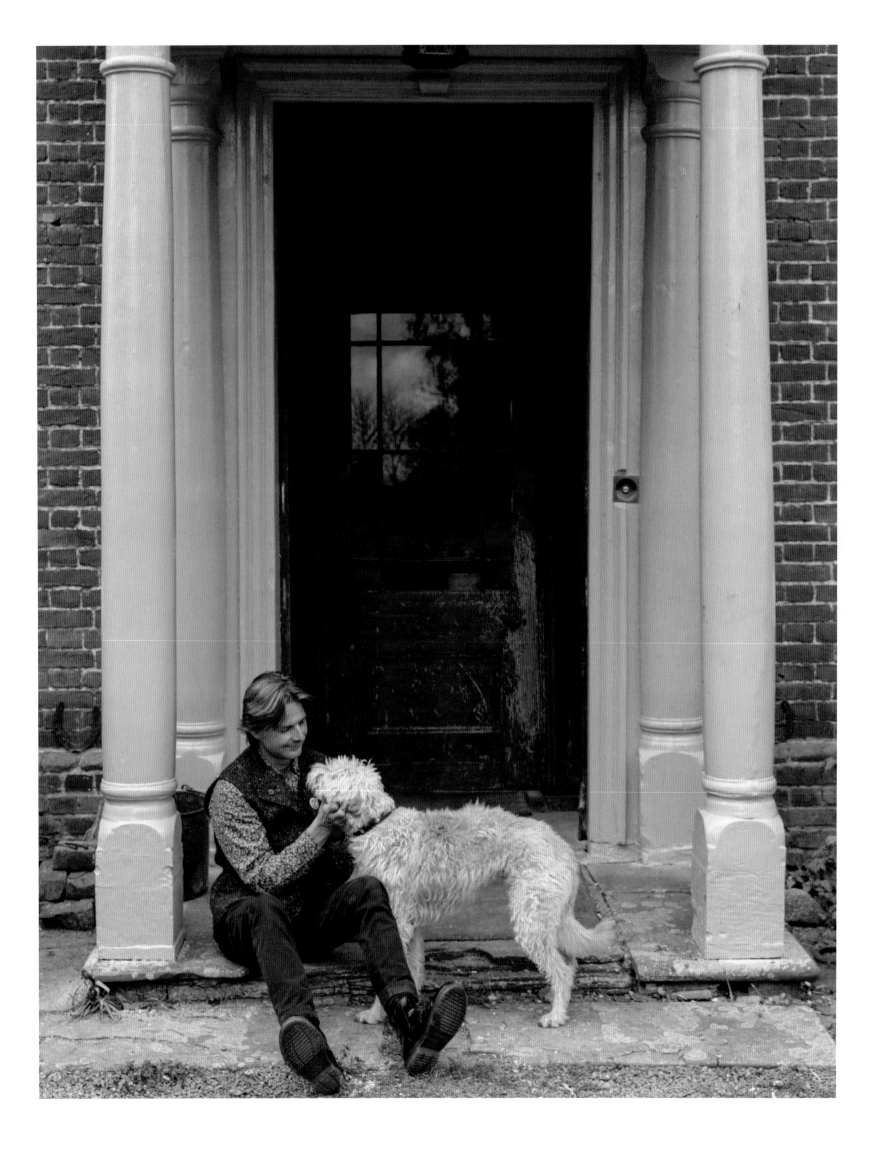

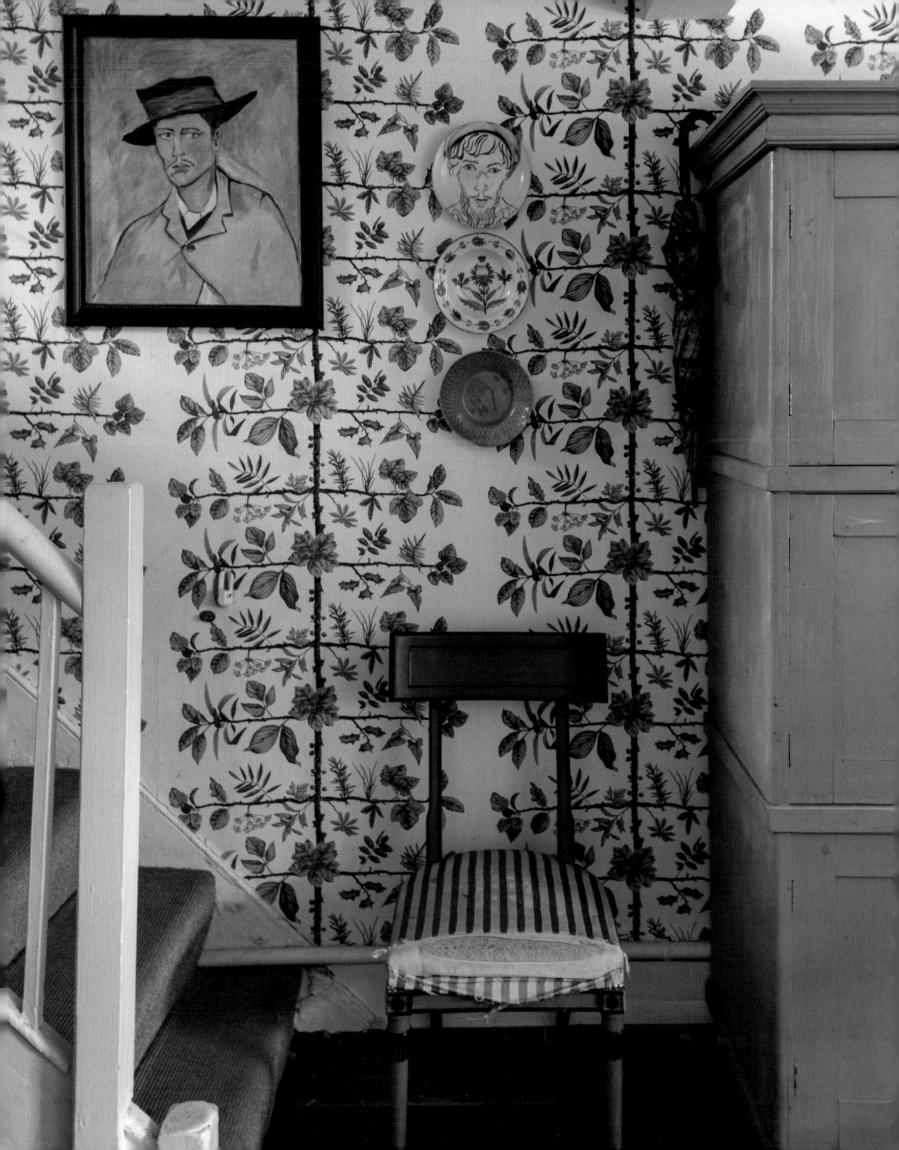

GAVIN HOUGHTON

Gavin Houghton says colourful ceilings are his 'thing', and the one in his drawing room has recently been painted mustard. 'You know how pubs used to be when everyone smoked,' is how he describes the effect. It's his favourite room in the house, either when he and his partner, Boz Gagovski, have friends over for dinner, or in the evenings when the fire's going and the two of them are sitting there with Jack and Jill, their two Jack Russells.

Gavin will probably be in the blue and white armchair, his favourite. It's a cosy and well lived-in room, with chaotically stacked bookshelves around the fireplace and walls crammed with art, including a number of drawings by Duncan Grant. It's also indicative of the rest of the house, which has an uncontrived bohemian charm to it – a sense that it has developed in a perfectly natural manner.

The early Victorian house is in Stockwell, south London. 'I like this area, it's real and there are quite interesting people here,' says Gavin. 'It's not over-manicured – I always say they have nasturtiums in their window boxes here, unlike in Notting Hill, where they have box hedges, which don't move me at all.'

Twenty years ago, when he bought the house, the neighbourhood was much more raffish than it is today, and the house itself was in pretty poor shape, having had a run of mainly artist tenants. 'The living room had been a painting studio – the floor was covered in green paint, which you can still see in places.' The house was empty when he first saw it; friends who lived next door had keys and let him in. 'It was pretty ropy, but had a very nice atmosphere.' And it was a house – something he never thought he could afford in London.

So into an empty, paint-spattered shell, Gavin introduced colour, pattern and exuberant decoration to create this welcoming and cheerful space. He also installed tenants on the top floor, which he still rents out. Favourite ceramics, including works by Hylton Nel and Michaela Gall, are positioned on table tops and mantelpieces. In the hallway, on the entry level, he painted the bare floorboards in a black and white chequerboard pattern and, elsewhere, brought in well-worn rugs. Where walls aren't painted in intense tones, they're papered in striking wallpapers, including a Brunschwig & Fils in the main bedroom which Gavin describes as 'the most wonderful wallpaper in the world – I've tried to work out why it's so successful'.

Even the bathroom walls are papered in Zoffany's 'Richmond Park', a bold leaf design, in what is now a discontinued colourway. 'The bathroom has a public loo vibe, with its subway tiles and brass fittings,' says Gavin. 'I bought the vanity on eBay, which I do a lot for clients – and the taps are vintage.'

Throughout the house, walls are hung with a wealth of artworks. That includes a painting of Van Gogh in the kitchen, which Gavin painted for his mother. 'She didn't like it – she said it was cross-eyed, so I got it back.'

There's a level of ingenuity throughout the house, and you get the sense that Gavin doesn't take himself too seriously. He grew up in an artistic household in

Opposite. Gavin Houghton's 'terrible but funny' copy of a Van Gogh portrait was a gift to his mother that she rejected. It hangs above the chair that provided the inspiration for his Josephine dining chair.

Hertfordshire – his father, who had studied at The Slade art school in London, worked in advertising, while his mother is an artist. She was also pretty handy around the house. 'She used to make curtains and things – I think I learnt a lot from her. I always knew if anything had been changed. She'd ask me, "Do you see anything new in the house?" and I'd know straightaway.'

It was 'a given', he says, that he went to art school, and he imagined that he'd become a painter. However, after hanging out with the fashion students and modelling for their collections, he ended up with a degree in fashion. One of his first jobs was at *The World of Interiors* magazine – and his first task was to make 'chintz jeans for all the girls for the Decorex [interior design show] stand'. He still sews, he says, but needs a new sewing machine. 'I want to make cushions – I would do them in pairs with beautiful fringes.'

For a number of years he was the promotions art director at *Vogue*, then in 2006, just as he was thinking of leaving and setting up his own interior design studio, he sat down next to someone at a dinner party who owned 'one of the earliest Jacobean houses in England – she was a friend of a friend of mine'. She called him soon after to say her husband had suggested they might like to work with Gavin.

'She wanted to do quite a lot of work,' he says. 'The house had been done in the Seventies by David Hicks. We left the Zuber wallpaper in the dining room and re-covered the dining room chairs in an assortment of pink leathers, which looked amazing.' He also worked on the main drawing room and master bedroom. 'I found it quite easy – it's not rocket science, it's wallpaper and curtains! I had been doing room sets for years at *The World of Interiors* so I wasn't afraid of colour.'

Since then, Gavin's work has mainly been private houses in the city and country, with the odd pub or Scottish hunting lodge thrown in. It's important to him to get to know the client properly before he starts working with them: 'I think I've got a good instinct about people.' I asked him what he thought I would like, and he said, 'Quite bright colours – classical and quite English and floral.' He was spot on.

Gavin keeps his business deliberately small, and has 'always hated going into an office'. It's the whole nine-to-five routine that doesn't appeal to him, and having to be there even when there's not much going on. 'I now think, "Sod it, I'm going to loosen it up." It's very nice this way.' His domestic life, similarly, lacks the daily grind. On weekends in London he walks the dogs, goes junk-shop hunting and visits exhibitions. On some weekends, he and Boz and the dogs go to Oxfordshire to a house they have a part share in. 'I just love it – in the winter I love it with cold nights and the fires roaring, and the muddy walks.'

For warmth they go to La Di Dar, their place in Tangier, 'which is like a playhouse. I like a bit of everything, but I do love this house and wouldn't want to give it up.' He dreams of opening a restaurant in Tangier – 'like a supper club, simple but tasty food. I'll get an ice cream machine, and make delicious ice cream with cardamom or saffron or rosewater. It will be a bit arty-farty, with all my art over the walls.' Even as he thinks about that, he imagines himself in his office in the garden in London, its walls painted bright red. 'When I'm really poor I can live in there and rent out the house.' He'd make it work – and you know it would be wonderful.

'THE LIVING ROOM HAD BEEN A PAINTING STUDIO – THE FLOOR WAS COVERED IN GREEN PAINT, WHICH YOU CAN STILL SEE IN PLACES.'

Opposite. The view from the living room through to the hallway, with its painted chequerboard floor. *Boy in Fez* is a portrait by Gavin of his partner, Boz Gagovski. Above the door is an Alexander Calder print.

Overleaf. The drawing room has a ceiling the colour of nicotine stain. The blue armchair, upholstered in a now discontinued fabric, is Gavin's favourite. He had the sofa made, and covered in a silk from Turnell & Gigon. The two nude drawings are by Duncan Grant.

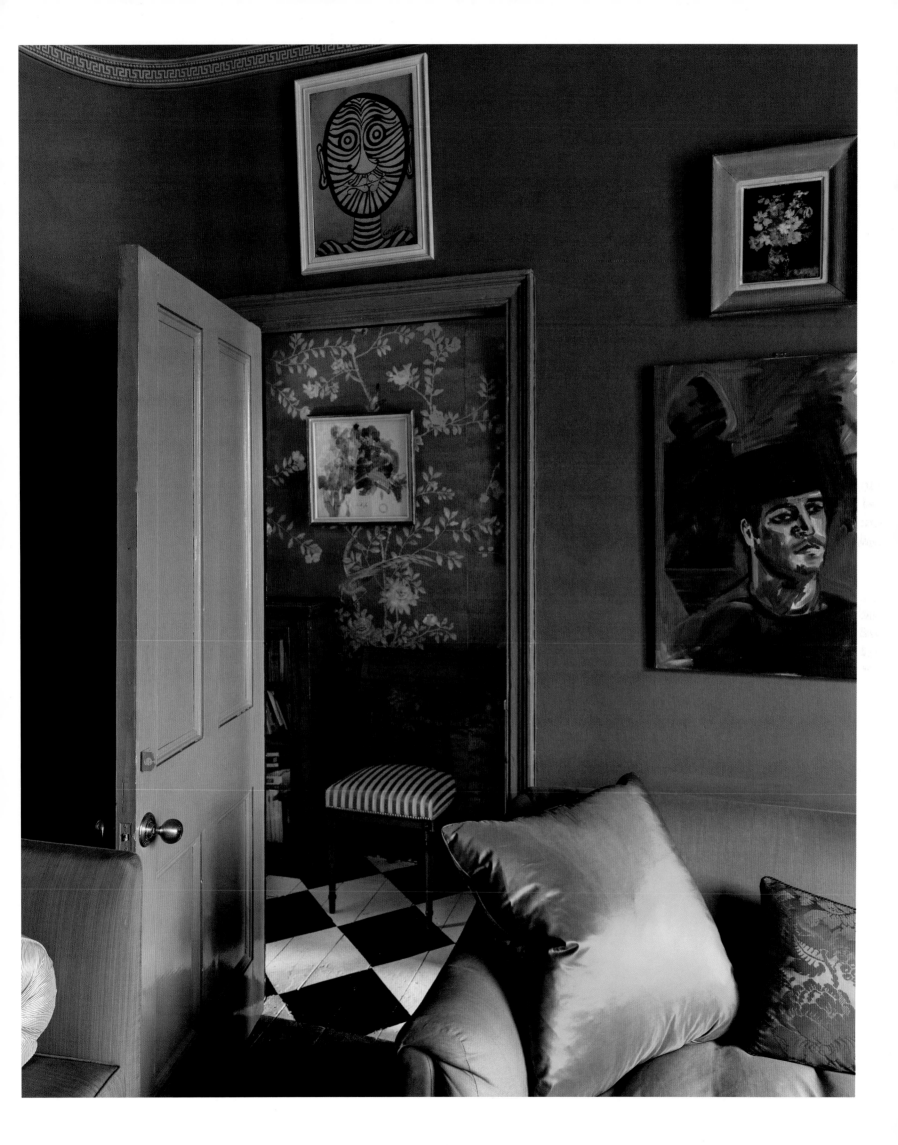

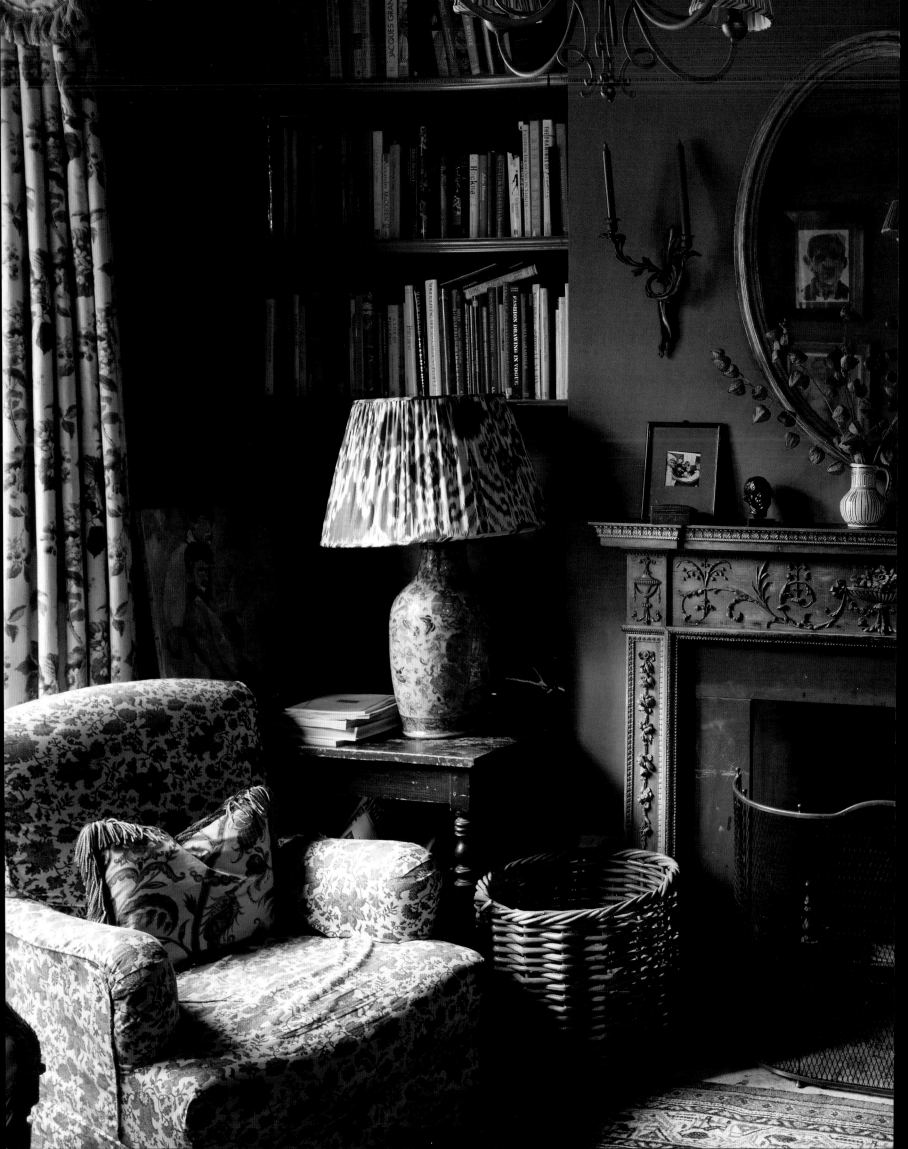

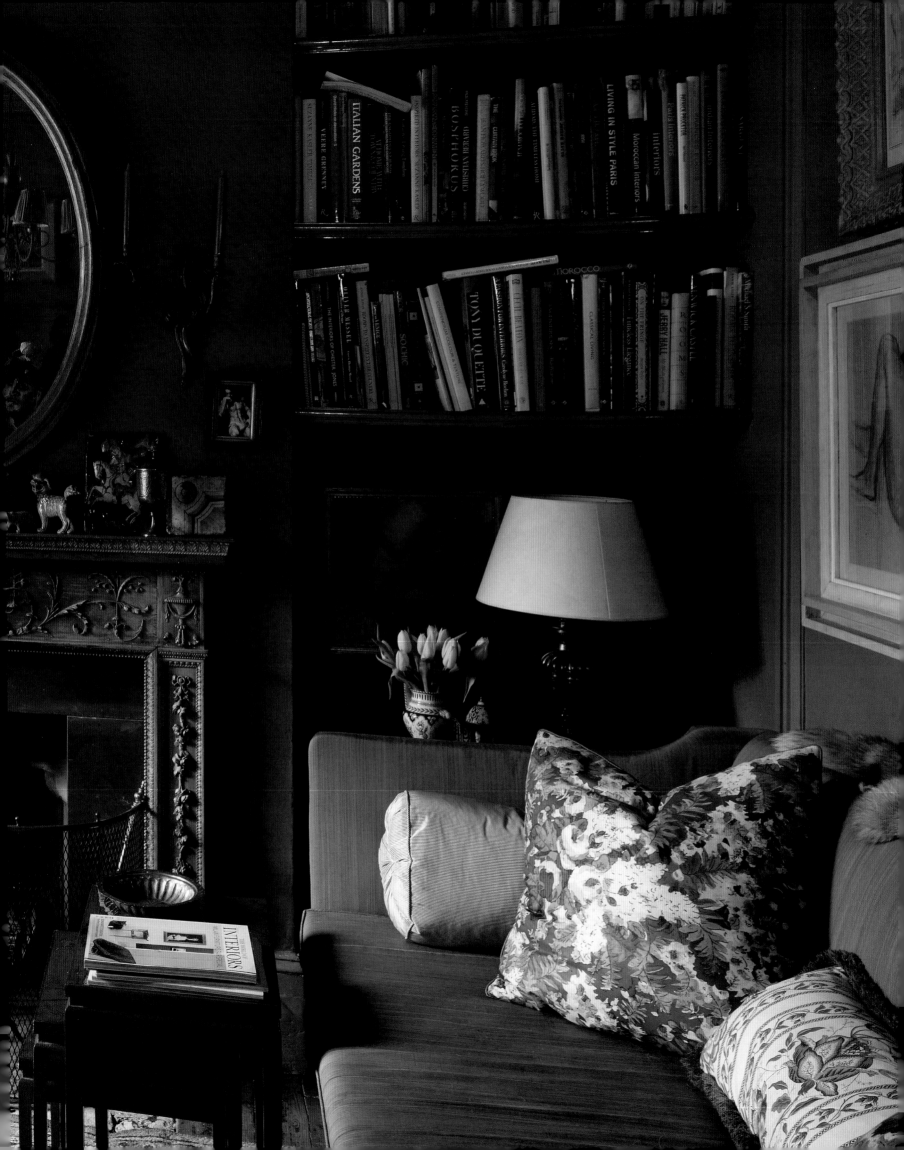

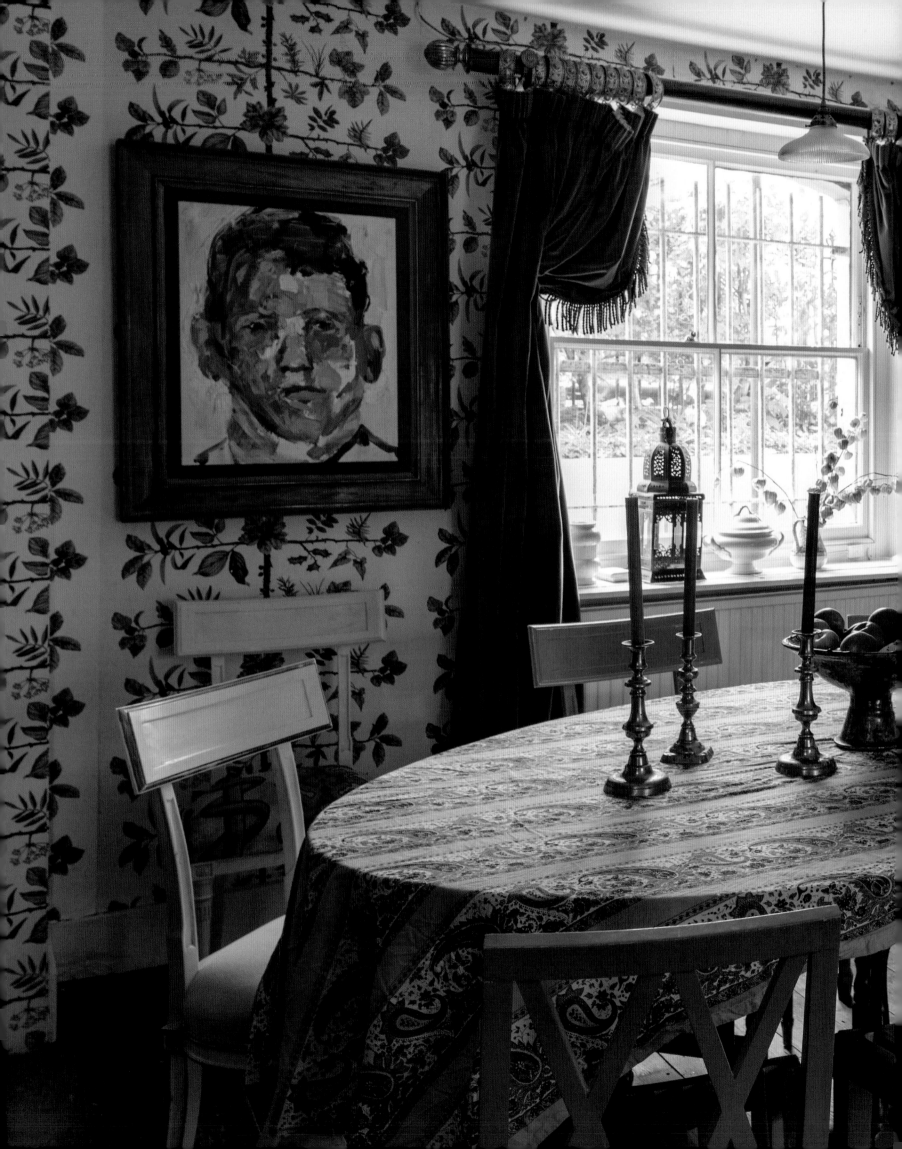

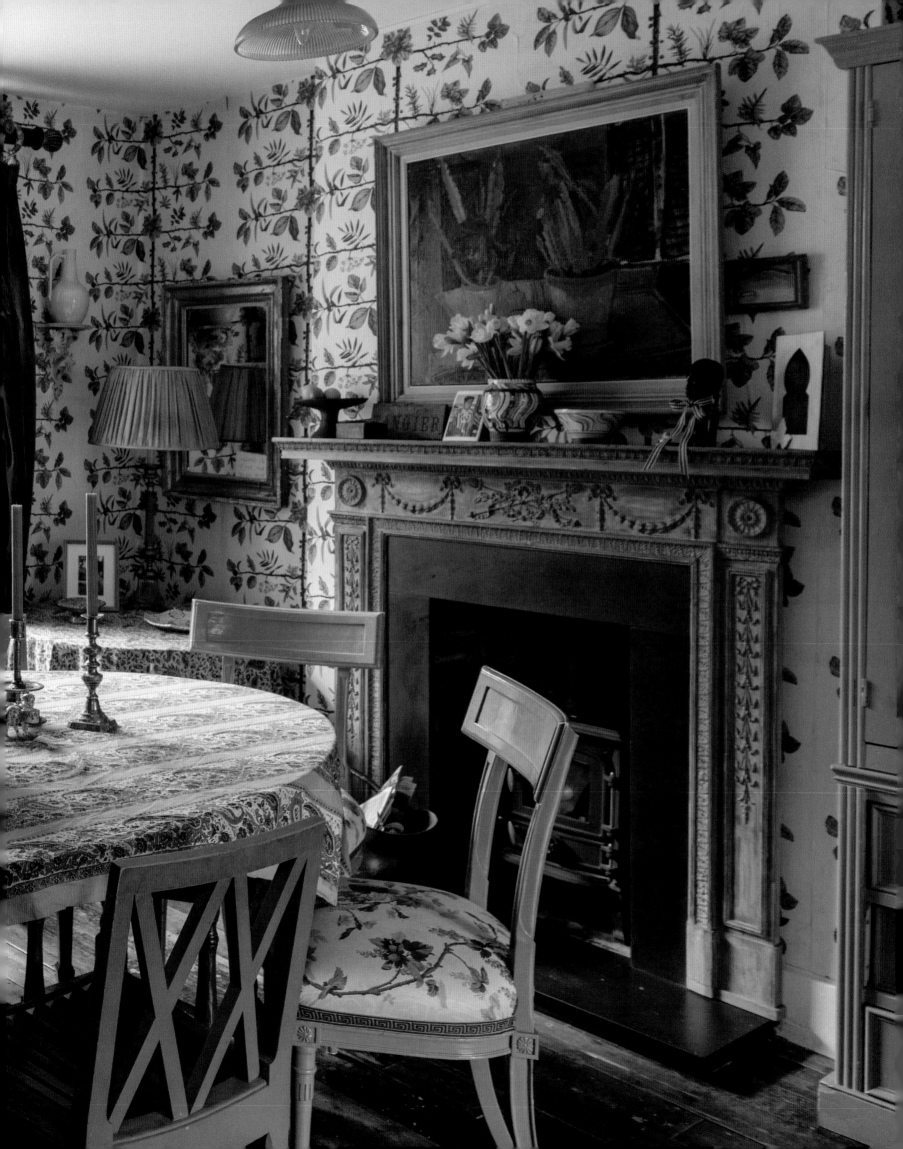

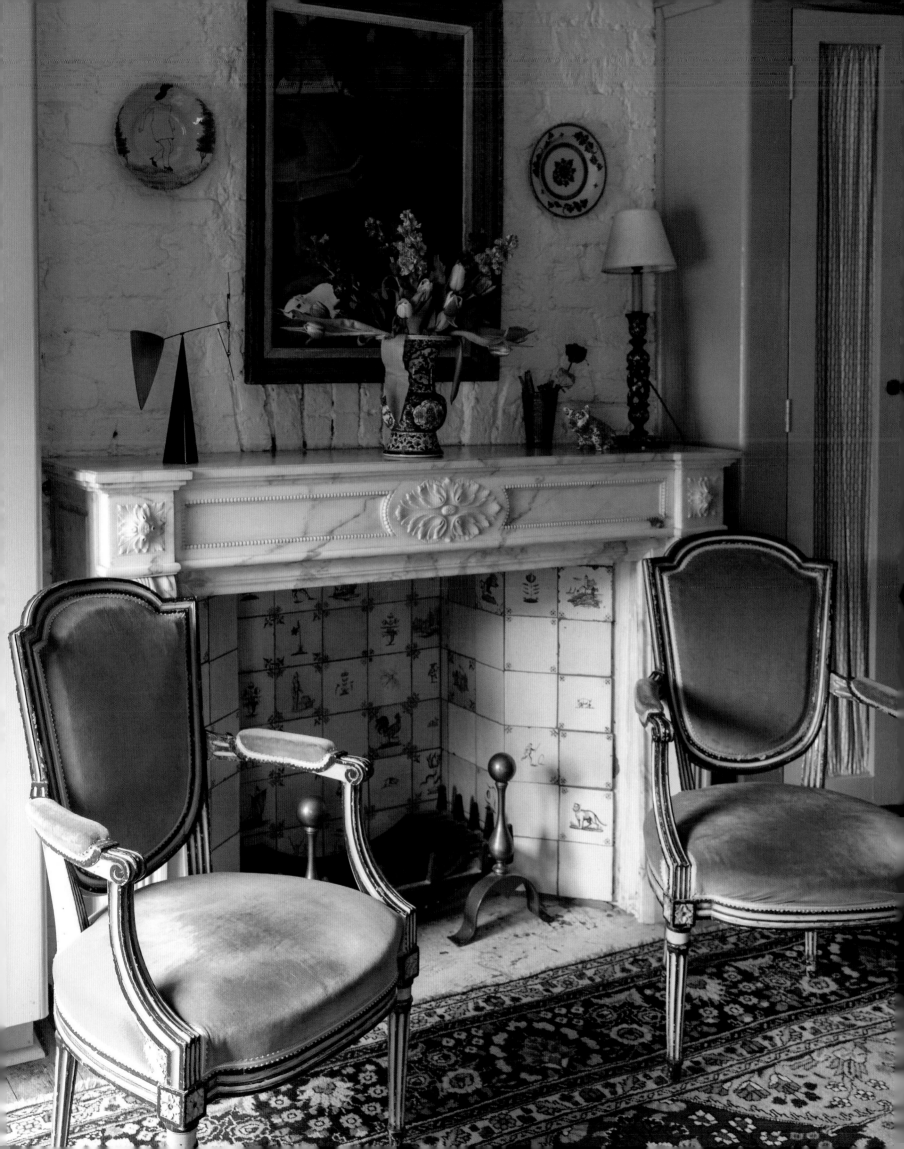

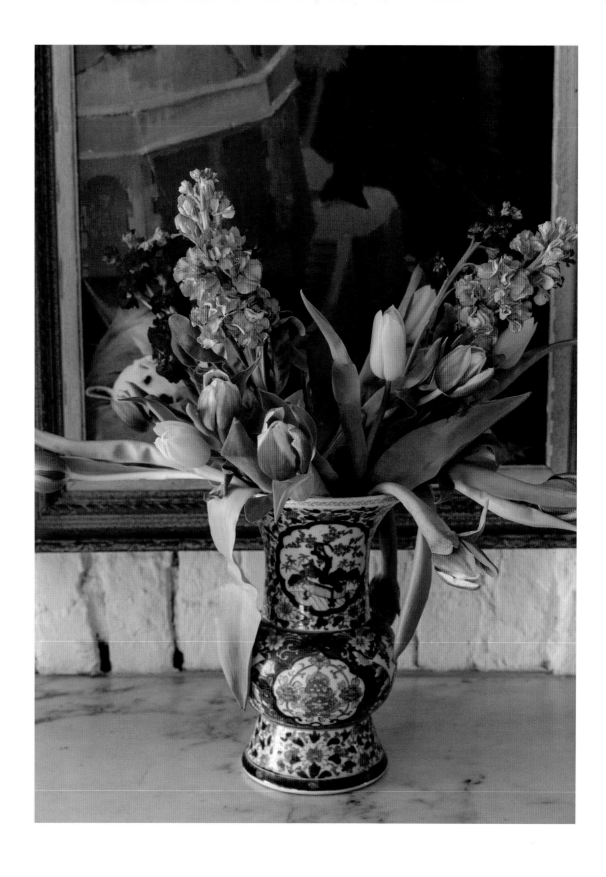

Previous page. The kitchen wallpaper is 'Espalier' by Pierre Frey. 'It's such a clever design, we love it,' says Gavin. The yellow boy painting is by Mike Rachlis from Toronto, which Gavin found on Instagram, a frequent source of artwork for him.

Opposite. Gavin bought the turquoise and brown French armchairs years ago, and had them upholstered in green velvet. The tiles are by Douglas Watson; the left-hand plate above the mantelpiece is by Hylton Nel, the other, from the 18th century, was a gift from Gavin's mother.

This page. 'I found this painting in the back of a van in the pouring rain on Portobello Road for £20,' says Gavin. 'I look at it from our bed, and it's a favourite of mine. I like to think it's by a famous painter and is worth millions.' The vase was found in a junk shop.

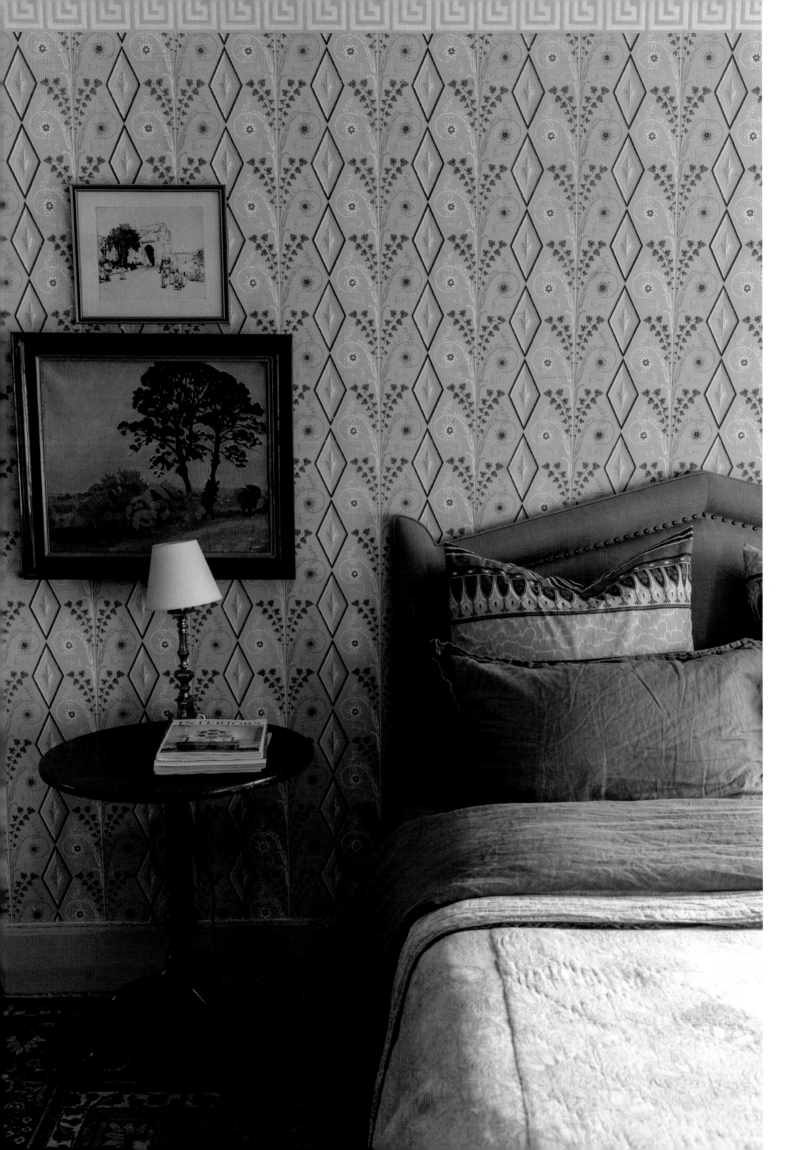

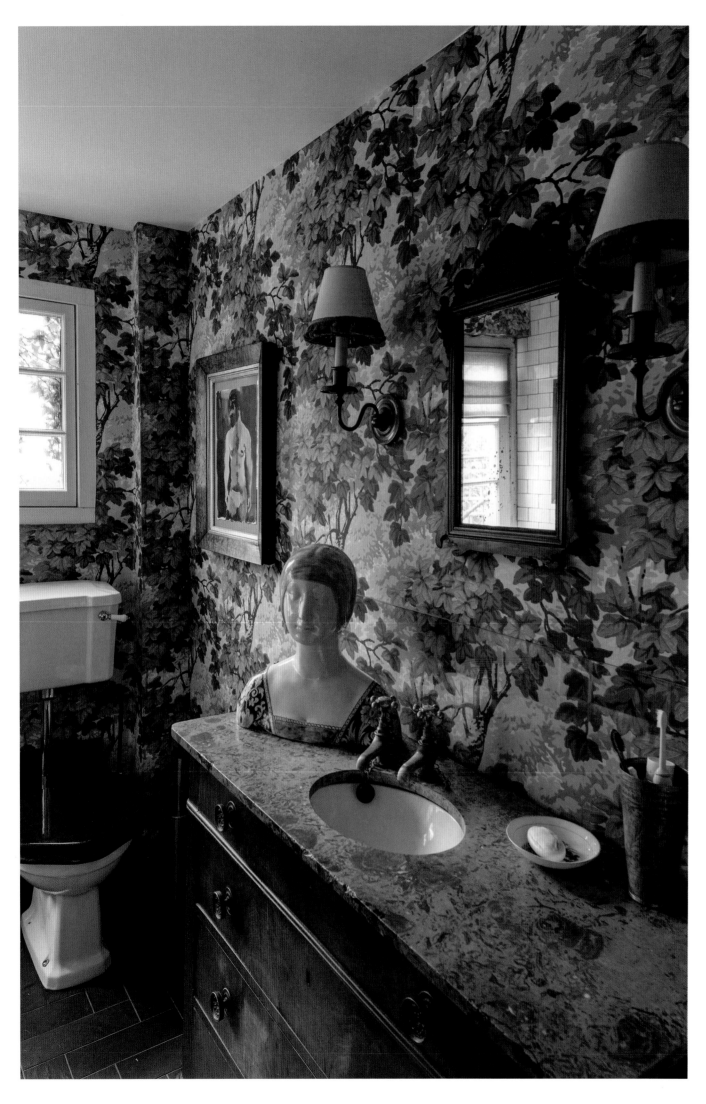

Opposite. Gavin uses the 'Gallier Diamond' wallpaper by Brunschwig & Fils quite often in his projects. 'I totally love it.' He designed the Egyptian-inspired and diamond-shaped bedhead to reflect it.

This page. The bathroom is papered in 'Richmond Park' by Zoffany. A watercolour by Gill Button, who Gavin describes as a 'brilliant painter', hangs on the wall. 'I collect paintings, it's my weakness,' says Gavin. 'Often the frames cost more than the paintings.'

271

Q&A

What does home mean to you?

A crackling fire with the dogs. I love fires – I have them in all my houses. I love keeping them going and the smell of them. All you need in a house is a fireplace and garden. In London you don't often see a real fire – it's like having someone in the room with you. A gas fire wouldn't do anything for you – it would be a dull evening.

How would you describe your aesthetic?

A bit of Bloomsbury, a bit of English, eclectic. I think it's quite classic. I like charm and fun, a bit of wit. I love the wall sconces above the fireplaces – I use them in all my houses.

How do you feel about entertaining?

I like being a host – I love people coming to me. I don't like drinks parties, I love giving dinners. I love cooking; I made home-made taramasalata this weekend.

Do you enjoy reading?

I'm not really an avid reader, but buy so many books.

Who have you been influenced by?

A bit of John Fowler. I quite like a bit of David Hicks. I also love what Robert Kime does. I love that English/Chinese/Moroccan mix – he set that benchmark very high, using really good ceramics and good paintings. In his shop, I would spend silly money.

What's your favourite room to design?

Definitely a drawing room – the sumptuousness of it. I love entertaining and love people sitting in a room.

Flowers or foliage?

Flowers – I always have them here.

If there was a fire, what would you grab?

The two chairs in my bedroom, which I love, and I guess the Duncan Grants. Obviously, Jack and Jill. I love having the dogs – they get me walking. I love walking!

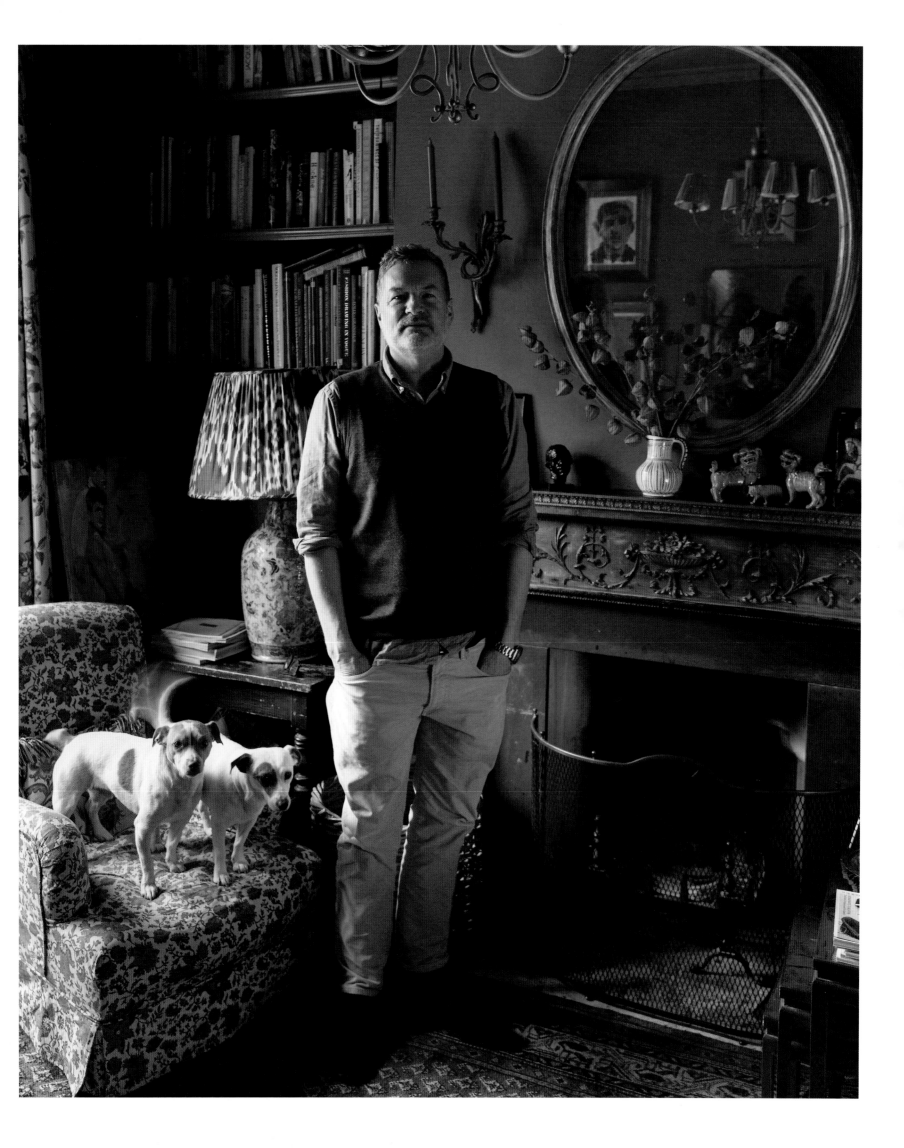

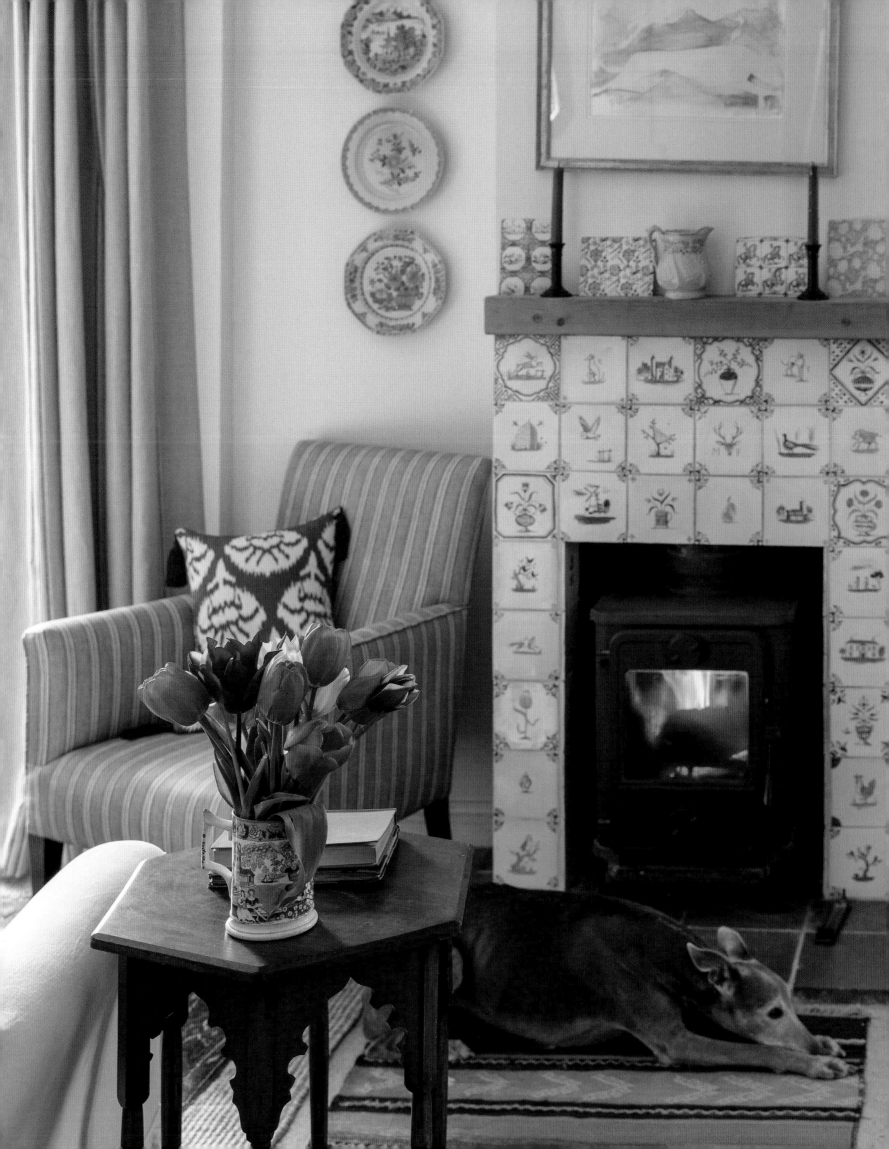

CARLOS SÁNCHEZ-GARCÍA

Carlos Sánchez-García, who grew up in a small village in Spain, arrived in London around 20 years ago to study English. He met his now-husband, Michael, soon after he arrived, and decided to stay. They made their life in the capital, but Carlos had constantly hankered for a more rural existence. It was a sunny autumn day when, 'in the middle of nowhere but pretty close to Holt' in Norfolk, the couple came across the elegant Manor Farmhouse, the earliest part of which was built in 1635, with later additions from the 18th century. 'We opened the door, it was completely empty inside and, after looking around, we said, "We could get used to this!"' The original idea was to use the house, more or less, as a weekender: 'The location is absolutely perfect for us because we live on the east side of London.'

Having been a working farmhouse, nothing much had been altered over the years. 'It has an enormous amount of personality,' says Carlos, 'and structurally we haven't done much to it at all.' Something he particularly loved about it from the start, he says, is that it's long and not too deep, an example of vernacular architecture. 'The main body of the house, from the entrance hall all the way to the end, is mostly only one room deep, so you have a very subtle enfilade – each room leads to another and another. I absolutely adore that – it's usually a feature of very grand houses, and this house isn't in the slightest bit grand.'

Carlos, known for his ability to layer pattern, textiles and antiques, studied business and international trade, and worked in finance for Mercedes-Benz, before studying design. 'My mother was constantly changing things around and redesigning rooms, and I have always loved that; but I was from a background where interior design wasn't seen as a career,' he says.

His first job involved working on the decoration of contemporary apartments in London. 'I learnt a lot, and it was a wonderful way to start a career in interior design.' Eventually, after three years, he set up his own company, working on a variety of houses around the UK.

The designer wanted his and Michael's country house to be very relaxed and, partly for this reason, tackled the kitchen first – 'pretty much the hub of the house. In Norfolk, everyone always comes in through the kitchen,' he says. Even though new, this welcoming space looks as if it could have been there for decades. The Aga was already there when the couple moved in, and they installed a reclaimed butler's sink. Carlos used a local carpenter for the cabinets, 'because I wanted them made in the old-fashioned way, with proper hinges'. Adding to the warmth, a collection of 19th-century mochaware sits on a shelf above the worktop and, against one wall, an early 17th-century Welsh dresser houses Carlos' assorted collection of pottery, including Staffordshire hens and Scottish spongeware.

To one side of the kitchen is a snug, which is 'probably our favourite room, because it's very cosy and full of deeply personal items to us both', says the designer.

Opposite. In the snug, Theodora rests on a vintage Turkish kilim in front of the fireplace, the tiles of which were made in 17th-century Delft style by a local artist to reflect Carlos and Michael and their two dogs' lives in Norfolk.

The most striking feature of the room is the log burner, surrounded by Delft-like tiles, which were custom made by a local artist to wittily incorporate aspects of the Norfolk life of Carlos and Michael and their two whippets, Theodora and Tristan.

On the other side of the kitchen is the utility room, its shelves lined with jams, chutneys and pickles that the couple makes from produce harvested from the garden – a clear indication that Carlos is embracing the country lifestyle he has craved for so long. By the kitchen door, a 19th-century Hungarian bench sums up his approach to design. For a start, there's something casual about the placement of such a handsome piece of furniture, but it's also a distinctly practical decision, being the perfect place to sit when removing boots. Carlos' skill at layering is evident even here, with the mattress covered in a suzani he found in Istanbul, and the cushions a mix of suzani, pre-revolution Russian print and Lee Jofa textiles. The curtain over the door is a Robert Kime weave – a wide hem of leather protects it from the couple's dogs and traffic in and out. 'I don't like to use fabrics that look too flash or too new,' he says. 'I really like the subtlety of Robert Kime fabrics, and love to mix things up and make it all comfortable. My purpose when I was doing this house was not to have it look as if it had been done in one go.'

In this area, as in the entrance hall, the original floor – in this case, pament tiles – had been covered by tar for insulation and, here, lino. In the hall, the original diamond stone and terracotta tiles were buried under concrete. 'You can still see remnants of tar – I didn't want to go too hard when restoring it, as it would have destroyed the patina.'

Elsewhere, the warmth and ease of Carlos' design continues. In the dining room, a wall is hung with a Zardi & Zardi printed linen panel 'to add depth', rather than a tapestry. An antique Spode Imari platter above the fireplace is held in place 'with just a bit of Blu-Tack'. Hanging above the 19th-century refectory table is a candlelit chandelier. 'We never use electricity in the room, only candles – we all look much better that way!' says Carlos.

The Eastern-inspired drawing room 'has a collection of things I really like', he says, including a 19th-century Djizak suzani draped over the sofa, lampshades made from silk ikats bought in Istanbul, cushions made from his grandmother's fabric, chairs upholstered in a Robert Kime textile, and an armchair covered in a luxurious silk velvet from Colony Fabrics. 'It marks just by looking at it, but it was just the shade of mustard I was after.'

Robert Kime's 'Tree Peony' is used to dress the four poster in the main bedroom, the posts of which are 18th century. 'They are exquisitely carved, and I had the rest of the bed built around them,' says Carlos. In the guest bedroom, its walls painted a light olive green, the headboard and curtain fabric is an exuberant design by Nicole Fabre, and the bedspread belonged to his grandmother. 'In Spain, interiors are more decorative, whereas in England, comfort is of utmost importance.'

Carlos has more plans for the house – two more bedrooms to decorate – but he is in no hurry. The plan to use the house mainly as a weekender has changed: 'Most of my work used to be in London, but after coming to Norfolk, the balance has been readdressed.' Michael still has to work in the capital during the week, but Carlos is more flexible. The tradespeople he hired to work on the house are so good, he says, that now he uses them in projects in the country. At the time of writing, he was working on a manor house nearby, as well as a house in the neighbouring county, Suffolk. 'When I started doing interior design, it was primarily in London, so the style wasn't really country,' he says. 'I always wanted to do English country style, but never had the chance to do so before now. To be able to do both is a treat.'

'THE MAIN BODY OF THE HOUSE, FROM THE ENTRANCE HALL ALL THE WAY TO THE END, IS MOSTLY ONLY ONE ROOM DEEP, SO YOU HAVE A VERY SUBTLE ENFILADE – EACH ROOM LEADS TO ANOTHER AND ANOTHER. I ABSOLUTELY ADORE THAT.'

Opposite. A Hungarian bench, with mattress covered in a late 19th-century suzani from Uzbekistan, sits by the kitchen door. The 19th-century botanical prints behind are hand-painted and from a set of three.

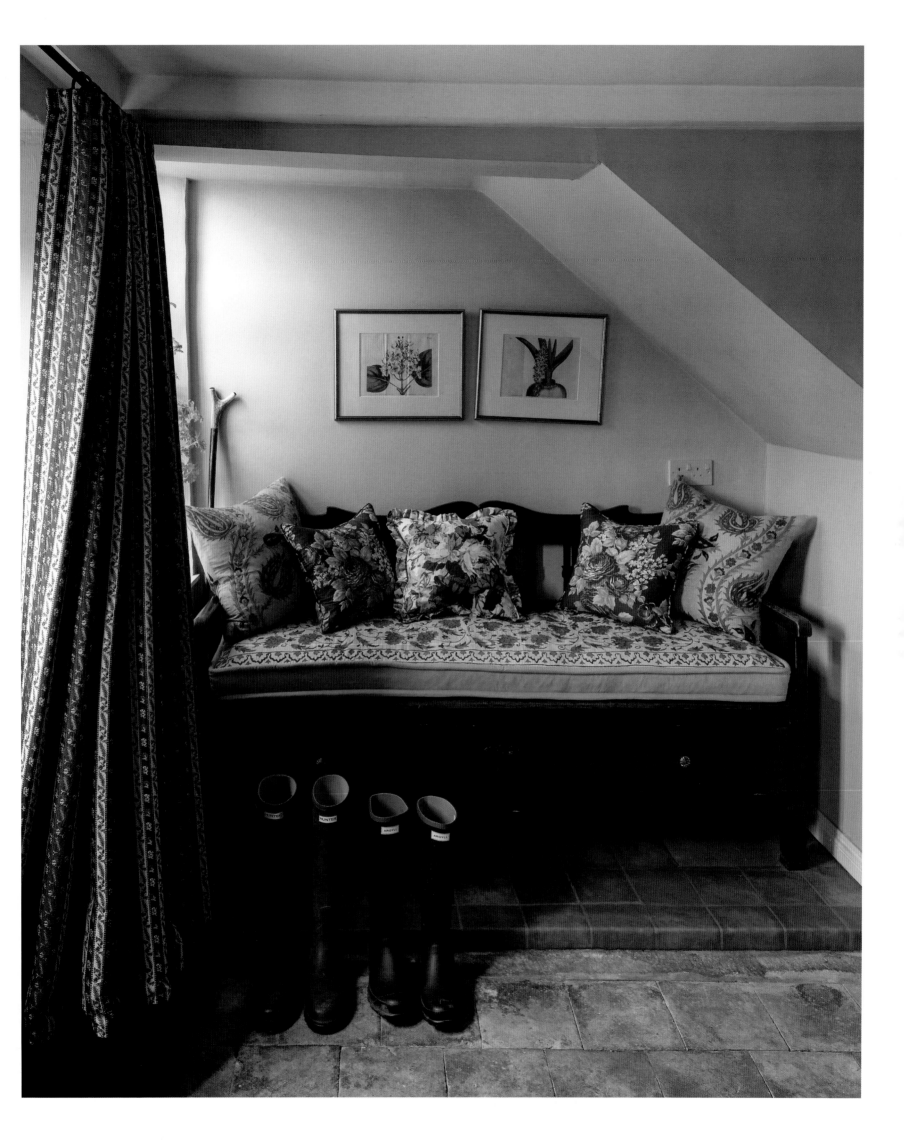

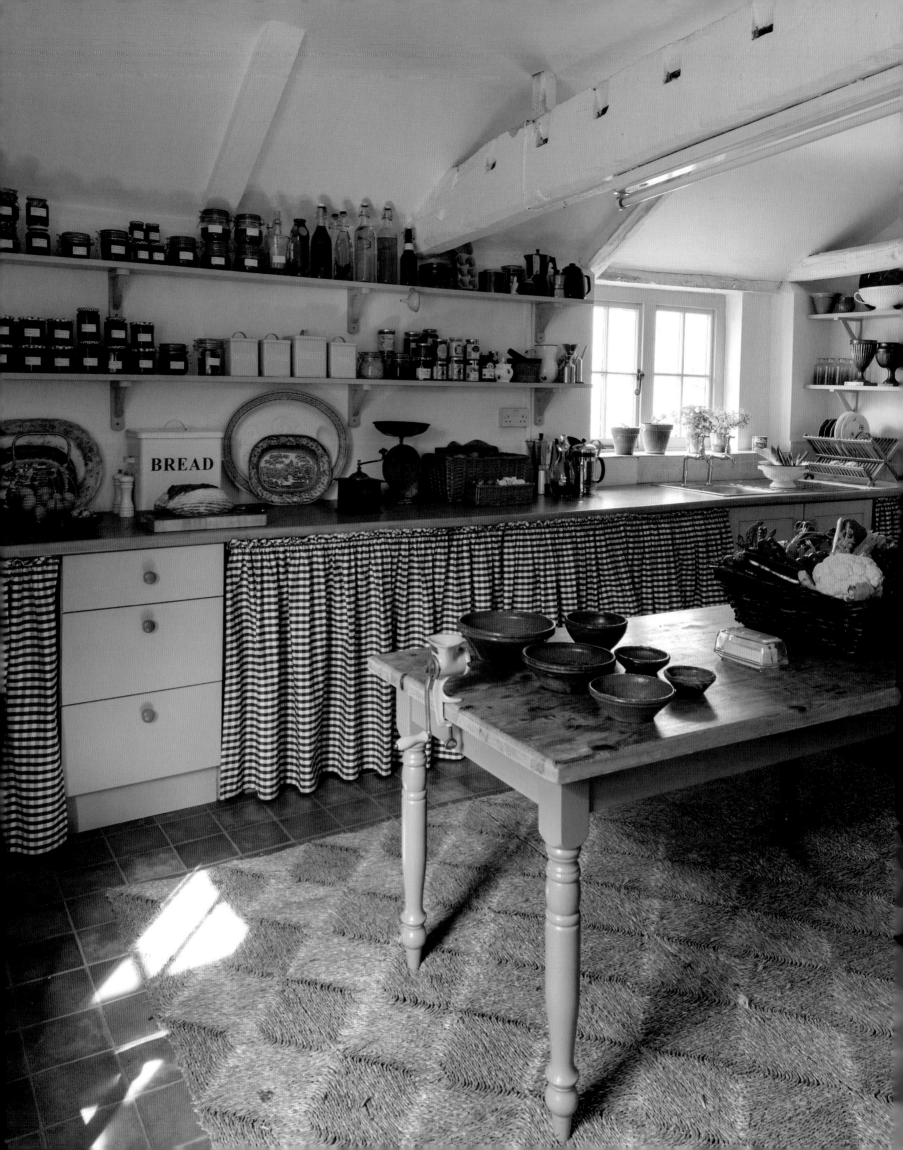

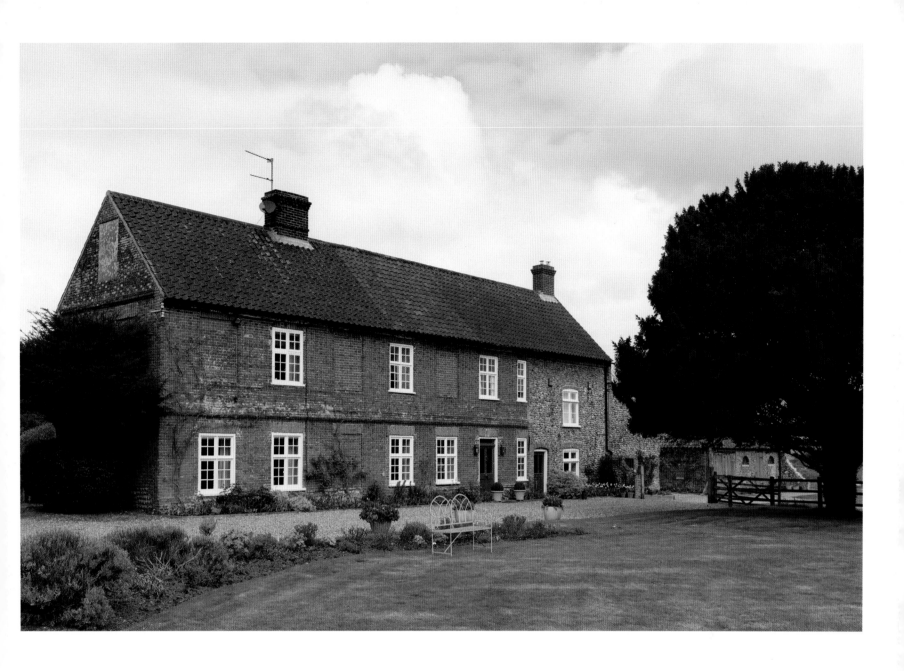

Opposite. All the jams and chutneys were made by Carlos and Michael, using produce from their garden. The collection of slipware was given to them by Carlos' mother, and the assorted platters are antique and were bought at a shop nearby.

This page. The oldest part of the farmhouse was built in 1635, with later additions made the following century. Some of the windows were blocked in the 18th century because of the window tax.

Overleaf. The two gothic Victorian nursing chairs in front of the fireplace in the drawing room were given to Carlos and Michael by a friend, and upholstered in a weave by Colony. The cushions that sit on them are made from an antique fabric and fringe from Carlos' grandmother.

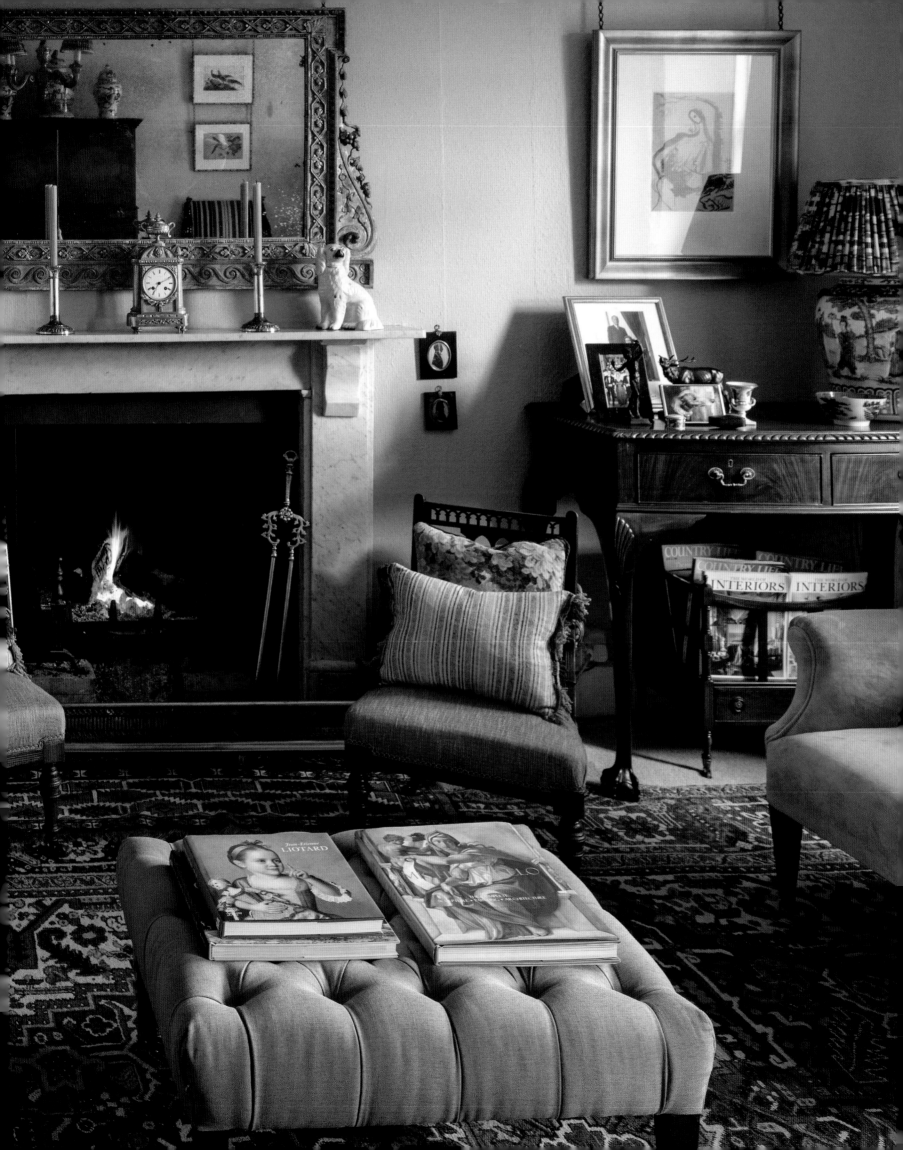

This page. A collection of mochaware is arranged on a shelf in the kitchen. The antique bowl holding the quinces is Iranian, and the tiles are antique Delft.

Opposite. A printed linen wall hanging by Zardi & Zardi is a feature of the dining room, and is based on a 17th-century tapestry in the V&A. The finely carved livery cupboard was made in the West Country in the 17th century.

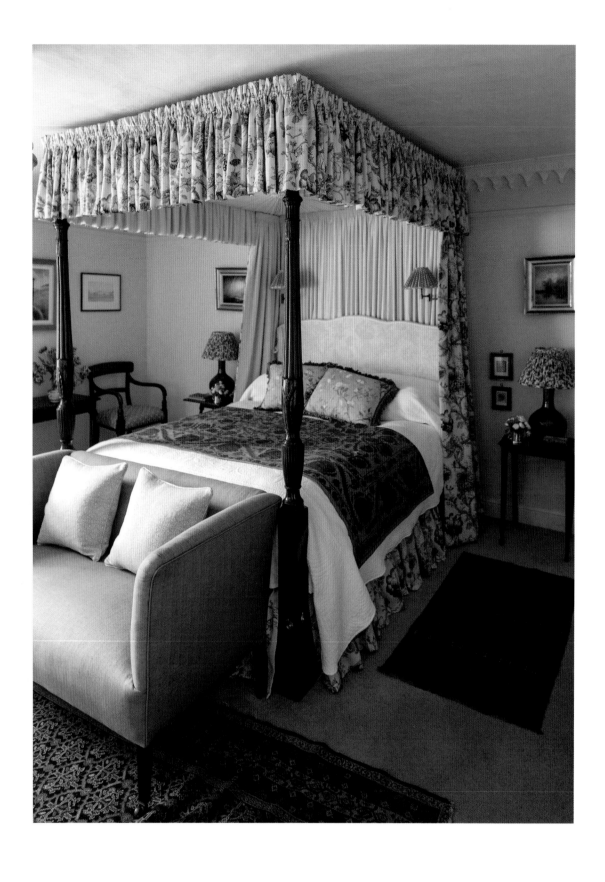

Opposite. A chair by William Morris sits beside a Georgian chest, bought at a local auction house.

This page. The four-poster bed was built around the two 18th-century carved Gillows posts which Carlos found in the Lake District.

This page. The dogs sleep on cushions made from a vintage Welsh blanket.

Opposite. Cushions on the sofa in the drawing room are covered in lampas by Colony and vintage ikats Carlos bought in Istanbul. The bespoke shade on the lamp in the background is also made from a silk ikat bought in Istanbul. The late 19th-century suzani is from Uzbekistan.

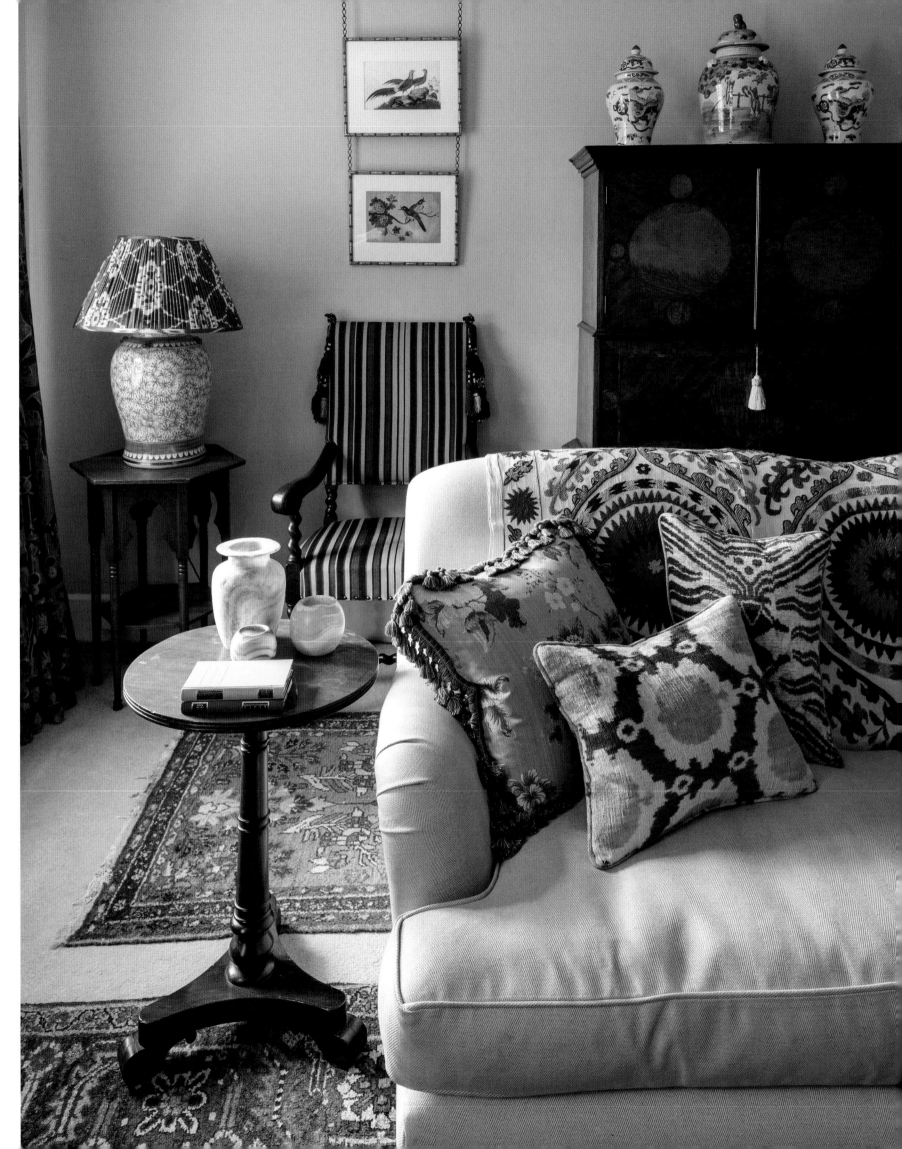

Q&A

What's your idea of home?

Being surrounded by things I love and having a feeling of safety and comfort. Also, having my dogs and Michael around me. Every single thing in this house means something to me – there's a little story behind everything. I particularly love to see things that my mum gave me – people stay close to me via objects.

Which designers have inspired you?

I have studied John Fowler's work a lot – he had a way to make things look elegantly comfortable. I also liked the way Nancy Lancaster brought a little wittiness into a room. Renzo Mongiardino and Geoffrey Bennison, too. I truly believe one has to learn from the past to inform the design of the future.

What's your favourite season?

People think I'm mad, but I love autumn and winter, I really do. I love the fast changing colours of autumn, and sitting by the fire on a cold winter's evening in the snug or in the drawing room with friends and a glass of wine. It's absolutely magical.

What does luxury mean to you?

The singing of birds at dawn, the silence around the house in the early morning over a cup of coffee, listening to the crackling of the fire or the wind howling outside. Friends and family around the candlelit dining table. The time to enjoy these things.

How do you relax?

I love to sit and listen to classical music or opera, or to read. Or take a walk with the dogs. Michael and I always have dinner together on Friday evening when he arrives, or we both do, from London. We love being in the kitchen together – this is real relaxation and luxury for me. We both work so hard, so it's appreciating the time we spend together.

Flowers or foliage?

I love gardening and adore bringing flowers into the house, and very rarely buy them. I try to be as seasonal as possible. I love using greenery in the entrance hall, and have geraniums all around the house. The tulips I plant are always chosen based on the decoration of the rooms in the house. I adore dahlias, and have planted many in this garden. My mother and grandmother always grew them, so for me it was a very natural thing to do.

Sheets or duvets?

Duvets – we always use down duvets with a bed cover on top. I like the way they don't give a totally perfect look. And as we live in Norfolk, electric blankets as well – we can't live without them.

What would you grab if there was a fire?

I've never thought about this, but it probably wouldn't be any furniture or a necessarily expensive item. Perhaps something given to me by Mama or Granny, or a very special book. And obviously the dogs!

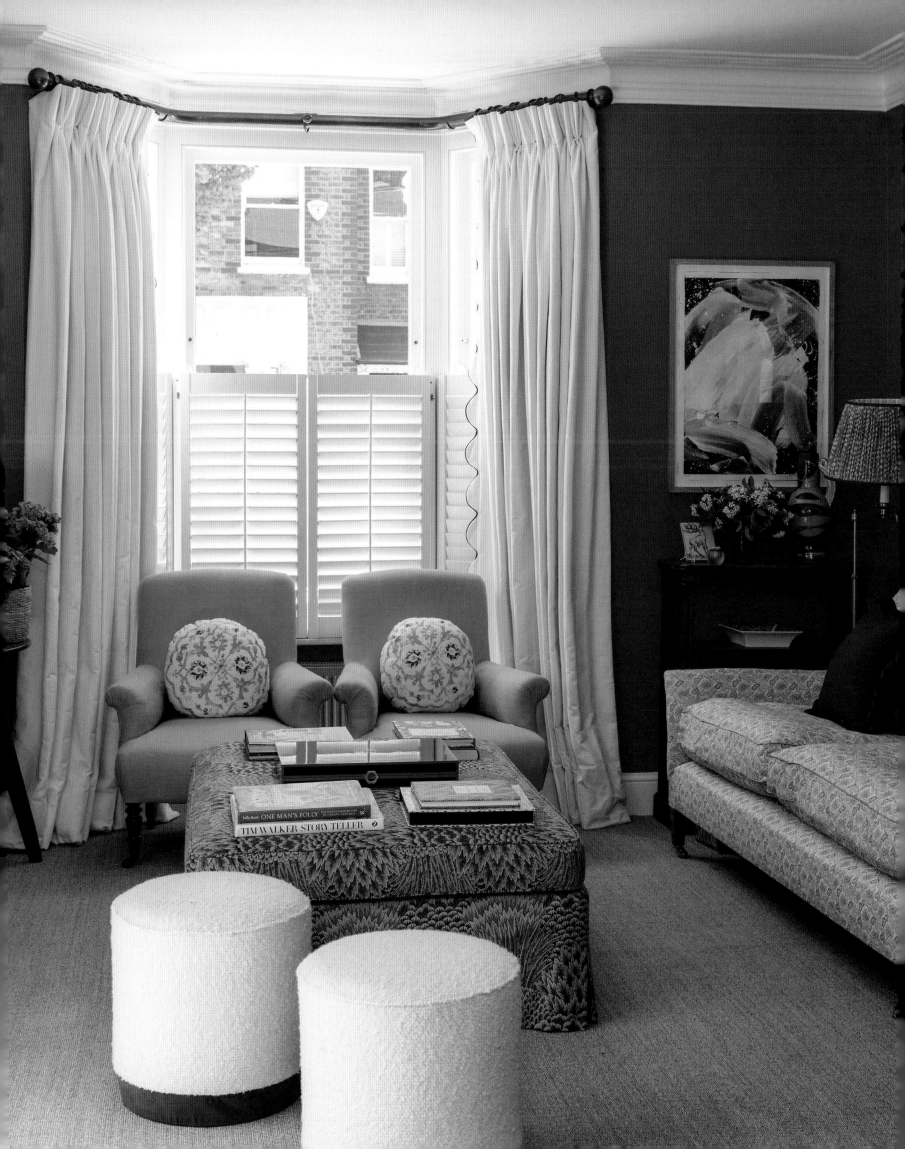

OCTAVIA DICKINSON

Soon after Octavia Dickinson started working with Cindy Leveson, she was told she'd essentially got the job because she knew what a good sofa was. 'I have a very large but close extended family, all of whom have decorated their own houses, so it was a pretty normal conversation to discuss fabrics and furniture,' says Octavia. When she was a child, she was constantly moving the furniture around in her bedroom. 'I went to boarding school at 11, and the first thing I did was to make my room as pretty as I could.'

Octavia comes from a creative family – her father, Simon, is an art adviser and fine art dealer; her mother was a school teacher; sister, Phoebe, is a well-known artist; and brother, Milo, deputy head of department at Christie's in London. As a child, Octavia had art lessons. 'My sister and I learnt to oil paint at a young age,' she says. 'I've always drawn, painted and made.'

Her plan had been to work in the art world; she studied at The Courtauld Institute of Art, and had stints working, among other places, with her father's company in both London and New York. 'I then realised that, although I love art, I hated selling, so I left, much to my father's dismay at the time.'

She worked as a researcher on art programs at the BBC for a while, but when a promised job there fell through, she applied for her first full-time job in design, with Cindy Leveson, her best friend's aunt, and stayed there for two-and-a-half years. 'She taught me everything,' says Octavia. One of the most curious projects she was involved in during that time was Hound Lodge on the Goodwood Estate in Chichester, West Sussex, a 10-bedroom house originally built in 1738 for the Duke of Richmond's dogs. It was being converted from a luxurious kennel into an exclusive rental holiday home. 'Every bedroom had to be different,' she says. 'We were creating a life there, with beautiful books, china and so on. It was so much fun buying for it, and doing it all.'

From there, Octavia went on to work for Flora Soames, whose aesthetic leans more towards the contemporary. 'I loved working for someone who had a slightly different eye to my own,' she says. While she was there, she did some small projects of her own on the side, before taking the plunge a few years ago and setting up her own business.

One of her early projects, which received publicity and gave her business a boost, was her own flat in Battersea, a few streets away from where she currently lives. 'I love this part of London because it's quite open – there's the park and the river – plus my sister lives next door, my parents are around the corner, and my brother lives close by.'

When Octavia and her husband, Harry, found the Victorian semi-detached house they are in now, it was uninhabitable and wasn't even deemed a 'house' in the eyes of the bank, on account of the lack of stairs, a kitchen or running water. They had a huge task, then, reworking it to suit the way they live. One of the major

projects was to extend the kitchen to the full width of the house and install a bank of doors opening to the garden. While the abundance of light and the deep blue of the walls give a contemporary feel to the space, the red baize doors provide a surprisingly historic element, albeit with a modern twist.

Elsewhere on the ground floor, Octavia lengthened the wall between the hall and sitting room slightly to accommodate a new two-metre-long sofa she had designed and to make the hall seem more substantial. A library was already in place off the hallway when she and Harry moved in – 'I just took out the not-very-nice joinery and designed new bookcases.' A slice was also taken off the library for the utility room, and a downstairs cloakroom was converted to a drinks cupboard.

Upstairs, the main bedroom and bathroom were reworked, with a wall between the two removed and bedroom cupboards built in what was once part of the bathroom. A staircase was also installed up to the attic, which had originally contained just one bedroom, which is now their son, Digby's. An additional bedroom and bathroom were built into the space, and skylights added.

Throughout the house, Octavia's attention to detail is paramount, and the combination of elements and design choices are often unexpected and highly individual. This fits with her design philosophy that a home should reflect the people who live in it, and 'it should therefore be unique'.

In the designer's own home, her favourite room is the bathroom. 'I just love it and can spend hours in there,' she says. But equally, it's all about how well the house works for entertaining. 'I love cooking, I love setting the table and having everything spread out for people to help themselves – we love having people here. The more the merrier!'

'I HAVE A VERY LARGE BUT CLOSE EXTENDED FAMILY, ALL OF WHOM HAVE DECORATED THEIR OWN HOUSES, SO IT WAS A PRETTY NORMAL CONVERSATION TO DISCUSS FABRICS AND FURNITURE.'

Opposite. The kitchen table, surrounded by antique chairs, was designed by Octavia for her previous flat. She couldn't afford the chandelier she really wanted, so bought a white one from Visual Comfort and spray painted it.

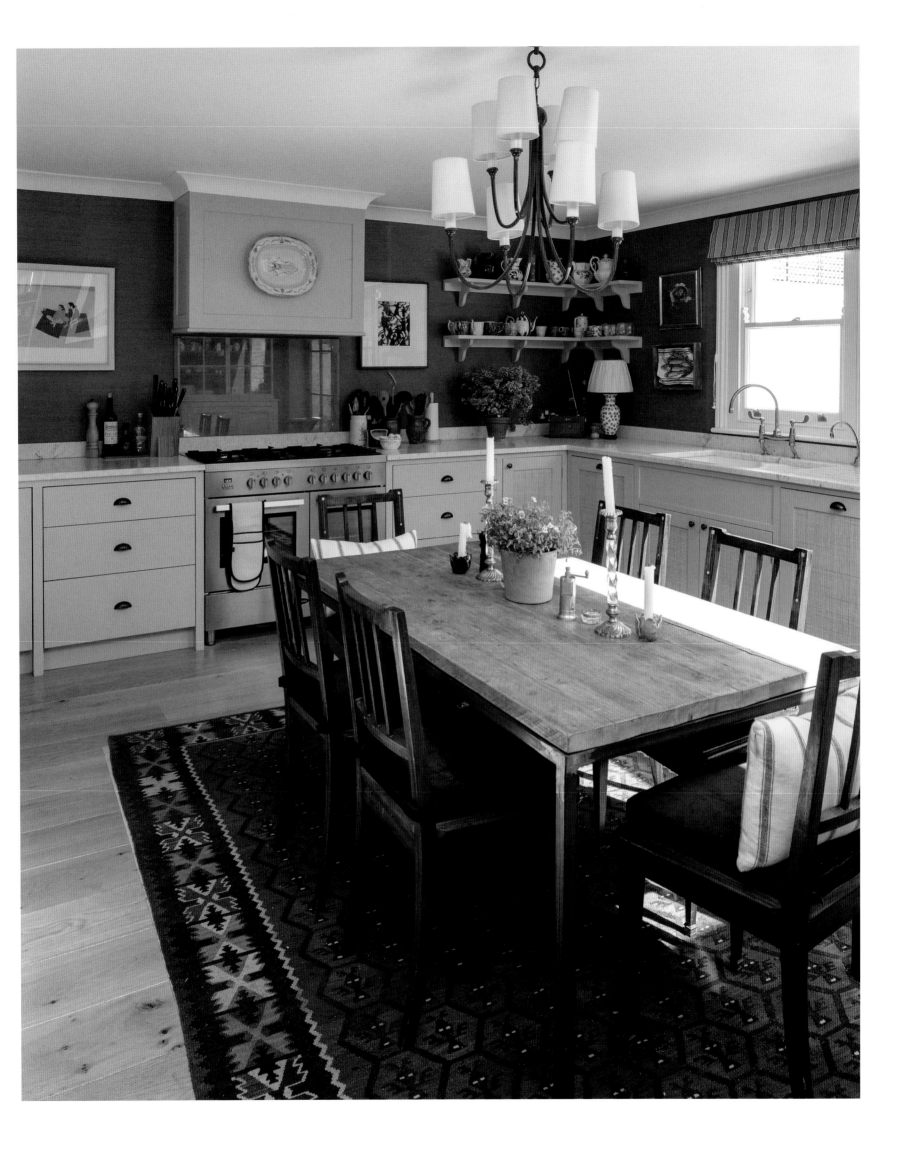

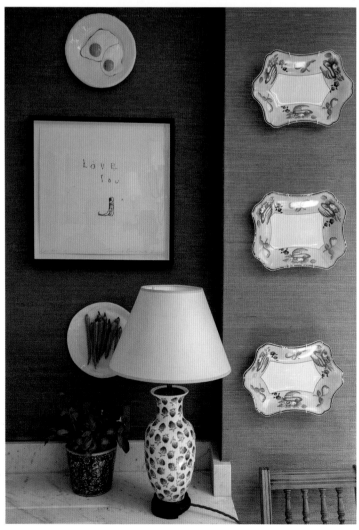
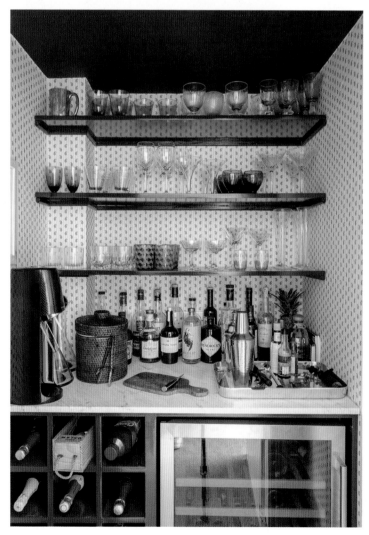

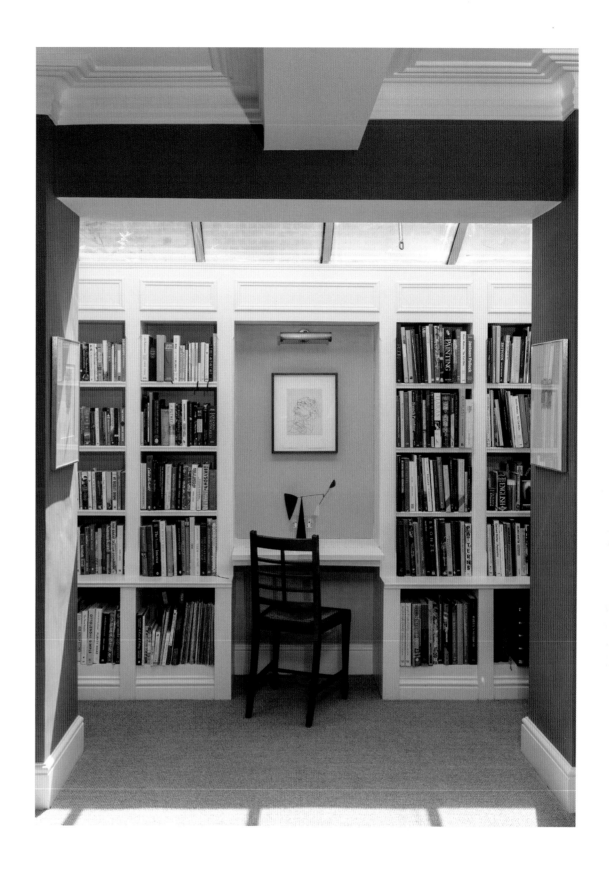

Opposite, clockwise from top left. The kitchen door is panelled in burgundy wool serge on one side and green wool serge on the other; a view from the kitchen into the sitting room and hall; the drinks cupboard is lined in Howe 'Mr Men Linen' in Clover; Octavia made the carrot and egg ceramic plates in her pottery class.

This page. Octavia replaced some temporary bookshelves with ones she designed to hold not only regular sized books but her deep photo albums and large collection of art books.

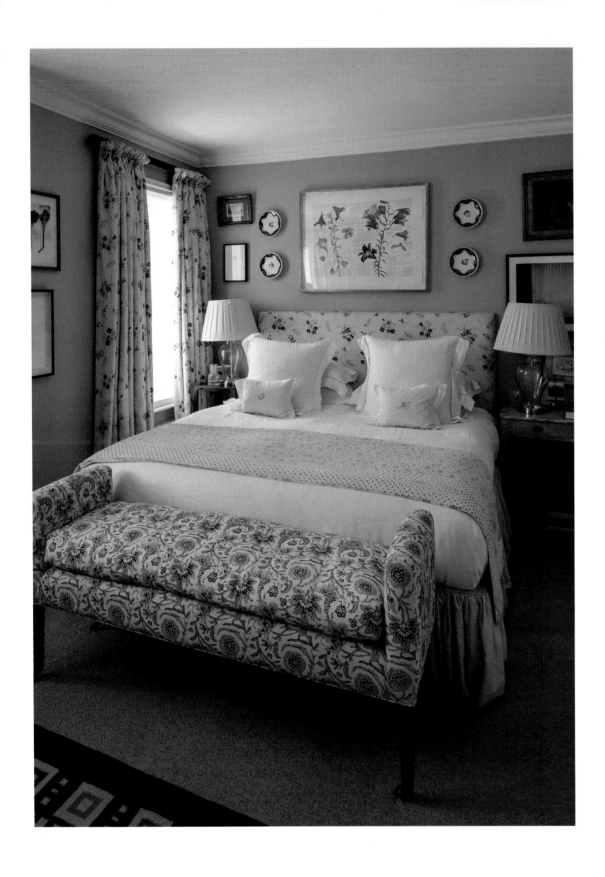

This page. The Claremont curtains and headboard in the main bedroom came from Octavia's old flat. She designed the stool at the end of the bed, and upholstered it in red on oyster Bennison 'Injigo Lace'.

Opposite, clockwise from top left. Bennison 'Petites Fleurs' is used for the vanity and bath panel; a view through the cupboards into the bathroom; a wall in the attic bathroom is covered in nursery plates, which Octavia collects; the coaching table in a spare bedroom was given to Octavia by Cindy Leveson.

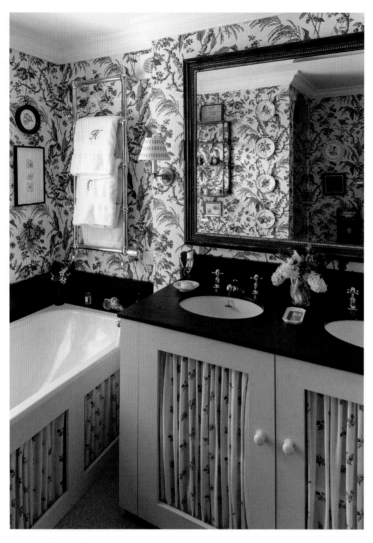

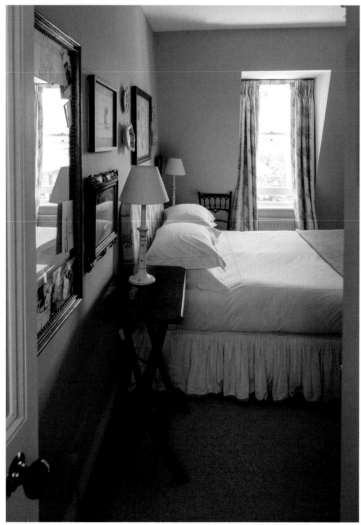

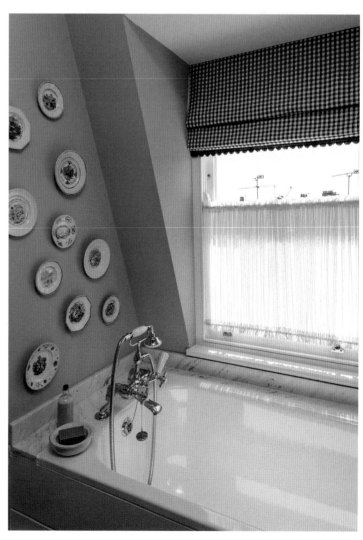

Q&A

What does the word 'home' mean to you?

Somewhere that my friends and family feel comfortable to pop round to at any time of the day, for any reason.

What's your idea of luxury?

Real comfort and space. I do also adore a hot bath in my bathroom. And really good food.

Is there anything, in particular, you collect?

China. And because I make porcelain vegetables, I do get given some as well, so I've started collecting them, too.

What's your favourite room to design?

I love bathrooms if I'm allowed to really go for it. I have always dreamt of designing a bath surrounded by bookshelves.

The best advice you've been given?

Be nice to builders – and don't be scared of using colour.

Do you have a set way of working?

I normally like to see the space and get a feel for it first, and discuss with the client how they want to use it. I think it is important to work this out, as we are living in a different way from previous generations and need to design our rooms to reflect this.

Is there anything else you'd like to do to this house?

I am currently designing some furniture, pieces that I can't seem to find anywhere, so I am excited about incorporating these into my house.

Who are you inspired by?

I love every single one of Robert Kime's fabrics and the way he mixes everything together. Also Piers von Westenholz – he has a wonderfully strong masculine aesthetic. I think Beata Heuman is incredibly original; and Cindy Leveson and Flora Soames, of course, inspired me a lot.

What kind of books do you like?

Fiction mainly, I like the escapism – I'm very open to what I read, and I'm always asking people for recommendations. I always try to finish what I'm reading, so it's bad if I'm not enjoying it!

Are you good at relaxing?

Yes. I relax in the bath, and I love a very lazy morning on the weekend. I also spend a lot of time outside in the garden at my parents' house in the country. I do pottery once a week on Wednesday evenings – it's very therapeutic.

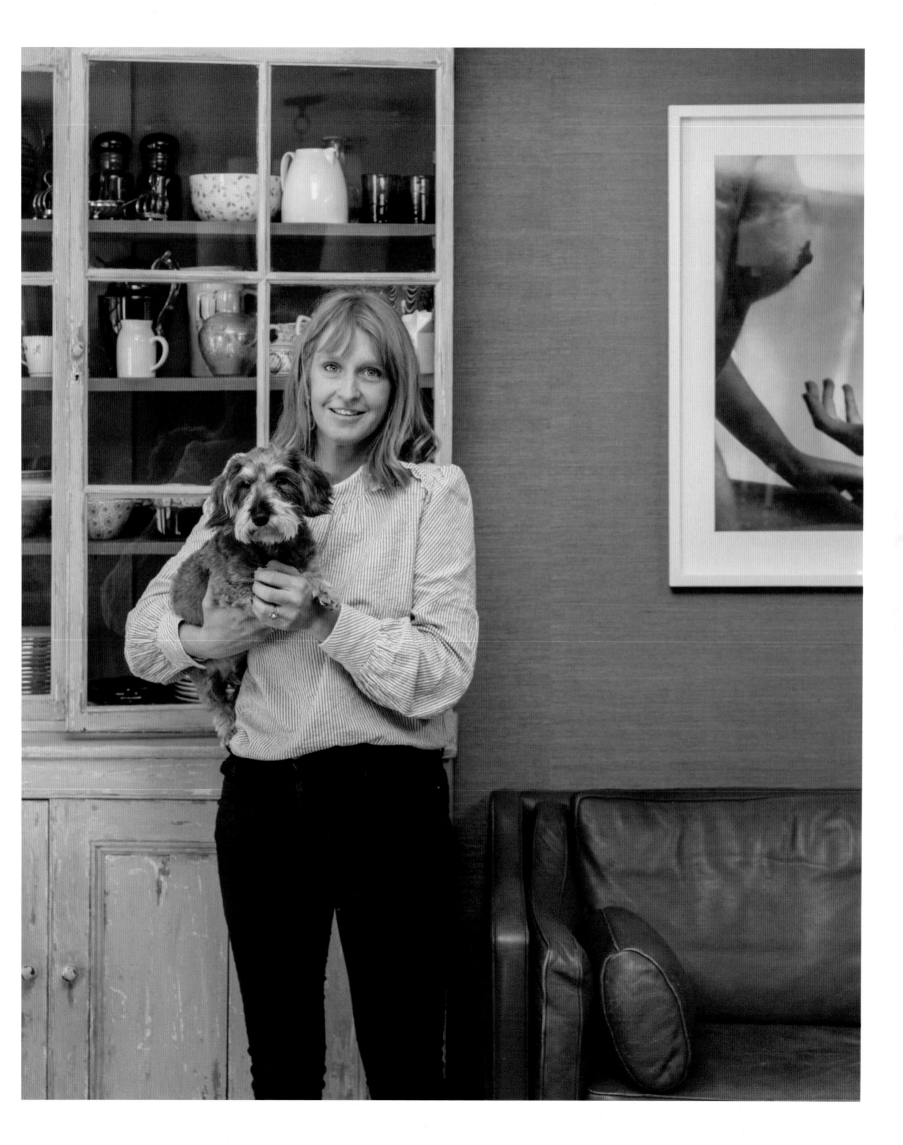

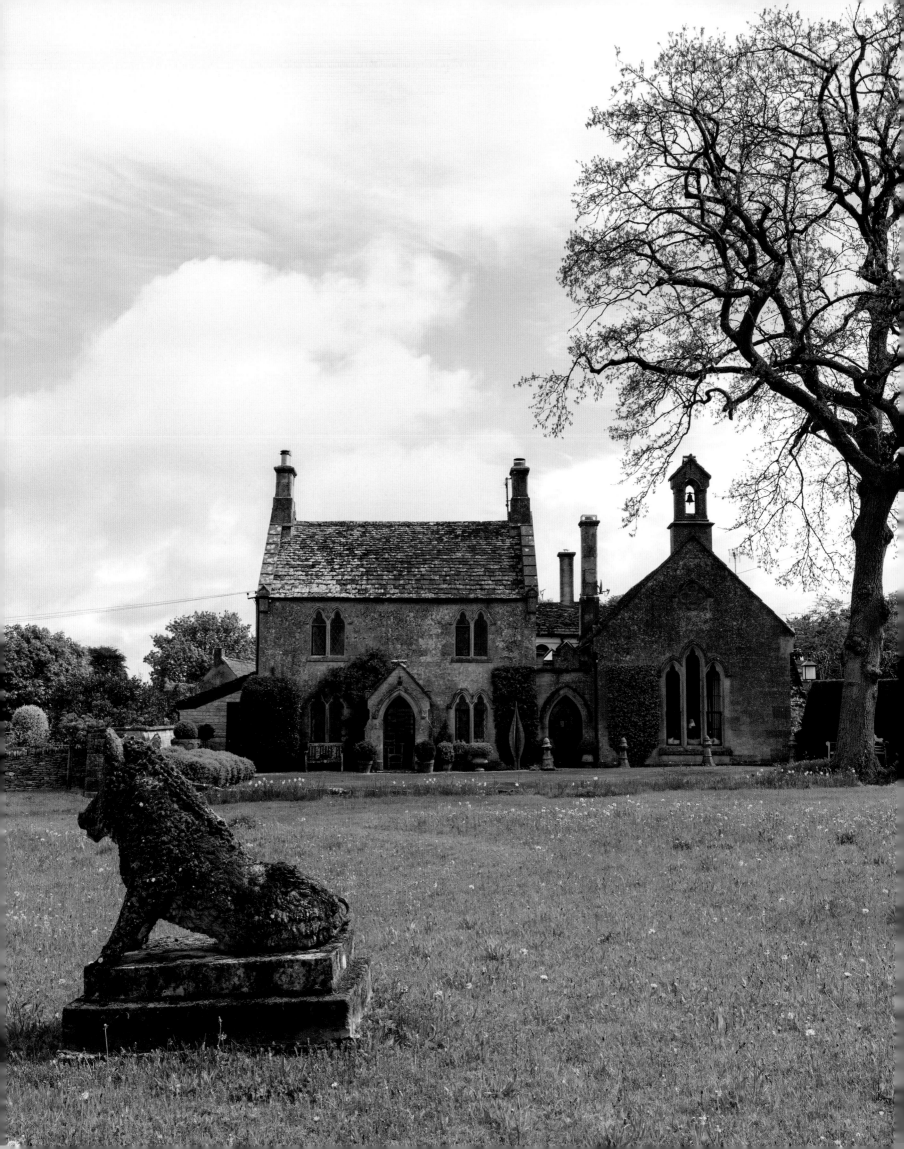

COLIN ORCHARD

Colin Orchard and his partner, William Yeoward, went to The Art & Antiques Fair in London's Olympia one year, looking for something to hang on a bare wall in their country drawing room. 'We split up and met up a couple of hours later,' says Colin. 'I said I thought I'd found something, and William said he had, too.' In fact, they had found the same piece – an enormous, framed, embroidered hatchment, with the motto 'Loyalty and Fidelity'. 'We both fell in love with the look and scale of it.'

There was only one slight problem – when they got it down to their house in the Cotswolds, it wouldn't fit through the front door. 'We had to get the framer to come all the way down here to take it out of its frame, and then reframe it to hang in the drawing room,' says Colin. 'So it's stuck in this room!'

The fact that they were both drawn to the same piece could be taken as a sign that, although the couple didn't always agree entirely when it came to design, they were very much in tune with one another. We visited their house in the Cotswolds when William was very sick – sadly, he died a few weeks later. The house says so much about the two of them, with signs of William everywhere; and, hopefully, this chapter will provide a fitting tribute to William and Colin's great love for it.

William's fabric and furniture can be found around the house; the blue bedroom, in particular, features his fabric, as well as a bed and chest of drawers from his country range, plus one of his rugs. 'This room was changed about three years ago,' says Colin. 'William had been sick, and was lying in the previous version of the bedroom when, one day, he said, "I can't be in this room anymore." I told him to redo it exactly the way he wanted it to be.'

A similar degree of comfort and intimacy can be found in the study, the 'everyday room', which Colin describes as 'enveloping', with its well-used bridge table and four chairs and, above the sofa, a painting by Adrian Hill of a working men's club in north-east England. The walls in this room, as well as the dining and drawing rooms, are all decorated in glazed paints. 'I don't trust solid colours,' he says.

Colin grew up in Edinburgh, and has been immersed in design since childhood – both his father and grandfather were architects. 'I always enjoyed the interiors side of things, and when I told my father I was interested in interior design, he stipulated that I would have to do a business degree first – I'm so grateful that I did.'

While Colin was working in Scotland for A.F. Drysdale, the agents for Colefax and Fowler, he used to travel to London two or three times a year to see the company's new collections. It was on one of these trips, in the early 1980s, that Tom Parr offered him a job. Colin met William, who was working for Tricia Guild at Designers Guild, around the same time. 'I had the rest of the Eighties at Colefax and Fowler, and eventually set out on my own in late 1989.' He's kept his office small, with only two people working full-time for him and someone who does all his drafting and drawing work. 'Everything I do is hand-drawn – I don't like CAD.'

Opposite. A stone boar, nicknamed Barry, is an early 20th-century copy of a sculpture in the Uffizi Galleries, and was Colin's present to William on his 60th birthday.

Most of Colin's clients are intensely private, he says, which means that his residential projects have had little publicity. Much of his work comes by word of mouth, although his award-winning restoration of Ballyfin, a country house hotel in County Laois, Ireland, 'has helped enormously'.

In 1990, Colin and William bought a small rundown cottage in the Cotswolds as a weekend retreat. 'We did it up – I was utterly enchanted by it.' A few years later, their solicitor was selling his house, a ramshackle property sitting on 18 acres of land, and they decided just to take a look. 'Amazingly, William realised that his aunt had lived there when he was very young, and he really loved this house. I had to agree with him.' They ended up buying it, but it took Colin a while to warm to the new house, as he still missed their 'beautiful cottage'.

They spent six months living in the new house to acquaint themselves with it, then moved out in order to create the drawing room, kitchen and hall, and amalgamate two rooms to form the study. About 10 years ago, they moved out again, knocked out the back of the house, built the new dining room and created the hallway (Colin designed the staircase) with a large bedroom above. The couple incorporated gothic elements throughout, such as cornices and doors, in keeping with the building's exterior. 'Then we had to stop, otherwise it was going to become a gothic museum!' says Colin. While work was being done, they lived in a cottage in the garden, away from the main house and tucked behind copper beech hedges. 'We called it the council house, but it's now known as the "guest disposal unit"!'

Part of the reason the house took some getting used to was that it was hardly conventional, and 'an absolute dump', says the designer. One part was a schoolhouse from the 1850s, and the other, quite separate section, was the schoolmistress' cottage. As part of the restoration, the two buildings were linked via a hallway with a skylight and a new front door added, which William later had painted bright red. The kitchen, which was once part of the junior school, was painted pink at the suggestion of Cath Kidston, a friend and neighbour. The drawing room, originally a schoolroom, too, used to have much higher sills, which Colin and William had lowered to bring in more light. Colin used original John Fowler drawings when designing the elaborate window treatment in the drawing room. William's preference, he says, would have been a pole with simple white linen curtains.

With its unusual provenance as an educational establishment, and the alterations to it that Colin and William made over the years, there's a sense that a house, like life, adapts and adjusts to circumstances, providing a sense of continuity. Colin still has plans for the dining room, which was only painted recently. 'What I want to do is find some deep pinky-red and white ticking for the curtains, thin like dress fabric, and with a big frill.' Nothing is ever static; change is inevitable, especially with design expertise at hand.

'I ALWAYS ENJOYED THE INTERIORS SIDE OF THINGS, AND WHEN I TOLD MY FATHER I WAS INTERESTED IN INTERIOR DESIGN HE STIPULATED THAT I WOULD HAVE TO DO A BUSINESS DEGREE FIRST – AND I'M SO GRATEFUL THAT I DID.'

Opposite. William and Colin designed the door, along with the side panels and quatrefoils above, all in a gothic style to suit the house. The collection of old canes sits in a bronze and brass fire brazier.

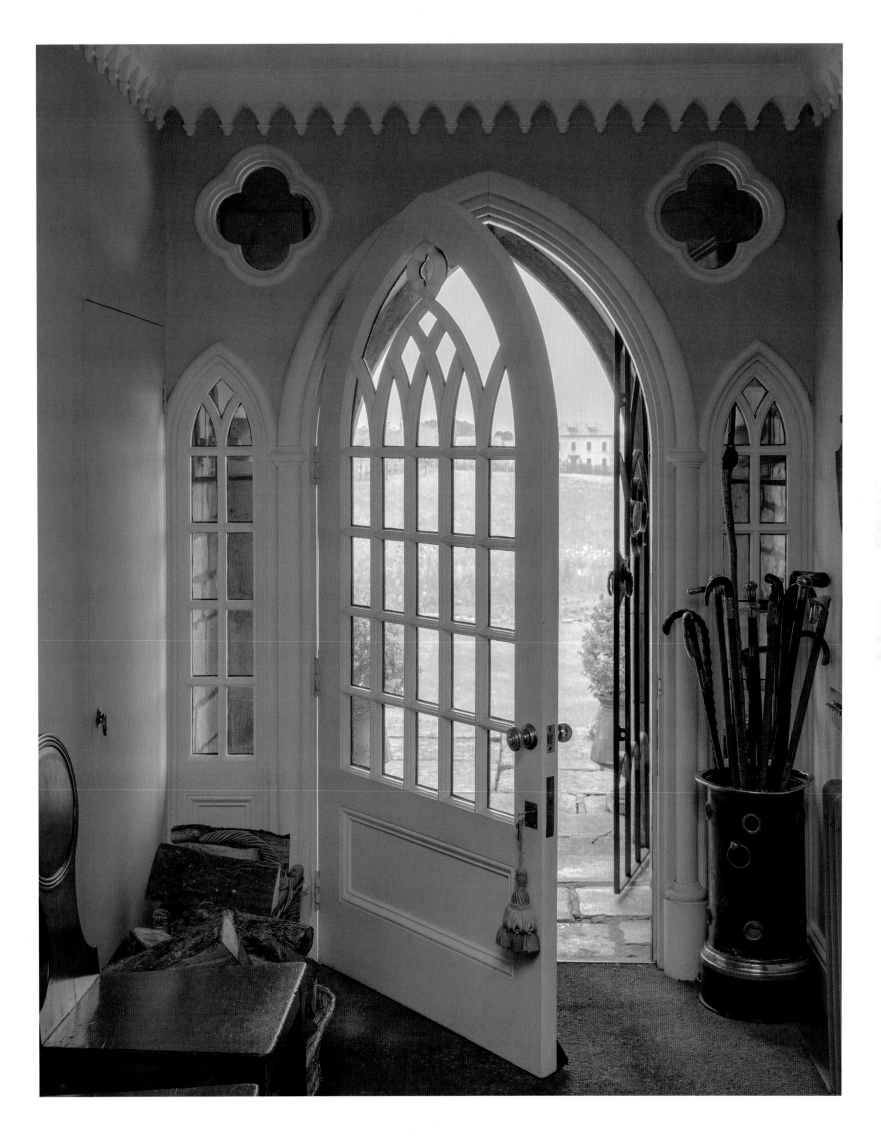

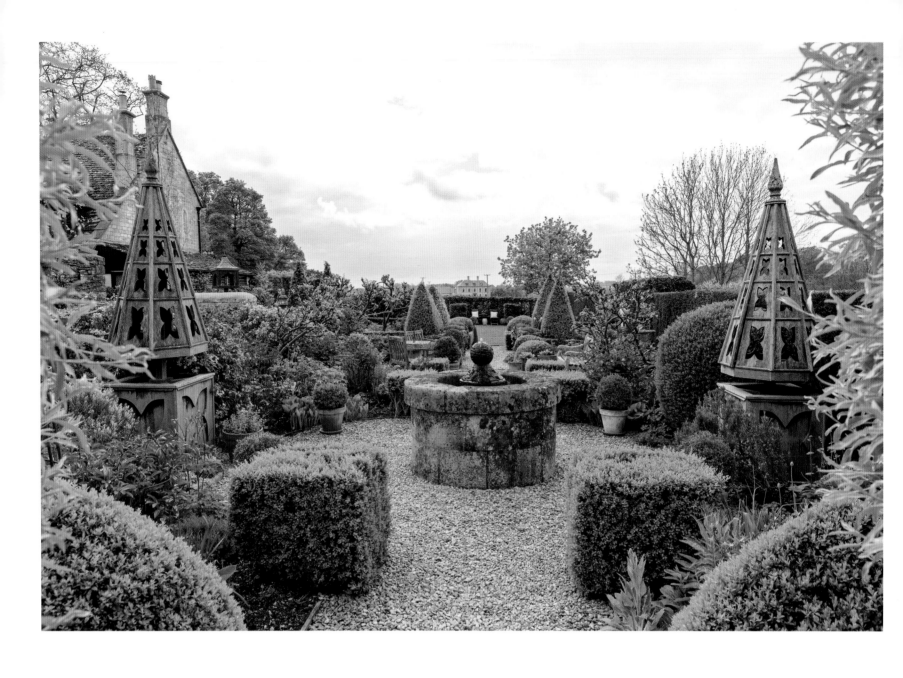

This page. William and Colin had the two bird houses made from an American design for the rear garden. An old well head, with the workings removed, forms a water feature.

Opposite, above. The Cherington bookcase was designed by William for the house, and made within his company.

Opposite, below. In the study, a painting by Adrian Hill of a working men's club hangs over the Percy sofa by William Yeoward, which is covered in one of his weaves.

Overleaf. The large portraits on either side of the fireplace in the drawing room were bought for their scale and colour. The Italian mirror hanging above the fireplace was found at The Country Trader in Sydney 20 years ago.

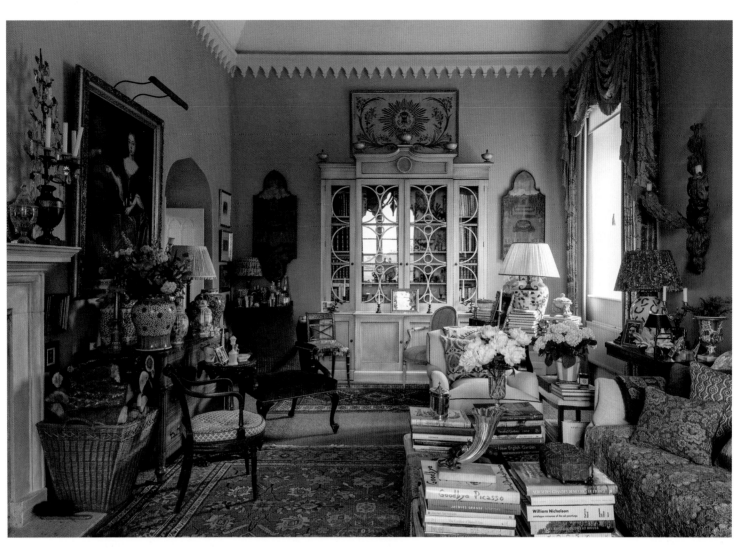

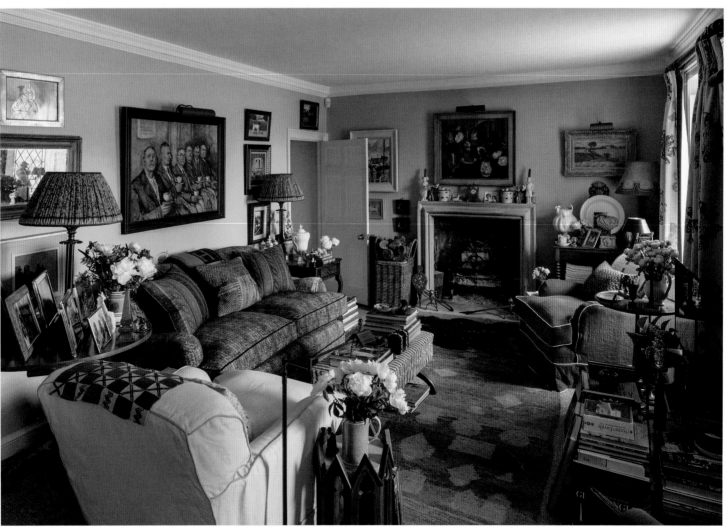

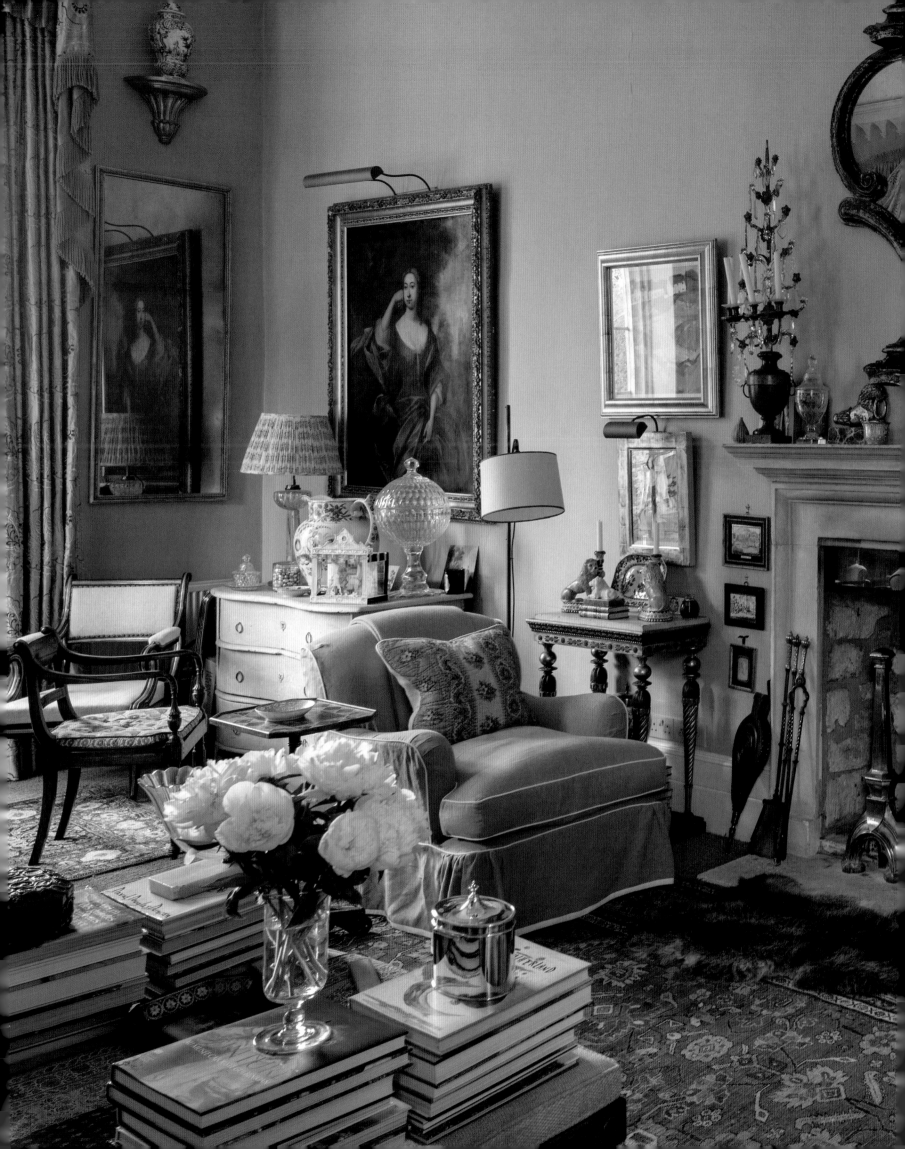

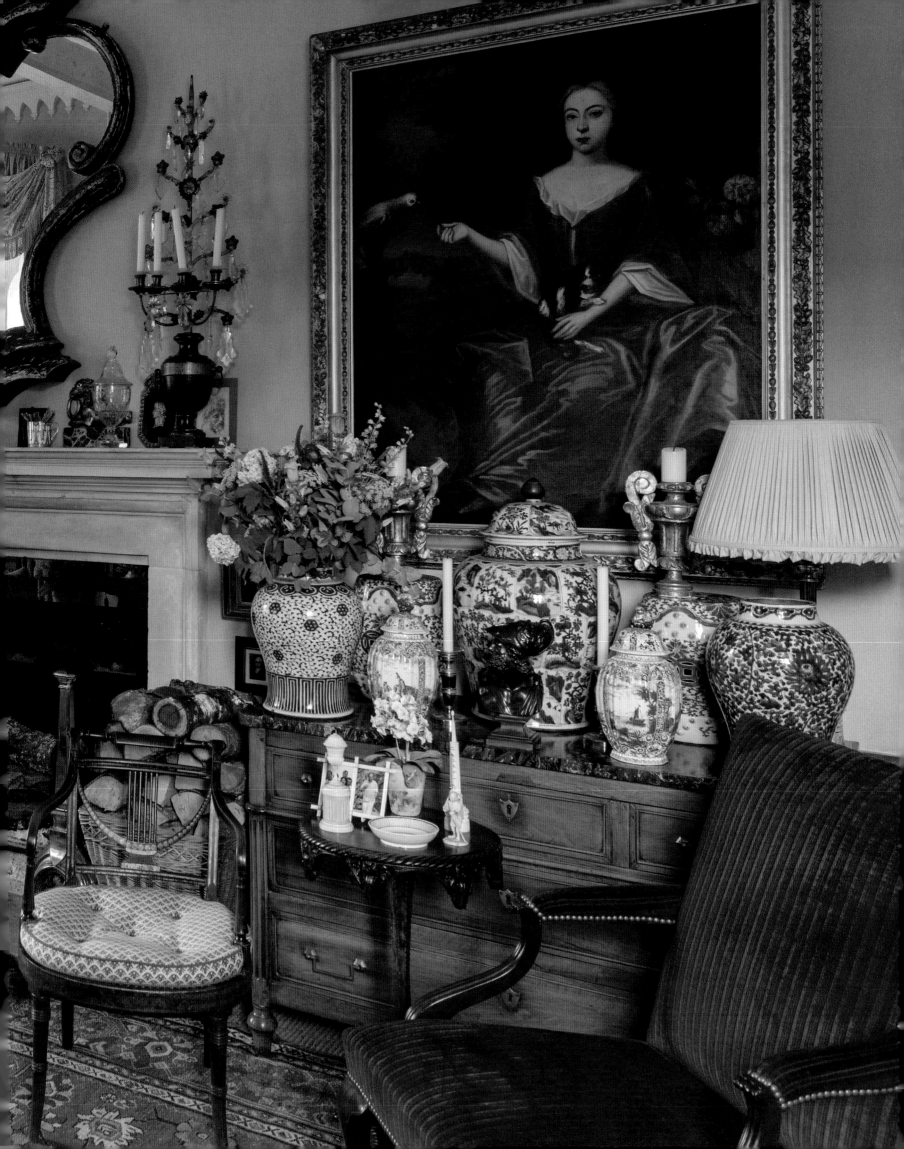

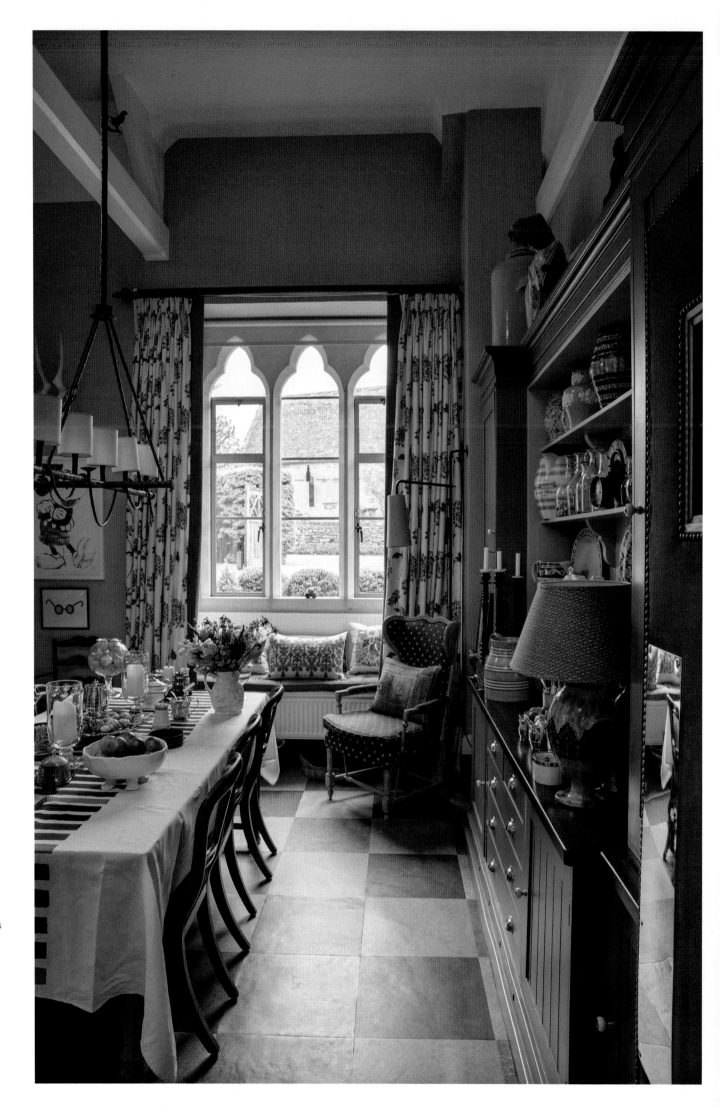

This page. A discontinued Designers Guild fabric was used for the curtains in the breakfast room. The chair near the window is by William Yeoward, and is covered in his spot linen.

Opposite, clockwise from top left. A Scottish Arts and Crafts table sits in the study, a room that is used daily; an Italian terracotta figure, bought in Lucca, provides a handy hatstand in the hall; a fish seller from the 19th century, probably Portuguese, hangs above the Aga, which is always left on; on a wall above the sofa is the framed hatchment which Colin and William were both drawn to.

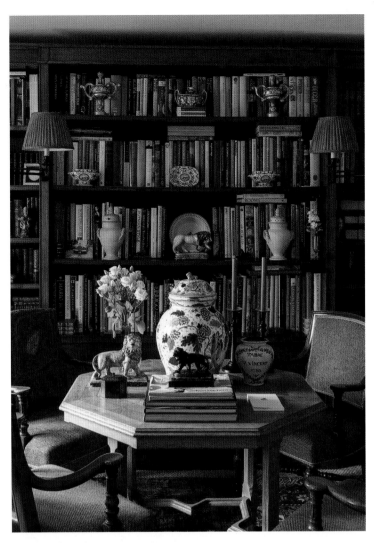
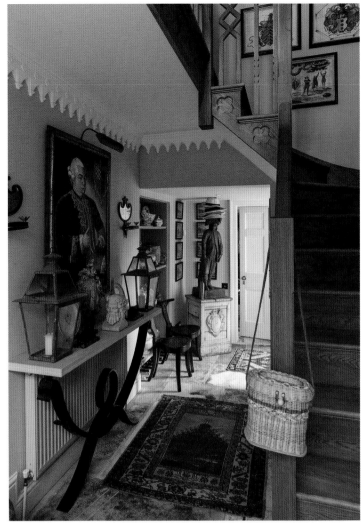
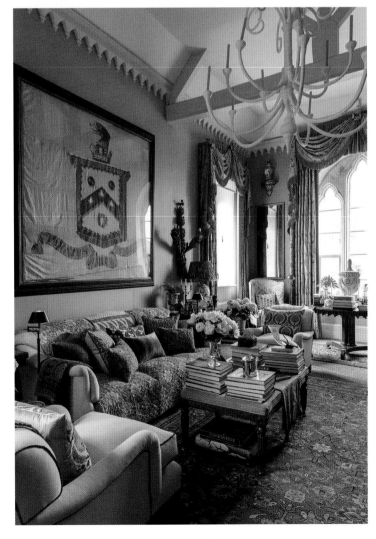
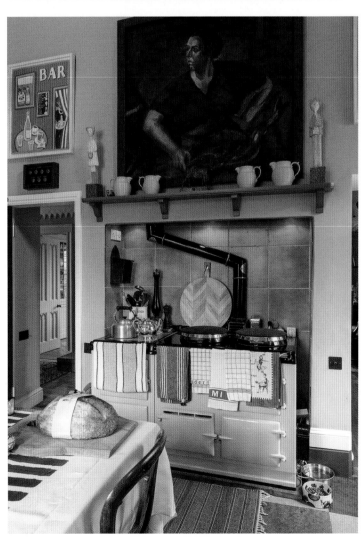

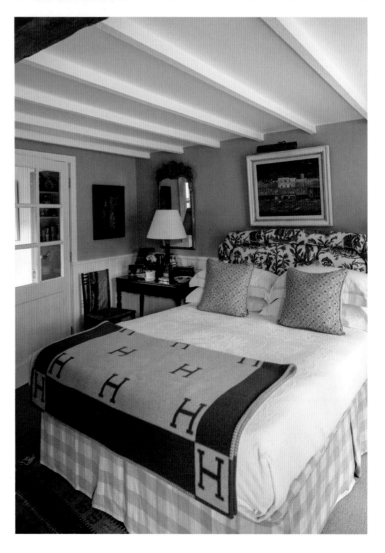

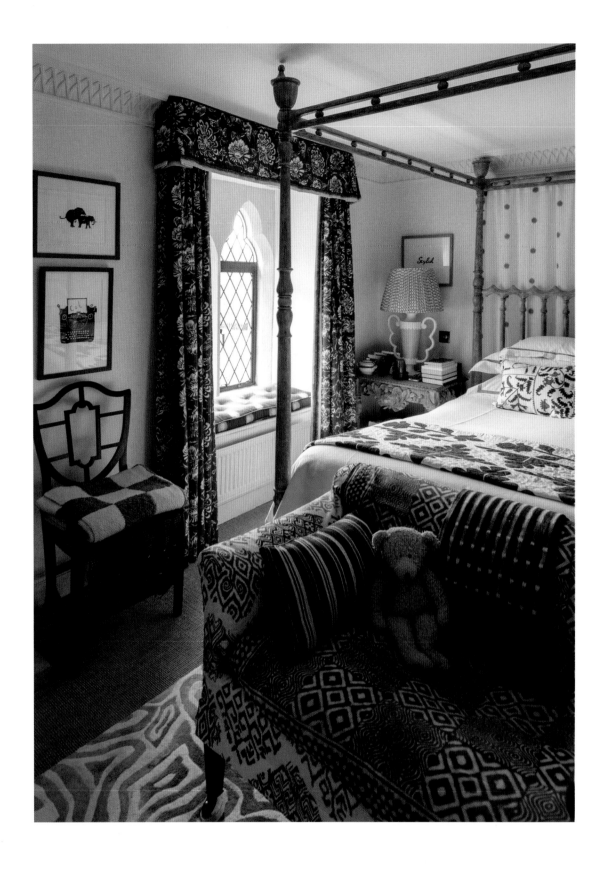

Opposite, clockwise from top left. 1950s wall lamps, from a Paris flea market, are a feature of the kitchen in the guest cottage; artwork bought on holiday hangs against William Yeoward wallpaper in one of the guest bathrooms; an old Pierre Frey print is used for the bedhead in a guest bedroom; the walls of the garden room are lined in a William Yeoward paper-backed printed linen.

This page. While William was ill, he redid the bedroom exactly how he wanted it. Colin's old teddy, Duncan, sits on the small William Yeoward Howard sofa, among various old textiles and cushions.

Q&A

How do you relax?

I sit in the drawing room with a glass of beer and the paper! I also love working in the garden, and walking Robert, our dog. I'm here, basically, from Friday afternoon until Monday mornings, so we do nice long walks.

Do you collect anything special?

I love looking for old or antique textiles. In London I have a collection of Scottish contemporary colourists. I think I'm beginning to move a little bit towards contemporary art. And lions, of course – I've probably got about 40 pairs. I don't know why, I've always loved them.

What's the best piece of advice you've been given?

Never make a client feel stupid or small. If they disagree with you, try to talk them around. Don't bully or patronise your clients.

As far as design goes, has anyone influenced you?

The people I very much admire are David Easton and Chester Jones – I very much like his work. I also like Robert Kime.

Fiction or non-fiction?

I read a lot – mainly non-fiction. I love reading about people's lives.

Which are your favourite countries?

For relaxing, Greece – I love the culture. For interest, definitely India. I'm passionate about India.

What's your idea of luxury?

Living with lovely things, and having fresh flowers in the house. Peonies are my favourite, and I adore sweet peas. On the opposite end of the scale and season, I adore dahlias in all their colours. They are the only things that keep me cheerful at the end of summer. When I was at college in Edinburgh and had to go home to eat because I was so poor, I always had flowers in my room.

Is there anything you don't like about your house?

The cost of running it!

Having done a whole hotel, is there a room you particularly enjoy designing?

Public rooms – libraries, drawing rooms, studies and dining rooms. I get a bit bored with bedrooms. And I never see the point of spending a huge amount on a kitchen, when you could keep it simple and have a few beautiful paintings instead. I'd rather have a lovely old dresser, stick it against a wall, and fill it with faience.

How would you describe your aesthetic?

Broken-down grand, bashed-up formal, a dog on the sofa!

If you weren't a designer, what would you be?

Probably a gardener, and buying and selling antiques. Certainly not a cook – William always used to say that if I did the cooking everyone would be in hospital in four hours, which is slightly unfair. I can do roast chicken and bread sauce.

ADDITIONAL INFORMATION

ROBERT KIME

Page 21 Top right: A pair of Stuart beech side chairs flank the commode. Walls are painted in Little Greene 'Drizzle'.

RITA KONIG

Page 24 Dresser, with douglas fir countertop, painted in Plain English 'Army Camp'. Vintage sink from Howe; taps from Plain English. Vintage glass light from Howe. Jug from Nook Antiques. John Derian marble design teapot for Astier de Villatte.

Page 27 Cushions on the Nina Campbell Collingwood sofa in Raoul Textiles 'Obi' and vintage Katherine Poole. Armchair upholstered in 'Nantes' by Lewis & Wood, with vintage crewelwork pillow. 'I love it – it's a bit big, but it's very soft,' says Rita. Vintage faux tortoise glazed ceramic lamp from Nimmo & Spooner. Marianna Kennedy Trumpet lamp from Rita Konig. Curtains in Claremont 'Straub Twill', with Nina Campbell 'Trianon' braid. Portrait of Nina's mother's Yorkshire terriers by Neil Forster above a junk shop find.

Page 29 Top right: Walls painted in Edward Bulmer 'Trumpington'. Below: Walls painted in Edward Bulmer 'Lilac Pink'. Geoffrey wingback chair from William Yeoward, upholstered in a Manuel Canovas check. Brass wall sconce from Doyle Antiques. Stella pendant by Pooky Lighting. Amanda Lindroth tray. *Artichoke II*, lithograph, by Sarah Graham.

Page 30-31 Bookcases designed by Rita Konig. William Yeoward brass table lamp on faux bamboo side table. 19th-century sofa from David Bedale. Victorian armchair by Gillows, with silk suzani cushion bought in Turkey and Colefax and Fowler fuchsia chintz cushion. *Circle (Pink to Purple with Free Wheels)*, 1968, by Michael Rothenstein, from Jenna Burlingham Fine Art, above *Still Life 2* by Breon O'Casey. Above the fireplace, *Bathers on a Riverbank*, attributed to Robert Duckworth Greenham, from Odyssey Fine Arts. The rug is from Robert Kime.

Page 32 Blind fabric is Titley and Marr 'Persian Paisley'. Light fixture by Antoinette Poisson; sconce by Pooky Lighting. Star bed linen from The Conran Shop; vintage D Porthault blue hearts bed linen bought on eBay.

Page 33 Clockwise from top: Lampshades by Robert Kime on the chest of drawers; Matilda Goad lampshade near window. Watercolours by Graham Rust of Tyringham House, where Rita's father was born. Lucy Jane Cope hand-painted Squiggle shade from Rita Konig on wall light by bed; D Porthault hearts pillow; Nicole Fabre fabric on eiderdown. Braquenié 'Vermicule' wallpaper in bathroom; timber painted in Little Greene 'Stock 37'; vintage fabric from Red Table, Hudson, NY; vintage chair from Nook Antiques.

Page 34 Above: Walls papered in 'Pomegranate' by Totty Lowther, from Lewis & Wood. Antique hand-embroidered cotton lawn curtain, a gift from Rita's mother, behind bed; 'Emilie' by Nicole Fabre curtains. Early Regency bench upholstered in Claremont check; vintage cast bronze giraffe lamp bought at Alfies Antique Market. Below: Walls painted in Little Greene 'Drizzle'. Above fireplace, a print of monkeys, part of a clear out Rita's mother had. To the left of the window, pastels of Walworth Castle, a house that belonged to Philip's family.

Page 35 Walls painted in 'Leather II' from Paint & Paper Library. Bathroom fittings from Burlington. English oak boards from Freeman Attwood. Basket for toilet paper bought on Instagram.

Page 37 Rita stands in the doorway to the scullery. Back wall is painted in Plain English 'Scullery Latch'. Plain English 'Milky Tea' door. Curtains are in Lee Jofa 'Entoto Stripe'.

VEERE GRENNEY

Page 42-43 Coffee table by Gerald Bland. Rug by Cogolin.

Page 51 Artwork by unknown artist. Cabinet by Maison Jansen. Bowl by New Zealand artist Gavin Chilcott.

WENDY NICHOLLS

Page 55 New Hall and Derby china on the mantelpiece.

Page 56 Curtains are 'Toile de Riom', bought from Sibyl Colefax & John Fowler, from the trompe l'œil panelled room at Brook Street.

Page 57 Top right: 19th-century painted chair has a seat in Sibyl Colefax & John Fowler 'Seaweed & Roses', which is discontinued, but there are plans to reprint it. The hyacinth vases are planted each year with bulbs. Below: Wendy bought the French abstract, artist unknown, over the fireplace before she had anywhere to put it. Left of the fireplace, a Keith Roper pastel hangs above a Sutherland landscape by Peter Beckett. To the right, a John Wells work from 1963 hangs above a Peter De Wint watercolour. The carpet is Jagger by Robert Stephenson.

Page 58-59 Abstract painting above sofa by Su Trembath. Sofa covered in Claremont ticking stripe. Cushions in Sibyl Colefax & John Fowler 'Auricula', discontinued, but can be ordered.

Page 60 Clockwise from top left: Chair covered in a discontinued Manuel Canovas weave; cushions Sibyl Colefax & John Fowler 'Leopard Stripe' in green, discontinued, but available to order; blue and white garden seat used as a table; one of a set of 18th-century prints of Roman pavements in England – 'I love them for their subject matter and abstraction,' says Wendy. Bench seat in Sibyl Colefax & John Fowler 'Seaweed & Roses', discontinued, but there are plans to reprint it; floor of original Norfolk paments. Bedroom walls painted in Paper & Paint Library 'Wattle'; 19th-century landscape hangs above Princess Charlotte Augusta by Cosway, being guarded by a British lion; circular table, with original paint, is 18th-century Scandinavian; lamps are sang de bœuf; curtain fabric from Chelsea Textiles.

Page 63 Walls painted in Farrow & Ball 'Gervase Yellow'. Curtain fabric is Chelsea Textiles 'Wild Flowers' in white. Bedspread is an enlarged copy of a Regency one Wendy owns, and reproduced for her by Chelsea Textiles. Housemaid's lampshades in an old Aleta fabric. Pictures include 19th-century botanical prints plus a watercolour of Wendy in her Moses basket.

BEATA HEUMAN

Page 66 Handmade stoneware Cormorant and Egret mirrors by Gail Dooley. *Ageing Picasso looking at his Ageing Tiger* by Marianne Stalin above the fireplace. 1970s French woven armchair.

Page 69 Mirror is bespoke. Simple unlined curtains are in a Pierre Frey linen.

Page 70-71 Striped fabric by Donghia. Bespoke pouffe in a Scalamandré silk velvet. Tray from The Lacquer Company. Painting above door on left is by Beata's husband's uncle, Donald Hamilton Fraser.

Page 73 Brass tap from deVOL. Wall light by Hector Finch and clock from Julian Chichester.

Page 74 Small rug from Penny Morrison. The sun chair and stool are vintage.

Page 75 Vintage Audoux Minet pendant light. Eiderdowns, of vintage fabric, found on Etsy. Zara laundry basket.

Page 76 Clockwise from top left: Shell wall lights from Felix Lighting; ferns from Beata's garden in frames around the basin. Bathroom wall lights from Felix Lighting; bespoke mirror; Christopher Farr linen, with Samuel & Sons grosgrain trim, for blind. Bedroom wall colour from Francesca's Paints; bespoke eiderdown in a George Spencer Designs silk; scatter cushion in a Le Manach by Pierre Frey fabric; bedside table from the Nicky Haslam for OKA Collection; print above mirror is an enlargement found in an 18th-century French book on fantastical sarcophagi by Delafosse – Beata tea-stained the paper for extra effect; light from Vaughan Designs, shade from Pooky Lighting; small copper etching on bedside table is by Beata's best friend, Vanessa Garwood. Bespoke bed in guest room covered in 'Palm Drop' by Beata Heuman; wall lights from Vaughan Designs and shades from Pooky Lighting; print above bed is from the Delafosse book, as above; seagrass wallpaper from Phillip Jeffries; roll cushion fabric, now discontinued, from Turnell & Gigon.

ROGER JONES

Page 80 Walls painted in Farrow & Ball 'Light Blue' emulsion; woodwork painted in Farrow & Ball 'New White' emulsion. Pair of fireside chairs covered in 'Seaweed' linen, custom-printed by Sibyl Colefax & John Fowler. George III tripod table from Roger's family. Early 18th-century Frankfurt faience converted to a lamp.

Page 83 Walls and woodwork painted in four shades of off-white emulsion based on Farrow & Ball 'Old White' and 'Off-White'. Ancaster stone floor. Convex Wall Lantern from Sibyl Colefax & John Fowler, from an old Colefax and Fowler design. Brussels weave stair carpet, custom-made to Roger's design. Two pictures from a set of nine late 18th-century copperplate engravings of paintings by Gaspard Poussin and others.

Page 84 Above: Roger and Gregory replaced the ochre lime render, which had been removed in the 1980s; all the chimneys were rebuilt and the house reroofed, using the original slates; bell on the side of the house dates from the early 20th century when the village school was held in three attic rooms; Craig Hamilton's Roman Doric portico just visible; steps lead up to the roof terrace outside the main bedroom. Below: The

matching overmantel mirrors were made from a pair of 19th-century French silver gilt mirrors; Michael Smith printed linen on the wing armchair; pair of Howard armchairs covered in Claremont 'Cunard'; painted 18th-century wall clock, bought at auction in Copenhagen; George III yew wood sofa table, bought from Sibyl Colefax & John Fowler; early 19th-century Scandinavian clock, 19th-century opaline column lamp and Chinese blue and white oval dish on table; pair of wall lights by Oliver Messel.

Page 86-87 Walls and curtains in a woven fabric by Larsen, discontinued. Sofa upholstered in green ticking from Claremont. Howard armchair upholstered in 'Honeysuckle', custom-printed on linen from Sibyl Colefax & John Fowler.

Page 88 Walls painted in Farrow & Ball 'Lime White' emulsion; woodwork in Farrow & Ball 'Bone' eggshell. Rush mat from Rush Matters. Chair seats in check fabric from Claremont. Oval yew wood French gateleg tabe from Edward Chetwynd. Oil painting of fish and fishing rod bought at an auction in Salisbury for this room, which overlooks the river in the valley below.

Page 89 Clockwise from top left: Banquette with fringe belonged to Nancy Lancaster – one of a pair in the Yellow Room at 39 Brook Street; Robert Kime linen print cushions; 18th-century Italian painted open armchair covered in 'Bees and Cloves', a custom print available through Sibyl Colefax & John Fowler, a favourite of John Fowler and Roger's; 18th-century painted tole lamp with shade made from a sari Roger bought in New Delhi. The kitchen window and shutters were originally in the hall; walls painted in Farrow & Ball 'Fowler Pink' emulsion, cabinets in Farrow & Ball 'Lime White' eggshell, and other woodwork in Farrow & Ball 'Bone' eggshell; ceramic French light from Hector Finch; Victorian pine table and kitchen chairs bought from a friend who was downsizing. Arched recess between the hall and drawing room was formerly square-headed and on the drawing room side; early 19th-century English faux-malachite painted, lyre-shaped clock bought from James McWhirter Antiques; pair of steel and brass lamps, by Ciancimino, from previous flat; oil painting by Charles Towne, bought from William Thuillier. Architect Craig Hamilton intended the garden hall ceiling to be vaulted, which Roger plans to do one day; walls and woodwork are painted in four shades of off-white emulsion based on Farrow & Ball 'Old White' and 'Off-White'; large 18th-century hunting scene in Kentian frame, attributed to Francis Sartorius, from Sotheby's sale of contents of Hadspen House, Somerset, in the 1990s; 18th-century Italian pen and ink drawings of fanciful architectural cornices, from Stephanie Hoppen; 19th-century bronze bust of an unknown youth, after an antique original from Pompeii, bought at auction in Copenhagen; 18th-century style camelback sofa, slip-covered in check fabric from Claremont, from previous London flat; pair of late 19th-century Minton ceramic garden seats; Roger and Gregory often have lunch or dinner in the summer at the oval mahogany tripod table, English, c.1760; late 18th-century English creamware tureen; 18th-century English walnut ladderback chairs; painted chest in foreground, 19th-century Moroccan, from previous London flat. Chinese export lacquer bureau bought from Geoffrey Stead Antiques. Pictures above Aga, reproductions of 1930s designs for Shell posters. Walls of attic bathroom painted in Tŷ-Mawr 'Strawberry Sundae' natural emulsion, and woodwork in Farrow & Ball 'Elephant's Breath' eggshell. Roger and Gregory have recently finished terracing what was once a steeply sloping wilderness. The 1810 wing of the house is to the left of the buttress, with the older part behind.

Page 90 Walls and ceiling of attic bedroom painted in Tŷ-Mawr 'Golden Sands' emulsion; curtains and cushions in Colefax and Fowler 'Climbing Geranium', now discontinued; abaca woven rug; C&C Milano double width woven fabric, now discontinued, for bedspreads; 19th-century English quilt; wing armchair and 18th-century Gainsborough chair upholstered in Colefax and Fowler woven fabrics, now discontinued; 18th-century Dutch elm desk chair, with cotton check upholstery, now discontinued; early 18th-century chest of drawers, bought locally; late 18th-century Gothic oak hall chair, one of a pair.

Page 91 Woodwork painted in Farrow & Ball 'Off-White' eggshell. Floor of reclaimed Victorian ceramic tiles with underfloor heating. Early 19th-century lithograph of a fig.

NINA CAMPBELL

Page 94 Addison standard lamp by Vaughan. Tini table and Ralph chair by Nina Campbell in foreground. Oval Pagoda metal coffee table by Nina Campbell. Sofa upholstered in Bintan weave fabric by Nina Campbell at Osborne & Little. Alice chair by Nina Campbell.

Page 97 Ombre gloss painted finish by Henry van der Vijver. Chairs upholstered in 'Donuts in Chocolate' by Galbraith & Paul.

Page 98-99 Nina found the fire surround on Atlantic Avenue, New York, while shopping with her daughter, Rita, and had it shipped over. It's not a working fire – crystal logs are in the fireplace. Glass etched screen by Guillaume Saalburg. Painting above fireplace by Sophie Coryndon. Fernand Léger lithograph above small table; all ceramics on table by Kate Malone, except cactus.

Page 101 Top left: Walls papered in 'Bonnelles' by Nina Campbell at Osborne & Little; Milborne headboard by Nina Campbell, upholstered in 'Colette' by Nina Campbell at Osborne & Little; half tester bed designed by Nina in sheer fabric with bauble trim; antique French chair upholstered in 'Fontainebleau' by Nina Campbell at Osborne & Little; Charlie chest of drawers by Nina Campbell. Below: Walls upholstered in 'Penrose' by Nina Campbell at Osborne & Little; linen blind in 'Colette' by Nina Campbell; Millais chair by Nina Campbell upholstered in 'Penrose' by Nina Campbell at Osborne & Little.

Page 103 Green Filigrano hand-blown Murano glass by Rita Konig; clear glassware by Nason Moretti at Nina Campbell; Marie Daâge plates from Nina Campbell; Green Fern napkins from Nina Campbell.

PAOLO MOSCHINO AND PHILIP VERGEYLEN

Page 107 'Opium' by Nicholas Haslam fabric on bed. A 1950s Maison Charles lamp by bed.

Page 112 Clockwise from top left: Stela standing lamp from Nicholas Haslam; oil painting by André Lanskoy at end of left-hand wall; two plates and goblet by Jean Cocteau. Black metal dining chair from Madeleine Castaing. Terracotta of Marie Antoinette on dresser. Paris table lamp from Nicholas Haslam Ltd; collection of wooden religious statues on the 18th-century Swedish chest of drawers.

Page 113 A collection of Kate Malone pottery on the mantelpiece. Sofas from Nicholas Haslam Ltd.

Page 114 Bedhead fabric by Robert Kime.

ALIDAD

Page 121 Ottoman panel, early 17th century, above Noletti painting.

Page 122 *khate poolsaze parsi*, by Mahmoud Bakhshi, on the left-hand wall. Hadrian octagonal side table with moleanus limestone top from Alidad's Velvet Furniture Collection. Nest of tables from Chelsea Textiles. 19th-century gilt twin seater sofa upholstered in 'Figaro' by Colony. Club fender, 'Ocelot' by Lelièvre. Aubusson-style rug made in China in the late 20th century, in 18th-century style.

Page 123 Head of Nijinsky, by Una Vincenzo, Lady Troubridge (1887-1963). The smaller painting above the console table is *Shrine at Messina*, by Alexander Mann, R.O.I.. Victorian button upholstered side chair, c.1800, covered in 'Lisere Ungherese All Over' by Colony.

Page 124-25 Middle cushion, with appliqué work, from Holland & Sherry. French oak fauteuil, to the right, in Regency style and covered in 'Sforza' by Pierre Frey.

Page 128-29 Painting above the fireplace of Ottoman Sultan Murad I, after Konstantin Kapıdağlı. Augustus console table with polished oak top from Alidad's Velvet Furniture Collection.

EMMA BURNS

Page 132: Walls painted in Farrow & Ball 'Buff'; skirting and staircase in Farrow & Ball 'Railings'.

Page 135 Walls painted in Farrow & Ball 'Biscuit'. Wing chair in matelassé de laine from Claremont Furnishing. Cushion on wing chair in Bennison Fabrics 'Benjelloun'. Victorian Measham bargeware teapot and ceramic butcher's shop bull from Greenway Antiques. Curtain poles from McKinney & Co. Lampshade on green demijohn lamp, Aleta 'Water Green Laura'.

Page 136-37 Joinery by Christopher Bell. Bespoke lantern over bench from Sibyl Colefax. Light over stable door by Howe.

Page 138 Napkins by Muriel Grateau. 17th-century oil painting under painted sign.

Page 139 Clockwise from top left: Rosso Antico marble benchtop. Lamp to left of photo made from antique soda siphon; cloth over Aga rail from Cabana. Antique sign from Valerie Arieta. Sink cupboard specialist painted; lampshades in a discontinued Le Manach toile; antique manganese Delft tiles; reclaimed flagstone floor.

Page 140 Slip covers in Robert Kime 'Opium Poppy' linen. Cushions all antique textiles from Susan Deliss. Billy Baldwin standard lamp by chair from Sibyl Colefax & John Fowler.

Page 141 Clockwise from top: Exterior timber painted in Farrow & Ball 'Pigeon' in gloss; joinery by Christopher Bell. Bedroom walls and woodwork painted in Farrow & Ball 'Shaded White'; antique screen from Sibyl Colefax Antiques; Ikea duvet and pillowcases, cushion on bed from Yastik; suzani on wall from Susan Deliss; single chair painted off-white and seat covered in leftover Fortuny; ashtray from David Hicks Paris. Bookcases painted in Farrow & Ball 'Shaded White'; vintage sofas covered in olive green corduroy; antique jajims as cushions; large red linen stool from Lorfords Antiques; large demijohn lamp from A.Prin Art; shade in Fermoie 'Poulton Stripe'.

Page 142 Walls painted in Farrow & Ball 'Buff', and balustrade and handrail in Farrow & Ball 'Railings'. Colefax and Fowler Gothic hanging lantern.

JANE CHURCHILL

Page 146 Tables are from William Yeoward. Painting of melons bought at M Charpentier Antiques.

Page 150-51 Walls painted in limewash from Francesca's Paints. Lamps are from OKA, and lampshades from Penny Morrison.

Page 152 Top left: Chandelier belonged to Jane's sister Melissa. Top right: Painting of Suffolk Punch horse by Susan Crawford; middle picture by William Shayer, bottom picture, 'Rather charming rubbish from a junk shop!'. Ceramic pot given to Jane by her middle son Dominic; greyhounds from David Ker Fine Art. Below right: Lamps from Tyson. London with shades from OKA. Artwork by Bianca Smith.

Page 155 Club fender from Acres Farm Club Fenders. Lamp from Tyson.London. Mauve cushion from Yastik.

MIKE FISHER

Page 156 George IV central table, c.1820, in flamed mahogany, from Jamb. Pair of flanking portraits by Robert Pine (1730-1788) of a gentleman and lady. Upper gallery painting, *Narcissus*, by Giacomo del Pò (1652-1726). Chandelier, c.1720, a replica of a George I gilt gesso one by James Moore, from Edward Hurst.

Page 162 Bird cage taxidermy by Ferry van Tongeren and Jaap Sinke.

Page 163 French-style chairs from The Parsons Table Company; 18th-century lantern, Delaval, from Jamb.

Page 164 Top left: The hall walls are painted in 'Merde de Pigeon', mixed by Tony Malins; a pair of architectural scenes by Antonio Joli (1700-1777) and a pair of classical scenes, *Figures Bathing in Landscape* and *A River Landscape with Figures Fishing*, by Jules César van Loo (1743-1821) hang on the walls. Bottom right: The sofa in the upper gallery is upholstered in Sabina Fay Braxton 'Tiger's Eye', Butterscotch, supplied by Alton-Brooke; cushions from Clarence House, in 'Samburu', Natural.

Page 166-67 Camelback sofas George III, c.1730, upholstered in cotton velvet by Alton-Brooke. Ziegler carpet, c.1900. Russian neo-classical chandelier by Johann Zech, c.1800. Faux bamboo ottoman from Tatiana Tafur, covered in 'Flocon De Neige' by Clarence House. Pair of 19th-century French fauteuils, upholstered in 'Madame du Barry' by Rubelli. Cornice details picked out in 22 carat gold.

Page 168 Walls painted in 10B and 10D Stone shades by Papers and Paints. Sofa upholstered in Zimmer + Rohde 'Loft'. Artwork *By Water* by Ivon Hitchens, c.1950.

Page 169 Walls painted in 'Buttercup', mixed for the room by Tony Malins. Curtains in Pierre Frey, Braquenié, 'Princess Palatine', and made by Manny Hopkins. *One for Brian*, by Ken Howard, is flanked by a pair of Swedish Empire wall sconces.

Page 170 Walls hung in Donghia 'Jack Rabbit' in Blue.

Page 171 Clockwise, from top left: Pair of 18th-century French painted chairs upholstered in Watts of Westminster 'Maurice Bead', Welbeck Blue; rug by Holland & Sherry. Antique bath from The Water Monopoly; roman blind fabric, 'Valkyrie Flame Stitch' in Delft from Schumacher; walls in Papers and Paints SC294; French silvered chandelier, c.1860, from Matthew Upham Antiques. Bed canopy by Studio Indigo and A.T. Cronin in 'Marinella', Celeste Blue fabric by Watts of Westminster; set of views of the Russian capital; walls painted in 'Beauvais Grey' by Papers and Paints; curtains in Mauve 'Queen Anne Vine Very Intense' by Chelsea Textiles, and made by Manny Hopkins; Klemens Deauville rug from Holland & Sherry.

Page 173 Walls of the drawing room painted in 'Battlesden Pink', mixed by Tony Malins. Portrait by Diarmuid Kelley.

SARAH VANRENEN

Page 180 Top left: Chest of drawers from a Lillie Road antique shop; chairs inherited from Grant's father. Top right: The space is brightened by the yellow chair, inherited from Grant's mother, lampshades, and multi-coloured cloth thrown over a large console. Middle row, left: Silver lamps from a Battersea decorative antiques fair surround and disguise the recessed television. Middle row, right: The terrace was added at the back as, previously, the house had no access to the garden.

Page 183 Sarah with Fly, a Bedlington terrier/Italian greyhound cross. A set of Sixties chairs with plastic cushions, previously owned by her mother-in-law, were painted blue by Sarah, and covered in French ticking.

DANIEL SLOWIK

Page 184 The plants were nurtured from cuttings, all gifts from gardening friends, and carefully sheltered over winter from the East Anglian cold.

Page 188-89 The table is laid with 19th-century ceramics from Minton and Wedgwood, 1960s glasses from Whitefriars and bud vases from Sibyl Colefax & John Fowler. An armchair and lampshade are both covered in an archive Sibyl Colefax pattern, 'Squiggle'. The curtains are vintage chintz, possibly French, that came with the house. Sibyl Colefax & John Fowler line painted console table, made to an original design by John Fowler.

Page 190 The monochrome sketches are 18th-century political subjects.

Page 191 Clockwise from top: Bennison Fabrics 'Wheat Flower' on the smaller sofa. An original 1970s Liberty print covers the larger sofa, given to Daniel by Roger Jones. Cushions made from a variety of antique African and Asian cloths, and the two 'Seaweed' cushions in a custom colour from Colefax and Fowler were made from the remnants of the fabric walling of a room in Colefax's former premises in Brook Street. Ceramics span seven centuries, with European, Asian, Middle Eastern and African examples, including contemporary work by Kate Malone. The plates on the wall brackets are Chinese Kangxi, and next to them hangs a large early 19th-century French Nocturne in its original frame. The room is mainly used at night, so it creates a wonderful 'moonlit window'. The 'worst copies ever' of the Marly Horses are a source of great amusement, given to them as a birthday present by a friend. Lilacs in a demi-lune tiered vase from Sibyl Colefax & John Fowler. In the 'library', the self portrait is an early work by close friend William Foyle. The blind is a Sibyl Colefax & John Fowler archive pattern, 'Venetian Stripe', designed by John Fowler. Ceramics from various periods sit on the desk, as do a Han dynasty pot made into a lamp, an unusual Qajar painted box, and 18th- and 19th-century English and French pieces. In the dining room, a drinks cupboard was adapted in the 1970s from a Georgian linen press and painted white, its handles changed for crystal, adding another white tone to the room. The armchair was found in a local house clearance auction for peanuts, and re-covered in a custom 'Squiggle' linen from Sibyl Colefax & John Fowler. The lampshade is the same design in a hand-screenprinted paper. The chrome lamp was designed by Billy Baldwin, and produced by Sibyl Colefax & John Fowler. Cushion is made from antique Swat Valley floss work, from Sibyl Colefax Antiques.

Page 192 Cushions are in an archive Colefax chintz, 'Bailey Rose'. The mantelpiece supports a collection of items 'collected for their extraordinary expressions' – a Chinese blanc de Chine figure of a goddess riding what appears to be a giant pug, a zebra with a face like a lurcher, a spaniel with a hang-dog air and a Kashmiri lacquer tray with a depiction of Heaven and Hell. The mirror has been cut down by 80 per cent at some point in its life. A 1930s oil painting of Eve tempting Adam bought from a French dealer, formerly in Paris. The felt work cushion glimpsed on the chair is of Bette Davis in *Whatever Happened to Baby Jane*.

Page 193 Large lamp, from Sibyl Colefax Antiques, made of papier mâché. Large gilt wood carving running along the wall is an architectural element from a Chinese court official's house.

Page 194 Clockwise from top left: 18th-century Venetian palazzo chair is slip covered in 'Bees', an archive Sibyl Colefax & John Fowler fabric; painted X-frame stool is after a design by John Fowler, and covered in Colefax and Fowler 'Malabar' in blue; brown and white transferware plate was made to celebrate the coming of age of Viscount Clive, a relation of Daniel's; wall bracket is a model made by Sibyl Colefax & John Fowler. Walls painted in a custom blue to pick out the blue in the vintage Bennison 'Roses' fabric of the curtains, given to the couple by a friend. The bedroom is covered in 18th- and 19th-century prints, and a collection of watercolours of Venice they have assembled together. Cushions on the bed covered in an African barkcloth and 'Malabar' in blue from Colefax and Fowler. Bedcover is a 1920s fabric given to them by their neighbours, found in an old family trunk. Floor is layered with rugs, including a custom Sibyl Colefax & John Fowler design, 'Roman Pavement'.

Page 195 A collection of Chinese and Japanese lacquer on top of the Aesthetic movement credenza made by Lamb of Manchester. White porcelain Meissen mirror is a 19th-century copy of an 18th-century original.

Page 197 1940s silver standard lamp has a shade made by Robert Kime for Benedict. Irish Georgian cane chair from Sibyl Colefax Antiques, the squab covered in a Colefax and Fowler plaid fabric.

KIT KEMP

Page 198 Curtain fabric by Abbott + Boyd. Found fabric upholstering the chair, and the cushion is of Kit's dogs, and made by Fine Cell Work.

Page 204 Fabric by China Seas on the chair. The sofa fabric is by Chelsea Textiles. The ottoman fabric is from Kurdistan.

Page 207 The sofa is upholstered in Kit's 'Friendly Folk' fabric for Andrew Martin. Molly Mahon's 'Oak' handblocked fabric is used for the curtains.

Page 209 Top left: Curtain fabric is by Nina Campbell.

JUSTIN VAN BREDA

Page 212 Walls painted in Farrow & Ball 'Cream'. The rug was from Justin's parents' dining room. 'The window casements house shutters, so we don't have or need curtains, and they are so pretty,' says Justin.

Page 219 Clockwise from top: Justin van Breda's Monty sideboard in a hand-painted and gilded finish. Chairs, in Belgian linen, are from his collection; Justin and Alastair created the mobile by hanging glass candle globes on a tree branch from the garden. The oldest cushion on the sofa is by Sanderson, last printed in 1952, 'so at least as old as the Queen's reign', says Justin. He bought the silver gilt lamps in 1995 at a junk shop in Cape Town for the equivalent of about £1. A ship's safe is in the fireplace.

Page 220 Clockwise from top: Walls painted in Farrow & Ball 'Slipper Satin'; kitchen table from Lorfords; chicken painting is by Patricia Van Diest. Bedroom walls are painted in Farrow & Ball 'Shaded White'. Furniture at the end of the bed belonged to Alastair's mother, and is now upholstered in Justin van Breda's 'Brighton Beach', Royal Navy colourway. The eiderdown is the way Justin always dresses a bed. He had it covered in a fabric called 'Persian Lamb' that he bought in South Africa. 'None of the paintings, apart from the one of Margot, is very special, so we hung them all together to create this interesting tableau,' says Justin. 'On the way up to the top floor, it's all images of friends at events and parties taken at the house over the years.'

PENNY MORRISON

Page 230-31 Walls are painted in Farrow & Ball 'Arsenic'.

Page 237 Penny is with Gobi.

GUY OLIVER

Page 238 Scroll cabinet with basketweave panels designed by Guy Oliver. Curtains in a brushed navy blue cotton by GP & J Baker. Indigo and ivory Japanese ceramics from Willer. Cobalt blue bowl made by Guy in a pottery class.

Page 241 The antique verde tinos chimneypiece was installed by Guy. The temple box he designed was made in Kabul by carvers from Turquoise Mountain Foundation. The rice sickle and carved, painted wooden bird are from Cambodia.

Page 242 Top left: Chair fabric is Colony 'Marly'; 1960s poster shows the home of Guy's friend and mentor Michael Inchbald; silver desk lamp designed by Guy Oliver. Top right: Antique Japanese table lantern was bought by Guy on a working trip to Japan. The cushions are by Fine Cell Work, a charity which Guy supports. The lamp base is by William Mahornay. Bottom right: The cabinet in the background was designed by Guy Oliver.

Page 243 The original fabric is still on the 1960s wing chair. Black Jasper table lamp.

EDWARD BULMER

All paints by Edward Bulmer Natural Paint.

Page 249 Bisque group of Ariadne on the Panther, after Dannecker. Lamp by Collier Webb.

Page 250-51 Curtains in block-printed cotton from Anokhi, Jaipur. Bessarabian design rug woven by David Bamford. Verre églomisé mirror from Julian Chichester.

Page 252 Clockwise from top right: Walls painted in 'Turquoise'; terracotta bust of the Comtesse de Noailles by Pajou, 1780; paint display cupboard designed by Edward. Queen Anne oyster veneer mirror in bathroom; designs by Edward for garden buildings. Side table in music room by Pembridge Furniture; printed cushions from Brigitte Singh; embroidered cushion from Javed Abdulla; lampshade from OKA.

Page 253 Kitchen walls painted in 'Brimstone' and 'French Grey'; curtain fabric by Tissus d'Hélène and Fermoie; sofa designed by Edward and covered in Lelièvre mohair velvet; chairs from his old company Bulmer & Barrow; lampshade from Celia Kibblewhite.

Page 254 Walls painted in 'Lilac Pink'. Curtain fabric by Mulberry. Rug from Roger Oates.

Page 255 Edward designed all the furniture apart from the two-seater Howard sofa from George Smith.

Page 256 Right: Walls painted in 'Cuisse de Nymphe Emue'. Natural flatweave from David Bamford. Bespoke tiles from Bobby Jones. Edward encased the original bath in cherry.

Page 257 Edward designed the bed and curtain cornices. Curtains and bed valance from Chelsea Textiles. Tiebacks by Edward, available from Collier Webb. Bedside table from Julian Chichester. Rug woven by David Bamford.

Page 259 Porch painted in 'Noke Stone' linseed oil paint. Edward with Molly, both dressed by The Great English Outdoors.

GAVIN HOUGHTON

Page 260 Plates from top: Afghan shepherd by Michaela Gall; one bought in Bulgaria; Gavin's leaving present from *The World of Interiors*, a Hylton Nel plate.

Page 263 Sofa is from Howe. Greek key border is from Tissus d'Hélène.

Page 264-65 Curtain fabric is from Colefax and Fowler – the pelmet, says Gavin, took a long time to get right. 'The proportion is key.' He bought the nest of 1960s Chinoiserie tables online, and loves the splash of red. Cushion fabrics on the sofa are from Turnell & Gigon.

Page 266-67 Gavin found the curtain rings years ago. 'They remind me of dog collars,' he says. He got the curtains when they were being thrown out by a client. Dining chairs are his designs – the upholstered one is the Josephine chair and the other, the Lodge chair. Fire surround and red table are from Sibyl Colefax Antiques. Still life over the fireplace is from his framers at Notting Hill. The reclaimed floorboards are from LASSCO. 'They totally transformed the room – it was concrete before.'

Page 270 The rug, from eBay, 'fits the room perfectly, and was as cheap as chips', says Gavin. Lithograph of the Kasbah entrance in Tangier, next to Gavin and Boz's house. Large cushion is by Madeleine Castaing from Turnell & Gigon.

Page 273 Gavin with Jack and Jill. 'Jill has the eye patch,' he says. 'They are husband and wife. I rescued them from up north, and they're the nicest dogs.'

CARLOS SÁNCHEZ-GARCÍA

Page 274 1900 Arts and Crafts for Liberty of London table. Georgian armchair upholstered in a Robert Kime Swedish ticking; ikat fabric on the cushion also by Robert Kime. The watercolour of two racing greyhounds above the fireplace is by Susan Crawford, and was bought at auction at the local church to raise funds to restore the lead roof that had been stolen. Plates are 17th- and 18th-century Chinese porcelain. Curtains are a heavy linen stripe by Ian Mankin with a bespoke fringe.

Page 277 Walls painted in Farrow & Ball 'Cooking Apple Green'. The handmade shepherd's crook, from Scotland, was a gift from a friend.

Page 278 Shelves, made by a local carpenter, painted in Farrow & Ball 'Cooking Apple Green'. Gingham by Ian Mankin. Table was bought from the couple's gardener for £5, and painted in Farrow & Ball 'Mole's Breath'. Platters from Richard Scott Antiques, Holt.

Page 280-81 Walls painted in Farrow & Ball 'Bone'. *Dulcinea*, the painting to the right of the fireplace, by Gregorio del Olmo. The chair in the foreground is an early Howard & Sons, upholstered in a Persian stripe by Susan Deliss, with a cushion covered in a Robert Kime ikat fabric. On the mantelpiece is a 19th-century French Empire clock and Staffordshire dogs. Mirror is 18th-century, in the style of William Kent, from Adam Bentley. Lamp on the left is made from a 19th-century imari vase, with shade from Robert Kime. The one to the right is 19th-century Chinese, with the shade made from silk ikat Carlos found in Istanbul.

Page 283 Walls are painted in 'Parma Gray' by Farrow & Ball. China on the cupboard is 18th-century Delft. The chairs, part of a set of 19th-century barley twist in the manner of William and Mary, are covered in a Turkoman stripe weave by Robert Kime with bespoke tassels.

Page 284 Cushion pad on chair is a Colefax and Fowler chintz. Bespoke lampshade in a silk voile by Aleta. One jug is antique Gaudy Welsh and the other Bohemia Crystal. The late 18th-century watercolour is by a German traveller to the UK.

Page 285 Walls painted in Edward Bulmer 'Rose Tinted White'. Bed upholstered in 'Tree Peony' by Robert Kime, with the lining a glazed cotton by Nile & York. Cushions on the bed are a lampas by Colony with bespoke tassels. Shades on bedside lights are an ikat from Robert Kime. Two elbow chairs, bought locally, are Regency provincial, and upholstered in a Namay Samay geometric weave. Edwardian sofa at the end of the bed is upholstered in a Soane fabric, with pink cushions a silk weave by Namay Samay. The pictures above the chairs are part of a series of watercolours by a late 18th-century German traveller. The large print above the table is by Eric Ravilious; above the right-hand side table is a painting by Gregorio del Olmo and above the left-hand side table is an artwork by Nicola Beattie. The pictures to either side of the bed are 19th-century cigarette box silk embroidery covers framed, a gift from Carlos' mother on one of her trips to visit the couple.

Page 287 The table with the converted Chinese lamp is one of a pair of antique Moorish Arts and Crafts Liberty tables. The cabinet is 19th century, in the style of William and Mary. Two 19th-century Chinese gouaches hang above the chair.

OCTAVIA DICKINSON

Page 290 Walls painted in Papers and Paints 1-023, and woodwork in Farrow & Ball 'Pointing'. Curtains Claremont 'Milano' linen 501, with piping in Claremont 'Milano' linen 521. Light bronze curtain poles from Hunter & Hyland. Octavia bought the chairs from The French House antiques for her previous flat, and covered them in Hesse linen. Chair cushions from Penny Morrison. Ottoman covered in Clarence House 'Pienza' Multi. Antique wooden bookcase was a present from Octavia's parents. Octavia bought the brass floor lamp at the Soane sale; lampshade is by Penny Morrison. Artwork by Barbara Kitallides.

Page 293 Chair seats in Linwood 'Omega' velvet and cushion by Ian Mankin. Kitchen joinery designed by Octavia and made by The London Workshop. Square mesh caning in cupboards from Cane Store. Cupboards painted in Little Greene 'Stone Mid Warm' 35; cupboard knobs bought on Etsy. Rug used to belong to Octavia's parents. Blind fabric, Namay Samay 'Marak' Sandalwood. Painting on left by Angela A'Court; black and white print of ice skaters by Bill Jacklin; painting of apples by Octavia's sister Phoebe Dickinson; ceramic sardines by Diana Tonnison. Ceramic squid plate on extractor, by a favourite ceramicist Claudia Rankin, was Harry's wedding present to Octavia (he calls her 'Squid') and was commissioned through Wilson Stephens & Jones. The strawberry lamp is one of a pair, and one of Octavia's prized possessions. Purple flower candlesticks from Penny Morrison. Freight brass pepper mill was given to Octavia and Harry by friends. 'It's the best pepper grinder there is.' Of the Roberts radio, Octavia says, 'Cindy Leveson taught me that you always need a pop of red in every room!'

Page 294 Clockwise from top left: Door fabric from J.D. McDougall; Holloways of Ludlow ebonised wood beehive door handle; Carrara marble top; floor by The Natural Wood Floor Company. Snake candlestick in the hall found at the Bath Decorative Antiques Fair; Richard Phethean yellow and blue vase was a present from Octavia to Harry; tile by Paula Rego; Stella is at the front door. Shelving in drinks cupboard is painted in RAL 5013 'Cobalt Blue' gloss; Kalinko rattan ice bucket; Octavia loves purple glass – both sets are antique; bright green glasses from OKA; she found the two small apricot glasses in a junk shop in Lewes where she goes china hunting with her cousin. Octavia changed the strawberry lamp flex to red, from Urban Cottage Industries; I love you print by Tracey Emin; pink Wedgwood plates are part of the collection hanging in the spare room, given to Octavia and Harry as a wedding present by her godmother.

Page 296 Walls painted in Farrow & Ball 'Lulworth Blue'. Linwood 'Pronto' in Chalk used for the valance, with a red border. Octavia's parents gave her the bed throw, from Le Club 55 shop in the South of France, as a birthday present years ago. Harry found the lamps at a car boot sale. The antique bedside table, to the left of the bed, was a gift to Octavia from her godfather. Wicklewood rug; Volga Linen bedding. Artwork above bed on left is a watercolour by Henry Harpinges, a gift to Octavia from her father; below it is a print by Sophie Mason from her series on plants; plates were a gift to Octavia from her parents; print in the centre by Elizabeth Blackadder; on right of bed is a painting by David Wilkie, a gift from Octavia's parents, and below, a photograph by Claudia Legge.

Page 297 Clockwise from top left: Walls of bathroom papered in 'Aspa' Raspberry by Sarah Vanrenen for Penny Morrison; joinery painted in Farrow & Ball 'Slipper Satin'; cupboard knobs from Chloe Alberry;

Vaughan Sussex swing arm bathroom lights in brass, with lampshades painted for Octavia by Sarah Blomfield; slate vanity, bath top and splashback; black and white plates from Anthropologie; colourful Charleston plate given to Octavia by her aunt; antique bamboo floor standing shelf; Harry found the mirror on eBay; artwork at left, by Octavia's cousin, Beatrice von Preussen, above, and Hugo Wilson, below. Stool in bathroom, from Philip Adler Antiques, was given to Octavia by her father, and has a top covered in a Nile and York fabric; bedroom cupboard knobs from Chloe Alberry; wooden pomegranates on hanging shelf a Christmas present from Flora Soames. Attic bathroom walls painted in Paint & Paper Library 'Glass V'; blind in Nicole Fabre 'Gigi' Poppy, now discontinued, with trim in Samuel & Sons 'Lancaster' border; café curtain in Hesse muslin; Carrara marble around the bath. Walls of the spare bedroom painted in Edward Bulmer 'Lilac Pink'; Claremont curtains and headboard fabric brought from Octavia's previous flat; valance used to belong to Octavia's mother; antique side chair given to Octavia by her parents; Vaughan Cornflower ceramic lamps with pale cream card shades.

COLIN ORCHARD

Page 305 Above: The panels, a recent purchase, are likely to be from a French panelled room. Below: Glaze wall colour specially mixed for the study. William Yeoward 'Percy' sofa covered in one of his weaves.

Page 306-07 Glaze paint, stippled onto the walls, was custom made. The red chair is an antique Gainsborough. The yellow chair is by William Yeoward, with slip cover in specially dyed linen with cream piping.

Page 308 Paint colour was specially mixed for the room. The new bronze light, taken from a Giacometti design, is by Tyson Bennison.

Page 309 Clockwise from top left: Antique Chinese pot and glazed biscuitware lion; William IV mahogany chairs. Hall walls painted in Farrow & Ball 'Hay'; the painting is of an Italian count; heraldic scenes, painted in vellum, are by Lucinda Oakes. The kitchen wall colour was specially mixed. The paint colour was specially mixed for the drawing room; cream linen-covered William Yeoward sofa, with an antique quilted bedcover on it; plaster over wire chandelier, bought from a Paris flea market; the carpet is an antique Ziegler, probably from around the middle of the 19th century.

Page 310 Clockwise from top left: Walls painted in Farrow & Ball 'Parma Gray'; antlers from a local junk yard; country style oak chair, around 1890s; hand-painted heads, glued to make a collage, bought at a Paris flea market; Mochaware china; antique creamware tureen; 1870s English oil painting of two dogs running. Bottles in the bathroom from a local junk shop. Cushions on the bed from Fine Cell Work, a charity that makes handmade products in British prisons; a pair of 19th-century copies of Adam mirrors; mahogany card table, c.1880, used as a bedside table. Painted table, probably French, and 1950s white painted cane chairs.

Page 311 Morris bed, designed and made by William Yeoward. Curtain fabric is a William Yeoward linen print. William Yeoward woven fabric loose cover on the sofa. William Yeoward rug. Antique chair with rush seat, oriental in design. Artwork by Hugo Guinness.

SOME FAVOURITE BRITISH BOOKS

Having devoured British children's books when I was growing up, it's not surprising that, as an adult, English writers, and particularly books set in England, have not lost their appeal. I have always loved the English country aesthetic, and I add books on this subject to my collection whenever I can. In my home, I love piling books on tables, here and there; that way they are always close at hand. I find myself moving them around and delving into them constantly. I have shelves crammed with books on the verandah, and this is a favourite place to read or, alternatively, gaze out at the garden. The following list is only a snippet of my favourite British books and authors, and I somehow feel they have played a big part in the way I like to decorate my home.

Almost anything by Anita Brookner, including *Hotel du Lac*, *Strangers* and *Leaving Home*

Ian McEwan's *Enduring Love*, *The Children Act* and *On Chesil Beach*

Many by Elizabeth Jane Howard, but especially *Cazalet Chronicles*

Mary S. Lovell, *The Churchills* and *The Mitford Girls*

Anne de Courcy, *The Viceroy's Daughters*

Christopher Lloyd, *The Well-Tempered Garden* and *The Year at Great Dixter*

The Gardener's Essential Gertrude Jekyll

Stephen Lacey, *Gardens of the National Trust*

Sarah Stewart-Smith, *Alidad The Timeless Home*

All of Nina Campbell's books

William Yeoward, *William Yeoward at Home*

William Yeoward, *Blue & White and Other Stories*

Martin Wood, *John Fowler: Prince of Decorators*

Chester Jones, *Colefax and Fowler*

Roger Banks-Pye, *Inspirational Interiors*

Nicky Haslam, *A Designer's Life* and *Folly de Grandeur*

Robert Kime, *Robert Kime*

Ros Byam Shaw, *Perfect English*

ACKNOWLEDGEMENTS

Firstly, I would like to thank Stephen King and Kate Pollard from Hardie Grant UK for agreeing to publish this book; I will never forget your enthusiasm at our first meeting at your office in London. Working with Kate has been a dream – her decisiveness and quick responses have made everything so easy. Thank you so, so much.

And thanks to Simon Griffiths for coming along and keeping up with the brutal schedule. There were exhausting days, I know – so thank you for all your hard work, and for the beautiful images in this book.

Preparing for this trip and project was quite daunting, in that I knew we had only one opportunity to capture everything we needed. I would especially like to thank Alex, my son, who helped me work out exactly what technical equipment I should be taking, and how to use it all. His assistance here was invaluable.

As with my first book, I would like to thank Kristiina, my daughter-in-law, who looked after the admin side of things and has kept her eye on media aspects of both books. I'm so grateful for your knowledge and expertise in this area.

And, of course, I can never thank the designers enough for their positive and enthusiastic participation in this project. Their warm welcome, hospitality, delicious lunches and, most of all, their valuable time was, and is, so greatly appreciated.

I could never have accomplished this book without my 'dream team' – Leta Keens, my incredibly clever editor, and Daniel New, our dream book designer. Leta, thank you for making everything so easy, enjoyable, fun and never stressful. And for keeping a steady hand on the project and making sure our schedule was kept to. I wonder how many thousands of emails have flowed back and forth between us. And Daniel, who's always calm, thank you for accommodating last-minute changes and requests, and for designing such a beautiful book. I will miss our meetings – our easy collaboration and our tea and cookies – even on the hottest of days when you had to 'borrow' a fan!

I would also like to mention and thank Jan and Royden Roche, our dear friends in Winchester. They looked after us on days off, taking us on lovely outings and inviting us to their home for Jan's excellent home cooking.

Lastly, I would like to thank my whole family – grandchildren included – for their enthusiasm, interest and support of both book projects. Having your encouragement has meant so much to me. I particularly want to thank Michael – Mr R-I – whose unfailing support and interest has kept me going. And for being such an enormous help while we were in the UK – doing the shopping, driving us around, organising train tickets and everything else, and for making sure I remembered everything. Thank you!

Published in 2020 by Hardie Grant Books,
an imprint of Hardie Grant Publishing

Hardie Grant Books (London)
5th & 6th Floors
52–54 Southwark Street
London SE1 1UN

Hardie Grant Books (Melbourne)
Building 1, 658 Church Street
Richmond, Victoria 3121

hardiegrantbooks.com

British Library Cataloguing-in-Publication Data. A catalogue record for
this book is available from the British Library.

British Designers at Home
ISBN: 9781784883461

10 9 8 7 6 5 4 3 2 1

Endpapers: Il Papiro Firenze together with Il Papiro Melbourne
Cover: Gavin Houghton
Title page: Colin Orchard
Contents: Penny Morrison

Publishing Director: Kate Pollard
Editor: Leta Keens
Design and Art Direction: Daniel New
Proofreader: Sarah Causton

Colour reproduction by p2d
Printed and bound in China by Leo Paper Products Ltd.